ARTS FUNDING

A Report on Foundation and Corporate Grantmaking Trends

Nathan Weber
Research Consultant

Loren Renz
Vice President for Research
The Foundation Center

Research Assistants:
Mirande Dupuy
Steven Lawrence

THE FOUNDATION CENTER

About the Report

The original research upon which this report is based was conducted by the Foundation Center with the support and collaboration of Grantmakers in the Arts. This comprehensive study of grantmaking trends is the fourth report published by the Foundation Center as part of its Benchmark Studies series. Other titles in the series include:

- *Alcohol & Drug Abuse Funding: An Analysis of Foundation Grants*, 1989
- *Crime and Justice: The Burden Study of Foundation Grantmaking Trends*, 1991.
- *Aging: The Burden Study of Foundation Grantmaking Trends*, 1991.

About Grantmakers in the Arts

Grantmakers in the Arts (GIA) is a national membership organization of primarily private sector grantmakers interested in the arts and arts-related activities. Its purpose is to strengthen arts philanthropy and its role in contributing to a supportive environment for the arts nationwide. Toward this goal, GIA sponsors a wide variety of activities which include convening an annual conference; publishing a newsletter several times a year; and coordinating special projects, such as the Benchmark Study, that address concerns of the nation's arts funders, practitioners, and participants.

About the Foundation Center

The Foundation Center is a national nonprofit service organization supported by foundations and corporations and by earned income from publications and services. The Center's mission is to collect, organize, analyze, and disseminate data on foundation and corporate philanthropy. Free public access to this information is provided through four Center-operated libraries (New York, Washington, DC, Cleveland, San Francisco) and through a network of more than 190 Cooperating Collections. In addition, through a program of regularly scheduled orientations and educational seminars, the Center introduces thousands of grantseekers each year to the funding research process.

Copyright © 1993
The Foundation Center
ISBN 0-87954-448-1
Printed and bound in the United States of America
Cover design by Apicella Design
Book design and production by Brice R. Hammack

Contents

Tables and Figures

6. TYPES OF SUPPORT: THE PURPOSES OF ARTS GRANTS

7. ARTS FUNDING BY TEN LEADING CORPORATE GIVING PROGRAMS

8. ARTS GRANTMAKING IN THE 1990s: PERSPECTIVES OF FUNDERS AND GRANTEES

Preface

Grantmakers in the Arts (GIA) is dedicated to the professional development of arts grantmakers and the advancement of arts philanthropy. In a funding field as large and complex as the arts, fostering effective, sensitive, and creative giving programs is an ongoing concern of grantmakers. We and our colleagues in GIA believe in the usefulness of information. We also assert that arts grantmaking is much more significant and critical than may have been traditionally acknowledged. With the goal of a more knowledgeable and empowered group of arts grantmakers, GIA raised the funds to commission the Foundation Center to produce an Arts Funding Benchmark Study.

Grantmakers in the Arts is committed to working nationally and regionally to assist arts grantmakers make the most effective use of the study, for such activities as planning, program focus development, arts giving guidelines, self evaluation, field and needs assessments, and local research and policy formation. We hope that it provokes debate, action, and more research.

We express our deep appreciation to the Foundation Center, expecially its vice president for research, Loren Renz, and research consultant, Nathan Weber; the members of the study's Advisory Committee; the members of the board of Grantmakers in the Arts; the many arts professionals who participated in the survey; the artists who provided commentary; and the generous funders who covered the costs of this endeavor, all of whom are noted in the acknowledgments.

> —Cynthia Gehrig
> President, *Jerome Foundation*
> Chair, Benchmark Study
> Advisory Committee
> —Ella King Torrey
> Director, *Pew Fellowships in the Arts*
> President, Grantmakers in the Arts

An analysis is, literally, a separating into parts in order to understand the whole. The analytic process applies as much to examining the themes and elements of arts grantmaking as it does to talking about art itself, or about almost any complex matter.

This study of arts funding was prompted by a series of questions directed to the Foundation Center by members of Grantmakers in the Arts in an attempt to better understand their role, especially at a time of turmoil in the arts world. Some of the questions raised about the funding process were highly qualitative, i.e., they dealt with performance and outcome. Many others sought to measure the extent of grantmaking by subject matter, grant purpose, and other definable elements. Still others aimed at measuring change in arts funding policy prompted by the prevailing crisis in the arts community.

Those questions best answered in a study of this magnitude—covering many thousands of grants, many hundreds of grantmakers, and nearly a decade of funding—are necessarily the more descriptive and quantitative. Yet to the best of our ability, through surveys and interviews, we have also tried to capture changes in perspective and differences in interpretation. It is our hope that when combined the study's many parts may provide an enlightened framework for understanding the "whole" of arts funding.

> —Loren Renz
> Vice President for Research
> *The Foundation Center*

Acknowledgments

This report was enhanced by the participation of many individuals who contributed invaluable time, energy, and intelligence. Chief among them are the members of the advisory committee, listed on page 10, who reviewed and critiqued everything from the survey instruments to the research methodology to the final analyses. To them goes much of the credit for the study's insights. Notwithstanding their contributions, any misstatement of fact or analysis is the sole responsibility of the authors.

Among the advisors, Cynthia Gehrig of the Jerome Foundation, who chaired the committee, and Ella King Torrey of Pew Fellowships in the Arts, who is president of Grantmakers in the Arts, deserve special mention for their leadership, encouragement, and articulation of key issues.

Several distinguished individuals contributed thoughtful essays on themes central to this report: Stanley N. Katz, on the place of the arts in philanthropy; Mary Schmidt Campbell, on the place of the arts in the national agenda; Maria Irene Fornes, on the purpose of funding the arts, especially theater; David Mura, on multiculturalism and the changing artist-community relationship; and Brenda Way, on the vital link between philanthropy and modern dance.

For a review of foundation arts funding prior to the 1980s (Chapter 3), the study drew extensively from the invaluable work of Professor Paul DiMaggio.

Without the superb efforts of research assistants Mirande Dupuy and Steven Lawrence, it is unlikely that this study would have seen the light of day. To summarize the work they did and the ideas they contributed in every phase of this project—from data collection to table and chart design—would require a chapter in itself.

Special appreciation is due to Jessica Chao and Holly Sidford of the Lila Wallace-Reader's Digest Fund, Adam Bernstein of the Fan Fox and Leslie R. Samuels Foundation, and Neal Cuthbert of the McKnight Foundation for sharing information on the process of policy change in their respective institutions. Interviews they granted were the basis of the case studies in Chapter 10.

Thanks are due to Tim McClimon of the AT&T Foundation, Cynthia Mayeda of the Dayton Hudson Foundation, and Judith Jedlicka of Business Committee for the Arts, for their advice on corporate giving data.

Central to this study was the recoding of thousands of grants in accordance with the National Taxonomy of Exempt Entities. Foundation Center staff who assisted with the recoding included Ruth Kovacs and Daniel Hodges, editor and assistant editor of the *Grants Index*, and Laurence Eldridge, Benjamin McLaughlin, and Linda Tobiasen.

Much of the requisite computer work and database design was provided by the Foundation Center's Margaret Derrickson and the Information Systems staff: Virginia Higgins, M. Lara Brock Steen, and Althea Ashman.

Thanks are also due to several individuals who provided a wealth of background information to the authors, especially: Mindy Berry of the National Endowment for the Arts, Charles Bergman of the Pollock Krasner Foundation, Jeffrey Love of the National Assembly of State Arts Agencies, Richard Mittenthal of the Conservation Company, and Leonard Vignola of the National Arts Stabilization Fund.

We extend our appreciation to Mike Fry of Bruce Bell and Associates, Inc., for assistance with the survey research program used in the surveys of grantmakers and arts organizations; to Brice Hammack for graphic design of both the survey instruments and the typeset manuscript; to Nancy Snyder for her expert services as proofreader; and to Cheryl Loe for coordinating cover design and book printing.

Our gratitude is similarly extended to the several hundred program officers and arts administrators who completed the survey questionnaires; to the directors of arts service associations who provided the names of arts groups for the survey; to the foundation and corporate officials who offered information for the profiles of their respective institutions; and to the contributions officers who provided details of their companies' 1989 arts grants for an analysis of ten large corporate giving programs.

Finally, we thank the board members of Grantmakers in the Arts whose names appear in Appendix A following the entry on GIA; and those individual foundations that provided the funding for this study, and with it, the belief in its value and the confidence in its execution: the AT&T Foundation, the Dayton Hudson Foundation, the Getty Grant Program, the John D. and Catherine T. MacArthur Foundation, the Pew Charitable Trusts, the Rockefeller Foundation, and the Fan Fox and Leslie R. Samuels Foundation.

—Loren Renz & Nathan Weber

ARTS BENCHMARK STUDY ADVISORY COMMITTEE

Chair—Cynthia A. Gehrig
Jerome Foundation

Elizabeth T. Boris
The Aspen Institute

Juan Carrillo
California Arts Council

Paul DiMaggio
Princeton University

Peter Hero
Community Foundation of Santa Clara
 County

Virginia Hodgkinson
Independent Sector

Judith Jedlicka
Business Committee for the Arts

Jonathan Katz
National Assembly of State Arts Agencies

Stanley N. Katz
American Council of Learned Societies

John Kreidler
The San Francisco Foundation

Ruth Mayleas
The Ford Foundation

Patricia Patrizi
The Pew Charitable Trusts

Carrolle Perry
The Philadelphia Foundation

Suzanne M. Sato
The Rockefeller Foundation

Ella King Torrey
Pew Fellowships in the Arts

Margaret Wyszomirski
National Endowment for the Arts

Alice Zimet
Chase Manhattan Bank, N.A.

Executive Summary

DIMENSIONS OF ARTS FUNDING IN 1983, 1986, 1989

AMID MANY CHANGES, SHARE OF FOUNDATION FUNDS TO THE ARTS REMAINED STEADY

In spite of significant changes within the ranks of arts funders, no major shifts in either the share of arts dollars or the share of the number of grants awarded to the arts by foundations were evident during the study years. About one in seven foundation dollars, and one in six grants, went to arts and culture in 1983, 1986, and 1989.

MORE DOLLARS TO ALL FIELDS, INCLUDING THE ARTS

While the share of arts funding did not vary appreciably during the study years, the total dollar amount flowing into the arts increased dramatically, even allowing for variations in the foundation sample over time. In 1983, arts giving was $237 million out of total giving of $1.62 billion. By 1989, based on a larger sample, foundations gave $503 million to the arts out of total spending of $3.69 billion. The increase was principally a function of more dollars from foundations to all fields. Between 1983 and 1989, annual disbursements by all U.S. foundations had surged 37 percent after inflation, reaching $7.91 billion.

FOUNDATIONS MADE MORE GRANTS TO MORE ARTS RECIPIENTS

Between 1983 and 1989, the number of arts grants awarded by sampled foundations jumped from 5,000 to nearly 8,000, up by 60 percent. Increased demands on funders by more arts groups may have played a part: over the study period, the number of recipients grew by nearly half, from 2,600 to 3,800.

TOTAL GRANTS TO ARTS OUTPACED INFLATION, FIRST LAGGING BEHIND, THEN SURPASSING GRANTS TO ALL FIELDS

A swelling stock market, relatively low inflation, and the entry of new funders during the 1980s pushed up foundation giving in all fields, including the arts. Growth in cultural funding initially trailed foundation giving in general, but eventually caught up and surpassed it.

FOUR OUT OF FIVE SAMPLED FOUNDATIONS SUPPORTED THE ARTS DURING DECADE

Measured by extent of grantmaker involvement, the arts ranked high among the fields of foundation activity during the 1980s. More than four out of five foundations in the *Grants Index* sample underwrote the arts each year of the study. In 1989, 596 grantmakers out of 697 in the sample gave to the arts.

MEDIAN GRANT TO THE ARTS OUTPACED INFLATION SLIGHTLY AT FIRST, THEN MORE ROBUSTLY

Throughout the study period, the median, or most "typical," arts grant rose faster than the cost of living. Adjusted for inflation, the median arts grant started at $16,000, increased slightly by 1986, and rose to $19,400 by 1989.

The mean arts grant also beat inflation, but only during the second half of the 1980s. From mid-decade to end, the mean grant rose 20 percent in real terms, from $43,100 to $51,700.

MILLION-DOLLAR-PLUS GIFTS TO A FEW LARGE RECIPIENTS ABSORB ONE IN SIX ARTS DOLLARS

About one in six arts dollars were contained in exceptionally large grants of $1 million or more—60 to 250 times the size of the typical or median arts grant. And those few large grants went to a small

number of major institutions—15 in 1983, 24 in 1986, and 32 in 1989—out of thousands that received grants.

SHARE OF DOLLARS TO TOP 50 ARTS RECIPIENTS DECLINED

While the concentration of arts dollars in large grants favored leading institutions throughout the 1980s, the imbalance was more striking at the start than at the end. Ranked by total dollars received, the top 50 arts groups—out of some 2,600 to 3,800 recipients—secured more than two out of five arts dollars in 1983, one out of three in 1986, and three out of ten in 1989. The top 50 institutions in 1989 represented just 1 percent of arts recipients.

FEWER SMALL GRANTS, MORE LARGE AND MID-LEVEL GRANTS AWARDED BY DECADE'S END

In 1983, two-thirds of all arts grants ranged between $5,000 and $25,000, a proportion that held steady through 1986. But by 1989, that proportion declined, as only half the arts grants were less than $25,000, while more than a fifth ranged between $25,000 and $50,000. The long-term impact of inflation on the value of small grants was no doubt a factor in raising grant size, as was the sizable growth in foundations' grant budgets.

SHARE OF FOUNDATIONS GIVING IN HIGHEST AND LOWEST RANGES DECLINED; IN THE MIDDLE RANGES ROSE

As the foundation sample size increased, the proportion of funders with total arts giving in both the lowest ranges (under $100,000) and the highest ($5 million to $25 million) declined. In the middle ranges ($100,000 to $1 million), the share of funders rose from two-fifths in 1983 to over half by 1989.

INDEPENDENTS PROVIDED LARGEST SHARE OF FUNDING; CORPORATE GIVING GROWTH DECLINED DESPITE GROWTH IN NUMBERS

The majority of arts funders were independent foundations, who also provided more than three-fourths of arts dollars. But over time, the number of corporate funders grew from one-sixth to nearly one-quarter. Despite their growth in numbers, the share of corporate dollars fell in 1986, but then gained ground by 1989, when several new corporate arts funders emerged.

The drop in giving by many leading corporate funders in the sample did not signal a retreat from arts funding; rather, it was a sign of curtailed spending in all fields due largely to falling company profits and restructuring. As a result, the rate of growth of corporate giving had declined.

SAME GRANTMAKERS PROVIDED MOST FUNDING, BUT CHANGES MARKED TOP 25 GIVERS

Ranked by dollar amount of grants, 13 foundations were among the top 25 arts givers in each of the study years. For the first two years, grants from the top 25 accounted for more than one out of every two arts dollars from all sampled foundations; by 1989, the proportion had dropped to one out of two and a half dollars.

ARTS FUNDING REDUCED BY SOME GRANTMAKERS, BOOSTED BY NEW AND GROWING FOUNDATIONS

While some key supporters of the arts sharply reduced their allocations for diverse reasons—program redirection, termination, loss of assets, and company buyouts or restructuring, among them—other funders increased their arts giving or became new supporters.

New funders represented every type of foundation, from corporate—AT&T and a few of the "Baby Bells," to community—Marin Community, to operating—the Getty Grant Program, to independent—the Lila Wallace-Reader's Digest Fund. By 1989, several of the new funders joined the ranks of the top 25 arts givers.

MAJORITY OF ARTS FUNDS ORIGINATED IN FEW STATES

Grantmakers in just five states provided around two-thirds of arts grant dollars each year. In 1983, the five states were New York, California, Pennsylvania, Texas, and Michigan. In the two later years, Illinois had displaced Michigan.

Grantmakers in ten states accounted for over 88 percent of arts funds in 1983, and 83 percent in 1989.

STATES THAT GAVE THE MOST GENERALLY RECEIVED THE MOST

Most of the states in which foundations awarded the greatest amount of arts dollars also received the largest amount of funds, a function of the localized

nature of most giving. An exception was the District of Columbia, which had few foundations and therefore gave little, but which hosts prestigious national arts institutions that received many grants.

A FEW FOUNDATIONS PROVIDED BULK OF ARTS DOLLARS WITHIN EACH STATE

Within each state, arts funding was borne highly unevenly by a few principal arts grantmakers. Typically, funds were concentrated in several large grants and disbursed to leading local cultural institutions. Distribution patterns varied, however, according to the programs and policies of the largest funders. Around one dozen of the very largest funders gave nationally, while some key funders, both national and local, gave more broadly to the arts through a larger number of grants.

HOW FOUNDATIONS ALLOCATED THEIR ARTS GRANTS

PERFORMING ARTS SHARE OF FUNDING DROPPED, MUSEUM SHARE ROSE IN 1980S

The performing arts—the broadest field in the arts and culture typology—received the largest share of funding throughout the 1980s, but its share diminished. In 1983, almost two out of every five arts dollars went to the field. By 1986, the ratio had dropped to one in three, where it remained in 1989.

Museums captured a rising share of soaring foundation appropriations. In 1983, museums received one-fourth of total arts funds—nearly $61 million of $238 million. By 1986, that share jumped to one-third and grant dollars rose to $106 million of $322 million. By 1989, museum support had dipped slightly—to 31 percent of arts spending, while dollars rose to almost $154 million of $503 million.

By share of number of arts grants, performing arts captured nearly half in 1983 and just over two of five in 1989. Museums received far fewer grants, but the ratio increased over time: from one in six in 1983 to one in five in 1989.

Regardless of type of foundation, the share of funding for performing arts declined and the share for museums increased. Significant factors affecting

the shift included large, one-time capital gifts; spending reductions or program redirection among some leading funders; and the influence of new funders.

IN PERFORMING ARTS, MUSIC AND THEATER DOMINANT; SUPPORT FOR THEATER DROPPED, FOR DANCE GREW

Music and theater consistently secured the largest shares of performing arts dollars, but trends varied widely by discipline. The most notable shifts in the 1980s were a decline in the share granted to theater, and the concurrent rise in the portions to dance and performing arts centers. Support for performing arts centers jumped in mid-decade; dance funding did not increase till the second half of the decade.

Music held a high share of arts funding at the start and end of the 1980s, but its share dropped abruptly in 1986, when orchestra funding growth failed to keep pace with all arts funding. Music's share of number of grants, however, dipped only slightly.

Large performing arts gifts—$250,000 and above—were given primarily to symphony orchestras and performing arts centers.

AMONG MUSEUMS, ART MUSEUMS FARED BEST, BUT GROWTH SHIFTED TO HISTORY AND SCIENCE MUSEUMS

As a single subcategory of the arts, art museums by far captured the largest share of foundation support: one out of five and a half arts dollars in 1983 and 1986, and one out of six in 1989. At mid-decade foundations gave away nearly twice as much for art museums as they gave for theater, and more than twice as much as they gave for music. The number of grants awarded, however, was far fewer.

Art museums received the lion's share of all museum funding throughout the 1980s, but the share slipped from more than two-thirds in 1983 to less than half in 1989. History and science museums were the principal beneficiaries of the changing shares.

Museums, especially art museums, were the most frequent recipients of the largest foundation grants. In 1986, eight of the ten largest grants went to museums. In 1989, museums received half of the ten largest grants.

Visual Arts: Support Disbursed Largely Through Museums

Most foundation grants for the visual arts—painting, architecture, photography, sculpture, etc.—were channeled through museums. Support other than through museums was limited, never rising above 3.2 percent of all arts dollars.

Most Media and Communications Grants Went to Public TV or University-Based Programs

Media/Communications received the third largest share of arts and culture funding throughout the 1980s. Its share dropped in 1986 but rebounded in 1989. The mid-decade decline was most evident in public television and radio support, but publishing and journalism also dipped that year.

More than two out of every five dollars granted to media went to television (not to film and video). The largest media grants—those of at least $250,000—were overwhelmingly directed first to public broadcasting stations, and second towards university-based communications or journalism programs.

Small or independent video, radio, and printing arts organizations rarely received large grants. A few of the large media grants, however, ultimately benefited a wider group of media artists, e.g., grants to public television to air the works of independent film producers.

Share to Multidisciplinary Arts Grew Throughout Decade

The multidisciplinary arts field ranked fourth, after performing arts, museums, and media, rising from nearly 7 percent to nearly 8 percent of all arts grant dollars. Its share of number of grants was larger—around one-tenth. Arts education accounted for nearly half these funds through 1986, and a little above a quarter by 1989.

Under a broader definition of arts education—including performing arts training and any project where a subsidiary purpose was education—support grew steadily, from 7 percent of all arts funding to nearly 10 percent.

Support for ethnic/folk arts grew sharply after mid-decade, but the amounts were extremely modest. When funds to all ethnic groups (museums,

dance companies, ensembles, arts centers, etc.) were combined, funding totaled about 4 percent of arts dollars in 1989—$18.6 million—compared to 2 percent in 1983.

Share to Arts-Related Humanities Rose Slightly

The share of arts funding allocated to the humanities for general programs, art history, history and archeology, and literature, rose slightly in the 1980s, finishing at just under 6 percent of grant dollars. More than two out of five dollars went to general programs. Another one-third went to history and archeology. Only a tiny amount went to literature and even less to art history.

Foundations Awarded 5 Percent of Grants for Historical Activities

Historical activities—primarily historic preservation—captured around 5 percent of foundation cultural giving. By mid-decade support had increased for other purposes, such as centennials and commemorations.

Among Recipients of Arts Grants, Colleges and Universities Ranked Third

Foundations awarded about 13 to 15 percent of arts dollars to academic institutions for arts centers; arts, humanities, and media departments; museums, theaters, and concert halls; and for scholarship and fellowship programs. Colleges and universities ranked third after performing arts groups and museums as primary recipients of arts grants.

THE PURPOSES OF ARTS GRANTS

Support for Capital and Operating Expenses Dropped, As Funds for Arts Programming Grew

More arts grant dollars were spent for capital projects—mainly buildings and endowments—than for any other purpose through the mid-1980s, but by 1989 spending for programs slightly exceeded capital support. Operating support, high at the start of the era, declined steadily and steeply, in part due to a concurrent rise in the share of grants with unspecified purposes.

The largest number of arts grants were made for program support, the second largest, for operating support. As with grant dollars, the share of number of operating grants declined in the 1980s.

All types of foundations—independent, corporate, and community—gave a smaller share of both arts dollars and number of grants for operating support in 1989 than in the earlier years.

OPERATING SUPPORT: "ORGANIZATIONAL STABILITY" FUNDING HIGH AT FIRST, THEN DECLINED

The largest share of operating support was unrestricted. But in 1983, grants intended to build up income sources and strengthen management of arts groups accounted for a third of operating support—$25 million—largely because the National Arts Stabilization Fund (NASF) was founded in that year. Inaugural grants from the Ford Foundation and other funders totaled $9 million, making NASF the largest single arts recipient of 1983. In later years "organizational stability" accounted for around a quarter of operating support and 5 percent of all arts funding.

CAPITAL SUPPORT: BUILDING GRANTS REMAINED HIGHEST, BUT SHARE DIPPED

Capital support overwhelmingly favored building or renovation projects, but as the 1980s advanced, it diversified, with more funds committed to endowments, capital campaigns, and equipment. Grants for collections acquisitions were highest in 1986. Few grants were made to reduce the existing debt of organizations.

PROGRAM SUPPORT: STEADY GROWTH

Grants that funded the programs of arts groups grew steadily throughout the 1980s. Trends within program support were influenced by changes in the foundation sample. In 1989, when the sample grew, more than half of program dollars were for general programs, up from less than one-third in 1986. More specific programmatic support favored performances, exhibitions, film and video productions, and publications. Funding of collections management decreased; funding of new works increased.

PROFESSIONAL DEVELOPMENT SUPPORT GREW SLIGHTLY

Institutional support for professional development, including fellowships, scholarships, internships, and awards and prizes, inched up in the 1980s and exceeded 6 percent in 1989. Much of the funding assisted individual artists or scholars, albeit indirectly. The bulk of support was for fellowships.

ARTS GRANTMAKING IN THE 1990S: VIEWS OF FUNDERS AND ARTS GROUPS

GRANTMAKERS AND ARTS GROUPS AGREE: OPERATING SUPPORT IS MOST CRITICAL NEED

A national survey of arts funders and grantees conducted by the Foundation Center in 1992 revealed that both populations viewed operating support, and especially unrestricted support, as the most critical funding need faced by arts organizations. Despite their agreement, far more grantees were emphatic about this need than grantmakers.

The same held true for endowments: both grantmakers and grantees viewed endowment funding as a critical need of arts groups, but far more grantees than grantmakers said so.

UNRESTRICTED SUPPORT LIKELY TO BE A FUNDING PRIORITY

Grantmakers most often cited unrestricted operating support as among the priorities likely to receive most of their funding in the coming year. More than half of the 180 respondents mentioned unrestricted support among their funding priorities. Next most frequently mentioned was program support.

GRANTMAKERS CHIDED FOR FAVORING LARGE GROUPS AND NEW PROGRAMS

Grantmakers and grantees agreed that the two most serious criticisms of arts funders included an imbalance in grants, which favor larger, more established arts organizations; and too much emphasis on "new" programming over basic support.

SYMPHONY ORCHESTRAS, MUSEUMS, AND ARTS EDUCATION LIKELY TO RECEIVE STRONG SUPPORT

Grantmakers and grantees both believe that the best-funded arts fields today—those receiving the largest share of arts funding—are symphony orchestras and museums. Notwithstanding that perception, funders indicated that the performing arts, in general, and museums were likely to receive their primary support during the coming year. Also cited to receive primary funding was arts education, which both populations agreed was sorely underfunded.

ARTISTIC ACCOMPLISHMENT AND MANAGEMENT HELD KEY TO GRANTS RENEWAL

A majority of the surveyed funders maintained that their main reason for renewing grants to the same organizations was that the latter had earned it, either through artistic merit or management accomplishments. Community foundations were just as likely to consider financial need and commitment to organizations over time. Corporate funders were more likely to renew grants based on guidelines and on company traditions.

COMPETITION FOR FUNDS AND RISK-TAKING SEEN AS MAJOR ARTS GRANTMAKING ISSUES TODAY

Grantmakers and grantees agree that the most serious issues in arts grantmaking today are competition for grants between the arts and other fields, competition among arts group themselves, and the capacity of funders to take risks in their grantmaking policies.

In response to the issue of intensified competition for funds and of public funding issues, some arts groups expected to increase their fundraising efforts, others to engage in more advocacy on behalf of the arts, and still others to concentrate on audience outreach. Some grantmakers acknowledged that they would be likely to shift some resources to human services. Other funders expected that their arts funding would remain constant, but that proposals would be more rigorously evaluated.

TWO-THIRDS OF GRANTMAKERS EXPECT ARTS FUNDING LEVELS TO STAY STEADY

More than two-thirds of surveyed grantmakers said their arts grants, as a proportion of overall funding, would not change over the next five years. Nearly one-fourth, however, reported that their arts grants would drop and only one-tenth looked forward to a larger share of funding for the arts.

AMONG CORPORATE GRANTMAKERS, FUNDING PROSPECTS ARE DIMMER

Prospects varied widely according to funder type. Independent and community foundations were far more positive than corporates regarding their capacity to maintain current levels of support. Three out of four independent foundations and seven out of ten community funders expected their share of arts funding to remain unchanged, compared with only two out of five corporate funders. Another two out of five corporate funders expected their arts support to decrease in the future.

Introduction

Without patronage, it is unlikely that the arts in America, as in other countries, would exist to the extent they do today. The sheer expense of creating a painting or sculpture, devising a dance or music or video piece, mounting an exhibition or staging a performance, and the ephemeral value of such creations, render the arts unsustainable by market forces alone.

In many societies—Europe, for example—patronage is largely public. Government funding of the arts is as prevalent in modern European welfare states as is public funding of health and human services. By contrast, in the United States, patronage is overwhelmingly private.

This is not to say that private support is the only form of income received by the nation's arts groups, which are largely nonprofit organizations. Philanthropic contributions account for at best two-thirds of nonprofit arts revenue, according to one recent estimate, and half of that likely consists of expensive art objects donated at current market value to large museums.[1] Other data imply that private donations (in all forms) account for only a quarter to a half of nonprofit arts income.[2] Most of the remaining revenue—up to half—is generated through ticket sales, dues, rentals, interest earnings, dividends, and asset sales. Finally, public support—federal, state, and local—accounts for only about 14 percent.[3]

Notwithstanding the different estimates, philanthropic funding of the arts by individuals and institutions is widely recognized as essential. And while varying national measures of such support have long been posited, a comprehensive review of actual trends in private arts giving during the past decade has been lacking. This study fills that gap for one vital source of private support—grantmaking foundations. It also presents a look forward at directions and issues in arts funding in the 1990s.

It should be underscored that the data in the following pages pertain only to independent, corpo-rate, and community foundations. The figures and trends discussed do not cover the single largest component of philanthropic support—donations from individuals—nor do they describe all business support of the arts, except for those companies that dispense their grants through foundations.

Yet even when isolated from other forms of private giving, U.S. foundations represent a surprisingly large source of revenue to the arts world. Foundations provided an estimated $966 million for arts and culture in 1987 or about 12 percent of the estimated total income of nonprofit arts organizations.[4] Equally surprising, estimated foundation arts spending between 1983 and 1989—the years covered in this study—was at least two and a half times greater than actual expenditures reported by the National Endowment for the Arts and state governments combined (see Chapter 4, Table 4-6).

Few other fields of nonprofit activity depend as much on foundation dollars as does the arts. Hence, understanding the relationship of grantmakers to the arts community takes on great importance. Developing baseline information on the scope and substance of arts funding is essential to that understanding.

To explore the historical trends in arts giving in the 1980s, to identify notable shifts in funding patterns and their possible causes and implications, to expose differences or similarities between arts funding and support of other fields, to pinpoint areas that may be underfunded, and finally, to open a window on the current thinking of arts supporters and arts professionals, Grantmakers in the Arts, a national network of funders, asked the Foundation Center to conduct this study.

Specifically, the following chapters provide information on:

- **The Scope and Size of Funding**—for the years 1983, 1986, and 1989, including the share of foundation dollars and grants going to the arts;

the growth of total arts dollars, grant size, number of grants, and number of recipients; growth patterns for independent, corporate, and community foundations; and grant distribution by state. Also shifts upward or downward among the largest funders, and the entry of new or newly large foundations into the arts funding community in the 1980s.

- **Trends by Subject**—including changes in allocations of dollars and number of grants to the performing arts, visual arts, museums, media, multidisciplinary arts, historic preservation, and arts-related humanities; also shifts in funding within each of these major groupings.

- **Trends by Purpose or Type of Support**—including changes in allocations of dollars and number of grants primarily for operating expenses, capital needs, program support, and professional development; also shifts in funding among the numerous subcategories of support.

- **Perspectives and Current Priorities** of 187 leading arts grantmakers, including foundations and corporate giving programs. Grantmakers' views regarding critical needs and issues in arts funding are compared with those of 133 arts professionals, representing diverse fields and types—arts producers, presenters, and service groups. Both grantmakers and arts groups were surveyed at the start of 1992.

- **Arts Programs** of 61 leading funders, including independent, corporate, and community foundations and corporate giving programs. These profiles, based on the most recent information available, are intended to complement the historical trends analysis and shed light on the diverse interests, distribution policies, and geographic scope of private funders.

METHODOLOGY

Information for the arts funding benchmark study was gathered from the Foundation Center's grants database, nationwide surveys of both grantmakers and grantees, publications provided by grantmakers, and interviews with foundation and corporate giving officials.

The data on arts funding trends cover only the years 1983, 1986, and 1989. Extensive changes in the grants classification system introduced in 1989 (see below) required the recoding of some 12,000 grants to render the data for the two earlier study years comparable to that for 1989. Time and expense constraints prohibited recoding the intervening years.

I. GRANTS ANALYSIS: 1983, 1986, 1989

For the three chapters analyzing historical trends in arts grantmaking, sampling frames were selected from the Foundation Center's database of grants awarded in calendar year 1983, 1986, and 1989. All grants (limited to those of $5,000 and above) had been published in various editions of the *Foundation Grants Index*.

Between 1983 and 1989, the number of all grants indexed by the Foundation Center rose from about 32,000 to more than 50,000 per year. The number of foundations in the sample rose from 454 to 697, including the 100 largest foundations, measured by total grants amount.

Although the sampled foundations represented less than 2 percent of the total number of active grantmaking foundations in the country, they accounted for around 40 percent of grant dollars awarded in 1983 and 1986, and nearly half of total dollars in 1989.

Arts Grants Sample. From the more than 100,000 database grants authorized in 1983, 1986, and 1989, approximately 20,000 had been designated as *primarily* Arts, Culture, and Humanities grants, as defined by the National Taxonomy of Exempt Entities, or NTEE (see Appendix B). These 20,000 comprised the vast majority of the grants analyzed in this study. To them were added grants to specialized libraries devoted to the arts and humanities, and grants for international cultural exchange. Removed from the sample were grants to humanities disciplines that were not specifically arts-related, including those for foreign languages, linguistics, philosophy or ethics, and theology or comparative religion.

Of the 20,000 arts grants analyzed in this study, the approximately 12,000 awarded in either 1983 or 1986 were recoded in accordance with NTEE to render them comparable to the roughly 8,000 grants

awarded in 1989, when the new classification system was first utilized. This recoding resulted in the removal of many grants formerly categorized under the arts, such as those for public libraries, reading arts programs, zoos, and botanical gardens, that are presently classified elsewhere.

Beyond the NTEE coding—classification by arts discipline and by recipient organization type—grants were coded for their purpose or type of support, and beneficiary group.

Corporate Giving Sample. Because only about a quarter of all U.S. businesses channel their contributions through company-sponsored foundations, supplemental grants data were solicited from 20 of the largest corporate giving programs, that is, from companies dispensing grants directly from income, rather than through a foundation. The 20 firms were identified by Business Committee for the Arts, an advisor to this project.

Ten of the 20 firms responded, providing grants data for 1989. Approximately 1,000 corporate grants were coded in accordance with NTEE subject classifications and the Foundation Center's typology of support purposes. The analysis of these 1,000 grants, which includes a comparison with corporate foundation grants, appears in Chapter 7.

Enhanced Coding. To gain a broader understanding of trends specific to arts grantmaking, several new "types of support" codes, beyond those already used in the Foundation Center's grants classification system, were developed. All grants from 1983, 1986, and 1989 whose purposes matched the new definitions were recoded accordingly.

New types of support added to the typology included: income development, management development, collections management (such as cataloging and materials preservation), commissioning new works, and awards and prizes. In addition, the code for fellowships was expanded to include residencies.

Finally, to gain a more comprehensive picture of the arts-in-education field, grants from various arts fields (i.e., dance, theater, museums) with a subsidiary educational purpose, were given a secondary arts education code and retrieved for analysis.

Variables. Following the recoding of the grants sample, grant lists and data tables were generated by the following variables: grant size, state location of fun-

ders and grantees, subject of grant, recipient organization type, purpose or type of support, beneficiary group, and foundation type (independent, corporate, community, operating). A complete listing of the subject/organizational codes and type of support codes used in the study appears in Appendix B.

To further enhance the analysis, and better understand trends, the data were crosstabulated by subject and foundation type, type of support and foundation type, subject and size of grant, and type of support and size of grant.

Limitations of the Grants Sample. The Foundation Center's *Grants Index* database is the most complete source of information available about foundation giving, capturing almost half of all grant dollars awarded by U.S. foundations, but it has certain limitations:

1. The sample is not randomly selected; rather it covers the grants of those foundations reporting voluntarily to the *Grants Index* through annual reports or grant lists or those ranked among the 100 largest by total giving. Only foundations with assets of at least $1 million or more or annual giving of at least $100,000 are eligible for inclusion. As a result, the sample is weighted toward large foundations.

2. The sample includes a high proportion of corporate foundations, which represent about one in four of the 1,000 largest foundations by total giving; and of community foundations, which account for many of the smallest funders in the sample.

3. Direct corporate giving programs, which account for roughly 60 percent of business contributions, are not included in the core analysis. (Unlike corporate foundations, these programs are not required to report their grants to the public.) To compensate for their exclusion, an analysis of 1989 grants data provided by ten of the largest corporate arts funders is presented in Chapter 7.

4. The grants database records grants authorized (when known) rather than grants paid. Because the study looks at grants awarded only in 1983, 1986, and 1989, large multi-year grants authorized in intervening years do not appear in the trend data.

5. The specificity of grants information provided by the foundations varies, thereby affecting the quality of the coding and the resulting analysis.

6. The sample excludes grants under $5,000; therefore funding trends associated with small grants, e.g., operating support, may be underreported.

7. The sample includes only arts grants awarded to organizations. Grants or fellowships given directly to individuals are excluded. To compensate for their exclusion, a summary of key funders that make grants to individuals artists appears in Chapter 6; in addition, several of these funders are profiled in Chapter 11.

II. Survey of Grantmakers and Arts Professionals

To ascertain the views of arts grantmakers and arts professionals on a variety of issues pertaining to arts funding today, surveys were sent at the start of 1992 to 498 grantmakers (both foundations and corporate giving programs) with a special interest in the arts, and to 316 arts organizations. Usable responses were returned by 37 percent of the grantmakers, and 43 percent of the grantees. Further descriptions of the selection process and characteristics of the surveyed populations appear in Chapter 8.

Limitations of the Survey Data:

1. Neither the funders nor arts groups were randomly selected; their responses, therefore, are not statistically representative of all U.S. grantmakers or arts organizations, strictly speaking. Given the broad-based selection process, however, the findings are reasonably descriptive of the views of the leading national and local arts grantmakers, and of a wide cross section of arts organizations.

2. The proportion of responding company-sponsored foundations, 24 percent, reflects the overrepresentation (noted above) of corporates among the 1,000 largest foundations. Community foundations are also overrepresented. Consequently, independent foundations, comprising around 90 percent of U.S. foundations of all sizes, are underrepresented in the survey.

III. Profiles and Case Studies

Profiles of key arts funders were prepared largely from materials submitted by the grantmakers, data appearing in various Foundation Center directories, and in some cases, interviews with program officers or other officials. All profiled grantmakers received review copies of the profiles; their observations and amendments were incorporated into the final drafts.

Case studies of grantmakers that made substantial changes in their arts funding policy over the past few years were developed through interviews with their respective arts program officers. Selection of grantmakers was based on the recommendations of advisors.

ENDNOTES

1. Lester M. Salamon, *America's Nonprofit Sector: A Primer*, The Foundation Center, 1992, New York, Page 94.

2. Nathan Weber (Ed.), *Giving USA 1991*, AAFRC Trust for Philanthropy, 1991, New York, Pages 165-169. For example, in 1990, private donations comprised 38 percent of the income of 89 prominent opera companies. Among other surveyed organizations, in theater, donations accounted for 31 percent; in symphony orchestra, 46 percent; in arts museums, 27 percent; in dance, 34 percent; and in public broadcasting, 51 percent.

3. Virginia Hodgkinson, et al., *Nonprofit Almanac 1992-1993*, Independent Sector, Jossey-Bass Publishers, San Francisco, 1992, Page 157.

4. The estimate for foundation arts giving was derived as a percentage of total actual foundation grants of $6.66 billion for 1987, reported in *Foundation Giving*, 1991 Edition. The estimated arts grant amount, $966 million, represented 12 percent of an estimated $7.8 billion in total revenue for arts, culture, and humanities organizations in 1987, the latest year for which data were provided (*Nonprofit Almanac 1992-1993*). Foundation giving amounted to about 35 percent of all private contributions including individual donations.

1

Can the Arts Enter the Philanthropic Mainstream?
by Stanley N. Katz

Stanley N. Katz *is President of the American Council of Learned Societies (ACLS) and Senior Fellow at the Woodrow Wilson School of Public and International Affairs, Princeton University. He is the author or co-author of, among other works,* "Foundations and Ruling Class Elites," Daedalus, Winter 1987; "History, Cultural Policy, and International Exchange in the Performing Arts," Performing Arts Journal, IX, 1985; and The American Private Philanthropic Foundation and the Public Sphere, 1890-1939, Minerva, 1981.

Arts activists may find the theme of this essay surprising: the arts are relative newcomers to the world of philanthropic funding in the United States, and they have not yet fully established their *bona fides* as citizens of the grant-recipient world.

We tend to forget how short is the history of modern philanthropic grantmaking in this country. While we have had an English charitable tradition since the earliest days of American settlement, philanthropic grantmaking in its current form originated only in the early years of the twentieth century.

Gift-giving in our earlier charitable tradition was personal, narrowly focused, and rehabilitative. The model for charitable giving was that of alms—free-will offerings to the poor, the ill, and the ignorant, most often in a religious context. The customary forms of benevolence had been summarized in the Elizabethan Statute of Charities in 1601, and there were few incentives to make gifts beyond the legally designated activities.

One consequence of such donative behavior was the absence of any rationale for "giving" to the arts. This situation was exacerbated by the fact that our new culture had neither a wealthy national Christian church nor rich aristocrats—the historical benefactors of arts and artists through traditions of patronage. Such arts patronage as existed in the United States prior to the Civil War was random, small scale, and noninstitutional.

The emergence of industrial multimillionaires with huge, expendable personal fortunes at the end of the nineteenth century created the possibility of a new form of giving. Magnates such as John D. Rockefeller, Sr., and Andrew Carnegie found both that they could not carry on the alms giving to which they were accustomed efficiently enough to

dispose of their wealth conscientiously, and that the almsgiving model of donation was inappropriate to their entrepreneurial instincts. They had made their fortunes by the dual application of the most advanced modern science and the best new management techniques to extractive industries, and they began to investigate ways to apply modern principles of science and organizational management to the art of giving.

The industrialists and their advisers came to think that the most efficient model for giving was that of applied science, which sought to discover the universal features of nature in order to achieve specific practical results. They realized that the function of almsgiving was, in effect, to ameliorate the adverse consequences of social problems, and sought instead scientifically to identify the underlying causes of poverty, illness, and ignorance so that they might eradicate social problems entirely. It was a breathtakingly new approach. Stated in the medical terms the new philanthropists frequently used, the model replaced the treatment of symptoms with attacks on the causes of disease.

The philanthropists invented a new institution as the primary vehicle for their efforts—the philanthropic foundation. Its essential features included being sustained by a large endowment, and governed by a self-perpetuating board of trustees who received only the most general instructions from the principal donor. The idea was that, since the endowments were mostly perpetuities, the governing structures should be flexible enough, in terms both of personnel and donative strategies, to sustain themselves over long periods of time which might witness radical changes in social need.

The earliest philanthropic foundations were established in the first two decades of the twentieth century, just about a generation after the creation of our major urban arts and cultural institutions—museums, symphony orchestras, and research libraries. The latter were modeled on European counterparts, instances of nineteenth-century *noblesse oblige* behavior by local elites desiring to establish their own status while educating the less well-bred. The foundations, on the other hand, were created by donors who displayed little interest in "high culture," but great commitment to social improvement. The result was that the paths of arts institutions and scientific philanthropy did not converge significantly for several generations.

The Rockefeller philanthropies, in particular, were primarily dedicated to research in medicine and public health, areas in which recent scientific progress promised rapid and dramatic results. And the promises were kept, especially in public health where epidemic scourges such as yellow fever were brought under control for the first time. Significant investments were also made in education (both traditional higher education, and schooling for black youth in the South), social planning, and economics—all based on the premise that scientific research could discover the causes of social problems, and point the way to practical mechanisms for their elimination. The earliest foundations acted both by awarding fellowships to promising individual scientists, and simultaneously by large block grants to universities and other research institutions. They innovated institutionally by stimulating the creation of what would today be called "think tanks," such as the Rockefeller Institute (now Rockefeller University) and the Brookings Institution.

The spirit of the new philanthropy was utilitarian. What mattered to the patrician boards of trustees was doing measurable good in the world. "Good" was defined in pragmatic terms—people cured of illness, social programs capable of changing social behavior and reality. Since the arts and culture were thought of almost entirely in non-utilitarian terms, neither the trustees nor the newly professionalizing staffs of the foundations identified them as legitimate sources of philanthropic investment.

There were, of course, exceptions. The principal early example of philanthropic concern for the arts is undoubtedly the Carnegie Corporation, under the guidance of its president in the 1920s and 1930s, Frederick Keppel. Keppel was interested in arts education, and managed a series of grant programs in that area for a number of years—but it is significant that even this exception proves the rule of foundation social utilitarianism, for Keppel was interested in the social uses of arts education, not in artistic creativity.

Another exception, this time supporting individual artists, was the John Simon Guggenheim Memorial Foundation. The Guggenheim was unique among early foundations in restricting its grantmaking to fellowships for distinguished scholars, and it included creative artists among its awardees from its start in the 1920s—not so much to further art as to reward genius wherever it was to be found. But the salient reality is that, prior to the 1960s, philanthropy ignored the arts almost entirely.

The two forces that brought the arts into the grantmaking mainstream were the Ford and Rockefeller foundations, with their decisions to begin major arts programs. Far and away the most important of these was the nearly $70 million effort of the Ford Foundation in the 1960s and 1970s, under the guidance of McNeil Lowry, who must be considered the prime mover in the creation of modern arts grantmaking. The second major force was the enactment, in 1965, of the National Foundation for the Arts and Humanities. The irony here is that those who pressed for this quintessentially Great Society legislation, including Lowry of Ford and Robert Lumiansky of the American Council of Learned Societies, included the arts as an afterthought, thinking that only the prestige of the national humanities organizations could secure federal funding for the arts.

The National Endowment for the Arts (NEA) was not the first government funding for the arts. The New Deal programs for artists during the Great Depression of the 1930s are well known, but they were created as economic relief agencies and thus were never institutionalized as arts programs. The American fear of government intervention in the private sphere, combined with persistent traditions of cultural localism, restricted the arts to private funding until after the second World War.

The lack was not widely perceived, however, since prior to the war there was little sense of artistic community in this country. In the postwar period,

as the arts began to extend their scope and appeal beyond traditional conceptions of high culture, various communities of artists began to discover their mutual aims and interests, and democratic arguments for public funding began to be heard. The response was the creation of arts councils in the states, and, especially, of NEA at the federal level.

This combination of government and prestigious private foundation funding legitimated the arts as an area for new investments by small and newer foundations. At the same time, the number of arts organizations increased exponentially, covering a range of activities extending from crafts to dance and all points between, in both plastic and performance arts. The new organizations were typically not-for-profit, and highly dependent upon both individual donors and grantmakers for programmatic support. Their funding increased dramatically in the 1960s and 1970s as private foundations and state and local governments acknowledged the importance of the arts and arts organizations. They were now joined by corporations, acting either through their public relations departments or through corporate foundations, with an especially large impact on large arts organizations.

Writing at the end of 1992, the years from the late 1950s to the late 1970s seem to have been the high point of exuberant expansionism in arts grantmaking. The cutbacks in the federal social budgets of the early 1980s forced both private and corporate funders to divert more resources to hard-pressed social service organizations, even though, surprisingly, their support for the arts did not waver.

The national recession which hit the United States harshly in the late 1980s and early 1990s was a second blow to funders, arts organizations, and individual artists. The most dramatic statistic in the years following World War Two had been the steady increase in the nature and volume of arts activity, and yet, there was less money available to be granted at a time when demand from artists and arts organizations continued to grow vigorously. The adversity of results depended upon the particular type of art and institution, but typically organizations trimmed staff, curtailed performances, cut back on support for individual artists, and generally emphasized income-producing activities rather than artistic quality, innovation, and outreach.

As if this was not bad enough, socially reactionary and religiously fundamentalist organizations mounted an assault on the arts communities and their funders. The Mapplethorpe-Serrano controversy at NEA, beginning in 1989, was only one sign of the serious political impact that controversies over the arts might have, both on funding and on freedom of artistic expression. There were real threats to the continuation of the National Endowment for the Arts, actual cutbacks in financial resources available to NEA, and (for the first time in a generation) actual doubt about the viability of continued federal funding for the arts. As the Clinton administration takes office, many feel cautious optimism that the worst may be over in terms of specific legislative punition for the arts; few, however, expect bold increases in funding any time soon.

Unfortunately, these political developments intersect with adverse conditions in the private and corporate foundation sectors. The steadily increasing federal budget deficit creates a climate in which private sector funders continue to feel an increased burden for the support of desperately needed social service activities. At the same time, private funders are behaving in ways that more nearly resemble those of the 1930s than the 1960s, focusing on short-term, utilitarian investments. The arts do not seem to appear an attractive philanthropic investment for many funders these days.

But we really do not know enough about arts funding to be sure. The serious study of arts philanthropy is less than a generation old, and we are just beginning the sorts of data collection and analysis (such as that represented by this Arts Funding Benchmark Study) which we need to make sound judgments about the field. The truly encouraging development is the emergence of a self-consciousness among arts funders (exemplified by the creation of Grantmakers in the Arts), which may pave the way to more thoughtful private and public funding strategies for the field.

Foundations, corporations, and governments have only recently discovered reasons for supporting the arts. Their confidence and support have ebbed somewhat. The challenge to the arts community is either to revitalize its existing appeal to funders, or to reconsider the grounds upon which it has based its appeal for the past 30 years.

Restoring the 'Public Persona' of America's Arts
by Mary Schmidt Campbell

Mary Schmidt Campbell *is Dean of New York University's Tisch School of the Arts. She was formerly Commissioner of New York City's Department of Cultural Affairs, and Executive Director of the Studio Museum in Harlem.*

Looking towards the 21st century, the American cultural community faces a troubling paradox: as the number, size and diversity of arts groups have grown exponentially over the past 25 years, the influence of cultural issues on public policy has diminished precipitously. So steep has been the decline that with the advent of a new presidential administration—a time to re-think national issues of all types—the arts have been virtually invisible on the national agenda.

For private funders, the peripheral role of the arts in American public life is cause for concern, since, for the past 25 years, the spectacular growth of arts organizations has been fueled by a robust public/private partnership, a symbiotic union in which both partners have become mutually dependent. Anything that threatens the public's positive view of the arts potentially threatens that partnership. For cultural groups, this slow devaluation of the importance of the arts is just one more item on a growing list of recent problems. Battered by a stubborn recession, dispirited by the relentless attack on the National Endowment for the Arts (NEA), and exhausted by an ever more competitive race for funds as the field grows more crowded and the dollars grow scarcer, the cultural community has scarcely had time to consider the more incipient danger of a diminished public persona. In addition to the problems besetting the community, the arts have also faced, in the past decade, stiff competition for a place on the agenda of national priorities as a plethora of domestic problems vie for attention. The country's mounting problems of AIDS, homelessness, drugs, crime, the environment—problems with voracious appetites for public dollars—seem to overwhelm national attention.

What does this mean for private philanthropy? What does it mean for the future of America's cultural institutions? Will the gains of the past 25 years disappear? Will only affluent cultural groups prevail? One of the striking aspects of this cultural community in 1993, compared to 1965, the year the NEA was established, is its rich cultural pluralism. African-American, Latino, and Asian dance companies, museums, theaters, and performing arts centers were virtually unheard of 25 years ago. Now they are among the country's most treasured institutions. Often located in communities where they maintain a bracing effect, they are frequently a hedge against encroaching urban decay or a lightening rod for radical urban change. As these institutions mature and begin to explore collaborative enterprises—MOCA, Studio Museum in Harlem, and the New Museum's Decade Show, for example—they offer the possibility of cultural reconciliation and synthesis in an era of dangerously proliferating balkanization. Given the shifting demographics in this country and the divisiveness of recent cultural clashes from Brooklyn's Crown Heights to South Central Los Angeles, cultural institutions forging collaborative associations may offer at least one possible route towards conciliatory and creative cultural encounters.

Reconciliation, however, is exceedingly difficult when survival is at stake. Arts groups must devote much of their energies to a quest for funding and, unfortunately, this quest for funds fails to capture the public imagination or answer the pervasive question: Why should we spend money on the arts when there are other more pressing problems? Our community's inability to articulate a positive affirmative argument for the arts was underscored dur-

ing the recent assault on the NEA. Responding defensively, the cultural community allowed its identity to be defined by the negative assaults on art, clouding in the public mind the true value of public support for cultural institutions. Public discourse at that time created a climate of cynicism, distrust, and indifference towards the value of art in American life.

The supreme irony of the current dilemma is that the past 25 years have yielded abundant evidence of the intrinsic value of strong cultural institutions in a pluralistic democracy. Perhaps the most profound impact of arts funding of the past quarter century has been in the arena of national self-definition. Our identity as a country is relatively new and the 20th century contribution to defining that identity is the assertive emergence of other than Eurocentric cultural groups. The current mix of large and small, encyclopedic and specialized, traditional and avant garde, European, Asian, Latino, and African institutions is fundamental to the idea of an inclusive democracy. To lose that pluralism is to risk losing the enfranchisement of diverse groups and to mute the possibility of meaningful cultural exchange. Moreover, supporting a range of institutions has also meant supporting a range of communities. Support of the Bronx Museum, for example, is support of an affirmative institution in the South Bronx. Similarly, support of the Harlem School of the Arts is support of an impoverished community, and of the children who regularly attend. Viewing cultural institutions in this light, it is possible to define their value not only in terms of the excellence of the art—always a prerequisite—but also in the strength of their role in the preservation of a vigorous culture of democracy. To this end, basic operating support becomes an essential aspect of funding.

Another important role for cultural institutions is educational. Arts education is a popular buzzword, but its meaning can range from a perfunctory arts exposure encounter to a transforming engagement with a discipline and the world of ideas. This latter aspect of arts education—training—deserves special attention for many reasons. It assures a future audience with an appetite for art and culture. More importantly, training is a means of engaging young people and cultivating alert, disciplined minds. Unfortunately, public schools—a major public policy arena—strapped for money, have long ago divested themselves of the responsibility for training in the arts. Yet first-rate training programs at all levels, from elementary and secondary, to pre-professional and professional levels, instill a sense of excellence. Mastery, the discipline of practice, the ability to organize and articulate ideas and feelings, the engagement with language and history—these are consequences of rigorous training in music, dance, theater, or creative writing. Additionally, in public school settings, the ensembles, choruses, orchestras, and theater groups are opportunities for collaboration, for developing interdependence and team work.

Though most public schools in large cities are bereft of meaningful training programs, cultural groups have filled in—sporadically—where finances permit. Their presence as agents of training should be encouraged. After-school and Saturday programs like the Children's Art Carnival or the Third Street Music Settlement capture the idle time and imaginations of young people and provide the benefit of attention from inspired adults.

The results of such programs can be dramatic; witness the City of New York's series of after-school cultural programs for children who live in temporary shelters and their families. Structured programs in theater, dance, creative writing, and science projects in small group settings in the City's cultural institutions have had a transforming effect. Teachers noted distinct changes in behavior in the students who participated. Pupils became more focused, they were more engaged by their school work, prompt to class, energetic. Summer institutes at cultural institutions as well as school-based and after-school programs continue the theme of constructive engagement.

Publicly the cultural community's strength in the area has been dramatically underestimated. In fact, in the face of competing needs—drug education, drop-out prevention, teen pregnancy—programs like the Feld Ballet's Original Ballet program in public schools or Boys Choir of Harlem have outstanding records of providing positive alternatives. Philanthropists might ask how funds can be directed away from supporting pathologies and towards more affirmative developmental programs that capture the talent and intelligence of our young people in public schools.

In addition to its value in public schools, training has an impact on the professional community. Many of our symphony orchestras, dance companies, and museums are notoriously homogeneous. In addition to providing diverse cultural institutions, we need to provide diversity within our institutions. Colleges, universities, and professional training schools are the major routes into arts professions these days. They need financial resources to offer opportunities for the gifted but financially limited student. The long-term survival of the cultural community requires this type of renewal.

Yet another public arena impacted by the funding of culture is the reclamation of our cities. Very often during the past 25 years, public institutions have been the only stabilizing anchor in otherwise crumbling cities. In many cases, the islands of stability and order are institutional: churches, libraries, colleges, universities, and cultural institutions. Large encyclopedic places like City College, New York University, or the Brooklyn Museum are often anchors in their respective communities. Frequently even smaller spaces like the Joyce Theater, the Studio Museum in Harlem, or the Bronx Museum have been catalysts for the rejuvenation of neighborhoods. As cities lost favor with the federal government, this role has been all but forgotten; resurrecting the value of this goal may very well be the salvation of our cities.

In the final analysis, what the cultural community needs most urgently is a passionate advocate, someone who is able to remind us—over and over—of why art and culture are essential to our lives. The substance is there; it's the articulation that needs more brilliance.

3

Foundation Funding of the Arts Before the 1980s

This brief history draws heavily on Paul DiMaggio's "Support for the Arts from Independent Foundations," published in January 1986 by Yale University's Program on Nonprofit Organizations (PONPO).[1] Unless otherwise noted, all quotes derive from the DiMaggio report. The principal sources upon which Professor DiMaggio drew are cited either in endnotes or in a list of additional references at the end of this essay. Research for the DiMaggio paper was funded by PONPO and by the Ford Foundation.

Almost since their founding at the beginning of this century, foundations have made grants to the arts, or to "aesthetics." But early on, the amount given was minuscule, from around 1 percent of all grants during the 1920s, to perhaps 2.7 percent in 1930. As the Great Depression dragged on, foundation arts funding dropped precipitously; it did not rise noticeably until the late 1950s.

Foundation funding of culture in these early years was largely idiosyncratic. Some foundations made almost all their donations to one or two groups—such as the Juilliard Foundation, which funded only its own music academy and the Metropolitan Opera—and exercised heavy control over the way the recipient organizations were administered. Other grantmakers, like the Carnegie Corporation and the Rockefeller Foundation, provided a wider array of grants and adhered basically to a hands-off approach.

THE CARNEGIE CORPORATION ERA

To refer to Carnegie's policy as noninterventionist is not to gainsay its dominance among private arts funders and its widespread influence over the development of art institutions themselves during the years of Frederick Keppel's leadership of the foundation—the 1920s and 1930s.

Excluding the Juilliard Foundation's grants to its music conservatory and the General Education Fund's donations for "industrial arts," Carnegie's

disbursements accounted for 82 percent of all private foundation giving to the arts in 1930.

Although Carnegie's thrust aimed more towards arts literacy than artist training or the creation of art works, its grants were nevertheless broadly distributed. The foundation funded graduate fellowships for leading art historians and museum directors; distributed art books, slides, photographs, and records to hundreds of universities and high schools; endowed music departments in institutions of higher learning; underwrote the operating costs of arts associations such as the American Association of Museums; and funded the first community arts councils.

Through its grants, Carnegie appears to have played no small part in "disseminating and institutionalizing" the "high culture" embodied by museums and orchestras after the late 1800s, fostering the "emerging union of the arts and universities," and encouraging the professionalization of museum and orchestra management. Indeed, not until the Ford Foundation set out in 1957 to revitalize America's performing arts would any single grantmaker so affect the contours of the cultural scene in the United States. Carnegie's retreat from arts funding after 1943 left the arts with only minor support from a few small foundations.

THE FORD FOUNDATION ERA

Where Carnegie looked largely to academic institutions as the medium through which culture was to be sustained and promoted, Ford focused on the needs of the arts groups themselves, especially symphony orchestras, dance ensembles, and theater companies. Symphonies, though numerous and firmly rooted, faced growing deficits. In the dance and theater world, however, viable groups were the exception; Ford's goal on their behalf was virtually to "creat[e] new industries where none existed."

With unprecedented cultural appropriations, Ford helped create strong regional performing arts companies, seeking direction from artists and directors themselves. Its emphasis on the needs of artists led Ford to assist the nonprofit arts groups that gave them work, helping these organizations to build up recurrent paying audiences and, later, to adopt sounder mangement techniques.

From the late 1950s through the 1970s, directed in its arts giving by W. McNeil Lowry, Ford provided tens of millions of dollars to the performing arts, helping to eliminate the crippling deficits of many symphony orchestras ($80 million was authorized for this single purpose in 1966); encouraging resident theaters to "reach and maintain new levels of artistic achievement"; enabling minority theaters to develop and present their craft; establishing a major service and monitoring organization for the theater—the Theatre Communications Group (TCG)—that became a model for other disciplines; supporting ballet and opera companies; and otherwise assisting artists and arts groups to produce and document new works and to gain professional training.

OTHER KEY PLAYERS

Ford clearly dominated arts funding during the 1960s and 1970s, but other foundations also became active, some heavily so. The Rockefeller Foundation, for example, started up arts funding in the late 1950s, focusing first on Lincoln Center, and then broadening its program in the 1960s. Although Rockefeller's grants to arts and culture during much of this time were but a fraction of Ford's disbursements, it funded a number of innovative ventures. Like Ford, it supported artistic professionalism; like Carnegie, it emphasized universities as a key arts medium. Professional training programs won support as did fellowship programs for creative artists.

Other notable national or international arts funders in the 1970s and into the 1980s included Andrew W. Mellon, Kresge, John Simon Guggenheim, JDR 3rd Fund (now defunct), and Rockefeller Brothers Fund. (Also a national presence, though not yet a grantmaker, was the J. Paul Getty Trust.) Local arts funders with wide-ranging programs included, among others, Hewlett, Mabel Pew Myrin (one of the Pew Charitable Trusts),

Ahmanson, and MacArthur (which only started grantmaking in the late 1970s).

Each followed its own course, some favoring capital expansion (Kresge), others the conservation of art masterpieces (Mellon), yet others international cultural exchange (Rockefeller Brothers and JDR 3rd). Through its operating programs, Getty supported scholarship, conservation, and arts education.

But the policies and interests of these arts funders— whether national or local—were not necessarily typical. Many other large grantmakers were providing cultural funding from the mid-1950s; their collective funding record provides a more balanced view of foundation arts support during those years.

The following statistical summary emerges from a Twentieth Century Fund study of the grants made by 47 of the 54 largest independent foundations between 1955 and 1979, measured in five-year intervals; these foundations accounted for 35 percent of all grant dollars appropriated in 1979.[2]

TRENDS IN ARTS FUNDING, 1955-1979

Among the significant developments during these years was the growth in the *number* of grants for the arts by these large foundations; it more than quadrupled, from 485 in 1955 to 2032 by 1979.

Equally significant, the *portion of foundation dollars* allocated to the arts during this period doubled, from around a tenth of all dollars to around a fifth, including Ford Foundation expenditures. Without Ford, the rise was from nearly 13 percent to about 20 percent. (A comparison of the absolute dollar amounts is misleading, because they are not adjusted for inflation.)

A closer look at the study years reveals that without Ford's involvement, the overall rise in the proportion of grant dollars going to the arts was not steady; increases and decreases occurred at various intervals and the rate of growth also varied. Excluding the Ford Foundation's allocations, the jump was most marked between 1955 and 1960 (from 13 to nearly 18 percent). Between 1965 and 1970, the share fell, but it rebounded five years later to the 1965 level (20 percent), where it remained until the end of the 1970s. (With Ford's involvement, the rise in the proportions of arts grants *was* steady.)

Even allowing for double counting of some grants in the sample, the most widely funded fields in 1955 (excluding Ford's contributions) were music—broadly defined—and museums, receiving 2.2 percent and 1.4 percent, respectively, of the total number of foundation grants to all fields. Music support rose by a third, from 2.2 to 3.1 percent of the grants. Similarly, museum funding rose from 1.4 percent to 2.3 percent of all grants.

In other areas, again excluding Ford's role, dance funding, which was virtually nonexistent in 1955, amounted to 0.7 percent of the number of grants 24 years later. The number to the theater, as a share of all foundation allocations, grew sevenfold, from 0.3 percent to 2.2 percent. And the share to the visual arts more than doubled, from 1.1 percent to 2.7 percent.

The growth in the share of grant dollars allocated for the arts by these 47 large foundations was also profound. Again excluding Ford's grants, funding of the arts as a share of all dollars grew by almost two-thirds during the period, from 12.8 percent to 20.3 percent. (With Ford's input, the rise was more than 100 percent.) In all the major categories, proportions grew, and in several they doubled. By 1979, museums captured 3.2 percent of dollars to all fields; media, 2 percent; and music, 1.5 percent.

Although Ford's involvement was by far the most important in terms of sheer size and national focus, its gifts to the performing arts were not inconsistent with the collective trends of the other grantmakers. But the very enormity of its allocations distorts the overall picture, at least for the performing arts. Counting Ford's grants to theater, for example, the share of dollars to that field grew four and half times; without Ford's grants, the share grew by less than two-thirds.

Two other developments during the era are noteworthy. First, as arts grantmaking grew in the 1960s and 1970s, so did the number of grant applicants. A review of the average grant size during that period shows that in some fields, such as theater and dance, foundations responded by making more, but smaller, grants. In other fields, such as music, and also for visual arts and museums, the average grant grew in size.

Second, in 1965, Congress authorized establishment of the National Endowment for the Arts (NEA), the most pronounced entry of the federal government into the American arts world since the Federal Theater Project, Federal Writers Project, and other arts initiatives of the New Deal.[3]

According to testimony submitted many years later to a national commission investigating the NEA's record, this governmental "presence and imprimatur encouraged and stimulated the growth of private foundations to become involved in the arts in many cities and regions throughout the United States where there was little activity prior to 1965. Further, the matching requirement attached to NEA grants [was] clearly responsible for stimulating large increases in private support."[4]

ARTS FUNDING AND THE ONSET OF THE REAGAN YEARS

Data on arts funding for the years 1980 to 1982 (that is, prior to the years examined thoroughly in this report) are based on a far larger sample of foundations and grants, drawn from the Foundation Center's grants database.[5] The sample includes corporate and community foundations, as well as independents. Despite differences in the sample and in the classification systems used, some useful comparisons may be drawn between the Center's data and the Twentieth Century Fund's findings regarding proportions of spending within the arts during key transition years.

In 1979-80, the final year of the Carter administration, foundations in the *Grants Index* sample allocated about 13.5 percent of their grant dollars to "arts and culture," a category that included, in addition to the visual and performing arts, architecture, history, language and literature, media, and "general" arts.

From 1980 to 1982, following governmental transition to the Reagan era, arts allocations as a share of all foundation giving first rose above 15 percent and then receded back to 14 percent, *still higher than 1980 levels.* Spending for museums and the visual arts increased from 3 percent to 3.9 percent over the period, while music's share of grant dollars rose from 2 percent to 2.4 percent. Not all arts fields advanced, however. Grants to theater and dance declined slightly, from 2 percent to 1.4 percent.

Despite small losses in individual fields, the data show that foundations had not abandoned the arts, as had been feared, to satisfy stepped up

demands from human service groups reeling under the impact of domestic program cutbacks. During these initial Reagan years, the arts maintained a stable slice of the philanthropic pie—which itself had begun to show growth in real dollars in 1981, as inflation came under control.

Not only did foundation assets swell with the stock market, but corporate foundation giving between 1979 and 1981 had jumped by 22 percent *after adjusting for inflation.*[6] By the early 1980s, several corporate foundations had become leaders in arts funding (see "Overview" chapter).

Although the establishment of the NEA, and especially its matching grant programs, had encouraged a wider national distribution of arts funds, most grantmaking foundations continued to follow a local orientation. At the start of the 1980s, even among the largest foundations, only a few gave nationally; and among large local givers, only a few sustained programs with long-term objectives to benefit the arts community.

Not surprisingly, smaller foundations almost invariably followed a local orientation; the effect was to perpetuate an uneven geographic distribution of philanthropic arts donations, with most of the money going to groups in cities or regions where foundations were concentrated. Further, the support was overwhelmingly focused on the larger, more prestigious institutions, most particularly among symphony orchestras and museums.

Improved data collection and grants classification since the findings in this chapter were originally developed allow for a more complete analysis of foundation funding trends beginning in 1983. The following chapters present trends in arts funding by overall annual allocations, by arts subject area, and by type of support. The analysis will especially focus on distribution patterns. Our inquiry will seek to determine whether funding in the 1980s "opened up" access to foundation grants, or continued to perpetuate fairly narrow distribution patterns.

ENDNOTES

1. Paul DiMaggio, "Support for the Arts from Independent Foundations, PONPO Working Paper No. 105, ISPS Working Paper No. 2105, Program on Non-Profit Organizations, Yale University, January, 1986, New Haven.

2. These data, from printouts on file at the Foundation Center in New York, were collected by Karla Shepard as part of a study sponsored by the Twentieth Century Fund.

3. Milton C. Cummings, Jr., "Government and the Arts: An Overview," in Stephen Benedict (ed.), *Public Money and the Muse*, W.W. Norton & Company, 1991, New York, Pages 32-77.

4. Richard Mittenthal, The Conservation Company, "Testimony Submitted to the Independent commission Reviewing the National Endowment for the Arts," July 23, 1990, Page 9.

5. *The Foundation Grants Index*, Editions 10, 11, and 12, The Foundation Center, 1981-83, New York.

6. Loren Renz, *Foundation Giving*, 1st Edition, The Foundation Center: New York, 1991, Page 31.

SELECTED ADDITIONAL REFERENCES CITED IN THE DIMAGGIO STUDY (SEE ENDNOTE 1).

American Foundations and their Fields. New York: Twentieth Century Fund, (various editions).

Andrews, F. Emerson. *Philanthropic Giving.* New York: Russell Sage Foundation, 1950.

Goody, Kenneth. "The Funding of the Arts and Artists, Humanities and Humanists, in the United States." *Report to the Rockefeller Foundation* (November 1983).

Jubin, Brenda. *Program in the Arts, 1911-1967.* New York: Carnegie Corporation, 1968.

Lindeman, Eduard C. *Wealth and Culture: A Study of One Hundred Foundations and Community Trusts and Their Operation During the Decade 1921-1930.* New York: Harcourt, Brace and Company, 1936.

Weaver, Warren. *U.S. Philanthropic Foundations: Their History, Structure, Management, and Record* (see especially essay by Brooks Atkinson on American foundations and the theater). New York: Harper and Row, 1967.

4

Dimensions of Arts Funding
in 1983, 1986, 1989

AMID MANY CHANGES, SHARE OF FUNDS TO THE ARTS REMAINED STEADY

Despite heightened competition for funds between the arts and all other fields in the 1980s, overall foundation support appeared remarkably constant. But along with this stability, the 1980s witnessed profound changes in foundation activity. Some traditional funders reduced their giving to the arts, new funders entered the field, minor funders became major contributors, total dollars (if not shares) increased considerably along with surging foundation assets, and the size of the grants changed—becoming larger at the end of the decade than at the start.

In terms of the stable trends, no major shifts in either the share of grant dollars or the number of grants awarded to the arts were evident from the start to the end of the study years. As demonstrated in Table 4-1, the nation's major arts funders allocated around one out of every seven dollars, and about one in every six grants, to the arts in 1983, 1986, and 1989. Foundation policy varied least by number of grants: the share of grants allotted to the arts started at 15 percent, went up in 1986 to 16.4 percent, and then inched down slightly towards the end of the 1980s. For arts dollars, the share dipped as a proportion of all giving in 1986, from 14.7 percent to 12.6 percent; it then rose slightly to 13.6 percent three years later.

Overall, throughout the 1980s, levels of support for the arts were highly similar, regardless of foundation type (Figure 4-1). In 1983, independent foundations, which included two out of three funders in the sample, gave a slightly larger share of their grant dollars to the arts. The share dropped in 1986, pulling down the larger sample. Corporate funders, on the contrary, increased their portion of support to the arts in 1986 and that share held steady in 1989. For community foundations, arts funding as a percent of all giving was steady through 1986, and then jumped sharply in 1989, the result of intensified spending by several newly large or new funders.

The trend among a smaller group of consistent funders—the same 180 included in the sample in each of the study years—was less assuring. Consistent funders showed a drop in share of arts grant dollars in 1986 and again in 1989. By the end of the 1980s, they also registered a decline in share of grant number.

MORE TOTAL DOLLARS TO ALL FIELDS INCLUDING THE ARTS

While neither the share of grant dollars nor number of grants to the arts varied appreciably during the study years for the sample as a whole, the total funds flowing into the arts increased substantially,

TABLE 4-1. ARTS GRANTS AS A PERCENTAGE OF ALL GRANTS FROM FOUNDATIONS IN *THE FOUNDATION GRANTS INDEX**

Year	Arts Funders[1]	All Funders	%	Arts Grant Dollars	All Grant Dollars	%	Arts Grant Number	All Grant Number	%
1983	372	454	81.9	$237,903	$1,618,195	14.7	4,982	33,273	15.0
1986	376	455	82.6	322,210	2,548,902	12.6	6,812	41,537	16.4
1989	596	697	85.5	502,883	3,691,741	13.6	7,842	50,683	15.5

Source: The Foundation Center, 1992.
* Dollar figures in thousands.
[1] Foundations sample drawn from *The Foundation Grants Index* database for grants authorized in the year indicated. Due to changes in the sample over time, comparisons are based only on percentages.

TABLE 4-2. GROWTH OF ARTS GRANTS VS. ALL GRANTS FOR ALL SAMPLED ARTS FUNDERS*

Year	Number of Funders	Number of Arts Grants	Arts Grants (Current)	% Change	Arts Grants (Constant)	% Change	Number of All Grants	All Grants (Current)	% Change	All Grants (Constant)	% Change
1983	372	4,982	$237,903		$238,858		33,273	$1,624,693		$1,624,693	
1986	376	6,812	322,210	35.4	293,987	23.1	41,537	2,548,902	57.5	2,325,640	43.1
1989[1]	596	7,842	502,883	56.1	405,551	37.9	50,683	3,691,741	44.8	2,977,210	28.0

Source: The Foundation Center, 1992.
* Dollar figures in thousands. Inflation adjustment based on CPI where 1982-1984 = 100.
[1] The *Grants Index* sample was substantially increased in 1989. Growth of arts funding from1986 to 1989 may be interpreted only in relation to growth of all grants and not as an absolute percent increase.

even allowing for variations in the sampling of foundations for each of the three years.

Arts funding by foundations in the *Grants Index* jumped from nearly $238 million in 1983, to $322 million in 1986, up some 23 percent after adjusting for inflation, and then to nearly $503 million in 1989, up 38 percent (Table 4-2). The jump from 1986 to 1989, however, overstates growth since it derives in part from an increase in the sample size. In 1983 and 1986, the *Grants Index* sample represented about 40 percent of all U.S. foundation spending. In 1989, it represented about 50 percent.

Nevertheless, data from a *matched set* of arts grantmakers— representing only those 180 foundations appearing in the sample in 1983, 1986, and 1989—confirm that total dollars to the arts during the study period, as to all fields, had grown sizably, even accounting for inflation (Table 4-3). Growth

FIGURE 4-1. ARTS GRANTS AS A PERCENT OF ALL GRANTS BY FOUNDATION TYPE

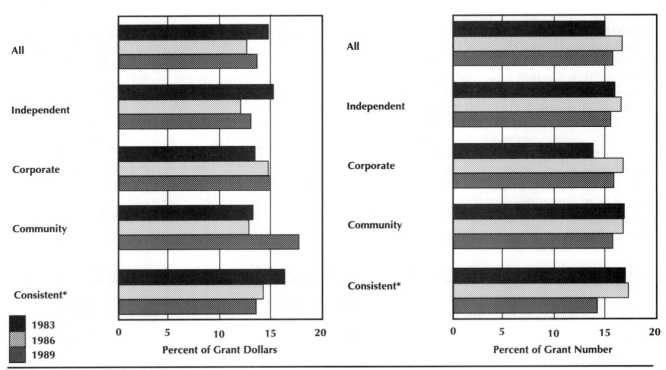

Source: The Foundation Center, 1992.
* Matched set of 180 foundations; includes all types.

TABLE 4-3. GROWTH OF ARTS GRANTS VS. ALL GRANTS FOR CONSISTENT ARTS FUNDERS*

Year	Number of Funders	Arts Grants (Current)	% Change	Grants (Constant)	% Change	All Grants (Current)	% Change	All Grants (Constant)	% Change
1983	180	$173,863		$174,562		$1,066,742		$1,071,026	
1986	180	223,832	28.7	204,227	17.0	1,571,929	47.4	1,435,154	33.9
1989	180	275,093	22.9	221,849	8.6	2,062,638	31.3	1,663,418	15.9

Source: The Foundation Center, 1992.
* Dollar figures in thousands. Inflation adjustment based on CPI where 1982-1984 = 100.
"Consistent funders" are those sampled foundations that reported arts grants in all three study years.

was strongest through 1986. Growth continued after that, but inflation took a larger bite.

Further, if data from the expanded sample of foundations overstate the rate of growth in arts funding for 1989, then data from consistent funders certainly understate the rate for both 1986 and 1989. This is because they exclude the many new and newly large funders who became active in arts funding after 1983.

In fact, the philanthropic community experienced tremendous growth during the 1980s, both in the giving capacity of the largest foundations and in the absolute number of large and mid-sized foundations. Annual disbursements from all U.S. foundations had soared 76 percent (almost 37 percent in real dollars) in the six years spanning 1983 to 1989, reaching $7.91 billion.[1] That growth was fueled primarily by an extended bull stock market, almost unabated from 1983 through most of 1987, which generated solid increases in foundation assets. (By law, foundations are required to spend 5 percent of their assets annually on grants and related expenditures.)

With the explosion of new wealth created in the 1980s came a related but unanticipated consequence: a sharp rise in the creation of new foundations. More than 3,000 foundations with assets in excess of $1 million were created in the 1980s.[2] After 1986, both new and newly large foundations provided important resources to the arts, as to all fields. To some extent, however, growth in private foundation support was offset by a decline in the growth of corporate giving and by a concurrent drop in federal government support. (See box.)

GRANTS TO ARTS OUTPACED INFLATION, FIRST LAGGING BEHIND, THEN SURPASSING, GRANTS TO ALL FIELDS

The combination of a swelling stock market, a relatively low annual growth rate in the cost of living

(around 4 percent a year during the 1980s), and the addition of new funding sources allowed foundation giving in all fields to far outpace inflation during the study years. The arts, of course, participated in this development, although increases to the field at first were not as sizable as funding growth in general.

Among the foundations in the *Grants Index*, as shown in Table 4-2, giving to all fields grew by 43 percent after inflation from 1983 to 1986, and by another 28 percent from 1986 to 1989 (the latter increase is based on a larger sample, as noted earlier, and is useful principally for comparisons with arts funding growth).

Arts funding dollars jumped as well, but from 1983 to 1986, at a lower rate than grants to all fields. The trend reversed from 1986 to 1989, when, stimulated by an influx of new funders, arts funding growth exceeded growth in other fields.

However, this did not hold true for the majority of consistent funders. From 1986 to 1989, among consistent funders, spending in all fields grew at a faster pace than in the arts, just as it had in the first half of the decade (Table 4-3). The result, revealed in Figure 4-1, was a decline in the percentage of arts grant dollars from consistent funders.

Concerning the growth rate in the *number* of arts grants versus all grants for all sampled foundations during the study period, the arts rate was higher at first (37 percent versus 25 percent), but then dropped behind. The disparity in growth between arts grants and all grants from 1986 to 1989 was most pronounced among consistent funders. By 1989, the number of arts grants made by consistent funders had declined 9.2 percent when compared with three years earlier, while the number of grants to all fields had grown another 11.3 percent.

FOUNDATION AND STATE ARTS FUNDING BEAT INFLATION IN 1980s, WHILE GROWTH OF FEDERAL GRANTS DECLINED

Grants from both private foundations and state arts agencies grew more quickly than inflation throughout the study period, unlike disbursements from the National Endowment for the Arts (NEA).

As shown below in Table 4-4, state allocations leapt 44 percent in real terms between 1983 and 1986, and then increased another fifth by 1989. While foundation gifts also beat inflation, the rate of growth in state arts funding from 1983 to 1986 was almost four times the *estimated* growth rate of all foundation grants. During the latter part of the decade, growth rates were far more equal: state arts dollars adjusted for inflation rose by 22 percent between 1986 and 1989; foundation dollars rose by 17 percent.

But federal support of the arts, as measured through NEA disbursements, declined in real terms during the era, first by a half of 1 percent, and later by more than 7 percent.

FOUNDATIONS FAR OUTSPENT GOVERNMENT IN SUPPORT FOR THE ARTS

Of equal significance is the *absolute* difference in dollar amounts among the three types of funders. During each of the study years, according to esti-

mates developed from data in the *National Data Book of Foundations*, private and community foundations provided far more funds to the arts than both the NEA and state agencies combined: between two and a half and two and three quarters times more for each year of the study.

While the above figures for all foundations are based on estimates, it is important to consider that only those foundations in the *Grants Index* sample, as shown in Table 4-1, together gave considerably more to the arts than federal and state agencies in the three study years: $238 million, $322 million, and $503 million. The sample, which grew larger over time, represented about 36 percent of all foundation giving in 1983, 40 percent in 1986, and close to 47 percent in 1989.

In 1989, the 597 independent, corporate, and community foundations in the sample outspent the NEA and state agencies by more than $120 million, or by nearly one-third, based on grants of $5,000 or more, and excluding their grants to individuals. In the same year, just the 25 top foundations ranked by total arts grants together spent $207 million, compared with $150.6 million dispensed by the NEA and $230 million by state arts agencies.

TABLE 4-4. COMPARISON OF GROWTH OF FOUNDATION, FEDERAL, AND STATE FUNDING OF THE ARTS, 1983-1989*

Year	Foundations (Est.)[1]			NEA[2]			State Arts Agencies[3]		
	Amount (Current)	% Change (Current)	% Change (Constant)	Amount (Current)	% Change (Current)	% Change (Constant)	Amount (Current)	% Change (Current)	% Change (Constant)
1983	$ 658,429			$131,275			$104,933		
1986	805,770	22.4	11.3	143,715	9.5	-0.5	166,278	58.5	44.0
1989	1,076,009	33.5	18.0	150,650	4.8	-7.3	230,054	38.4	22.3

* Dollar figures in thousands. Inflation adjustment based on CPI where 1982-1984 = 100.
[1] Estimate based on percent of arts giving by foundations in *Grants Index* sample (see Table 4-1) as a proportion of total giving reported in the *National Data Book of Foundations*.
[2] National Endowment for the Arts, *1991 Annual Report*, Washington, DC: NEA, 1992. Figures include NEA program funds and other federal transfers. NEA figures do not include administrative expenses.
[3] National Assembly of State Arts Agencies, *The State of the State Arts Agencies 1992*, Washington, DC: NASAA, 1992. Figures represent legislative appropriations less 15 percent for adminstrative expenditures.

FOUR OUT OF FIVE SAMPLED FOUNDATIONS MADE GRANTS IN THE ARTS

The relative constancy of funding in the arts throughout the 1980s, even accounting for the dip in 1986, may be interpreted not only through the percentage of dollars and grants allocated to the field, but also through the share of funders who supported the arts. Regardless of changes in the foundation sample, the arts maintained a very high rate of participation among funders. In each of the study years, more than four out of five funders in the sample made grants to the arts (Table 4-1). By 1989, when the *Grants Index* sample jumped in size by over one-half, including far more mid-size corporate and independent foundations, the participation rate reached up to 85 percent.

It should be noted, however, that although the overall share of participants was high, many of these funders made only minimal contributions to the arts. Only a small number each year gave the arts at least 25 percent of their overall funds.

MEDIAN GRANT TO THE ARTS ALSO OUTPACED INFLATION, FIRST SLIGHTLY, THEN MORE ROBUSTLY

If the share of neither grant dollars nor grant numbers awarded to the arts changed significantly between 1983 and 1989, how did the "typical" or most representative arts grant—the median amount—fare?

Throughout these years, it outpaced inflation, rising 18 percent in real terms during the second half after a slight 2 percent rise during the first half (Table 4-5). The median—which means that half the grants each year were above it and half were below it—is generally acknowledged as a more representative measure of the typical grant than the mean or

"average" measure, because the median is not influenced by extreme amounts at either end.

The inflation factor is crucial. The cost of living, as measured by the Consumer Price Index, grew 10 percent from 1983 to 1986, and then another 13 percent by 1989—an average of about four percent each year. Before adjusting for inflation, the median arts grant rose by almost 13 percent by mid-decade—from $16,000 to $18,000, and then surged significantly higher towards the end, up to $24,000.

But as shown in Table 4-5, the real median arts grant—its purchasing power after adjusting for inflation—rose 20 percent from the start to the end of the era.

The large jump in the after-inflation median arts grant may surprise those in the arts community who had experienced deep financial problems by the end of the decade. But the financial distress was likely caused by other factors, especially over-indebtedness and cutbacks in corporate giving. Independent and community foundations, whose assets had climbed along with a booming stock market (except for the latter part of 1987), were obliged to increase their allocations. It is reasonable to expect that they would also increase the size of their individual grants.

One other explanation is that the size of the sample grew in 1989, which might have affected the size of the typical grant.

In fact, when compared to the median grant for all fields, the median arts grant, though at first smaller in size, grew more quickly. Table 4-5 shows that the real median grant—after inflation—to all fields rose by only 6.2 percent throughout the study period, first dropping by 4.3 percent, then rising 10.5 percent. The overriding fact was that the typical grant to all fields during the 1980s did not gain as much purchasing power as the typical arts grant. By 1989, the two were nearly identical.

TABLE 4-5. MEDIAN ARTS GRANTS VS. MEDIAN GRANTS TO ALL FIELDS*

Year	Median Arts Grants (Current)	% Change	Median Arts Grants (Constant)	% Change	Median All Grants (Current)	% Change	Median All Grants (Constant)	% Change
1983	$16,000		$16,064		$19,000		$19,076	
1986	18,000	12.5	16,423	2.2	20,000	5.3	18,248	-4.3
1989	24,000	33.0	19,355	17.9	25,000	25.0	20,161	10.5

Source: The Foundation Center, 1992.
* Inflation adjustment based on CPI where 1982-1984=100.

MILLION-DOLLAR-PLUS GIFTS TO LARGE INSTITUTIONS ABSORBED ONE IN SIX ARTS DOLLARS

A substantial share of foundation arts funds—one sixth—was channeled each year through a tiny number of exceptionally large grants, and those few grants went to an even smaller number of the nation's premier arts institutions. This fact emerges in a review of the largest arts grants and of the top-ranking recipients. It is also suggested by an exploration of mean, as opposed to median, arts grants.

As seen in Table 4-6, although the mean grant moved in a direction similar to that of the median grant during the second half of the study period, both increasing in value, the *mean amount* was two and a half times the median throughout the era. Precisely because mean averages tend to be strongly skewed by a few extremely high grant amounts, the greater the difference between the mean and the median, the more likely the distortion at one end of the grant spectrum.

The disparity was manifest throughout the study period. For example, in 1986, more than one out of every six dollars was contained in grants of over $1 million each—60 to 250 times the size of the typical or median art grants. And those one in six arts dollars went to just 24 organizations around the country—out of nearly 3,500 arts groups that received grants from sampled foundations. Furthermore, a few of those institutions—the Philadelphia College of Art (now the University of the Arts), the National Gallery of Arts, and the Los Angeles County Museum—each received more than one of those $1 million-plus grants. (Table 4-7 lists the ten largest arts grants awarded each year.)

Virtually identical disparities were evident at both the beginning and end of the study period. In 1983, just under one in six arts dollars were allocated through 16 grants above $1 million. Just 15 orga-nizations received the grants, out of more than 2,600 recipients that year.

Once again, in 1989, one in six arts dollars was allocated in the form of grants of over $1 million each to 32 organizations, out of nearly 3,800 that received arts grants that year. Two of the grants were above $8 million each, another two were for $5 million each, one was for almost $4 million, two for $3 million, eight for at least $2 million, and so forth. Three of the recipient organizations each secured more than one of these 37 grants.

A review of a wider range of large grants start-ing at $500,000 reinforces the picture. In 1983, out of nearly 5,000 arts grants awarded, 73 (1.5 percent) were for $500,000 and above; yet the total sum con-tained in these 73 grants amounted to nearly a third of all arts dollars distributed that year—almost $82.3 million out of $237.9 million.

The same was true for 1986 and 1989. By mid-decade, 111 arts grants out of 6,800, or a minuscule 1.6 percent, were for at least $500,000 each. But those awards accounted for 35.5 percent of the total amount of arts money awarded—$113.9 million out of almost $322 million.

By decade's end, 34.5 percent of foundation arts funding, or one in three dollars, was allocated through 161 grants of $500,000 or over, out of some 7,800 arts grants awarded by the sampled founda-tions.

LARGE GRANTS SKEW FUNDING IN ALL FIELDS INCLUDING THE ARTS

The vast disparity in the size of grants—from the median to the largest—and the concentration of funding in a relatively few grants is in no way con-fined to the arts field. In 1989, for example, just 1 percent of all foundation grants—those of $1 million or over—represented almost one-quarter of total grant dollars.

	Mean Arts Grants (Current)	% Change	Mean Arts Grants (Constant)	% Change	Mean All Grants (Current)	% Change	Mean All Grants (Constant)	% Change
TABLE 4-6. MEAN ARTS GRANTS VS. MEAN GRANTS TO ALL FIELDS*								
Year								
1983	$44,746		$44,926		$48,634		$48,829	
1986	47,300	5.7	43,157	-3.9	61,365	26.2	55,990	14.7
1989	64,127	35.6	51,715	19.8	72,840	18.7	58,742	4.9

Source: The Foundation Center, 1992.
* Inflation adjustment based on CPI where 1982-1984 = 100.

TABLE 4-7. TEN LARGEST ARTS GRANTS BY YEAR

Recipient	Donor	Amount	Purpose
1983			
1. National Arts Stabilization Fund	Ford Foundation	$7,000,000	To improve financial health of performing arts and other groups.
2. Menil Collection	Brown Foundation	5,000,000	For construction of art museum.
3. Indiana State Symphony Society	Krannert Charitable Trust	3,127,000	For capital support.
4. Stanford University	Knight Foundation	3,087,500	For Knight Journalism Fellowship Program.
5. Metropolitan Opera Association	Texaco Foundation	3,054,950	Not specified.
6. Philadelphia Museum of Art	Pew Memorial Trust*	3,020,000	For acquisitions and for exhibition support.
7. Amon Carter Museum	Amon G. Carter Foundation	2,243,560	For general support.
8. Museum of Fine Arts of Houston	Brown Foundation	2,241,536	To extend matching grant for ten years.
9. University of Pennsylvania	Pew Memorial Trust*	2,000,000	Toward renovation of University Museum.
10. Commission for Downtown	Lilly Endowment	2,000,000	For renovation of Circle Theatre.
1986			
1. Philadelphia Museum of Art	Pew Memorial Trust*	$5,000,000	For challenge grant to support current capital campaign.
2. Children's Museum of Indianapolis	Lilly Endowment	4,500,000	Toward capital campaign.
3. Indianapolis Museum of Art	Lilly Endowment	3,500,000	For capital campaign to construct new pavilion.
4. Amon Carter Museum	Amon G. Carter Foundation	3,020,588	For general support.
5. Natural History Museum of Los Angeles County	Weingart Foundation	3,000,000	For construction of Pavilion of Evolving Life.
6. United States Holocaust Memorial Museum	Helena Rubinstein Foundation	3,000,000	To endow cinema in Museum's Cultural and Conference Center.
7. Woodrow Wilson National Fellowship Foundation	Andrew W. Mellon Foundation	2,780,000	For program of Mellon Fellowships in the Humanities.
8. National Gallery of Art	Morris & Gwendolyn Cafritz Foundation	2,660,000	For art acquisition.
9. National Gallery of Art	Andrew W. Mellon Foundation	2,500,000	For permanent endowment of Paul Mellon Fund.
10. Pittsburgh Trust for Cultural Resources	Howard Heinz Endowment	2,201,182	For operating support and for Benedum Center capital campaign.
1989			
1. Indiana State Symphony	Lilly Endowment	$8,500,000	For acquisition of Circle Theatre.
2. Gene Autry Western Heritage Museum	Autry Foundation	8,088,400	Not specified.
3. Massachusetts Institute of Technology	Knight Foundation	5,000,000	To endow Knight Science Journalism Fellowships.
4. Woodrow Wilson National Fellowship Foundation	Andrew W. Mellon Foundation	5,000,000	For program of Mellon Fellowships in the Humanities.
5. Amon Carter Museum	Amon G. Carter Foundation	3,918,902	For general support.
6. Charlotte, City of	Foundation for the Carolinas	3,150,000	For North Carolina Performing Arts Center at Charlotte.
7. Baylor University	Houston Endowment	3,000,000	Toward construction of Mary Gibbs Jones Theater.
8. National Gallery of Art	Morris & Gwendolyn Cafritz Foundation	2,500,000	For art acquisition.
9. Metropolitan Museum of Art	Charles Engelhard Foundation	2,446,406	Not specified.
10. Art Institute of Chicago	Pritzker Foundation	2,100,000	Not specified.

Source: The Foundation Center, 1992.
*The Pew Memorial Trust is one of seven individual charitable funds collectively known as The Pew Charitable Trusts. Although grant distributions are made from the individual trusts, in all other respects they function as a single grantmaking institution. Through 1987, grants were reported in the *Grants Index* under the names of the individual trusts.

The huge gap in grant size across nearly all fields reveals both profound differences in the giving policies of funders and the diverse size and character of nonprofit groups themselves—from the very largest institutions serving the broadest audiences and employing thousands, to the smallest community-based groups, whose staff are wholly voluntary.

SHARE OF DOLLARS TO TOP 50 ARTS GROUPS DECLINED; NUMBER OF RECIPIENTS UP BY HALF

A more direct measure of the highly skewed concentration of arts grants is the share received by the top 50 grantees in each study year. What the measure shows is that while the distribution of grants remained top heavy, the bias was far less at the end of the 1980s than at the beginning.

Ranked by total dollars received, the top 50 grantees secured more than two out of five arts dollars (42.4 percent) in 1983, one out of three (34.5 percent) in 1986, and three out of ten (30.9 percent) in 1989.

While the data show a trend towards greater equity in the distribution of arts grants during the 1980s, it should be recalled that the top 50 competed among some 2,600 to 3,800 arts grantees (and presumably, many more arts groups seeking funds). By decade's end these select few represented just over 1 percent of all recipients. That they secured three out of ten arts dollars by 1989 still raises a fundamental question regarding access to private funding.

Even accounting for changes in the sample, it appeared that access increased in the 1980s given: a) the jump in the number of grants—up by more than half over the period; and b) the jump in the number of recipients—up by just under one half. But not all funders embraced wider distribution policies. Many foundations in the sample, especially those that were unstaffed, continued to give out few grants to institutions linked closely to their founders. And even some larger staffed foundations continued to provide major support to just a few organizations.

Table 4-8 lists the top ten arts organizations in 1983, 1986, and 1989, ranked by the total amount of dollars received.

Some Large Grants Benefit Many Groups. To a limited extent, the steep concentration of dollars in rela-

tively few arts grants was mitigated by the intended scope of some of those grants. For example, in 1983, the Ford Foundation committed $7 million, or almost half its arts allocations, to one organization,

TABLE 4-8. TOP TEN ARTS RECIPIENTS BY YEAR

Recipient Name	Amount	Percent of Arts Dollars	No. of Grants
1983			
1. National Arts Stabilization Fund	$9,000,000	3.8	3
2. Metropolitan Museum of Art	5,850,250	2.5	34
3. Metropolitan Opera Association	5,564,012	2.3	31
4. Menil Collection	5,000,000	2.1	1
5. Indiana State Symphony Society	4,577,000	1.9	3
6. Stanford University	3,759,500	1.6	8
7. Museum of Fine Arts of Houston	3,471,806	1.5	12
8. Philadelphia Museum of Art	3,157,000	1.3	4
9. Museum Associates (Los Angeles County Museum of Art)	2,639,438	1.1	10
10. Dallas Symphony Association	2,626,100	1.1	11
Total	**$45,645,106**	**19.2%**	**117**
1986			
1. National Gallery of Art	$6,468,000	2.0	15
2. Philadelphia Museum of Art	6,108,100	1.9	11
3. Metropolitan Museum of Art	5,293,005	1.6	35
4. Childrens Museum of Indianapolis	4,500,000	1.4	1
5. Indianapolis Museum of Art	4,260,000	1.3	3
6. Museum Associates (Los Angeles County Museum of Art)	3,975,191	1.2	8
7. Pittsburgh Trust for Cultural Resources	3,711,182	1.2	7
8. Philadelphia College of Art	3,625,000	1.1	3
9. Woodrow Wilson National Fellowship Foundation	3,363,887	1.0	3
10. K T C A Twin Cities Public Television (Minneapolis)	3,239,500	1.0	12
Total	**$44,543,865**	**13.7%**	**98**
1989			
1. Metropolitan Museum of Art	$11,103,337	2.2	45
2. Indiana State Symphony Society	8,845,000	1.7	4
3. Gene Autry Western Heritage Museum	8,138,400	1.6	2
4. Art Institute of Chicago	7,391,932	1.5	27
5. Philadelphia Museum of Art	5,987,520	1.2	17
6. National Gallery of Art	5,984,500	1.2	26
7. Educational Broadcasting Corporation	5,171,252	1.0	16
8. Massachusetts Institute of Technology	5,010,000	1.0	2
9. Woodrow Wilson National Fellowship Foundation	5,000,000	1.0	1
10. Amon Carter Museum	4,128,902	0.8	3
Total	**$66,760,843**	**13.3%**	**143**

Source: The Foundation Center, 1992.

the National Arts Stabilization Fund. But the purpose of that fledgling entity was to support a broad range of performing and other arts groups (see Chapter 5). Ford's single grant, in other words, was designed to benefit the larger arts community.

Likewise, the John D. and Catherine T. MacArthur Foundation's grant of more than $1.5 million in 1986 to a public television station (ACSN: The Learning Channel) enabled numerous independent film and video artists to air their productions each week throughout the year.

Similarly, the Andrew W. Mellon Foundation's Humanities Fellowship Program, administered annually through the Woodrow Wilson National Fellowship Foundation, provides opportunities for scholarship to a broad academic audience. And the Knight Foundation's Journalism Fellowship programs are intended ultimately to benefit many recipients.

But these are the exceptions. For the most part, the largest grants were limited to the benefit of their immediate recipients. And these recipients, as has been shown, were relatively few.

FEWER SMALL GRANTS, MORE MID-LEVEL AND LARGE GRANTS AWARDED TO THE ARTS DURING DECADE

Growth in the median and mean grant signaled shifts upward in the distribution of arts dollars by individual grant size, not surprising in light of the concurrent growth of inflation. In 1983, two-thirds of all grants to the arts ranged between $5,000 and $25,000, a proportion that held steady through 1986 (Figure 4-2). But by 1989, that proportion declined, as only half the arts grants were less than $25,000, more than a fifth ranged between $25,000 and $50,000, and another fifth ranged between $50,000 and $250,000.

At the higher end of the scale, where individual arts grants amounted to at least $250,000 (and reached up to more than $5 million), the percentage awarded remained steady during the first part of the study, and then grew, but only slightly, by decade's end. In 1986, only one in 29 arts grants was of that size. By 1989, the proportion reached about one in 20. (At the very highest levels, where grants amounted to $1 million or more, the shares remained fairly steady: from three-fifths of 1 percent of all grants during the earlier years, to four-fifths of 1 percent at the end.)

In the middle ranges, with grants varying between $25,000 and $250,000, the change was much more pronounced, growing from less than one in three grants at the start of the period to almost one in two at the end.

In sum, responding to inflationary pressures, the number of small arts grants declined sharply by the end of the decade, and the number of mid-size grants jumped. The proportion of large grants grew also, but only modestly.

Large Grants Account for Less Funding. Also notable is that while the number of large arts grants ($250,000 or over) increased, the total amount of large-grant dollars—as a share of all arts grants— did not; instead it *declined* slightly in 1986 and then held steady in 1989 at 47 percent (Figure 4-2).

Concerning the smaller grants, those ranging between $5,000 and $25,000, the shares of both the number and the amount dropped. For the first two study years, the total arts dollars distributed in grants of this range amounted to just above 13 percent. By 1989, the comparable proportion was 10 percent.

In the middle ranges, for grants between $25,000 and $250,000, the total dollar amount, as a proportion of all arts grants, grew during the decade, slightly at first, and then more strongly. In 1983, mid-size grants accounted for about 38 percent of all arts grant dollars; the percentage rose to nearly 40 percent in 1986, and climbed again to 43 percent in 1989.

SHARE OF FOUNDATIONS GIVING IN THE HIGHEST AND LOWEST RANGES DECLINED, IN MIDDLE RANGES ROSE

Another perspective on changes in the disbursement of arts grants during the 1980s is suggested through a review of the ranges of *total arts giving* among sampled foundations (distinct from the ranges of individual grant size, discussed above). The share of foundations dispensing total arts grants in both the lowest (up to $100,000) and highest ($5 million to $25 million) ranges declined throughout the era (Table 4-9).

By contrast, in most of the middle ranges, the share of foundations rose, if not steadily then at least by the end of the era. This was especially true for foundations giving anywhere from $100,000 to under $1 million, which grew from 39 percent to

nearly 51 percent over the study years. Just above that range, where total arts giving spanned $1 million to $5 million, the proportion of foundations at first rose, then declined, but it was still higher in 1989 (19.8 percent) than it was in 1983 (18.5 percent).

The proportion of foundations dispensing arts grants in the lowest range—less than $100,000—dropped by a third, from 39 percent in 1983 to 27.4 percent in 1989. The decline was most pronounced for arts funders at the bottom of the category—those spending less than $50,000.

Correspondingly, at the middle and higher levels of total arts disbursements—with amounts starting at $100,000—the proportion of foundations included in each range went up, without exception, throughout the study period. It was only at the very highest level of total arts allocations ($5 million and above) that the percentage of funders declined. The increase in the sample size in 1989, including many more mid-sized independent and corporate foundations, undoubtedly influenced distribution patterns.

INDEPENDENTS ACCOUNTED FOR MOST ARTS FUNDERS AND MOST DOLLARS; CORPORATE SHARE OF FUNDERS GREW IN 1980S

Independent foundations consistently comprised the majority of funders in the *Grants Index* sample. In 1983, as shown in Figure 4-3, they represented

nearly 70 percent of the 372 arts funders; by 1989, that share dropped to 65 percent (of 596 funders). By contrast, corporate foundations increased their representation from one in six arts funders in 1983 to one in four by the decade's end. Nearly all of the remaining funders in the sample were community trusts.

The sharp rise in the proportion of corporates in 1989, and the corresponding drop in the share of independents and community trusts, was closely linked to a 50 percent increase in the sample size in that year (see Table 4-1). The larger sample was far more representative of corporate foundations, which by 1989 comprised about 25 percent of the 1,000 largest U.S. foundations, ranked by total giving.

As corporates gained in numbers, they also accounted for a larger share of arts dollars compared with independent and community foundations. But this was true only between 1986 and 1989, and the resulting increase in dollar share was modest. After dropping slightly in 1986, the share of the sample's arts dollars provided by corporate foundations grew from 14.5 percent to just over 17 percent, a far smaller percentage increase than their growth in numbers. Over the same six-year span, independent foundations consistently provided more than three-fourths of arts dollars, although that share dipped slightly from a high of 79 percent in 1983 to 77 percent in 1989.

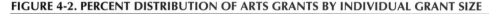

FIGURE 4-2. PERCENT DISTRIBUTION OF ARTS GRANTS BY INDIVIDUAL GRANT SIZE

TABLE 4-9. DISTRIBUTION OF ARTS GIVING BY TOTAL DOLLAR RANGE*

Arts Giving Range	1983				1986				1989			
	No. of Funders	%	Amount	%	No. of Funders	%	Amount	%	No. of Funders	%	Amount	%
$5 mil. and over	13	3.5	$76,885	32.3	12	3.2	$97,762	30.3	14	2.3	$149,394	29.7
$1 mil. to $5 mil.	69	18.5	89,252	37.5	81	21.5	148,556	46.1	118	19.8	232,626	46.3
$500,000 - $1 mil.	47	12.6	32,831	13.8	46	12.2	31,451	9.8	80	13.4	56,284	11.2
$100,000 - $500,000	98	26.3	27,054	11.4	107	28.5	33,515	10.4	221	37.1	57,347	11.4
Under $100,000	145	39.0	11,881	5.0	130	34.6	10,926	3.4	163	27.4	7,232	1.4
Total	**372**	**100.0%**	**$237,903**	**100.0%**	**376**	**100.0%**	**$322,210**	**100.0%**	**596**	**100.0%**	**$502,883**	**100.0%**

Source: The Foundation Center, 1992.
* Dollar figures in thousands.

The corporate data take on significance in light of the much-reported decline in business charitable contributions, not only for the arts but for all causes.[3] What they imply is that, in current dollars, growth in corporate foundation arts funding fell behind growth in independent foundation giving through the mid-1980s, but that company-sponsored foundations that began grantmaking during the decade nevertheless brought an influx of new money to the arts.

GIVING BY CONSISTENT CORPORATE FUNDERS DROPPED

These findings are reinforced by a review of arts grants data from a matched set of 25 corporate foundations that appeared in the sample in each of the three study years. Among the consistent givers only, company-sponsored foundations accounted for a sharply declining share of dollars. Not only did their share of arts funding drop vis-a-vis other types of foundations, but so did their actual grant disbursements. At a time of intense pressure on private funding sources, these 25 corporate foundations collectively spent fewer dollars on the arts in 1986 and in 1989 than they had spent in 1983—and that in current dollars, that is, before adjusting for inflation. The drop in levels of support by many consistent business funders did not signal a retreat from the arts *per se*; rather it reflected a serious reduction or no-growth policy in all areas of corporate funding.

Regardless of the cause, the import for arts organizations was that by the mid-1980s, grantseekers

FIGURE 4-3. DISTRIBUTION OF ARTS FUNDERS, ARTS GRANTS, AND ARTS GRANT DOLLARS BY FOUNDATION TYPE

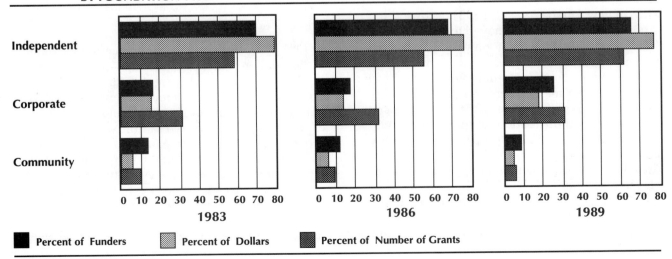

Source: The Foundation Center, 1992.

could no longer rely on the same corporate sponsors for steady and increasing support. In fact, by the end of the decade, their funding source was just as likely to be a new or "restructured" corporate funder.

Corporate Funders Awarded Nearly One-Third of Grants. Corporate funders are especially important to the arts community because of their broad distribution of grants. Business foundations tend to make many more and smaller grants than independent foundations. Figure 4-3 shows that in each of the study years, corporates awarded nearly one out of three foundation grants, or about twice their share of arts grant dollars. Independents gave out nearly three out of five grants in each year, compared with more than three out of four grant dollars. In 1989, community foundations in the sample gave out about one in 16 arts grants and one in 20 arts grant dollars.

TRENDS AMONG LEADING GRANTMAKERS

SAME GRANTMAKERS PROVIDED MOST FUNDING, BUT CHANGES MARKED THE TOP 25 GIVERS

The top arts grantmakers—those that provide the largest amount of funds to the field—tend to remain a relatively stable group. Yet the 1980s witnessed enormous change within the funding community for reasons cited above: tremendous growth of assets for some, decline of fortunes for others, mergers or dissolution for yet others, and finally, the birth of new foundation entities. Thus, over the study years, new funders moved to the top, while funders once near the top, for a variety of reasons, moved down the scale.

Although a few foundations genuinely changed their course, for many others changes in funding levels and in rank from one year to another merely reflected typical fluctuations in grant allocations. Years of unusually high appropriations generally alternated with periods of reduced authorizations, especially if asset values over the same period fell or stayed the same.

Among the top 25 arts funders, the minimum grants level—the total amount of grant dollars given by number 25 on the list—climbed from $2.6 million

TABLE 4-10. 25 LARGEST ARTS FUNDERS, 1983

Foundation	State	Amount	%	No.
1. Pew Charitable Trusts[1]	PA	$16,104,600	6.8	66
2. Ford Foundation	NY	13,098,858	5.5	73
3. Andrew W. Mellon Foundation	NY	12,342,000	5.2	62
4. Brown Foundation	TX	8,624,806	3.6	18
5. ARCO Foundation	CA	6,620,674	2.8	309
6. Kresge Foundation	MI	5,690,000	2.4	30
7. Lilly Endowment	IN	5,329,282	2.2	13
8. Krannert Charitable Trust[2]	IN	4,972,000	2.1	4
9. San Francisco Foundation	CA	4,810,685	2.0	119
10. Dayton Hudson Foundation	MN	4,442,300	1.9	182
11. Vincent Astor Foundation	NY	4,283,000	1.8	21
12. Knight Foundation	OH	3,904,250	1.6	41
13. Sherman Fairchild Foundation	CT	3,354,959	1.4	11
14. Texaco Foundation	NY	3,337,950	1.4	22
15. Ahmanson Foundation	CA	3,275,380	1.4	55
16. Rockefeller Foundation	NY	2,955,698	1.2	54
17. Starr Foundation	NY	2,934,000	1.2	18
18. Amon G. Carter Foundation	TX	2,918,282	1.2	12
19. Morris and Gwendolyn Cafritz Foundation	DC	2,808,906	1.2	43
20. John D. and Catherine T. MacArthur Foundation	IL	2,807,730	1.2	63
21. Boettcher Foundation	CO	2,690,140	1.1	13
22. Houston Endowment	TX	2,643,500	1.1	19
23. W.M. Keck Foundation	CA	2,625,000	1.1	9
24. William Penn Foundation	PA	2,610,857	1.1	29
25. John and Mary R. Markle Foundation	NY	2,148,453	0.9	15
Subtotal		**$127,333,310**	**53.4%**	**1,301**
All other foundations		110,569,385	46.6	3,681
Total		**$237,902,695**	**100.0%**	**4,982**

Source: The Foundation Center, 1992.

[1] Includes grants reported to the *Grants Index* by seven separate trusts, principally Pew Memorial, Mabel Pew Myrin, J.N. Pew, Jr., and J. Howard Pew Freedom Trust.
[2] Trust dissolved in 1987.

in 1983 to $3.3 million in 1986, and ended the decade at $3.8 million (Tables 4-10 through 4-12). Despite the 46 percent jump (in current dollars), combined giving from the 25 largest foundations declined as a percent of all giving in 1989, a fact that may be explained by the expanded sample size and by the growth of many more large funders. For the first two study years, grants from the top 25 accounted for an astounding one out of every two arts dollars donated; by 1989 the proportion had dropped to two out of five dollars (39 percent).

Ranked by dollar amount of grants, the same 13 foundations were among the top 25 arts givers in

TABLE 4-11. 25 LARGEST ARTS FUNDERS, 1986

Foundation	State	Amount	%	No.
1. Pew Charitable Trusts*	PA	$19,750,900	6.1	111
2. Andrew W. Mellon Foundation	NY	17,324,000	5.4	50
3. Lilly Endowment	IN	14,452,218	4.5	29
4. Ahmanson Foundation	CA	9,985,451	3.1	60
5. Ford Foundation	NY	8,253,824	2.6	89
6. Kresge Foundation	MI	7,955,000	2.5	28
7. John D. and Catherine T. MacArthur Foundation	IL	7,454,600	2.3	133
8. J. Paul Getty Trust	CA	7,133,633	2.2	109
9. Brown Foundation	TX	7,000,612	2.2	63
10. James Irvine Foundation	CA	5,668,700	1.8	34
11. Helena Rubinstein Foundation	NY	5,099,000	1.6	72
12. Morris and Gwendolyn Cafritz Foundation	DC	4,962,000	1.5	40
13. Dayton Hudson Foundation	MN	4,748,709	1.5	114
14. Lynde and Harry Bradley Foundation	WI	4,491,733	1.4	31
15. Rockefeller Foundation	NY	4,346,200	1.3	90
16. William Penn Foundation	PA	4,059,198	1.3	42
17. Weingart Foundation	CA	3,843,000	1.2	4
18. Dillon Fund	NY	3,838,500	1.2	19
19. Chicago Community Trust	IL	3,829,566	1.2	65
20. Henry Luce Foundation	NY	3,659,400	1.1	44
21. Howard Heinz Endowment	PA	3,646,382	1.1	43
22. Bush Foundation	MN	3,603,268	1.1	26
23. AT&T Foundation	NY	3,545,100	1.1	202
24. William and Flora Hewlett Foundation	CA	3,420,000	1.1	29
25. Amon G. Carter Foundation	TX	3,349,033	1.0	12
Subtotal		**$165,420,027**	**51.4%**	**1,539**
All other foundations		156,790,025	48.6	5,273
Total		**$322,210,052**	**100.0%**	**6,812**

Source: The Foundation Center, 1992.

* Includes grants reported to the *Grants Index* by seven separate trusts, principally Pew Memorial, Mabel Pew Myrin, J.N. Pew, Jr., and J. Howard Pew Freedom Trust.

TABLE 4-12. 25 LARGEST ARTS FUNDERS, 1989

Foundation	State	Amount	%	No.
1. Andrew W. Mellon Foundation	NY	$23,610,500	4.7	98
2. Pew Charitable Trusts*	PA	19,159,400	3.8	104
3. John D. and Catherine T. MacArthur Foundation	IL	15,000,595	3.0	113
4. Lilly Endowment	IN	14,827,565	2.9	25
5. Ford Foundation	NY	14,257,745	2.8	123
6. Knight Foundation	FL	10,360,000	2.0	73
7. Ahmanson Foundation	CA	9,869,913	1.9	75
8. Rockefeller Foundation	NY	8,835,250	1.7	135
9. Brown Foundation	TX	8,825,607	1.7	65
10. Kresge Foundation	MI	8,475,000	1.7	25
11. Autry Foundation	CA	8,238,400	1.6	3
12. Houston Endowment	TX	7,202,000	1.4	17
13. Ann and Gordon Getty Foundation	CA	5,899,043	1.2	110
14. Lila Wallace-Reader's Digest Fund	NY	5,363,714	1.1	71
15. Morris and Gwendolyn Cafritz Foundation	DC	4,789,500	0.9	44
16. William Penn Foundation	PA	4,739,692	0.9	89
17. Horace W. Goldsmith Foundation	NY	4,637,500	0.9	54
18. Amon G. Carter Foundation	TX	4,527,402	0.9	13
19. William and Flora Hewlett Foundation	CA	4,435,000	0.9	55
20. James Irvine Foundation	CA	4,044,100	0.8	58
21. Dayton Hudson Foundation	MN	3,977,442	0.8	127
22. Coral Reef Foundation	NY	3,913,930	0.8	4
23. Marin Community Foundation	CA	3,899,450	0.8	32
24. Ford Motor Company Fund	MI	3,861,694	0.8	111
25. Meadows Foundation	TX	3,852,698	0.8	47
Subtotal		**$206,603,140**	**41.1%**	**1,671**
All other foundations		296,279,715	58.9	6,171
Total		**$502,882,855**	**100.0%**	**7,842**

Source: The Foundation Center, 1992.

* Starting with 1987, all Pew grants were reported in the *Grants Index* under the Pew Charitable Trusts.

each of the study years and six of them—Andrew W. Mellon, Ford, Lilly, Pew (includes various family trusts), Brown, and Kresge—appeared consistently among the top ten.

Other foundations that consistently ranked among the top 25 included: Rockefeller, John D. and Catherine T. MacArthur, William Penn, Morris and Gwendolyn Cafritz, Amon Carter, Ahmanson, and Dayton Hudson—the only corporate foundation with that distinction.

Foundations that reached the top 25 by 1986 and remained there at the decade's end included two of

California's largest—James Irvine in Los Angeles and William and Flora Hewlett in the Bay Area. Both reported tremendous asset growth in the mid-1980s, which raised their overall level of giving, including arts giving.

Other consistent funders that increased their arts giving in the second half of the decade and appeared on the list of the largest in 1986 or 1989 included Bush, Meadows, Houston Endowment, Henry Luce, and the Ford Motor Company. The Knight Foundation, whose funding was just below the top 25 range in 1986, raised its arts support to

over $10 million in 1989, placing it among the ten largest arts funders.

Some Funders Reduced Spending. While some foundations increased their arts funding, other top-ranked funders reduced spending. These included:

- ARCO Foundation, which ranked fifth in 1983 and had been the largest corporate foundation supporter of the arts. Its arts grants dropped from $6.6 million to $2.3 million in 1986, down 65 percent before adjusting over the same period for inflation. ARCO's spending in all fields had plummeted, from nearly $32 million to $15 million—due to heavy losses experienced by the petroleum industry. By 1989, ARCO had reduced foundation spending in all fields by another 36 percent. Although its arts grants in 1989 captured around a fifth of all its grant dollars—a share equal to allocations in the early 1980s—the actual dollar amount at the end of the decade was far less: $1.9 million for the arts, compared to $6.6 million in 1983—a drop of more than 71 percent, again before adjusting for inflation.

- San Francisco Foundation, which ranked ninth in 1983 and, with arts grants of $4.8 million, ranked first in arts support among community foundations. In calendar year 1986, its arts appropriations were at $3 million. Later, it lost its principal endowment, the Buck Trust, which was reorganized as the Marin Community Foundation. Spending in all fields dropped by almost two-thirds. By 1989, San Francisco reported arts spending of around $600,000, out of a total of $3 million. (Note: Funding levels rebounded in the 1990s. See Profiles, Chapter 11.)

- Texaco Foundation, which ranked fourteenth in 1983. Like ARCO, Texaco's profits fell prey to a slump in the oil industry. The foundation's arts disbursements dropped from a high of $3.3 million in 1983 to under $2 million in 1986, and then ended the decade at $1.2 million, down by nearly two-thirds in current dollars. In 1983 Texaco spent more than one out of two foundation dollars on the arts (56 percent); its commitment diminished to 39 percent by decade's end.

- Vincent Astor Foundation, which ranked eleventh in 1983. Astor gave $4.3 million (over 40 percent of its grants) to New York arts organizations for capital projects that year. After 1985, it reduced spending in all fields to conserve principal and shifted its emphasis to housing and literacy, two serious urban problems. Arts spending in 1986 was less than $1 million. In 1989, funding was up due to a special one-time endowment grant.

- Krannert Charitable Trust, which ranked eighth in 1983 with arts disbursements of nearly $5 million. The Indiana foundation had spent down its endowment by the mid-1980s and ceased operations in 1987.

Many other foundations—especially corporate foundations—merged or terminated in the 1980s, thus reducing the pool of local sources of arts funding.

New and Newly Large Foundations Boosted Arts Funding. The above examples of dramatically reduced arts support from consistent funders may fortunately be matched with numerous other examples of rising support—in this case from foundations that started up or greatly increased their grantmaking after 1983. (Since most funders give only locally, however, the new sources could not be seen as replacements for the old). These included:

- AT&T, Southwestern Bell, and US West, all corporate foundations created after 1983;

- The Getty Grant Program, created by the J. Paul Getty Trust, in 1984; in 1986 the program disbursed some $7 million in institutional grants;

- Lynde and Harry Bradley Foundation, which greatly increased in size in 1986, and made gifts that year of $4.5 million to cultural institutions in Wisconsin;

- Marin Community Foundation, which began grantmaking in 1987, and by 1989 spent close to $4 million on the arts;

- Aaron Diamond Foundation, which was reorganized in 1987 after its assets grew substantially. By 1989, it gave away about $3.3 million to the arts out of a budget of $20 million;

TABLE 4-13. TEN LARGEST CORPORATE FOUNDATION ARTS FUNDERS, 1989

Foundation	State	Amount	No.
1. Dayton Hudson Foundation	MN	$3,977,442	127
2. Ford Motor Company Fund	MI	3,866,694	112
3. AT&T Foundation	NY	3,548,000	157
4. US WEST Foundation	CO	2,892,374	83
5. Southwestern Bell Foundation	MO	2,633,475	63
6. Burlington Northern Foundation	TX	2,589,000	71
7. Humana Foundation	KY	2,168,130	18
8. American Express Foundation	NY	1,942,017	40
9. ARCO Foundation	CA	1,929,638	67
10. Times Mirror Foundation	CA	1,752,500	47

Source: The Foundation Center, 1992.

TABLE 4-14. TEN LARGEST COMMUNITY FOUNDATION ARTS FUNDERS, 1989

Foundation	State	Amount	No.
1. Marin Community Foundation	CA	$3,899,450	32
2. Foundation for the Carolinas	NC	3,760,309	10
3. Chicago Community Trust	IL	2,076,670	33
4. Columbus Foundation	OH	1,288,700	23
5. Cleveland Foundation	OH	1,218,690	16
6. Hartford Foundation for Public Giving	CT	1,166,334	12
7. Grand Rapids Foundation	MI	1,140,000	4
8. Sacramento Regional Foundation	CA	971,391	9
9. Saint Paul Foundation	MN	888,000	19
10. New York Community Trust	NY	731,500	18

Source: The Foundation Center, 1992.

- Lila Wallace-Reader's Digest Fund, which started up in 1987 (see below);

- Ann and Gordon Getty Foundation, which began grantmaking in the late 1980s—uniquely in the arts—and gave away about $5.9 million in 1989; and

- Autry Foundation, a pass-through foundation which in 1988 began to make large gifts to a few institutions with links to its donor, Gene Autry; grants in 1989 amounted to $8.2 million.

From Obscurity to Dominance. One of the more striking changes over the years was undertaken by the Lila Wallace-Reader's Digest Fund. In 1983, its predecessor, the LAW Fund (for Lila Acheson Wallace) ranked ninety-second among sampled arts funders. In 1987, a new foundation was formed out of the merger of LAW and the High Winds Fund, another Wallace foundation. The Fund grew rapidly. By 1989, Lila Wallace leapt to fourteenth place among arts funders by awarding grants of close to $5.4 million. Three years after the study period, in 1992, the Lila Wallace Fund was reportedly the nation's largest funder of the arts.[4]

COMMITMENT TO THE ARTS VARIES BY INDIVIDUAL LARGE FUNDERS

Even among funders who made exceptionally large disbursements to the arts, levels of institutional commitment were far from equal. For example, in 1989, consistent funders such as Ford, Pew, Kresge, Rockefeller, Hewlett, Lilly, Houston Endowment, Irvine, Meadows, Bush, and Penn allocated less than

one-fourth of their total grants budgets to the arts. (For five of the above, the share was less than 15 percent.)

On the other hand, Mellon, Knight, Ahmanson, Amon Carter, Brown, Dayton Hudson, and Cafritz—also consistent funders—gave between one-third and two-thirds of their total grant dollars to the arts and arts-related humanities.

Many of the new and newly large arts funders mentioned above, such as Lila Wallace, the Getty Grant Program, Autry, and Ann and Gordon Getty, gave a very high percentage of their total allocations to the arts.

NUMBERS OF GRANTS BY TOP FOUNDATIONS VARY WIDELY

Dollars alone are an insufficient criterion for evaluating major arts givers. The number of grants is equally important, for it reveals how widely arts funding is distributed. Tables 4-10 through 4-12 reveal that on average, the top 25 arts donors disbursed their funds through 67 grants each year. (The number of grants is probably close to, but not identical with, the number of organizations receiving their grants, since some arts groups may receive more than one.)

But deviations from the average varied enormously, with several of the top 25 giving relatively few grants, and others giving many. The fewer the grants, the less accessible the foundation is to grantseekers. In 1983, the Krannert Charitable Trust awarded close to $5 million in arts grants, earning it eighth place among top funders that year. But all of that money was allocated through just four grants

and all recipients were in Indianapolis. By contrast, the fifth-ranking ARCO Foundation gave more than $6.6 million through 309 awards. (Corporate donors, as noted earlier, typically award far more grants than independent foundations.)

Other examples reflected this pattern. In 1986, the Weingart Foundation ranked 17th, having granted more than $3.8 million. But that money was distributed to just three organizations in Southern California. (Weingart has no consistent or articulated programmatic interest in the arts.) That same year, the John D. and Catherine T. MacArthur Foundation ranked seventh among funders with almost $7.5 million given to the arts. The MacArthur funds were allocated both locally and nationally through 133 grants.

The pattern continued through the end of the study period. In 1989, the eleventh-ranked Autry Foundation gave out $8.2 million in just three grants (almost exclusively to support the Gene Autry Western Heritage Museum), whereas the Ford Motor Company Fund (no relation to the Ford Foundation) disbursed nearly $4 million that year through 112 grants.

The ARCO Foundation gave the largest number of arts grants in 1983, or more than 6 percent of the total in the sample that year. Dayton Hudson was next, with close to 4 percent. In 1986, AT&T led the list by grant number. In 1989, that place was held by Rockefeller, followed closely by Dayton Hudson and Ford. The growth in the number of arts grants made by *some* independent and community foundations during the 1980s signaled an intent to distribute funds to a broader segment of the arts community.

GEOGRAPHIC DISTRIBUTION OF ARTS FUNDING

FEW LARGE FUNDERS GIVE NATIONALLY TO THE ARTS

As has been observed throughout this overview, many of the top-ranked arts funders concentrated their dollars in large grants, and those monies were frequently given to local institutions. Only about a third of the largest funders each year gave grants nationally. Exceptions included corporate foundations—Dayton Hudson, Ford Motor Company, AT&T, Texaco, and ARCO, for example—whose

funds were largely restricted to areas of company operations, and those independent foundations whose funding policies were either national, a mix of local and national, or even national and international. These included Ford, Mellon, MacArthur, Pew, Rockefeller, Knight, Luce, Kresge, Lila Wallace, the Getty Grant Program (international), and Ann and Gordon Getty (one-third of funding was distributed nationally).

A handful of other large or mid-sized funders—generally those who concentrated their funding in the arts (or media)—also distributed grants more broadly. By 1989, examples included the Nathan Cummings, Graham, Jerome, Kress, Lannan, Markle, and Nakamichi foundations. Descriptions of most national funders are provided in the "Profiles" chapter of this report.

In addition, a few mid-sized funders awarded the majority of their arts grants to local groups, yet gave nationally or even internationally through one or two specified programs. Examples in the 1980s included the Skaggs Foundation's Folklore/Folklife and Historic Interest programs, and the J.M. Kaplan Fund's grants in historic preservation.

MAJORITY OF FUNDS ORIGINATE IN FIVE STATES

Foundations in ten states provided over four-fifths of the total arts dollars granted in the nation throughout most of the 1980s (Table 4-15). And grantmakers in the top five states provided for around two-thirds. Further, a relatively few foundations within each of the states provided a vast share of the arts dollars each year.

New York, which claimed at least one of five funders in the sample in each of the study years, led the nation both in the amount of dollars and the number of grants awarded to the arts, providing around a quarter of all arts dollars and a quarter of arts grants in 1983, 1986, and 1989.

California, with only one in nine arts funders, was second all three years, likewise both in dollars and number of grants. California's share of foundation arts giving increased from around 12 percent in 1983 to around 14 percent during each of the two later years. (Note: Its share would have undoubtedly grown larger had two of its largest arts funders—ARCO and the San Francisco Foundation—not been forced to reduce funding in the mid-1980s.)

Pennsylvania, Texas, and Michigan ranked the next highest, in that order, in terms of both total dollars and number of grants, in 1983. By 1986, Illinois supplanted Michigan among the top five states in dollars awarded. (Due largely to increased funding by the MacArthur Foundation, Illinois' arts dollars had nearly tripled over three years, and its number of grants had grown more than two and half times.)

In 1989, Illinois surpassed Texas, ranking fourth by both total dollars and total number of grants. Texas' share of dollars dropped slightly in the mid-1980s when the petroleum industry hit hard times, thereby reducing the assets and giving capacity of many of the state's largest funders.

STATES GIVING MOST GRANTS RECEIVE LARGEST SHARE OF DOLLARS

Most, but not all, of the states in which foundations disburse the largest share of arts funding also attract the largest share, a reflection of the localized nature of most foundation giving. One significant exception is the District of Columbia, which, due to the concentration of national institutions and monuments, was among the top five recipient locations each year of the study (Table 4-16), but whose foundations gave away a much smaller percentage of total grant dollars (Table 4-15). In addition, Massachusetts,

thanks to its preeminent academic and cultural institutions, made the list of top ten recipient states in all three study years, even though its funders did not rank among the largest.

States that ranked among the top ten whose funders gave away far more proportionally than recipients in the state took in included New York, home of the largest concentration of national arts funders, followed in 1983 by Michigan and Pennsylvania. By 1986, Illinois also gave away a larger share of arts funds than local organizations received; by 1989, when MacArthur's appropriations reached $15 million, the gap had widened significantly.

LEVEL OF COMMITMENT TO THE ARTS VARIES WIDELY AMONG STATES GIVING MOST DOLLARS

The arts compete for philanthropic dollars with numerous other areas of nonprofit activity, from human services to education to international affairs. In which of the top-ranked states above—those providing the largest amounts to the arts—do funders give the most to arts and culture *as a percentage of their total giving*? In which states do funders give the least?

Figure 4-4 shows that in 1989 sampled foundations in five of the top-ranked states gave notably higher than the national average—that is, more than

TABLE 4-15. TOP TEN STATES BY ARTS GRANT DOLLARS AWARDED*

	1983					1986					1989			
State	No. of Funders	%	Amount	%	State	No. of Funders	%	Amount	%	State	No. of Funders	%	Amount	%
New York	80	21.5	$67,805	28.5	New York	76	20.2	$78,091	24.2	New York	120	20.1	$127,903	25.4
California	41	11.0	28,734	12.1	California	44	11.7	47,178	14.6	California	67	11.2	70,626	14.0
Pennsylvania	29	7.8	27,416	11.5	Pennsylvania	30	8.0	36,930	11.5	Pennsylvania	35	5.9	43,652	8.7
Texas	20	5.4	25,144	10.6	Texas	15	4.0	24,925	7.7	Illinois	46	7.7	40,482	8.0
Michigan	22	5.9	14,226	6.0	Illinois	26	6.9	23,766	7.4	Texas	32	5.4	36,408	7.2
Minnesota	19	5.1	11,746	4.9	Minnesota	19	5.1	17,213	5.3	Ohio	33	5.4	24,385	4.8
Indiana	5	1.3	10,895	4.6	Michigan	22	5.9	15,675	4.9	Michigan	26	4.4	23,419	4.7
Ohio	24	6.5	8,279	3.5	Indiana	4	1.1	15,015	4.7	Minnesota	25	4.2	19,303	3.8
Connecticut	14	3.8	7,990	3.4	District of Columbia	11	2.9	6,807	2.1	Indiana	8	1.3	18,907	3.8
Illinois	19	5.1	7,736	3.3	Ohio	21	5.6	6,324	2.0	New Jersey	23	3.9	12,258	2.4
Subtotal	273	73.4%	$209,980	88.4%		268	71.4%	$271,294	84.4%		415	69.6%	$417,343	83.0%
All other states	99	26.6	27,938	11.6		108	28.6	50,916	15.6		181	30.4	85,540	17.0
Total	372	100.0%	$237,918	100.0%		376	100.0%	$322,210	100.0%		596	100.0%	$502,883	100.0%

Source: The Foundation Center, 1992.
* Dollar figures in thousands.

one in every seven dollars awarded (see Table 4-1)—while three met the national average, and two gave substantially less.

In Ohio, for example, due principally to a dramatic leap in arts and media spending by the Knight Foundation, one in every three and a half foundation dollars went to those fields. In the same year in Indiana and Texas, one out of every five grant dollars supported arts and culture, while in Minnesota and California, the arts secured about one in five and a half grant dollars—still well above the national average.

Funders in New York, Pennsylvania, and Illinois provided around one in seven grant dollars for the arts in 1989—equal to the national average. But for New York, that proportion was less than in 1983, while in Illinois, arts funding (as a share of all funding) had grown since mid-decade, with much of the growth accounted for by the MacArthur Foundation.

Finally, states spending far less of their grants budgets on the arts than the national average included Michigan and New Jersey. Based only on those foundations in the *Grants Index* sample, the arts obtained just one in 14 grant dollars in each of those states in 1989.

FEW FOUNDATIONS PROVIDED BULK OF ARTS DOLLARS IN EACH STATE; FUNDS CONCENTRATED IN FEW LARGE GRANTS

Within each of the top states, and across all three years of the study period, the share of arts funding was borne highly unevenly by the principal arts grantmakers. And, as reported earlier, very few organizations benefited from a disproportionate share of the dollars.

In New York, for example, virtually one out of every five dollars for the arts in 1983 was given by the Ford Foundation—more than half of whose total arts outlay ($13.1 million) went to a single project: the National Arts Stabilization Fund. (The Fund's purpose, however, stated earlier, was to strengthen arts institutions in cities throughout the country.) The Mellon Foundation's arts grants of $12.3 million that year accounted for almost another fifth of New York State's share.

Similarly, in California, at the start of the study period, the ARCO Foundation distributed $6.6 million in arts grants, or almost one out of every four arts dollars (23 percent) in that state. One out of six arts grant dollars ($4.8 million) was given by the San Francisco Foundation.

The same pattern is evident in the other leading states. Pennsylvania's $27.4 million of arts funding in 1983 came from 29 foundations, but the Pew Charitable Trusts provided nearly three out of five

TABLE 4-16. TOP TEN STATES BY ARTS GRANT DOLLARS RECEIVED*

1983					1986					1989				
State	Amount	%	No. of Grants	%	State	Amount	%	No. of Grants	%	State	Amount	%	No. of Grants	%
New York	$56,490	24.0	1,100	22.3	New York	$52,549	16.5	1,407	20.9	New York	$103,560	20.8	1,781	23.0
California	29,755	12.6	743	15.1	California	46,701	14.7	869	12.9	California	66,931	13.4	1,014	13.1
Texas	25,740	10.9	321	6.5	Pennsylvania	32,705	10.3	444	6.6	Texas	36,641	7.4	391	5.1
Pennsylvania	21,439	9.1	375	7.6	District of					Illinois	32,940	6.6	460	5.9
District of					Columbia	23,187	7.3	351	5.2	District of				
Columbia	11,398	4.8	251	5.1	Texas	22,342	7.0	360	5.4	Columbia	28,287	5.7	461	6.0
Indiana	11,077	4.7	58	1.2	Illinois	20,933	6.6	510	7.6	Pennsylvania	26,868	5.4	419	5.4
Minnesota	10,952	4.6	325	6.6	Minnesota	18,606	5.9	429	6.4	Massachusetts	23,318	4.7	252	3.3
Michigan	8,636	3.7	128	2.6	Indiana	14,843	4.7	51	0.8	Minnesota	19,907	4.0	384	5.0
Massachusetts	7,473	3.2	111	2.3	Ohio	8,756	2.8	255	3.8	Indiana	17,763	3.6	81	1.0
Illinois	7,076	3.0	241	4.9	Massachusetts	7,294	2.3	185	2.8	Ohio	14,638	2.9	228	2.9
Subtotal	**$190,036**	**80.6%**	**3,653**	**74.2%**		**$247,916**	**78.1%**	**4,861**	**72.4%**		**$370,853**	**74.5%**	**5,471**	**70.7%**
All other states	45,620	19.4	1,273	25.8		69,930	21.9	1,858	27.6		127,356	25.5	2,268	29.3
Total	**$235,656**	**100.0%**	**4,926**	**100.0%**		**$317,846**	**100.0%**	**6,719**	**100.0%**		**$498,209**	**100.0%**	**7,739**	**100.0%**

Source: The Foundation Center, 1992.
* Dollar figures in thousands.

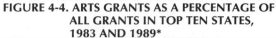

**FIGURE 4-4. ARTS GRANTS AS A PERCENTAGE OF
ALL GRANTS IN TOP TEN STATES,
1983 AND 1989***

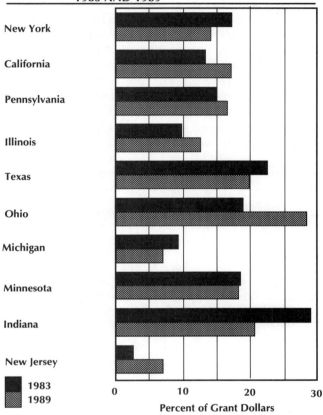

Source: The Foundation Center, 1992.
* Ranked by total arts giving in 1989 (see Table 4-15).

dollars ($16.1 million). Although Pew's arts funds were distributed in 66 grants, four-fifths of their total grant dollars ($13 million) was contained in large grants to just 15 institutions; the grants ranged from $250,000 to just over $3 million. Recipients—both local and national—included the Philadelphia Museum of Art, the University of Pennsylvania, Massachusetts Institute of Technology, and the Smithsonian, among others.

Another 14 percent of Pennsylvania's arts grants came from just two other foundations: William Penn ($2.6 million) and Pittsburgh ($1.26 million). Both funded locally.

Texas' 20 arts grantmakers provided more than $25 million in grants in 1983, but more than a third of that money—$8.6 million—came from the Brown

Foundation. Equally significant, almost all of Brown's funds went to three institutions, all located in Houston: the Menil Collection, the Houston Museum of Fine Arts, and the Houston Ballet.

Michigan followed the pattern as well. Its $14.2 million in arts grants in 1983 came from 22 foundations, but the Kresge Foundation gave 40 percent of it. Kresge's arts funds were distributed nationally through 30 grants, with large sums ($250,000 and over) for capital construction to Wake Forest University, Carnegie Hall, the San Francisco Ballet, WTVS Detroit Educational TV, Chicago's Orchestral Association, the California Institute of the Arts, and the Walker Arts Center in Minneapolis, among others.

The uneven distribution of grants, at least by grantmakers in the five top states, remained the pattern throughout the decade. For example:

1986: Three foundations in New York—Mellon, Ford, and Helena Rubinstein—provided more than $30.5 million, or two out of five dollars given by the state's 80 arts funders. Of Mellon's grants alone, 30 out of 50 in 1986 ranged from $250,000 to $2.78 million. The largest grant that year went to the Woodrow Wilson National Fellowship Foundation. Both Mellon and Ford operate national arts funding programs; Rubinstein gave locally.

In California, the Ahmanson Foundation, the Getty Grant Program, and the James Irvine Foundation allocated more than $22 million of the state's $47.2 million arts funding—almost half. Ahmanson's nearly $10 million was distributed in Southern California through 60 grants, but only two organizations—Los Angeles County Museum of Art and the Huntington Library—received $4 million of it, while another six grantees obtained gifts of at least $250,000 each.

In Pennsylvania, the Pew Trusts provided more than half of that state's $36.9 million given to the arts. The next two largest arts funders—William Penn and Howard Heinz Endowment—brought the proportion to more than 70 percent.

Arts grants in Texas and Illinois revealed the same pattern. In Texas, 15 foundations provided almost $25 million for the arts, but more than half of that amount—53.7 percent—came from only three grantmakers: Brown, Amon G. Carter, and Meadows. More than half the funds awarded by

Brown went to three organizations; Amon Carter gave virtually all its funds to the museum bearing its name; and Meadows gave a third of its $3 million arts disbursements to four Texas institutions.

In Illinois as well, the three top grantmakers—MacArthur, Chicago Community Trust, and Regenstein—supplied well above half (55.9 percent) of the state's nearly $23.8 million in arts grants. While the first two allocated their funds broadly—133 grants by MacArthur and 65 by Chicago Community—Regenstein donated almost all its money to the Art Institute of Chicago.

1989: In New York, the top four foundations—Mellon, Ford, Rockefeller, and Lila Wallace—provided 41 percent of arts grant dollars. Likewise in California, more than two out of five arts dollars were donated by four foundations: Ahmanson, Autry, Ann and Gordon Getty, and Hewlett.

Illinois' arts grants of almost $40.5 million in 1989 came from 46 foundations, but as in the previous study years, one foundation—MacArthur—provided the lion's share: $15 million, or more than 37 percent. That year MacArthur dwarfed even the other large Illinois arts donors; its total giving amounted to more than five times the amount reported by the next largest funder, the Regenstein Foundation.

Pennsylvania was no exception. Arts grants of almost $44 million were distributed by 35 foundations, but as in past years, the Pew Charitable Trusts donated more than two-fifths of the funds. Grants by Pew and the William Penn Foundation together comprised almost 55 percent of all Pennsylvania's arts grants that year.

Finally, in Texas the arts received more than $36.4 million from 32 foundations, but the top three—Brown, Carter, and Houston Endowment (the latter had moved up considerably in rank)—provided well above half.

ENDNOTES

1. Loren Renz and Steven Lawrence, *Foundation Giving: Yearbook of Facts and Figures on Private, Corporate and Community Foundations*, The Foundation Center, 1992, p. 7.

2. Ibid., p. 20.

3. Nathan Weber, *Giving USA 1991*, AAFRC Trust for Philanthropy, New York, 1990, p. 89; and earlier editions.

4. *The New York Times*, April 2, 1992.

5

Where the Money Went: How Foundations Allocated Their Arts Grants in 1983, 1986, and 1989

The typology and definitions of arts fields used in this study are drawn from the National Taxonomy of Exempt Entities (NTEE), adapted by the Foundation Center for its grants classification system (see Appendix B).

TWO-THIRDS OF GRANT DOLLARS TO PERFORMING ARTS AND MUSEUMS

Museums and the performing arts were the two broadly defined program areas that secured most of the arts dollars provided by foundations in 1983, 1986, and 1989 (Table 5-1 and Figure 5-1). Together, they received around two out of every three dollars and nearly two out of three grants allocated to the arts in each of the three years.

However, since both museums and the performing arts comprise most of the art world's subdivisions (art museums, ethnic museums, music, dance, theater, etc.), the allocation of funds appears to be more lopsided than it actually was. The seven types of museums and the many categories of performing

arts shown in Table 5-3 together amount to almost half of the classifications within the arts and culture field itself, broadly defined.* Further, museums alone account for roughly half of all income generated in the broader arts world.[1]

Throughout the 1980s, the performing arts consistently commanded the largest share of foundation arts funding, but while its lead was substantial in 1983—39 percent compared with 26 percent for second-ranked museums—by 1986 it was only a half of 1 percent ahead of museums; each field received roughly one-third of arts funds that year. The performing arts remained in first place by 1989, but only because museums had lost a few percentage points to media and to multidisciplinary arts.

Among the performing arts, music—especially orchestras—and theater secured the greatest shares of dollars during the study period. By 1989, theater's share had dropped, and funding for dance appeared to be on the rise.

FIGURE 5-1. PERCENTAGE OF ARTS GRANT DOLLARS BY MAJOR SUBJECT *

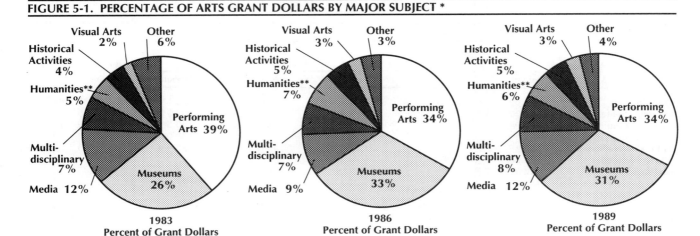

Source: The Foundation Center, 1992.
*Due to rounding, figures may not add up. Figures represent percent of total grant dollars for each year.
**Excludes grants specified for non-arts related humanities including philosophy, theology, ethics, and foreign languages.

Among museums, art museums commanded the major share throughout the decade, but the ratio declined from about two-thirds of all museum funding in 1983 to less than half in 1989. History and science museums reaped the benefit.

The third largest share of arts funds went to media and communications, which secured between 8 and 12 percent of all arts dollars during the study years. The proportion was highest in 1983 at 12 percent; it dropped to 8.6 percent in 1986, and then moved back up at the end of the decade to just under 12 percent.

ALLOCATION OF NUMBER OF GRANTS: PERFORMING ARTS' SHARE DECLINED

The distribution of grant dollars reflects one trend in arts funding; allocation of the *number* of grants reflects another trend of equal importance. As revealed in Table 5-1, performing arts captured nearly half of all arts grants in 1983, but by 1989, that share had dropped to just over two out of five.

Just as the share of museum dollars grew during the period, so did the share of the number of grants to museums, from 16.5 percent to 20 percent. Museums also gained ground in comparison to the performing arts. The ratio of performing arts grants to museum grants was 3:1 in 1983; by 1989, that ratio had declined to 2:1.

Third-ranked media's share of grants began at nearly 10 percent, declined slightly in 1986, but climbed back up to nearly 11 percent in 1989.

Measured by number of grants, multidisciplinary arts programs exceeded media's share slightly in both 1983 and 1986.

The fact that museums consistently captured a far larger share of grant dollars than number of grants (the reverse was true for performing arts groups) confirms inequalities in grant size. Museum grants, on average, were larger than performing arts grants (Figure 5-2). By 1989, for example, the *mean* grant for museums had reached $98,500, compared with $50,700 for the performing arts.

Further, as shown in Figure 5-2, among the largest arts grants—those valued at $250,000 or over—the proportion of dollars allocated for museums climbed sharply between 1983 and 1989, from 33 percent to 40 percent, while the share of large grant dollars for the performing arts dropped, from 34 percent to 25 percent.

Finally, the *median* grant in 1989, while less divergent than the mean grant, also revealed a gap: $25,000 for museums, versus $20,000 for the performing arts.

EXPLORING THE SHIFTS: SHARP SWINGS, NEW FUNDERS

A closer look at the behavior of the three main foundation types—independent, company-sponsored, and community—reveals several key developments marking the sometimes dramatic shifts in arts funding during the 1980s (Figure 5-3). Among these developments were: a) exceptionally large, one-time

TABLE 5-1. FOUNDATION ARTS GRANTS BY MAJOR SUBJECT*

Subject	1983				1986				1989			
	Amount	%	No.	%	Amount	%	No.	%	Amount	%	No.	%
Performing Arts	$92,289	38.8	2,351	47.2	$108,087	33.5	3,033	44.5	$169,113	33.6	3,331	42.5
Museum Activities	60,670	25.5	821	16.5	106,275	33.0	1,261	18.5	153,544	30.5	1,579	20.1
Media/Communications	28,905	12.1	476	9.6	27,560	8.6	560	8.2	59,363	11.8	839	10.7
Multidisciplinary Arts	16,043	6.7	484	9.7	22,090	6.9	699	10.3	38,068	7.6	722	9.2
Arts-Related Humanities	12,445	5.2	264	5.3	21,975	6.8	435	6.4	28,886	5.7	343	4.4
Historical Activities	9,668	4.1	268	5.4	16,841	5.2	380	5.6	23,311	4.6	474	6
Visual Arts	4,031	1.7	114	2.3	10,372	3.2	184	2.7	13,552	2.7	240	3.1
Other[1]	13,851	5.7	204	4.1	9,010	2.8	260	3.8	17,077	3.5	314	4
Total	$237,903	100.0%	4,982	100.0%	$322,210	100.0%	6,812	100.0%	$502,883	100.0%	7,842	100.0%

Source: The Foundation Center, 1992.
* Dollar figures in thousands. Due to rounding, figures may not add up.
 Includes broad range of supporting activities or organizations identified by 12 "common codes" including advocacy, management, fundraising, and technical assistance; also includes art libraries, international cultural exchange, and arts grants not elsewhere classified.

FIGURE 5-2. DISTRIBUTION OF ARTS GRANT DOLLARS BY MAJOR SUBJECT AND BY INDIVIDUAL GRANT SIZE RANGE, 1983 AND 1989

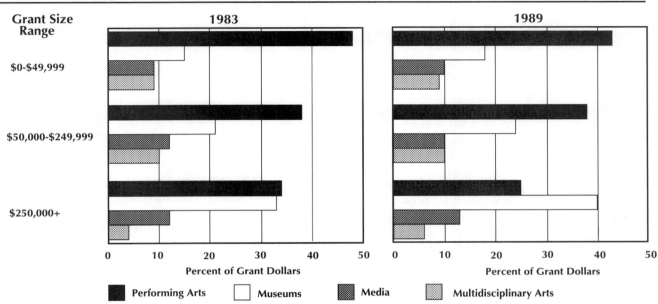

Source: The Foundation Center, 1992.

gifts; b) sharp reductions and increases in spending, or shifts in program direction by the leading funders; and c) the influence of new funders in the field.

Large gifts. Giant grants to museums were notable in all three years of the study, and especially so in 1986, the year of the highest rise in museum funding as a portion of all arts grants. Of the top ten arts grants of 1986 listed in Chapter 4, Table 4-7, each valued at $2.2 million or more, eight were awarded to museums, all by independent foundations. Donors included the Pew Trusts, Lilly Endowment, the Amon Carter Foundation, Helena Rubinstein Foundation, Weingart Foundation, the Cafritz Foundation, and the Andrew W. Mellon Foundation. Recipients were diverse, from the Philadelphia Museum of Art, to the Children's Museum of Indianapolis, to the U.S. Holocaust Museum. Beyond these eight gifts, there were 12 other million dollar or larger grants, all to museums.

Were it not for a drop in museum funding at the end of the decade by independents as a whole (see below), and the strong influence they exert due to their higher numbers and greater allocations, the share of arts funding captured by museums might well have risen in 1989. Especially given the Autry Foundation's $8 million gift of that year to the Gene Autry Western Heritage Museum—the single largest museum grant reported throughout the study years.

The performing arts as well were marked by exceptionally large gifts in all three years of the study. Some of these grants are described below. Selected large gifts to other arts fields, such as visual arts and humanities, are presented under their respective categories later in this chapter.

Program redirection. Major program redirections were undertaken by some leading independent foundations during the study period, most frequently in response to funding needs perceived *within* a particular arts field, i.e., Ford's support of Hispanic and black theater.

By and large, however, the steep shifts *across* the arts were most evident among the corporate and community foundations, particularly in increasing support for museums and decreasing it for performing arts. By contrast, independent foundations, which accounted for two-thirds of grantmakers in

the sample each year, showed a much slighter variation in funding patterns.

The figures presented in Table 5-2 illustrate this finding. Community trusts reduced their support of performing arts funding from nearly 60 percent of their arts dollars in 1983 to 45 percent in 1989, with the steepest dive at mid-decade. At the same time they doubled their museum support, from 11 to 22 percent. Corporate support for performing arts was reduced more gradually, but almost as steeply, from more than half of its arts dollars at the start of the period, to under half in the middle, and down to 42 percent at the end. At the same time, the business donors increased their share of support for museums, from 17 percent to 26 percent.

Among independents, support for museums increased only a few percentage points, from 28 percent at the start to 32 percent at the end. But even slight shifts among the independents had a significant influence, given their much greater number—and their vastly larger disbursements—among the sampled foundation types. For example, the decline of 3 percentage points in the independents' share of museum funding in 1989 was sufficient to pull down the entire sample's allocation of museum dollars, as a portion of all arts grants, from mid-decade to end.

Startups and Terminations. New arts funders of major significance came on to the scene during the study period, and former funders left. Examples included the Lila Wallace-Reader's Digest Fund, AT&T Foundation, Getty Grant Program, Marin Community Foundation, the Ann and Gordon Getty Foundation, and the Krannert Foundation, among others. See Chapter 4 for details.

Finally, many corporations merged or were restructured in the 1980s. Others saw their profits decline. In either case, the result was a reduction in grants budgets. Cuts in spending, especially in the performing arts, by some of the largest corporate arts funders are documented below.

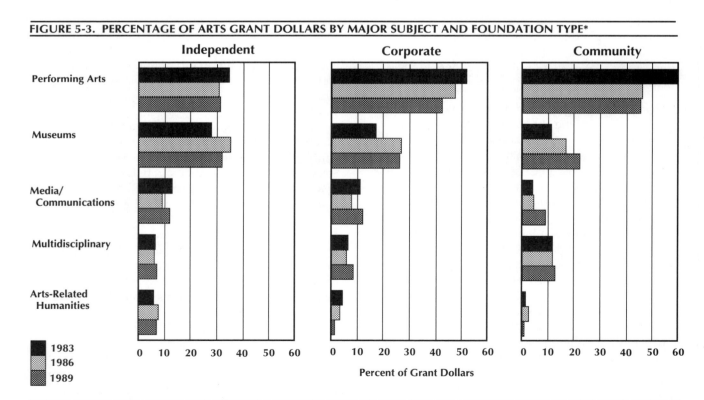

FIGURE 5-3. PERCENTAGE OF ARTS GRANT DOLLARS BY MAJOR SUBJECT AND FOUNDATION TYPE*

Source: The Foundation Center, 1992.
* Includes arts subjects that received at least 5 percent of grant dollars for at least one type of grantmaker.

PERFORMING ARTS: MUSIC FALLS AND RISES, THEATER DOWN, DANCE UP

The performing arts received the largest share of total arts dollars throughout the study period, although the proportions changed (Table 5-3). In 1983, almost two out of every five arts dollars awarded by the sampled foundations went to the performing arts. By 1986, the ratio had dropped to one in three, where it remained in 1989.

Perhaps the three most notable funding shifts within the performing arts during the study period included: a) a mid-decade drop in the share given to music—especially symphony orchestra— and a subsequent rise by the end; b) a decline in the share granted to theater from start to end of the decade, after a surge at mid-point; and c) a concurrent rise, although far less dramatic, in allocations to dance and to performing arts centers (Figure 5-4). (Often, however, a grant to a performing arts center indirectly benefits dance, music, theater, or other performing arts disciplines.)

Music. Encompassing symphony orchestras, ensembles, choral groups, and composition, music has traditionally held a preeminent place in the world of

TABLE 5-2. ARTS GRANTS BY MAJOR SUBJECT AND FOUNDATION TYPE*

Foundation Type	Dollar Value of Grants											
	1983				1986				1989			
	Amount	%	No.	%	Amount	%	No.	%	Amount	%	No.	%
Independent												
Performing Arts	$65,428	34.8	1,347	46.3	$76,244	30.9	1,672	43.8	$121,526	31.4	2,007	41.5
Museums	53,014	28.2	458	15.7	87,374	35.4	659	17.3	124,193	32.1	879	18.2
Media/Communications	24,446	13.0	283	9.7	22,385	9.1	309	8.1	46,921	12.1	563	11.7
Multidisciplinary	12,152	6.5	273	9.4	15,039	6.1	404	10.6	27,439	7.1	453	9.4
Arts-Related Humanities	10,786	5.7	214	7.4	18,972	7.7	315	8.3	27,296	7.0	279	5.8
Historical Activities	6,932	3.7	165	5.7	13,967	5.7	233	6.1	17,577	4.5	304	6.3
Visual Arts	3,230	1.7	76	2.6	6,127	2.5	105	2.8	10,433	2.7	149	3.1
Other[1]	12,135	6.4	92	3.2	6,601	2.7	116	3.0	12,093	3.1	197	4.1
Total	**$188,153**	**100.0%**	**2,908**	**100.0%**	**$246,708**	**100.0%**	**3,813**	**100.0%**	**$387,479**	**100.0%**	**4,831**	**100.0%**
Corporate												
Performing Arts	$18,493	51.8	736	46.8	$21,851	47.4	1,035	47.9	$36,621	42.4	1,113	45.7
Museums	6,061	17.0	301	19.1	12,331	26.7	458	21.2	22,554	26.1	566	23.3
Media/Communications	3,879	10.9	172	10.9	3,515	7.6	192	8.9	10,266	11.9	235	9.7
Multidisciplinary	2,261	6.3	149	9.5	2,650	5.7	189	8.8	7,191	8.3	209	8.6
Arts-Related Humanities	1,497	4.2	40	2.5	1,489	3.2	67	3.1	1,038	1.2	39	1.6
Historical Activities	1,917	5.4	66	4.2	1,102	2.4	87	4.0	4,370	5.1	136	5.6
Visual Arts	322	0.9	23	1.5	1,832	4.0	29	1.3	1,018	1.2	40	1.6
Other[1]	1,246	3.5	87	5.5	1,332	2.9	103	4.8	3,408	3.9	96	3.9
Total	**$35,676**	**100.0%**	**1,574**	**100.0%**	**$46,103**	**100.0%**	**2,160**	**100.0%**	**$86,466**	**100.0%**	**2,434**	**100.0%**
Community												
Performing Arts	$8,368	59.5	268	53.6	$9,839	46.1	309	45.9	$10,880	45.4	206	44.2
Museums	1,565	11.1	62	12.4	3,565	16.7	97	14.4	5,302	22.1	97	20.8
Media/Communications	566	4.0	20	4.0	936	4.4	41	6.1	2,145	8.9	39	8.4
Multidisciplinary	1,630	11.6	62	12.4	2,474	11.6	81	12.0	3,023	12.6	50	10.7
Arts-Related Humanities	178	1.3	11	2.2	534	2.5	39	5.8	191	0.8	12	2.6
Historical Activities	818	5.8	37	7.4	1,495	7.0	50	7.4	970	4.0	29	6.2
Visual Arts	480	3.4	15	3.0	1,657	7.8	25	3.7	369	1.5	16	3.4
Other[1]	470	3.3	25	5.0	865	4.0	31	4.6	1,107	4.6	17	3.6
Total	**$14,074**	**100.0%**	**500**	**100.0%**	**$21,365**	**100.0%**	**673**	**100.0%**	**$23,987**	**100.0%**	**466**	**100.0%**

Source: The Foundation Center, 1992.
* Dollar figures in thousands. Due to rounding, figures may not add up.
[1] Includes broad range of supporting activities or organizations identified by 12 "common codes" including advocacy, management, fundraising, and technical assistance; also includes art libraries, international cultural exchange, and arts grants not elsewhere classified.

TABLE 5-3. ARTS GRANT DOLLARS BY MAJOR SUBJECT AND BY SUBCATEGORY*

Subject≠	1983				1986				1989			
	Amount	%	No.	%	Amount	%	No.	%	Amount	%	No.	%
Performing Arts	**$92,289**	**38.8**	**2,351**	**47.2**	**$108,087**	**33.5**	**3,033**	**44.5**	**$169,113**	**33.6**	**3,331**	**42.5**
Performing Arts Centers	9,877	4.2	165	3.3	16,271	5.0	199	2.9	21,547	4.3	288	3.7
Dance	8,688	3.7	301	6.0	9,271	2.9	406	6.0	18,801	3.6	468	6.0
Ballet	5,751	2.4	132	2.6	4,450	1.4	153	2.2	10,368	2.0	237	3.0
Unspecified—Other	2,848	1.2	161	3.2	4,424	1.4	243	3.6	8,257	1.6	225	2.9
Choreography	89	0.0	8	0.2	398	0.1	10	0.1	176	0.0	6	0.1
Theater	23,784	10.0	666	13.4	32,201	10.0	918	13.5	37,405	7.4	824	10.5
Theater—General	23,439	9.9	645	12.9	31,895	9.9	902	13.2	36,430	7.2	790	10.0
Playwriting	345	0.1	21	0.4	305	0.1	16	0.2	974	0.2	34	0.4
Opera/Musical Theater	12,242	5.2	245	5.0	14,023	4.4	318	4.7	21,379	4.3	378	4.8
Music	28,914	12.2	692	14.0	27,809	8.6	875	12.8	55,306	11.0	1,032	13.2
Orchestras	22,383	9.4	360	7.2	18,632	5.8	440	6.5	37,454	7.4	544	6.9
Ensembles/Groups	1,646	0.7	73	1.5	2,296	0.7	108	1.6	4,290	0.9	136	1.7
Choral Music	599	0.3	48	1.0	757	0.2	50	0.7	1,213	0.2	57	0.7
Music Composition	347	0.1	14	0.3	284	0.1	18	0.3	1,482	0.3	23	0.3
Music Unspecified	3,938	1.7	197	4.0	5,840	1.8	259	3.8	10,867	2.2	272	3.5
Performing Arts Education	5,375	2.3	160	3.2	4,511	1.4	174	2.6	8,609	1.7	169	2.2
Multi-Media	838	0.4	10	0.2	219	0.1	12	0.2	774	0.2	14	0.2
Circus Arts	55	0.0	7	0.1	152	0.0	13	0.2	275	0.1	11	0.1
Unspecified/Other	2,515	1.1	105	2.1	3,629	1.1	118	1.7	5,017	1.0	147	1.9
Museum Activities	**$60,670**	**25.5**	**821**	**16.5**	**$106,275**	**33.0**	**1,261**	**18.5**	**$153,544**	**30.5**	**1,579**	**20.1**
Art Museums	40,806	17.2	423	8.5	57,567	17.9	584	8.6	74,912	14.9	669	8.5
Children's Museums	1,393	0.6	38	0.8	6,021	1.9	51	0.7	4,766	0.9	83	1.1
Ethnic/Folk Museums	1,220	0.5	25	0.5	1,153	0.4	52	0.8	6,791	1.4	76	1.0
History Museums	3,091	1.3	88	1.8	12,112	3.8	152	2.2	22,618	4.5	199	2.5
Natural History Museums	5,235	2.2	70	1.4	12,936	4.0	113	1.7	12,186	2.4	110	1.4
Science Museums	1,853	0.8	51	1.0	5,326	1.7	109	1.6	13,134	2.6	164	2.1
Unspecified/Other	7,072	3.0	126	2.5	11,162	3.5	200	3.0	19,137	3.8	278	3.5
Media/Communications	**$28,905**	**12.1**	**476**	**9.6**	**$27,560**	**8.6**	**560**	**8.2**	**$59,363**	**11.8**	**839**	**10.7**
Film/Video	1,846	0.8	46	0.9	3,883	1.2	70	1.0	5,949	1.2	134	1.7
Television	13,410	5.6	198	4.0	12,174	3.8	183	2.7	27,437	5.4	301	3.8
Publishing/Journalism	6,838	2.9	107	2.1	4,871	1.5	163	2.4	15,893	3.1	206	2.6
Radio	2,748	1.2	68	1.4	2,645	0.8	67	1.0	5,824	1.1	94	1.2
Unspecified/Other	4,064	1.7	57	1.1	3,987	1.2	77	1.1	4,260	0.9	104	1.3
Multidisciplinary Arts	**$16,043**	**6.7**	**484**	**9.7**	**$22,090**	**6.9**	**699**	**10.3**	**$38,068**	**7.6**	**722**	**9.2**
Multidisciplinary Centers	4,939	2.1	141	2.8	7,899	2.5	221	3.2	15,343	3.0	258	3.3
Ethnic/Folk Arts	835	0.4	45	0.9	1,286	0.4	50	0.7	5,523	1.1	71	0.9
Arts Education	7,735	3.3	186	3.7	10,072	3.1	278	4.1	10,798	2.3	237	3.0
Unspecified/Other	2,533	1.0	112	2.3	2,832	0.9	150	2.2	6,403	1.2	156	2.0
Arts-Related Humanities	**$12,445**	**5.2**	**264**	**5.3**	**$21,975**	**6.8**	**435**	**6.4**	**$28,886**	**5.7**	**343**	**4.4**
Humanities—General	5,460	2.3	51	1.0	10,018	3.1	75	1.1	15,156	3.0	84	1.1
Art History	923	0.4	38	0.8	1,618	0.5	49	0.7	1,064	0.2	47	0.6
History/Archeology	4,010	1.7	104	2.1	5,429	1.7	180	2.6	8,865	1.7	121	1.5
Literature	2,052	0.9	71	1.4	4,910	1.5	131	1.9	3,801	0.8	91	1.2
Historical Activities	**$9,668**	**4.1**	**268**	**5.4**	**$16,841**	**5.2**	**380**	**5.6**	**$23,311**	**4.6**	**474**	**6.0**
Historic Preservation	9,200	3.9	249	5.0	14,433	4.5	331	4.9	17,743	3.5	349	4.5
Historical Societies	351	0.1	12	0.2	789	0.2	29	0.4	2,775	0.6	61	0.7
Unspecified/Other	117	0.0	7	0.2	1,619	0.5	20	0.3	2,793	0.5	64	0.8
Visual Arts	**$4,031**	**1.7**	**114**	**2.3**	**$10,372**	**3.2**	**184**	**2.7**	**$13,522**	**2.7**	**240**	**3.1**
Visual Arts–General	2,759	1.2	65	1.3	5,690	1.8	98	1.4	8,259	1.6	137	1.7
Architecture	447	0.2	21	0.4	2,241	0.7	22	0.3	1,683	0.3	42	0.5
Photography	502	0.2	10	0.2	498	0.2	17	0.2	1,078	0.2	25	0.3
Sculpture	239	0.1	11	0.2	1,290	0.4	20	0.3	1,875	0.4	18	0.2
Design	9	0.0	1	0.0	29	0.0	3	0.0	155	0.0	5	0.1
Painting	20	0.0	2	0.0	145	0.0	8	0.1	83	0.0	2	0.0
Drawing	20	0.0	2	0.0	198	0.1	6	0.1	330	0.1	8	0.1
Crafts/Ceramics	35	0.0	2	0.0	281	0.1	10	0.1	60	0.0	3	0.0

Other	$13,851	5.7	204	4.1	$9,010	2.8	260	3.8	$17,077	3.5	314	4.0
Policy/Education/ Administration	494	0.2	28	0.6	1,760	0.5	35	0.5	1,049	0.2	52	0.7
Fundraising/Management	9,665	4.1	26	0.5	1,986	0.6	29	0.4	5,844	1.2	62	0.8
Arts Libraries	295	0.1	10	0.2	668	0.2	9	0.1	2,282	0.5	32	0.4
International Exchange	787	0.3	12	0.2	579	0.2	12	0.2	1,456	0.3	22	0.3
Unspecified/Other	2,611	1.1	128	2.6	4,017	1.2	175	2.6	6,447	1.3	146	1.9
Total	**$237,903**	**100.0%**	**4,982**	**100.0%**	**$322,210**	**100.0%**	**6,812**	**100.0%**	**$502,883**	**100.0%**	**7,842**	**100.0%**

Source: The Foundation Center, 1992.
* Dollar figures in thousands. Due to rounding, figures may not add up.
≠ Arts categories are those used in the Foundation Center's grants classification system and are adapted from the National Taxonomy of Exempt Entities (NTEE). See Appendix B.

performing arts funding. The field obtained nearly a third of all dollars allocated to the performing arts at the start and finish of the study period. But in between its share plummeted to one-quarter. As a result, grants to theater surpassed grants to music in 1986, both in dollars and number of grants awarded.

The mid-decade music decline is traceable directly to fluctuations in funding for symphony orchestras, which experienced a drop in exceptionally large gifts. Orchestras' share of performing arts dollars in 1983 had been 24 percent; three years later, the share dropped to 17 percent. By the end of the era, however, their share of performing arts dollars had risen back to 22 percent.

Shifts in orchestras' fortunes were also evident within the context of total arts funding, not just for the performing arts. As shown in Table 5-3, in 1983 orchestras received more than 9 percent of all foundation arts dollars and over 7 percent of grants. While their share of the number of grants remained stable, by 1986 their share of arts dollars had fallen by a third, to under 6 percent.

Orchestras recovered some of their funding share by 1989. Support for other types of music and for music composition held steady or gained over the study period.

Theater. Theater in 1983 had commanded more than a quarter of all performing arts allocations, a portion that grew to almost 30 percent by mid-decade (Figure 5-4). But in 1989, the trend reversed itself; theater's share dropped to about a fifth. Equally significant, out of total arts dollars granted by the sampled foundations, theater's share had dropped from 10 percent at the beginning of the study period to 7.4 percent at the end (Table 5-3).

Measured in numbers of performing arts grants, theater's share (including playwriting) began and ended near one-fourth; in the middle, however, it had reached 30 percent.

With regard to overall sources of theater revenue, private philanthropy—from corporations and individuals as well as foundations—accounted for around 30 percent during 1989. Earnings from performances provided about 61 percent of theater income, and the remaining 8 percent came from government grants.[2]

Of all private donations, foundations provided roughly a fifth, up from around 16 percent in 1986, according to the Theatre Communications Group (TCG). Corporations, by contrast, gave about 25 percent in 1989, compared with 20 percent in 1986.

The apparent contradiction between the drop in the share of foundation allocations to theater, based on the study sample, and the modest growth in foundation theater revenue share reported by TCG may be explained either by the relatively small number of theater groups in the TCG sample (50), or the extremely strong growth in total foundation spending between 1986 and 1989, as reported in the "Overview" chapter. For example, among consistent funders—those that gave to the arts each year of the study—arts giving had increased by 25.6 percent, after adjusting for inflation.

Dance and Performing Arts Centers. Dance (modern, ballet, and choreography), meanwhile, increased its share of performing arts dollars slightly, from 9.4 percent at the start to 11 percent at the end (Figure 5-4), although as a portion of total arts funding, the amount granted to dance remained relatively steady, averaging between 3 and 3.7 percent between 1983 and 1989.

Likewise, performing arts centers commanded about one in nine performing arts dollars in 1983, and one in eight dollars by 1989. As with dance, however, the portion of total arts grants allocated to the centers remained virtually unchanged, from 4.2 percent to 4.3 percent, after having swelled in the middle of the decade.

Within the dance category itself, ballet took the largest share of funds, and modern and other forms received the next largest share. Choreography secured a tiny proportion of funding each study year.

Shifts in funding other performing arts disciplines were slight. Opera and musical theater consistently obtained around 13 percent of all performing arts dollars (Figure 5-4). Performing arts education also remained fairly steady at around 5 percent.

FIGURE 5-4. PERFORMING ARTS, GIVING TO SUBCATEGORIES*

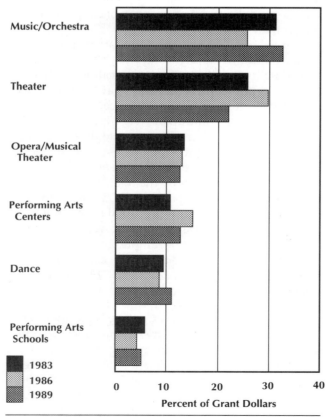

Source: The Foundation Center, 1992.
* Excludes unspecified and other minor categories of grants.

INDEPENDENTS SHIFTED THE MOST IN FUNDING THE PERFORMING ARTS

Shifts in the above funding patterns were especially true for independent foundations. In 1986, for example, they had allocated almost a third of their performing arts dollars to theater and less than a quarter to music; by 1989, those percentages had reversed.

Corporate allocations for music and theater, by contrast, were more consistent throughout the 1980s. Business giving to music consistently ranked above donations to theater, while performing arts centers consistently held third place.

Community foundations at the start of the period followed a trend almost opposite to that of the corporates, giving far more to theater than to music. In fact, of all foundation types, the community trusts gave the smallest share to music; they also gave the largest share to performing arts centers. By mid-decade, the community trusts had evened out their respective shares to music and theater, and by 1989 gave their largest share, one-third, to performing arts centers.

Concerning opera, the small drop in giving to that art form reflected, in part, changes in the funding patterns of corporate foundations. In 1983, corporates gave more to opera than to any other of the performing arts, including second-ranked music, largely due to the Texaco Foundation's $3 million gift to the Metropolitan Opera Association (see below). That year, in fact, corporates gave 14 percent of total arts funding to opera. By 1989, the share had been reduced to only 4 percent (that is, from one out of seven dollars to one out of 25 dollars).

Community foundation support for opera also declined between 1986 and 1989. The drop in funding by corporate and community foundations was offset by an increase in support from independents at the end of the decade. As a portion of total arts funding, independents gave more for opera (4.4 percent) than for either dance (3.7 percent) or performing arts centers (2.8 percent).

LARGE PERFORMING ARTS GIFTS FAVORED ORCHESTRAS AND CENTERS

A review of some of the largest performing arts grants during the study period illustrates the trends mentioned above—large one-time gifts, termina-

tions, reductions, etc. Most of the largest grants in the field were given to local performing arts groups or to organizations within the funders' states or regions. Examples include:

1983

- $3.13 million to the Indiana State Symphony Society, for capital support, from Krannert Charitable Trust. The Trust, mentioned earlier, spent over $4 million for music and theater in 1983, more than any other grantmaker that year. Because of its plans to terminate in 1987, its disbursements had fallen by mid-decade, leaving a substantial gap in performing arts allocations.

- $3.05 million to the Metropolitan Opera Association from the Texaco Foundation. Texaco's funding for the arts totaled $3.3 million in 1983, including outstanding support of opera and the performing arts. Economic setbacks in the petroleum industry forced Texaco to reduce its foundation budget in the mid-1980s; the oil company's support of music and opera in 1986 dropped to $1.5 million.

- $500,000 to the Dallas Symphony Orchestra from the ARCO Foundation. ARCO gave almost $3.4 million to the performing arts in 1983, nearly all of it for music and orchestras. Like Texaco, ARCO experienced heavy financial losses after 1983, which forced it to slash the foundation's total grants budget by two-thirds in 1986, from $6.6 million to $2.3 million. Spending for the performing arts declined to under $700,000.

- $300,000 from the San Francisco Foundation, a community trust, to the San Francisco Opera to improve marketing and development. The foundation gave out over $3.2 million in 1983 for the performing arts, distributed broadly in 74 grants for theater, music, centers, and dance. But funding was cut in half in 1986, when the foundation lost the Buck Trust, its principal endowed trust.

1986

- $2.1 million to the Philadelphia College of Art (now the University of the Arts), for renovation of the Shubert Theater, from the Pew Charitable

Trusts. The Trusts gave over $8 million to the performing arts in 1986, more than any other grantmaker.

- $1.8 million to the Indiana Repertory Theater, for general support and debt elimination, from the Lilly Endowment. Due to this exceptionally large, one-time grant, Lilly gave over $1.9 million to theaters in 1986, about two and a half times more than it had approved for theater grants in either 1983 or 1989.

- $1.1 million to the Center for Puppetry Arts in Atlanta, to acquire Spring Street School to house the Center, from the Joseph P. Whitehead Foundation. Puppetry arts fall within the "other" component of the performing arts typology.

- $500,000 to the Music Center of Los Angeles County to develop an earned income program, from the James Irvine Foundation. Irvine ranked second in support of the performing arts in 1986, spending nearly $4.5 million, principally for centers and theater.

- $300,000 to the Spanish Theater Repertory Company, New York City, to expand the company's ensemble and to strengthen management and fundraising, from the Ford Foundation. Ford distributed nearly $2.4 million in 20 theater grants in 1986, and ranked first in theater support. Its grants to theater in 1983 had amounted to less than $800,000.

1989

- $8.5 million to the Indiana State Symphony for acquisition of a theater, from Lilly Endowment. This was the largest single arts grant awarded during the study period. Lilly approved nearly $10 million for the performing arts in 1989, most of it for music. The Endowment's arts grants were part of its community development program to strengthen local institutions.

- $3.15 million to the City of Charlotte for the North Carolina Performing Arts Center, from the Foundation for the Carolinas, a community trust. This was the largest grant reported to any performing arts center during the study years.

- $1.1 million to the San Francisco Symphony, from the Ann and Gordon Getty Foundation. Not to be confused with the J. Paul Getty Foundation, an operating foundation, this San Francisco-based independent, formed in 1986, supports both the performing and visual arts, including museums. In 1989, it provided over $4.8 million in 90 grants for music and opera.

- $1 million to the Houston Ballet Foundation toward endowment, from the Brown Foundation. Brown gave away $3.9 million to the performing arts in 1989, all of it in Texas. Brown's support of the arts increased dramatically at the end of the decade.

- $780,000 to the Westminster Choir College in Princeton, to match a challenge grant from the New Jersey Education Department, as well as to refurbish facilities and support operating costs, from the Pittsburgh-based Hillman Foundation.

- $500,000 to the Guthrie Theatre, Minneapolis, for a capital and endowment campaign, by the Dayton Hudson Foundation. In both 1986 and 1989, Dayton Hudson ranked first among corporate foundations in support of the performing arts. It gave especially strong support to theater.

- $300,000 to the San Francisco Ballet to improve curricular, faculty, and administrative development, from the Andrew W. Mellon Foundation. Mellon spent over $1.5 million for dance in 1989, more than any other grantmaker. Its total contributions to the performing arts that year came to over $4.6 million.

- $250,000 to Meet the Composer, New York City, in support of new music, from the Lila Wallace-Reader's Digest Fund. As noted above, the Fund was established in 1987 and grew rapidly. It awarded $4 million to the performing arts in 1989, broadly disbursed to theater, music, and dance.

MUSEUM FUNDING SHIFTED FROM ART TO HISTORY AND SCIENCE MUSEUMS

For the purposes of this study, museums fall into seven categories, of which art and natural history are perhaps the best known. Some museums, such as those dedicated to science, hobbies, sports, maritime affairs, or other specialized subjects, are not directly related to the arts and humanities, as generally understood. Nevertheless, because of their role in collecting, preserving, and exhibiting "culture," museums as a group are classified under the arts by the NTEE (see Appendix B), and are usually funded from foundations' arts or culture programs.

Museums secured the second largest share of arts dollars in each year of the study period, behind the performing arts. But the share fluctuated during the decade, rising from about a quarter of all arts funds to a third, then dropping to slightly under 31 percent (Table 5-3).

The primary trend within the Museum category was the drop in the share of foundation dollars to art museums, and the rise in funding of history and science museums (see below).

By number of grants, museums' share rose steadily, if slightly, throughout the era. They secured one in six arts grants at the start of the period, less than one in five at midpoint, and exactly one in five at the end. (The reverse trend was experienced by performing arts; during the same period, the share of the number of arts grants to the performing arts declined steadily, from nearly one in two to around two in five.)

By foundation type, independents far outspent corporate and community foundations on museum programs, allocating to them 28 percent of all their arts dollars in 1983, 35 percent in 1986, and 32 percent in 1989 (Table 5-2). At mid-decade, independents—which constitute two-thirds of all the foundations in the sample—were spending more on museums than on performing arts, a trend that continued into 1989.

While corporate foundations allocated far less to museums, they dramatically increased the share during the study period, from 17 percent of all corporate arts dollars in 1983 to 26 percent in both 1986 and 1989. As the museum share rose, the performing arts share fell proportionately throughout the 1980s, from more than half of all business dollars in 1983 to 42 percent in 1989.

The change in giving patterns among community foundations was equally startling, doubling the museum share from 11 percent in 1983 to 22 percent in 1989. Over the same period, the community trusts' support for performing arts fell from 60 percent of funding to 45 percent.

Leading museum funders in the early 1980s were, almost without exception, independent foundations. Throughout the decade their commitment to museums remained solid. At the same time, with the exception of a few foundations in the Southwest whose assets derived from gas and oil, most independent foundation grant budgets were doubling. This not only enabled traditional funders to raise their support for museums, it enabled new donors—corporate and community funders as well as independents—to join them.

More information on museum funding trends by foundation type appears later in this chapter.

Art Museums' Share Highest, but Declined Steadily

Perhaps unsurprisingly, art museums secured most of the funds and most of the grants allotted to museums throughout the study period. But despite a substantial increase in actual dollars received, the share to art museums dropped from more than two-thirds ($40.8 million out of $60.7 million) in 1983 to 54.1 percent by mid-decade, then to less than half the museum funds in 1989 (Figure 5-5). As a share of all arts dollars, art museums slipped from 17 percent to 15 percent (Table 5-3).

Their share of the number of museum grants also dropped, from around half at the start to two-fifths at the end (although as a portion of the number of all arts grants, art museums' share remained steady at 8.5 percent).

Where did the museum shares go? Primarily to history and science museums. The history institutions had secured only one in 19 museum dollars (or 1.3 percent of all arts funds) at the start of the study period. By decade's end, history museums' share had nearly tripled to one in seven museum dollars (or 4.5 percent of total arts funding). A larger proportion of the number of museum grants also went to history museums, beginning at around 11 percent and growing to more than 12 percent.

Science museums, too, had seen their share of museum dollars rise—almost tripling, from 3 percent at the start to nearly 9 percent at the end (or from under 1 percent of total arts dollars to 2.6 percent).

The share of funds to natural history museums zigzagged; it rose from one in 12 museum dollars in 1983 to one in eight dollars in 1986, then back down to one in 13 by the end of the period. In terms of

total arts giving, natural history museums almost doubled their original proportion by mid-decade (from 2.2 percent to 4.0 percent), then moved back down in 1989.

Ethnic and folk museums also saw their share of museum dollars rise significantly; lesser growth was experienced by childrens' and by other specialized museums.

Independents Favored Art and History Museums; Corporates Preferred Science

Independent foundations gave one out of five arts dollars to art museums in 1983 and 1986, but the share dropped to one out of six by 1989. In the early 1980s, independents gave nearly twice as much to art museums as did corporate foundations, and nearly four times as much as community foundations. The gap narrowed slightly by 1989.

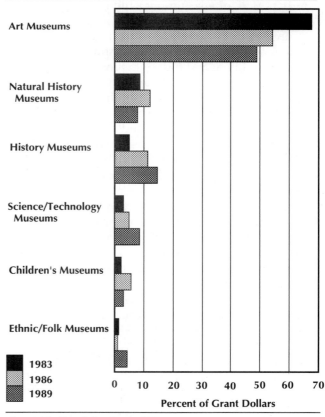

FIGURE 5-5. MUSEUMS, GIVING TO SUBCATEGORIES*

Percent of Grant Dollars

1983
1986
1989

Source: The Foundation Center, 1992.
* Excludes the category of unspecified grants.

The independents, especially those in the West and Southwest, were largely responsible for the significant jump in giving to history museums, although all three foundation types reported increased support.

Not surprisingly, corporate foundations were strong supporters of science and technology museums, giving far more proportionally than independents or community foundations. In fact, by 1989, corporates gave 5 percent of their total arts allocations to science museums, compared to 2 percent from independents and 3 percent from community trusts.

Community foundations in 1989 disbursed only 6 percent of their total arts funds to art museums (compared to 11 percent from corporates and 16 percent from independents).

ART MUSEUMS FAVORED AMONG LARGEST GIFTS

Art museums were consistently among the recipients of million-dollar-plus gifts throughout the study period, often claiming a high share of the largest arts grants.

In 1983, for example, gifts to art museums represented 31 percent of the dollars disbursed in gifts above $1 million, and four of the top 16 grants. The Menil Collection received the second largest arts award that year: $5 million from the Brown Foundation for construction of a building (the National Arts Stabilization Fund received the largest). The Philadelphia Museum of Art received the sixth largest grant in 1983, securing $3.02 million from the Pew Charitable Trusts for exhibitions, acquisition of art objects, and general operations. The Amon Carter Museum in Ft. Worth and the Museum of Fine Arts of Houston were next, each receiving more than $2.2 million from the Carter and Brown Foundations, respectively. The Carter Foundation provides major annual support for the museum.

In 1986, of the 28 arts grants over $1 million, 11 went to eight art museums, which received from these awards alone more than $18.3 million—almost half the combined value of all the largest grants. The Philadelphia Museum of Art received the largest grant in 1986, $5 million, from the Pew Charitable

Trusts for a capital campaign. Other large grants that year included:

- $2.66 million to the National Gallery of Art to purchase a work of art, from the Morris and Gwendolyn Cafritz Foundation (DC);

- $1.87 million to Museum Associates (Los Angeles County Museum of Art) for the purchase of paintings, from the Ahmanson Foundation;

- $1.5 million to the Huntington Library, Art Gallery, and Botanical Garden, for capital development, from the Getty Grant Program.

In 1989, once again, art museums were heavily represented among recipients of the largest individual grants, receiving 11 out of 37 arts grants in excess of $1 million, and totalling around one-fourth of the dollar value of all arts grants. That year the Amon Carter Museum received the largest art museum grant—$3.9 million—for general support from the Carter Foundation. Among notable recipients the Philadelphia Museum of Art, the Metropolitan Museum of Art, and the Art Institute of Chicago received several of the largest grants.

HISTORY MUSEUMS FAVORED WESTERN FRONTIER AND JEWISH HISTORY

Much of the history museum funding appeared to be directed towards two broad subjects: America's Western frontier, and Jewish history, especially the Holocaust. Large funding also went to the restoration of the Statue of Liberty and the founding of a history museum on Ellis Island.

Large Western history grants began to appear in 1986. They included $1 million from the Lilly Endowment to the Conner Prairie Foundation; $697,000 from the Peter Kiewit Foundation to the Western Heritage Society in Omaha; and grants of $500,000 and $260,000 from the Samuel Roberts Noble and Southwestern Bell foundations, respectively, to the National Cowboy Hall of Fame.

In 1989, the second largest arts grant of the year—$8.09 million—was given by the California-based Autry Foundation to the Gene Autry Western Heritage Museum. (The Autry Foundation had been

formed in 1974, but until the mid-1980s grantmaking had been very limited.) Other large Western history grants that year included:

- $1 million from the Robert Woodruff Foundation (GA) to the Buffalo Bill Historical Center, Wyoming, which had also received $300,000 from the Kresge Foundation for construction of a Cody firearms unit;

- $900,000 from the Peter Kiewit Foundation to the Western Heritage Society;

- $575,000 from the Houston Endowment to the Galveston Historical Foundation.

Large museum grants with a focus on the Holocaust and other aspects of Jewish history included, in 1986, $3 million from the Helena Rubinstein Foundation to the U.S. Holocaust Memorial Museum, and $250,000 from the Pew Charitable Trusts to the Museum of American Jewish History. In 1989, large Jewish history grants included $500,000 from the Koret Foundation and $400,000 from the recently created Milken Family Foundation (1986) to the U.S. Holocaust Memorial Council.

Grants to the Statue of Liberty and Ellis Island Foundation included, in 1986, $1 million from the William Randolph Hearst Foundation and $750,000 from the Kresge Foundation. In 1989, the Kluge Foundation, formed in 1984 by billionaire John Kluge, gave $1 million to the new museum. Historic preservation is one of several interests of the Maryland-based grantmaker.

GRANTS TO VISUAL ARTS AND ARCHITECTURE

Often used as a synonym for "art," the visual arts comprise architecture, photography, sculpture, design, painting, drawing, and crafts. Although in popular terminology museums, especially art museums, are the preeminent visual arts institutions, for the sake of this report, and in line with the National Taxonomy of Exempt Entities (Appendix B), museums are considered a separate field, explored above.

As a result of this dichotomy, funding for the visual arts tends to be obscured. While it is clear that most grants to art museums covered a range of visual arts programs, funding was subsumed under the category "Art

Museums." Nevertheless, some museums did receive "visual arts" grants, if the grants specified one of the visual arts, such as a sculpture exhibit or a photography catalog. Moreover, grants to schools, universities, galleries, and arts centers for one or more named visual arts programs were tracked under the visual arts.

As defined by the National Taxonomy of Exempt Entities, the visual arts received a small share of total arts grants from the sampled foundations in all three years of the study (Table 5-3). Proportions rose from 1.7 percent in 1983 to 3.2 percent in 1989, and then fell back to 2.7 percent towards the end of the decade. *Were the shares to "Visual Arts" and "Art Museums" combined, the portion of arts dollars allocated to this expanded category would have amounted to 18.9 percent, 21.1 percent, and 17.6 percent, respectively, for each of the study years.*

During each year, the bulk of visual arts funding—from more than half to more than two-thirds—went to broadly based visual arts organizations, rather than to single-subject areas such as drawing or photography.

FIGURE 5-6. VISUAL ARTS, GIVING TO SUBCATEGORIES*

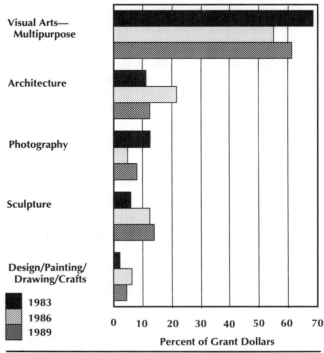

Source: The Foundation Center, 1992
* Visual arts category excludes most grants to art museums.

A few notable changes occurred during the study period. Architecture increased its share of the visual arts allocations from around one in nine dollars to about one in five dollars by mid-decade; it dropped back down in 1989. Sculpture grew consistently as a share of visual arts funding, from 6 percent to 14 percent by 1989. Patterns of support within the visual arts are illustrated in Figure 5-6.

Because of the relatively small size of the field, visual arts giving trends were strongly influenced each year by individual large grants. As a result, funding patterns by foundation type were not consistent. Independent foundation support for the field grew steadily as a share of all arts dollars, while community and corporate foundation support tended to fluctuate.

Although the major share of visual arts went to broad-based programs, large grants of at least $250,000 were often earmarked for one specific visual arts form. Grants went for such purposes as fellowships, materials conservation projects, advanced study, urban design centers and programs, and publication of historical papers.

Examples of large grants in 1989 included:

- $317,000 from the William Penn Foundation to the Foundation for Architecture, Philadelphia, to review and improve directional signage of Delaware Valley;

- $310,000 from the Pew Charitable Trusts to Bucks County Community College, for the Philadelphia Photography Sesquicentennial Project;

- $270,000 from the Getty Grant Program to the National Institute for Conservation of Cultural Property, for a national inventory and conservation assessment of American photography;

- $250,000 from the Andrew W. Mellon Foundation to American University, for editing the Frederick Law Olmstead papers. Olmstead was an architect and urban designer who designed New York City's Central Park and other parks and recreational areas across nineteenth century America.

In addition to the funders cited above, others showing an interest in one or more of the visual arts included: for painting, the Ahmanson Foundation; for sculpture, the Hall Family Foundation; for art conservation, the Getty Grant Program and the Kress Foundation; for architecture and urban design, the J.M. Kaplan Foundation; for the visual arts in general, the Lannan Foundation.

A few notable funders established in the late 1980s and not included in the data sample for this study also specialize in the visual arts. Among them:

- The Andy Warhol Foundation for the Visual Arts (1987) funds painting, sculpture, printmaking, and photography;

- The Robert Mapplethorpe Foundation (1988) funds photography as a fine art;

- The Pollock-Krasner Foundation (1985) funds individual visual artists.

A description of the giving programs of these and other arts grantmakers may be found in the "Profiles" chapter of this report.

MEDIA RECEIVES THIRD LARGEST SHARE OF ARTS FUNDS

Media and communications includes video and film, television, radio, journalism and publishing, and multimedia endeavors. Grantees produce or disseminate the media works, or provide production facilities. They include not only media organizations, but also universities, media and communications centers, journalism schools or departments, media policy centers, and other organizations.

For the purposes of this study, media and communications included only those grants where the primary subject was media. Excluded were those secondary media grants, such as for religious broadcasting, close captioned television for the hearing-impaired, a science film for educational television, or a grant to a dance company to videotape a performance. In fact, many arts grants, especially performing arts grants, are closely linked to media. While these grants were coded by their primary subject or discipline—e.g., dance, art history, theater, etc.—the media content of the grants was captured under "Type of Support" as film and television production (see Chapter 6).

Media arts as a primary field received the third largest proportion of arts grants, after performing arts and museums, throughout the study period (Table 5-3). In 1983, media secured more than 12 percent of all arts funding. By mid-decade, the proportion dropped to under 9 percent, but that was still the third largest amount that year. By 1989, the overall media share climbed back up to almost 12 percent.

In terms of numbers, media represented about one in ten arts and culture grants in 1983 and 1989, although, as with dollars, the share of numbers had slipped in 1986, to one in 12.

Most media funding during the period went to public television stations, and to universities. (See Figure 5-10 for data on arts grants to educational institutions.)

Independent foundations were the major supporters of the media field, allocating a larger share of their art dollars to it each year of the study than either corporate or community foundations (Table 5-2). However, the latter two foundation types actually increased their shares to media from the beginning to the end of the decade (again, with a corporate dip in the middle), while independents decreased their share. The community foundations, in fact, had doubled their share to media over the decade.

Among the independents, the rebound in 1989, after the mid-decade slip, benefited journalism and publishing. Among the corporate and community funders, the 1989 rise benefited television. Among the sampled foundations as a whole, film and video remained steady at 1 percent of total arts dollars.

LARGEST MEDIA GRANTS TO PUBLIC TV STATIONS, UNIVERSITIES

Close to one out of two dollars granted to media each study year went to television (not to be confused with video), which also received the largest share of the number of media grants—from a third to two-fifths. The top heavy share of media dollars to public television each year should come as no surprise to media arts organizations, who have long insisted that they comprise a neglected, or at least sorely underfunded, arts community (Figure 5-7).[3]

Equally important, the large media grants—those of at least $250,000—were overwhelmingly

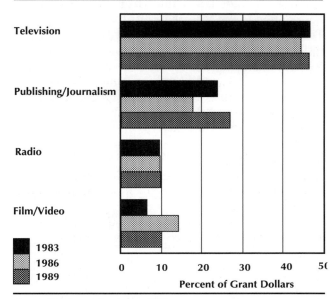

FIGURE 5-7. MEDIA AND COMMUNICATIONS, GIVING TO SUBCATEGORIES*

Source: The Foundation Center, 1992.
* Excludes the category of unspecified grants.

directed towards public broadcasting stations, and secondarily towards large universities, not to the small or independent video, radio and printing arts organizations.

For example, in 1983, almost 52 percent of the total amount granted to media was made in the form of large gifts (from $250,000 to over $3 million) to public television and radio stations for programming and operating costs; or to universities and colleges, like Stanford, Massachusetts Institute of Technology, St. Augustines, and Clark Atlanta. Funded projects included journalism fellowship programs (Stanford), construction of a learning research laboratory at an arts/media technology center (MIT), purchase of television equipment (Clark Atlanta), and establishment of a new major in mass communications (St. Augustines).

Much the same picture emerged in 1986 and 1989. In the latter year, large grants ($250,000 and above) to public broadcasting stations accounted for almost 60 percent of the total of all large media arts grants—$16.4 million out of $27.6 million.

Most of the remaining large grants in 1989 supported journalism and publications (which, again, had increased its share from independent founda-

tions). These grants, too, went to major institutions of higher learning or established periodicals. Examples included: $5 million from the Knight Foundation to the Massachusetts Institute of Technology to endow journalism fellowships; $2 million from Knight to the University of Missouri for construction of a building to house the school's daily newspaper; and $1 million from the Roderick MacArthur Foundation to *Harper's Magazine* to continue publication and "carry out other charitable literary endeavors."

SUPPORT FOR INDEPENDENT MEDIA ARTISTS: ROLE OF THE MACARTHUR FOUNDATION

To be sure, some of the large grants ultimately benefit the smaller, independent media artists. A $666,800 MacArthur Foundation grant in 1983 to ACSN-The Learning Channel funded a presentation of 26 one-hour programs by independent film and video producers, focusing on the documentation of the arts and "significant social issues." In 1986, MacArthur gave the same station more than $1.5 million to broadcast the works of the independents every week of the year. Likewise, MacArthur's grant of $500,000 in 1983 to the Sundance Institute for Film and Television made possible the establishment of a fund "to provide strategic financial investments in production and distribution of independent feature films." And finally, in 1989, MacArthur made a $1.75 million grant to the Learning Channel, a unit of the Appalachian Community Service Network, for a series from independent video artists.

The MacArthur Foundation, however, may be fairly unique among major grantmakers in terms of its interest in supporting independent media artists and struggling media arts centers. In fact, no discussion of media funding would be complete without specific attention to MacArthur.

A 1991 survey of media centers noted that MacArthur's grants have been "a boon, even a life saver."[4] Among the 47 centers polled, almost two-thirds acknowledged MacArthur grants as "important and influential," representing "the only substantial new cash infusion the field has received in years, having come at a crucial time for a number of long-established organizations." Others noted that MacArthur's grants were second in importance only to those of the National Endowment for the Arts.

MacArthur grants apparently not only supported, but virtually sustained, the media arts during the 1980s. One of the survey's participants maintained that, "Had the MacArthur Foundation not come forth at the moment that it did, the media arts field would quite possibly not exist in its current form." Another media center noted that MacArthur grants have "had a profound impact as the most generous and least restrictive of foundations funding the media arts, enabling [us] to move ahead on much needed capital improvements and revitalize [our] equipment access program at a time when no other foundation recognized the importance of these programs."

The Rockefeller Foundation also deserves mention for its Intercultural Film/Video Fellowship program begun in 1986. Its purpose was to "enable film and video artists of unique vision to undertake projects that interpret diverse cultures," according to a report from the Whitney Museum's New American Film and Video Series project.[5] Recipients are those whose media works "move beyond conventional formats to extend our understanding and representations of cultures."

Television. Public television received the largest share of media arts dollars throughout the decade, although as a proportion of total arts allocations, TV dipped from 5.6 percent in 1983 to 3.8 percent in 1986, then went back up by 1989 to 5.4 percent (Table 5-3). In each year of the study, more than two out of every five media arts dollars went to television: 46 percent in 1983, 44 percent in 1986, and again 46 percent during the last year (Figure 5-7).

Much of the funding for television, furthermore, was made in the form of large gifts, ranging from $250,000 to almost $2 million. Examples in 1989 included:

- $1.86 million from the John D. and Catherine T. MacArthur Foundation to the Educational Broadcasting Corporation for production of Bill Moyers' "World of Ideas";

- $965,000 from Johnson & Johnson Family of Companies Contributions Fund to WGBH Educational Foundation, Boston;

- $900,000 from the Chicago Community Trust to WTTW, for a program entitled "Focusing the Power of Television on Chicago's Community Issues." (This single grant was largely responsi-

ble for the jump in community foundation support for public television at the end of the decade);

- $500,000 from the Hall Family Foundations to Kansas City Public Television, to upgrade equipment;

- $250,000 from the Ahmanson Foundation to KCET Community Television of Southern California for replacement of obsolete equipment and other capital improvements.

Publishing/Journalism. Publishing and journalism received the second largest share of primary media arts grants throughout the decade (Figure 5-7). In 1983, this subfield accounted for almost a quarter of the media funds ($6.8 million). By mid-decade, that share had dropped to less than a fifth, but it moved up to almost 27 percent by 1989. Again, however, publishing and journalism accounted for a very small percentage of all arts grants, alternating from 2.9 percent in 1983, to 1.5 percent in 1986, to 3.1 percent at the end of the study period (Table 5-3). By number of grants, journalism and publishing captured between 2 and 2.5 percent of all arts grants.

Several of the largest journalism grants are mentioned above, especially those made by the Knight Foundation. Knight's exceptionally large gifts to endow journalism fellowships in 1989 are reflected in the jump in support for that discipline revealed in the data tables. Other notable funders of journalism and publishing in 1989 included MacArthur, Sloan, the Times Mirror Company, Scripps Howard, and the New York Times Company foundations.

GRANTS TO MULTIDISCIPLINARY ARTS: SHARE GREW THROUGHOUT DECADE

Multidisciplinary arts, as its name implies, incorporates more than one of the other arts disciplines. Grants so labeled fund programs that produce, promote, or otherwise offer access to a broad range of arts experiences, from visual to media to performing. Recipients of such grants include ethnic and folk arts centers, schools, universities, community arts programs, arts festivals, arts councils— even institutions in other fields such as theaters or museums that present programs featuring several disciplines.

In all three years of the study period, multidisciplinary arts programs ranked fourth, after performing arts, museums, and media, in terms of the allocation of arts dollars. However, their share of support improved slightly during the decade, rising from 6.7 percent to 7.6 percent of all arts dollars (Table 5-3).

Within the category, multidisciplinary arts education claimed nearly one-half of the dollars during the first two years of the study, but that share dropped to about a quarter at the end (Figure 5-8). By comparison, arts centers obtained less than a third of the dollars in 1983, but by 1989, that share had jumped to 40 percent.

Ethnic arts programs, which represent only a tiny share of funding, also increased their share of dollars over the study period.

By numbers, multidisciplinary programs consistently claimed one out of ten arts grants, with one-third each to arts education and arts centers, and the remaining third to all other programs.

Community foundations far outspent independents and corporates for the field (Table 5-2), consistently allocating around 12 percent of their arts grants (more than half of that given to arts centers). Independents' allocations ranged from 6 to 7 percent, with around half of that for arts education. Corporate foundations increased their share of spending for multidisciplinary programs from 6 percent in 1983 to 8 percent in 1989.

Few grants above $1 million were made for multidisciplinary programs. An example of a large grant in 1986 included $1.04 million to the Polish Institute of Arts and Sciences of America by the Alfred Jurzykowski Foundation for purchase of a building to house the organization. In 1989, large multidisciplinary arts grants included:

- $1.44 million to the Minnetrista Cultural Foundation from the Ball Brothers Foundation, for capital acquisition;

- $1 million from the Timken Foundation of Canton, Ohio, to the Lincoln Cultural Development Center to renovate and equip a building; and

- $700,000 from the James Irvine Foundation to the California Institute of the Arts, for intercultural projects, scholarships, and other purposes.

FIGURE 5-8. MULTIDISCIPLINARY ARTS, GIVING TO
SUBCATEGORIES

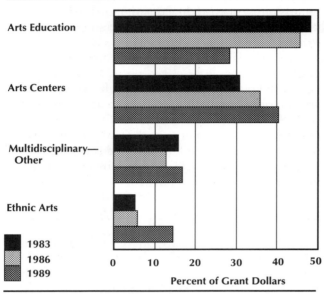

Source: The Foundation Center, 1992.

Two areas of special interest in the multidisciplinary category include arts education and ethnic arts.

ARTS EDUCATION FUNDING GREW

Arts education has traditionally been treated merely as one subject among many, separate from—and usually less important than—reading, writing, math, science or history.

But as educators, public officials, and business leaders began to acknowledge the deteriorating state of American schooling during the 1980s, especially in the face of fierce economic and technological competition from other countries, observers took a renewed look at the function of the arts as an educational tool in its own right.

Citing a number of studies, for example, the Business Committee for the Arts concluded that arts in education enhances students' ability to improve their skills in verbal and nonverbal communication, conceptualization, problem-solving, and comprehension and appreciation of other cultures; arts in the classroom (and beyond) enhances pupils' capacity to enjoy the arts themselves (thereby "insuring future audiences"). These improvements, further, are as pronounced among students from poor

neighborhoods as they are among those from more affluent areas. [6]

Multidisciplinary Arts Education. In terms of total giving to the arts, arts education—as a primary subject only—*appeared* to command a small 3.3 percent in 1983, and even less—2.3 percent—by the end of the decade (Figure 5-3). However, because of definitional limitations, these findings greatly understate the larger arts education or arts-in-education field, which obviously cuts across many subject areas represented in this study.

As defined by the national classification system used to code grants for this study, multidisciplinary arts education includes only those schools and programs that promote education "in a wide variety of artistic disciplines," such as the Institute for Fine Arts at New York University, the California Institute of the Arts in Valencia, or the San Antonio Arts Institute.

A Broader View of Arts and Education. Excluded from the amounts shown in Table 5-3 were grants for performing arts training (captured under Performing Arts), visual arts schools, and a broad range of arts in education programs reflecting single disciplines, such as music education. In the latter case, for example, a grant would be assigned a primary "music" code, and a secondary "arts education" code.

If all of these disparately coded grants from the sample were drawn together, how did foundation funding of arts in education—taken in its broadest sense—fare during the 1980s?

It grew, but only because of arts projects in which education was a subsidiary purpose. As noted above, primary grants for multidisciplinary arts education, amounting to $10.8 million in 1989, did not grow as a proportion of all funding; they actually dropped to 2.3 percent. Similarly, grants for performing arts training, which reached $8.6 million at the end of the decade, had declined as a percentage of all grants, from 2.3 percent to 1.7 percent.

Even adding in data from performing arts schools is insufficient to show the true picture of the arts/education overlap, for they reflect only grants in which the *primary* purpose was arts education or training. In reality, many grants are used for purposes in which education is subsidiary, but no less educational.

Examples are numerous, and pertain to virtually all the other arts disciplines: a visual arts workshop receives a grant to display the works of major photographers, and to train public school students in the techniques of taking pictures. A museum obtains a gift to stage a traveling exhibition which will visit high schools throughout the country. An orchestra receives support for its concert season, including a series of programs for young people. In each case, the grant would be defined primarily as a visual arts, or museum, or orchestra grant; however, all three support education in the arts.

In 1989, those grants with a subsidiary purpose of arts or performing arts education totaled $30.4 million, up from just $3.6 million in 1983 and $11.4 million in 1986. Subsidiary arts education grants grew far more rapidly than primary grants during the study years. In fact, by 1989 they far exceeded primary arts grants in total dollars: $30.4 million vs. $19.4 million.

When primary and subsidiary grants are combined, the total disbursements for arts education reached $49.8 million in the final year of the study, compared with $16.7 million in 1983 and $26.9 million in 1986. *More revealing, as a percentage of all arts grants, the combined arts and education categories grew from 7 percent in 1983, to 8.3 percent in 1986, and then to 9.9 percent in 1989.*

Given the strong interest in arts education voiced by grantmakers in the 1992 survey (see Chapter 8), there is good reason to believe that the trend towards increased funding will continue into the 1990s. (For recent commentary by grantmakers and scholars on the relationship between arts and education, see Chapter 8.)

One grantmaker that has advocated nationally for the arts in education is the J. Paul Getty Trust.[7] Other funders with an interest in the field include the Pew Charitable Trusts, and the Aaron Diamond, the Rockefeller, the Geraldine R. Dodge, and the David and Lucile Packard foundations.

Arts and Children. As the examples above reveal, arts in education has mostly to do with young people. Thus another perspective on the interaction between arts and education emerges from the data on all arts grants—from childrens' museums to Sesame Street—that were geared towards children. While not all such programs were specifically designed as a method of formal education or schooling, it is reasonable to assume that most arts programs for young people were intended to involve them in a learning process they might not otherwise experience.

In 1983, arts grants designating children or youth as the beneficiaries accounted for $10.3 million, or 4.3 percent of all grant dollars that year, and one out of 12 grants. The proportion rose to 5.3 percent in 1986 ($18 million), while the share of number of grants stayed the same. In 1989, when the size of the foundation sample increased the share of dollars dropped to 4.2 percent ($21.1 million), and only one in 14 grants was so designated.

ETHNIC ARTS GREW SLIGHTLY

As another component of the multidisciplinary arts "field," ethnic arts comprise programs that foster artistic expression—visual, performing, or otherwise—within specific ethnic, racial, or cultural population groups. Programs that enhance public awareness of the creations endemic to specific cultures are also included in this category.

Foundation grants to ethnic arts grew by the end of the decade, but not significantly. In 1983 and 1986, these grants accounted for about one of 20 dollars awarded to the multidisciplinary field—but less than one half of 1 percent to arts grants overall. (Figure 5-8 and Table 5-3). By 1989, ethnic arts commanded about one in seven multidisciplinary arts dollars, or about 1.1 percent of total foundation arts grants.

Ethnic arts grants represented in the multidisciplinary arts category exclude programs that embrace a single arts field, such as an African-American dance company, a Japanese design center, or a Latino theater group. Grants in this category also exclude ethnic art museums and ethnic history museums, discussed above under museum programs. As a result, data shown in Table 5-3 represent just one part of total funding for ethnic or multicultural programs.

In 1989, for example, a mere 1 percent of total arts dollars ($5.5 million) supported ethnic arts and cultural centers. However, another 1.4 percent of grant dollars ($6.8 million) went to ethnic museums. When combined, these figures still undercut the larger (yet still limited) dimensions of ethnic arts funding.

A more complete view emerges when analyzing all arts grants by their beneficiary groups. These data show that in 1989, a total of $18.6 million, or 3.7 percent of arts funds, went to ethnic or racial minority arts groups or programs. That compared with 3.3 percent of arts dollars in 1986 ($10.8 million), and 2.3 percent in 1983 ($5.4 million). The share of number of grants also increased during the decade, from one in 29 in 1993 to one in 18 in 1989.

Some of the largest ethnic arts grants awarded in 1989 went to the Asian Cultural Council, the Armenian Assembly of America, the Cultural Center for American Jewish Life, Indiana Black Expo, Puerto Rico Traveling Theater Company, and San Diego's Russian Arts Festival.

GRANTS TO ARTS-RELATED HUMANITIES

The humanities pertain to the study or appreciation of a variety of fields, some of which are directly related to the arts, such as art history, and some of which are not, such as philosophy, ethics and linguistics. For the purposes of this study, only the former are included: art history, archeology/ history, and literature, as well as humanities grants that are either not specified, or that deal with more than one arts-related subcategory; these appear under the term "general."

It should be emphasized that, in popular parlance, the humanities are as much a subset of education as of arts and culture. Consequently, many programs that scholars deem within the humanities are never defined as such by the foundations that fund them. Since it is virtually impossible to extract all the true "humanities" grants from gifts to the broad field of education, the tables below necessarily present an incomplete picture. Nevertheless, the trends implicit in the data are valid portrayals of those arts-related humanities grants that were explicit enough to be so classified by the Foundation Center.

SUPPORT STRONGEST FOR BROAD HUMANITIES PROGRAMS

The share of arts funding allocated to the humanities increased very slightly during the study period,

ETHNIC ARTS IN AMERICA

Ethnic arts as a field gained prominence during the 1960s and 1970s, accompanying the movements for political and economic parity among American blacks, Hispanics, Native Americans, and other ethnic minorities, and among women. A cornerstone of those movements was the argument that the artistic heritage of people of color and other minorities had been devalued, if not ignored, by white, male-controlled cultural institutions that traced their origins primarily to Western Europe.

By the start of the 1990s, ethnic arts and "multiculturalism" had emerged as subjects of controversy, matching if not surpassing in intensity the debate over the censorship/obscenity issue. Among art critics, multiculturalism was both championed and condemned. Not coincidentally, their debate accompanied heated frays over changes in academic curricula to accord non-European heritage and values a position equal in stature to those of Europe.

The overall vigor of the debate may have much to do with changing American demographics. The rapid growth of many non-European "cultural communities" may negate "the idea that we can still melt them into a single cohesive, yet American, entity," notes Robert Garfias, an anthropologist and member of the National Council on the Arts.[8]

He argues that America's cultural elitism—and its failure to adequately represent non-European arts and humanities—may ironically encourage the growth of multiculturalism. Noting that a general lack of acceptance by white communities makes many non-European immigrants and other minorities hesitate to leave their neighborhoods, Garfias write our nation's "concert halls, museums and libraries represent...for these...newcomers the same hostility and unwelcomeness they experience when they venture out" of their geographic neighborhoods.

Elimination of the "cultural myopia" of the American mainstream, he concludes, will only occur when "individuals who can serve as spokespeople for the different cultures are seated around the [arts institutions'] tables when decisions are being made."

from 5.2 percent at the start to 5.7 percent at the end (Table 5-3). In mid-decade, however, it had reached higher, 6.8 percent.

Most of the funding in this category—more than one out of two dollars by 1989—went to broad humanities programs, or to projects that did not indicate a particular focus (Figure 5-9). As a portion of total arts giving, these grants rose from 2.3 percent in 1983 to 3 percent in 1989.

Programs dealing with archeology and history (apart from art history) received the largest number of humanities grants each year, and the second largest share of dollars, between one-third and one-fourth.

Literature funding peaked in 1986 both in dollar share and by number of grants. Art history received the smallest share of arts-related humanities dollars and the lowest number of grants each year.

Very few foundations that funded in the arts were active in the humanities. For example, in 1989, out of 596 foundations in the sample, only nine made even one grant in art history, 68 awarded a grant in history or archeology, and 59 made a general humanities grant (the same grantmakers may be represented in multiple categories).

Most humanities funders were independent foundations, which in 1986 distributed fully $19 million of the $22 million to the field that year, or nearly 8 percent of their total arts dollars. Community foundations also gave their highest share of arts dollars to the humanities in 1986, just 2.5 percent, most of it for history. Corporates gave over 4 percent of arts funding to the humanities in 1983; by the end of the era, that share had dropped to just 1 percent.

Role of Andrew W. Mellon Foundation. The top-ranked funder in the humanities throughout the study period was the Andrew W. Mellon Foundation. Mellon gave a third of its total authorizations in 1989 to the arts, culture, and humanities, or some $24 million out of nearly $72 million. (The proportion in 1986 was almost 26 percent, and in 1983 more than 38 percent.)

Mellon's contributions to the humanities in those years accounted for a significant share of all foundation support. Many of Mellon's grants of $250,000 or over funded either clearly defined humanities projects, or museum programs akin to the humanities, such as research and scholarly cata-

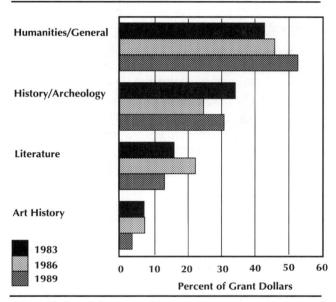

FIGURE 5-9. ARTS-RELATED HUMANITIES, GIVING TO SUBCATEGORIES

Source: The Foundation Center, 1992.

logs relating to permanent art collections.

Examples of major Mellon Foundation grants to the humanities during the study period included: $750,000 to the Humanities Council of New York for its endowment and research programs, 1983; $2.78 million to Woodrow Wilson National Fellowship Foundation (Princeton University) to fund the Mellon Fellowships in the Humanities, 1986; $750,000 to the Committee on Institutional Cooperation at the University of Illinois, for minority fellowships in the humanities, 1986; $1.25 million to the Founding Fathers Papers in Princeton, New Jersey, to cover editorial costs, 1989; and $400,000 to Literary Classics of the United States to place volumes of the Library of America series in public libraries throughout the United States, 1989.

Large Humanities Grants. Examples of other large grants for the humanities included:

* $600,000 from the Pew Charitable Trusts to the American Council of Learned Societies, for an emergency bridge grant, 1986;

* $578,887 from the Getty Grant Program to the Woodrow Wilson National Fellowship Program, for art history fellowships, 1986. (Getty is one of

only a handful of grantmakers interested in art history and is by far the largest funder. Kress and Ahmanson have also made grants in this field);

- $600,000 from the W. M. Keck Foundation to Mills College in Oakland, CA, to endow professorships in creative writing, 1989;

- $300,000 from the Knight Foundation to the University of Florida and the Florida Museum of Natural History, to endow professorships in Florida archeology, 1989; and

- $250,000 from the Ahmanson Foundation to the Center for Medieval and Renaissance Studies at the University of California, Los Angeles, for fellowships in the Italian Renaissance, 1989.

This category includes grants to historic preservation, historic societies, centennials, war memorials, and genealogy. During the study period, it accounted for between 4 and 5 percent of arts dollars each year. By number of grants, the share for historical activities was slightly higher, ranging up to 6 percent (Table 5-3).

In 1989, all types of foundations gave about equal shares of funding to historical activities, although that was not the case in earlier years. Undoubtedly, a few large grants accounted for this change in funding patterns.

Historic Preservation Share Declines. Historic preservation clearly accounted for the lion's share of funding in this category throughout the study period, but the ratio declined steadily, from more than nine in ten dollars at the start to seven in ten at the end. The same proportions held for the number of grants to preservation.

The shift, most of which benefited centennials and commemorations (subsumed under "other" historic activities in Table 5-3), most likely reflected growing national attention to the country's Vietnam Veterans in 1986 and the bicentennial of the U.S. Constitution in 1989. Examples included a 1986 grant of $250,000 from the Meadows Foundation to the Vietnam Veterans Memorial Fund of Texas, and a 1989 grant of $250,000 from the RJR Nabisco Foundation to the Foundation for the Commemoration of the United States Constitution. No large grants (at least $250,000) for commemorations were distributed in 1983.

Examples of large gifts for historic preservation included:

- $1 million from the GM Foundation to Historic Flint Autoworld Foundation (now defunct), 1983;

- $750,000 from the Boettcher Foundation to the Colorado Historical Foundation, for completion of a Georgetown Loop Railway and Mining project, 1983;

- Two grants totaling $2.95 million to the Pittsburgh Trust for Cultural Resources, from the Howard Heinz Endowment and the Claude Worthington Benedum Foundation, 1986;

- $300,000 from the Lilly Endowment to the Crown Hills Heritage Foundation, to renovate a historic Indianapolis cemetery, 1986;

- $1.2 million from the Winthrop Rockefeller Trust to the Colonial Williamsburg Foundation, 1989; and

- $750,000 from the Joseph B. Whitehead Foundation to the Underground Festival Development Company, for a facility to house a multimedia exhibition of Atlanta's history and culture, 1989.

GRANTS TO OTHER ARTS FIELDS

The "Other" category refers primarily to grants given to organizations whose functions are not endemic to the arts alone, but are common to all fields, from education to the environment to human services. In the National Taxonomy, these functional classifications are referred to as "common codes."

Such organizations include, for example, professional associations, alliances, management and technical assistance providers, research and policy institutes, fundraising coalitions, information and referral programs, and accreditation or regulatory bodies.

The core activities of these umbrella groups, whose members stretch across all arts disciplines, are often identical to activities nonprofits may provide for themselves, often by hiring staff. Fundraising is an apt example. This overlap of functions may confuse readers unfamiliar with the rules of indexing.

For example, the "subject" of a grant to a dance company to hire a professional fundraiser is "dance"; fundraising—that is, how the dollars will be used—in

this case is judged to be a "type of support." On the other hand, the subject of a grant to an arts fundraising coalition for startup costs is "arts fundraising"—not dance, theater, painting, or anything else—while the type of support is "program." Thus, what appears as the subject in some grants—those identified by common codes—may turn up as a type of support in others.

For the purposes of this report, the "Other" category, in addition to embracing umbrella organizations, also includes arts and humanities libraries and international cultural exchange programs.

Between 1983 and 1986, the share of grants to the "Other" arts category dropped by more than half, from 5.7 percent of all arts funding to 2.8 percent. It rose again by 1989 to 3.5 percent, but that was still almost 40 percent below what it had been at the start of the period. The sharp drop in dollar share, however, is not matched by the share of the number of grants. Throughout the study years, foundations gave around 4 percent of their grants to the "Other" category (Table 5-3).

Arts Fundraising and Management. Fluctuations in the data can be traced to fundraising and management, which in 1983 accounted for more than two-thirds of the money reported in the "Other" category ($9.7 million out of $13.9 million). In that year, the arts field witnessed the birth of a major new organization, the National Arts Stabilization Fund, the purpose of which was and remains to help performing and other arts organizations improve their financial health and sharpen their management skills. For more on NASF, see Chapter 6.

The Ford Foundation, which had developed the Fund as an in-house program, provided $7 million—more than half of its total arts grants in 1983—to spin NASF off as an independent unit. Joining Ford with startup funds were the Mellon Foundation ($1.5 million) and the Rockefeller Foundation ($500,000).

That $7 million Ford grant was unmatched in the fundraising/management or "other" field by any other foundation either in 1983 or in the two later years. Had Ford not made the grant, the share of total arts funding allocated to the "Other" category in 1983 would have been around 2.9 percent—not appreciably different from the ratios in 1986 and 1989.

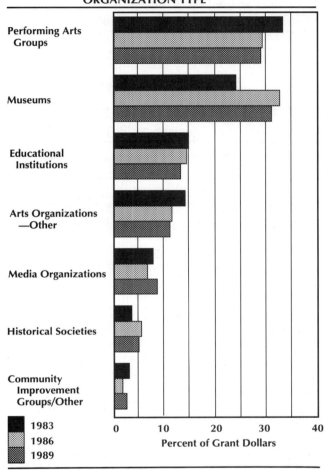

FIGURE 5-10. ARTS GRANT DOLLARS BY RECIPIENT ORGANIZATION TYPE*

Performing Arts Groups

Museums

Educational Institutions

Arts Organizations —Other

Media Organizations

Historical Societies

Community Improvement Groups/Other

■ 1983
▨ 1986
▨ 1989

Percent of Grant Dollars

Source: The Foundation Center, 1992.
*Excludes humanities organizations; they received 0.6 percent of funds in 1983, 0.9 percent in 1986, and 1.4 percent in 1989.

NASF itself continued to receive grants through-out the study period, although the amounts were far less. In 1986, the Hall Family Foundation awarded it $766,666—all earmarked for Kansas City arts groups. In 1989, Ford infused another $2 million into the Fund, which resulted in an overall increase in the fundraising category.

Donors to the Fund were all independent foundations. Corporate and community foundations showed little interest in fundraising organizations through mid-decade. By 1989, however, corporate foundations gave nearly 2 percent of their arts dollars ($1.5 million) to fundraising, while community foundations gave nearly 5 percent.

Arts Libraries, International Cultural Exchange. As a percentage of total arts funding, both libraries and international cultural exchange programs represented very tiny shares and very few grants. In 1989, 0.5 percent of arts dollars ($2.3 million) went to libraries, and 0.3 percent ($1.5 million) to international programs.

COLLEGES AND UNIVERSITIES RANK THIRD AMONG RECIPIENTS OF ARTS GRANTS

In each year of the study, foundations awarded between 13 and 15 percent of arts grant dollars to colleges, universities, and other educational institutions. Figure 5-10 shows that academic institutions ranked third after performing arts groups and museums as primary recipients of arts and culture grants. Performing arts groups ranked first in 1983, but were surpassed by museums as top recipients in both 1986 and 1989.

Grants to colleges and universities, as revealed in numerous sample grants throughout this analysis, generously supported arts centers; arts, humanities, and media departments; museums and theaters; arts scholarship programs; humanities and journalism fellowship programs; and professorships and endowed chairs.

Non-arts groups other than academic institutions received about 2 to 3 percent of arts dollars each year. Chief among these were community improvement organizations that sponsored arts festivals and public art, urban design, and preservation projects. Occasionally, municipalities were themselves recipients. An example in 1989 was the City of Charlotte, which received $3.15 million from the Foundation for the Carolinas to build the North Carolina Performing Arts Center.

ENDNOTES

1. Museum operating income in fiscal 1988 was about $3.6 billion, exclusive of zoos, aquariums, botanic gardens and nature centers, according to unpublished data from the American Association of Museums. Total income for all Arts, Culture and Humanities 501(c)(3) organizations at the same time was estimated at $7.26 billion by the National Center for Charitable Statistics (*Nonprofit Almanac 1992-93*, Page 167, Table 4.13).

2. Barbara Janowitz, "Theatre Facts 89," *American Theatre*, April 1990, Pages 34-43.

3. Don Adams and Arlene Goldbard, *The Bottom Line: Funding for Media Arts Organizations*, National Alliance of Media Arts Centers, 1991, New York, Pages 6, 16.

4. Adams and Goldbard, op. cit., Pages 25, 26.

5. Janet Sternburg, "Views from an Unstable Landscape," *New American Film and Video Series*, Whitney Museum of Modern Art #64, April 15-May 10, 1992.

6. *Why Business Should Support the Arts: Facts, Figures and Philosophy*, Business Committee for the Arts, 1990, New York, Page 5.

7. *Beyond Creating: The Place of Art in America's Schools*, J. Paul Getty Trust, 1985; also Harold Williams, *The Language of Civilization: The Vital Role of Arts in Education*, President's Committee on the Arts and Humanities, 1991, Washington, D.C.

8. Robert Garfias, "Cultural Diversity and the Arts in America," in Stephen Benedict (ed.), *Public Money and the Muse*, W.W. Norton Company, 1991, New York, Page 185.

6

Types of Support: The Purposes of Arts Grants

SUPPORT FOR CAPITAL AND OPERATING EXPENSES DROPPED, AS FUNDS FOR ARTS PROGRAMMING GREW

Foundation grants are classified by four major and three minor types of support, or grant purposes. Major support types include capital, program, operating, and professional development. Lesser types of support include research, emergency grants, and technical assistance. Grants for which the purpose is not known are coded "unspecified." Occasionally, grants are awarded for multiple purposes and are therefore coded twice or more. Hence, percentage totals in the tables and figures do not add up to 100 percent. For definitions of Types of Support, see Appendix B.

Of the four broad purposes for which grants were awarded to the arts during the 1980s, capital support—used mainly for buildings, endowments, and capital campaigns— received the largest share of funds during the first half of the decade, but fell to second place behind program support at the end (Table 6-1 and Figure 6-1). Funding for operating support, high at the start of the era, declined steadily and steeply. (To a small extent, capital grants may indirectly subsidize operating expenses. See discussion of "endowments" later in this chapter.)

In 1983, capital support had been funded by almost two out of every five arts dollars (38 percent); by 1989, that ratio dropped to fewer than one in three dollars (32 percent). As support for capital purposes declined, support for programming increased, from 29 percent to 34 percent.

Operating support, which encompasses both unrestricted funds to cover rent, salaries, and

FIGURE 6-1. MAJOR TYPES OF SUPPORT FOR THE ARTS*

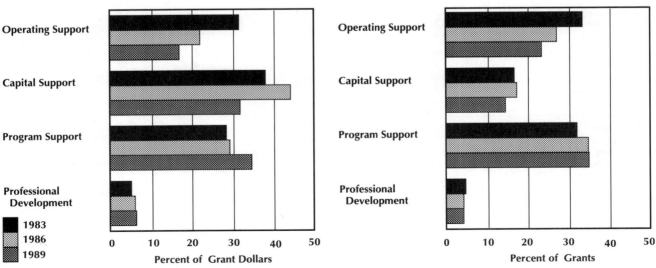

Source: The Foundation Center, 1992.
*Only types of support representing at least five percent of grant dollars in any of the three study years are included.

TABLE 6-1. TYPES OF SUPPORT AWARDED FOR THE ARTS*

Type of Support	Dollar Value of Grants						Number of Grants					
	1983		1986		1989		1983		1986		1989	
	Amount	%	Amount	%	Amount	%	Number	%	Number	%	Number	%
Operating Support	**$74,356**	**31.3**	**$70,467**	**21.9**	**$89,711**	**17.8**	**1,658**	**33.3**	**1,839**	**27.0**	**1,770**	**22.6**
Annual Campaigns	833	0.4	1,056	0.3	1,393	0.3	28	0.6	26	0.4	39	0.5
Unrestricted	48,448	20.4	51,413	16.0	64,786	12.9	1,266	25.4	1,346	19.8	1,232	15.7
Income Development	20,979	8.8	12,796	4.0	14,084	2.8	242	4.8	287	4.2	275	3.5
Management Development	4,096	1.7	5,202	1.6	9,448	1.9	122	2.5	180	2.7	224	2.9
Capital Support	**90,285**	**38.0**	**141,949**	**44.1**	**161,720**	**32.2**	**831**	**16.7**	**1,178**	**17.3**	**1,162**	**14.8**
Capital Campaigns	5,183	2.2	32,049	9.9	29,559	5.9	78	1.5	139	2.0	204	2.6
Building/Renovation	54,084	22.7	58,011	18.0	63,780	12.7	464	9.3	593	8.7	515	6.6
Equipment	4,855	2.0	6,921	2.1	11,945	2.4	113	2.2	168	2.5	156	2.0
Computer Systems	652	0.3	2,573	0.8	2,960	0.6	24	0.5	59	0.9	52	0.7
Land Acquisition	120	0.1	60	0.0	397	0.1	2	0.0	5	0.1	5	0.1
Endowments	15,731	6.6	24,835	7.7	38,880	7.7	95	1.9	131	1.9	160	2.0
Debt Reduction	1,613	0.7	4,542	1.4	3,914	0.8	10	0.2	20	0.3	25	0.3
Collections Acquisitions	8,047	3.4	13,008	4.0	10,285	2.0	45	0.9	63	0.9	45	0.6
Program Support	**67,909**	**28.5**	**93,032**	**28.9**	**169,897**	**33.8**	**1,585**	**31.8**	**2,362**	**34.7**	**2,736**	**34.9**
Program Development	24,163	10.2	29,218	9.1	86,074	17.1	642	12.9	897	13.2	1,508	19.2
Conferences	1,345	0.6	3,554	1.1	3,060	0.6	76	1.5	124	1.8	104	1.3
Faculty/Staff	3,657	1.5	4,419	1.4	2,403	0.5	33	0.7	52	0.8	28	0.4
Professorships	1,364	0.6	2,588	0.8	3,660	0.7	12	0.2	14	0.2	16	0.2
Film/Video/Radio	5,906	2.5	6,987	2.2	15,544	3.1	96	1.9	104	1.5	140	1.8
Publications	4,551	1.9	8,812	2.7	10,415	2.1	123	2.5	218	3.2	135	1.7
Seed Money	2,699	1.1	5,145	1.6	3,230	0.6	35	0.7	58	0.8	56	0.7
Curriculum Development	1,454	0.6	1,608	0.5	596	0.1	18	0.4	32	0.5	14	0.2
Performances	8,171	3.4	12,819	4.0	16,070	3.2	322	6.5	456	6.7	379	4.8
Exhibitions	7,462	3.1	6,801	2.1	13,206	2.6	115	2.3	198	2.9	168	2.1
Collections Management/Preservation	5,251	2.2	7,238	2.2	6,083	1.2	61	1.2	118	1.7	95	1.2
Commissioning New Works	1,886	0.8	3,843	1.2	9,556	1.9	54	1.1	91	1.3	93	1.2
Professional Development	**12,274**	**5.2**	**19,595**	**6.1**	**30,190**	**6.0**	**240**	**4.8**	**296**	**4.3**	**334**	**4.3**
Fellowships/Residencies	8,634	3.6	13,218	4.1	18,539	3.7	106	2.1	143	2.1	153	2.0
Internships	663	0.3	1,603	0.5	1,559	0.3	25	0.5	29	0.4	37	0.5
Scholarships	1,779	0.7	2,825	0.9	4,526	0.9	62	1.2	78	1.1	94	1.2
Awards/Services	600	0.3	1,674	0.5	4,026	0.8	33	0.7	37	0.5	39	0.5
Unspecified	598	0.3	275	0.1	1,540	0.3	14	0.3	9	0.1	11	0.1
Other	**6,897**	**2.9**	**6,283**	**2.6**	**12,915**	**2.6**	**114**	**2.3**	**118**	**1.7**	**111**	**1.4**
Research	6,019	2.5	5,003	1.6	9,729	1.9	84	1.7	77	1.1	84	1.1
Emergency funds	15	0.0	608	0.2	1,691	0.3	2	0.0	2	0.0	6	0.1
Technical aid	863	0.4	672	0.2	1,495	0.3	28	0.6	39	0.6	21	0.3
Unspecified	**27,374**	**11.5**	**38,662**	**12.0**	**130,041**	**25.9**	**964**	**19.3**	**1,563**	**23.0**	**2,558**	**32.6**
Qualifying≠												
Continuing	65,581	27.6	71,097	22.1	123,912	24.5	1,436	28.8	1,765	25.9	1,658	21.0
Matching	22,550	9.5	42,238	13.1	39,374	7.8	194	3.9	284	4.2	196	2.5

Source: The Foundation Center, 1992.
* Dollar figures in thousands. Grants may occasionally be for multiple types of support, i.e., a grant for new works and for an endowment, and would thus be counted twice.
≠ Qualifying types of support are tracked in addition to basic types of support, i.e., a challenge grant for construction, and are therefore represented separately.

administrative costs, as well as restricted grants to stabilize finances and improve management, received the second highest share at the start of the study period, but dropped to third place, behind program support, at mid-decade, and fell even further by 1989. As Table 6-1 reveals, the share of arts dollars allotted to operating support was reduced by almost half from start to end, from 31 percent of all arts grant dollars, to 18 percent.

Nor was the decline in operating support evident only in the share of grant dollars. The proportionate number of grants for operating support also dropped steeply throughout the 1980s, from a third of all arts grants in 1983, to 27 percent in 1986, and then down to well under a fourth by 1989.

The drop in operating support between 1986 and 1989 can be explained in part by changes in the foundation sample (it increased from 376 to 596 foundations) and the concurrent growth in "unspecified" grants. The additional grantmakers—many of which were large corporate foundations or independent foundations that grew larger in the 1980s—reported their grants only on 990-PF tax returns and did not provide a purpose statement for each grant. It may be assumed that at least some of these "unspecified" grants were intended for operating support.

But the increase in sample size offers only a partial explanation, since: (a) operating support declined most sharply between 1983 and 1986, prior to the change in sample; and (b) from 1986 to 1989, in spite of the sharp rise in "unspecified" grants, the proportion of program support grants *increased* dramatically. In other words, the change in the sample did not affect all types of support equally.

Finally, the loss of operating support was not limited to the arts funding world. According to trend data published in the 1992 edition of *Foundation Giving*, general or unrestricted support had declined across all nonprofit fields during the 1980s.[1]

OPERATING SUPPORT FAVORED BY COMMUNITY TRUSTS, CAPITAL GRANTS BY INDEPENDENTS

While each of the grantmaker types decreased its operating support funding during the 1980s, community foundations were far more likely than either independent or corporate foundations to award operating support in each of the study years (Figure 6-2). For example, in 1983, more than half of all community foundation arts dollars went for operating support, compared to less than a third from the independents, and slightly above a quarter from business foundations. Similar variances in types-of-support proportions were evident in the succeeding study years.

A caveat is in order. The portion of "unspecified" grants from company-sponsored foundations was extremely high—37 percent—in 1983, jumped to 46 percent in 1986, and with the expansion of the foundation sample in 1989, leaped to over 58 percent. The absence of important grants information from the business grantmakers renders comparisons fairly tentative.

In terms of capital support, given the data available, the independents appeared most likely to provide this type of funding through the mid-1980s. In fact, in 1986, independents gave out half their arts grant dollars for capital purposes, more than double the share spent by community foundations. But by 1989, community foundations had surpassed the independents in their respective shares of capital grants (41 percent vs. 36 percent).

For program support, the independents increased their share from start to finish, while the community foundations followed the opposite pattern. Independents provided about 29 percent of arts funds for programs in 1983; by 1989, the share so allocated was over 38 percent. By almost identical proportions, community foundations decreased their share of support for programs: from 41 percent at the start to 33 percent at the end.

The drop in the shares of both dollars and numbers of operating support grants undoubtedly left a gap deeply felt by the arts groups, and acknowledged by the funders: three years after the study period, in 1992, both grantmakers and grantees agreed that the most important need faced by arts organizations was funding of ongoing operations (see Chapter 8).

MEAN GRANT VARIED GREATLY BY SUPPORT TYPE, MEDIAN DID NOT

Because of some exceptionally large capital donations, the mean average grant for capital purposes tends to be far greater than the average operating and program grants. The mean capital support grant

in 1989 amounted to $139,200 compared with $50,700 for operating support and $62,100 for program support.

Among medians, however—a far more reliable measure of "typical" grants—the differences in size among types of support were barely noticeable. The median grant for capital purposes in 1989 was

$25,500, compared to $20,000 for operating grants and $25,000 for program grants.

The difference between the median and the mean can be explained by the unequal distribution of types of support among the largest grants (Figure 6-3). In 1989, for example, capital support claimed nearly half of all dollars represented by grants of

FIGURE 6-2. ARTS GRANTS BY MAJOR TYPES OF SUPPORT AND BY FOUNDATION TYPE*

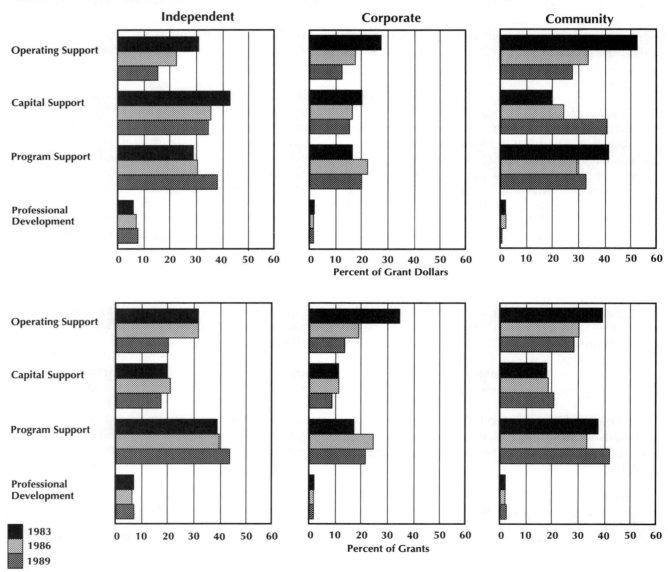

Source: The Foundation Center, 1992.
*Only types of support representing at least five percent of grant dollars in any of the three study years are included.

$250,000 or over, down from 69 percent in 1986; and two out of five grants in that range, down from nearly three out of five. Program support captured close to one-third of the dollars in that range and nearly two out of five grants. Operating support represented just 13 percent of dollars of the largest grants and about one in eight grants.

Among mid-sized and smaller grants, program support in 1989 far exceeded capital support (and also operating support) by share of both dollars and number of grants. Among the smallest grants—those up to $50,000—one in three grant dollars and one in three grants went for program support; one in five grant dollars and one in five grants for oper-

FIGURE 6-3. ARTS GRANTS BY MAJOR TYPES OF SUPPORT AND BY GRANT SIZE*

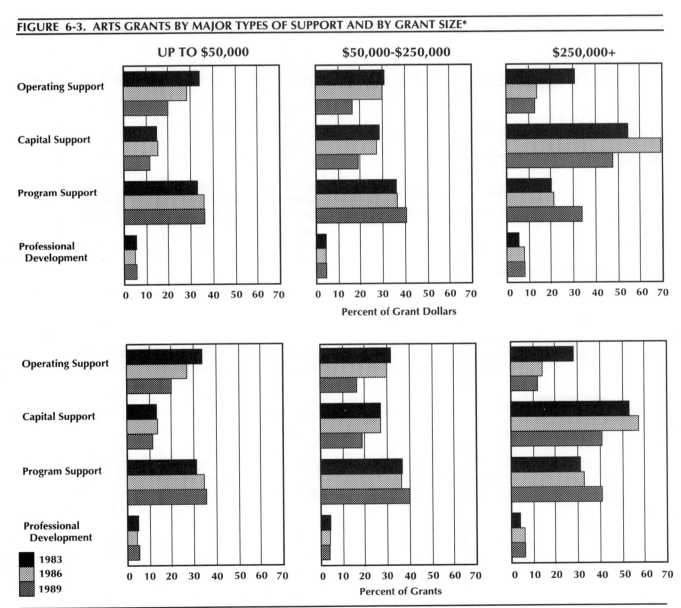

Source: The Foundation Center, 1992.
*Only types of support representing at least five percent of grant dollars in any of the three study years are included.

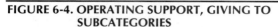

FIGURE 6-4. OPERATING SUPPORT, GIVING TO SUBCATEGORIES

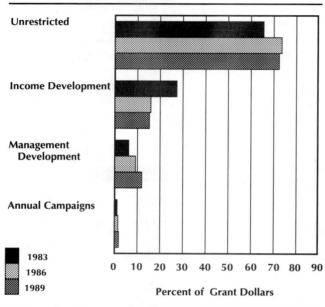

Source: The Foundation Center, 1992

ating support; and only one in ten dollars and one in ten grants for capital support.

OPERATING SUPPORT

As a category, general operating support comprises unrestricted support, which received the largest portion of funds each year; annual campaigns; and organizational stability—by which funders seek to broaden sources of income, expand audiences, and improve management skills of the organization.

While operating support as an overall category declined steeply during the study years—from a third to less than a fifth of all arts dollars—the impact on its most important subcategory, unrestricted operating, was less severe. As a percent of all arts dollars, unrestricted dropped from 20 percent to 13 percent (Table 6-1). By number of grants, its claim eroded from 25 percent to 16 percent.

As a percent of total operating grants dollars, however, unrestricted grants rose steeply. In each of the study years, unrestricted funding secured the lion's share of operating support dollars, starting at

two-thirds in 1983, and climbing steadily until it reached closer to three out of four such dollars by 1989 (Figure 6-4).

ARTS GROUPS' PROBLEMS SPUR PUBLIC AND PRIVATE SUPPORT FOR ORGANIZATIONAL STABILITY

By the early 1980s, operational support for arts groups had diversified beyond the two basic categories (unrestricted support and annual campaigns). More strategic funding goals emerged, aimed largely at boosting income and improving management. Included were grants to build fundraising capacity, develop audiences, improve marketing, boost ticket sales, develop a long-term fiscal plan, hire a manager, etc. Collectively, the purpose of such grants was to secure the future of arts organizations by stabilizing their operations.

What was the impetus for this new type of support? As the 1980s progressed, grantmakers confronted an arts world experiencing what one influential report later called "organizational dysfunction."[2] Its causes, the analysis held, included: a) overwhelming debt, itself part of a broader "debt culture" in America; b) an exodus of talented people from the arts into other fields, as maturing baby boomers sought higher paying and more secure jobs than most arts organizations could offer; and c) an incapacitating reliance by arts groups on overly regulated "conditions, environments, and market places."

Whatever the causes, the manifestations of dysfunction were tangible throughout the arts community. Many emerging arts groups found themselves barely able to survive and even mature arts institutions faced an uncertain future. As signs of distress mounted, the NEA responded with a series of funding programs, including its Advancement Program, aimed primarily at emerging and culturally diverse arts groups; its Locals Program, aimed at local arts agencies; and its Challenge II program, which between 1983 and 1989 awarded $131 million to foster organizational stability.

Private grantmakers—both national and local—also took steps to address the issue, in some cases prompted by the matching requirements of the government programs cited above. While data are not available for earlier years, those actions can be measured starting in 1983, a seminal year that saw the

creation of a new genre of private arts intervention embodied in the National Arts Stabilization Fund (NASF).

National Arts Stabilization Fund.

The Fund, described briefly in the preceding chapter, was spun off from the Ford Foundation with major grants from Ford, Rockefeller, and Mellon. From its donors, the new Fund received over $9.5 million in 1983 ($7 million from Ford alone) for the express purpose of helping the arts community, in partnership with cities and local funders, to strengthen its financial and management operations.

Due largely to this exceptional, one-time infusion of funds, grants for income and management development together accounted for 10.5 percent ($25 million out of $237.9 million) of all funding dollars in 1983 (Table 6-1) and one-third of all operating support funding (Figure 6-4). Those percentage shares dropped sharply in 1986—to 5.6 percent of all funds and one-quarter of operating support. They remained close to those levels in 1989.

Were the start-up Ford grant to be removed—and with it an additional $1.5 million from the Andrew W. Mellon Foundation and $500,000 from the Rockefeller Foundation—the combined income and management development category would have represented, in 1983, about one in five operating support dollars rather than the roughly one in three shown in the data. In effect, the removal of the Ford and accompanying grants reveal that no significant movement in this support category took place at least through 1986.

Further, had it not been for Ford's investment, and for the gifts to NASF from cooperating foundations, the broad category of "operating support" in 1983 would have accounted for about a fifth of all types of support funding—around the same as in 1986—rather than nearly a third.

Similarly, although grants for organizational stability, as a portion of total dollars, dropped steadily, the number of grants for the purpose, as a proportion of all grants, held steady through 1986 at around 7 percent and then dipped slightly (Table 6-1).

And as a share of operating support grants, the number actually climbed from 1983 to 1986. About one in five operating support grants were directed towards organizational stability at the start of the period; by 1986, the share rose to one in four grants.

In effect, at a time when unrestricted operating grants were losing ground, funds targeted to help arts groups achieve fiscal stability were increasingly favored.

NASF itself received the largest stabilization grant in 1986, $766,666, from the Hall Family Foundations (MO). But in this case, rather than provide overall support for the Fund, the grant was channeled to a local initiative: it supported a stabilization plan for six Kansas City arts institutions.

By 1989, despite changes in the *Grants Index* sample, organizational stability funding more or less held its own. Grants for income and management development amounted to about $23.5 million, or 4.7 percent of all funding dollars that year and nearly 7 percent of grants. As a portion of operating support, they equaled more than one-fourth of dollars and 30 percent of the grant number. Included in the $23.5 million was a $2 million supplementary grant to NASF from the Ford Foundation.

Other Stabilization Efforts.

Although the NASF's debut in 1983 marked a pronounced, dramatic effort to strengthen the operational capacity of America's arts organizations, it was not the first such effort, either by the Ford Foundation or other grantmakers. As far back as 1933, when the Juilliard Foundation (now defunct) offered funds to the Metropolitan Opera (in keeping with the terms of the donor's bequest), the foundation's officers required in return administrative reforms as well as membership on the Met's board of trustees.

And in the late 1960s and early 1970s, according to social historian Paul DiMaggio, the Ford Foundation gave tens of millions of dollars to resident and minority theaters, symphony orchestras, and other groups to "maintain new levels of artistic achievement and *financial stability*" (emphasis added).[3] (See Chapter 3.)

Examples of large grants to stabilize the operations of arts groups during the study period, beyond those made to the National Arts Stabilization Fund, included:

In 1983:

- $450,000 from the Eloise and Richard Webber Foundation (MI) to the Detroit Symphony Orchestra, for a marketing plan;

- $350,000 from the Lyndhurst Foundation (TN) to Allied Arts of Greater Chattanooga, to expand the base of arts support in the area;

- $350,000 and another $400,000 from the John and Mary R. Markle Foundation (NY) to the Media Commentary Council, to continue publication of *Channels Magazine*, increase circulation and advertising, and expand its coverage;

- $345,000 from the William Penn Foundation (PA) to the Afro-American Historical and Cultural Museum, in part to start up a development office, and also for collections management;

- $300,000 from the San Francisco Foundation to the San Francisco Opera, for marketing and development strategies.

In 1986:

- $600,000 from the Fred Meyer Trust (OR)—now the Meyer Memorial Trust—to the Portland Opera, to expand support from individuals and business;

- $500,000 from the James Irvine Foundation (CA) to the Music Center of Los Angeles County for an earned income program;

- $250,000 by the Andrew W. Mellon Foundation to the National Faculty of Humanities, Arts and Sciences to improve its base of support.

In 1989:

- $400,000 from ARCO Foundation to the Los Angeles Theater Center, for a financial stabilization campaign;

- $291,000 from the Lilly Endowment to the American Symphony Orchestra League, to increase the effectiveness of governing boards of American orchestras. (Awarded as part of Lilly's national effort to strengthen nonprofits, and not under its local community development/arts program;)

- $275,000 from the Ford Foundation to the Puerto Rican Traveling Theater, to expand its audience and increase income;

- $250,000 from the Meadows Foundation to the Dallas Theater Center, to help meet a National Endowment for the Arts challenge toward fiscal stability, and for Project Discovery.

Stabilization a Goal of Large and Smaller Funders Alike. Concern over the survival of arts groups was in no way limited to the largest funders or to large grants. Many smaller stabilization grants were made by mid-size arts funders during the study years. Some of them specified the purpose in detail, others merely indicated that the gifts were to be used for "administrative improvements" or managerial salaries. These grants were made either to arts groups directly or to local arts councils and area-wide arts funds.

Examples of smaller grants made directly to arts groups with very strategic goals included those made by the L. J. Skaggs and Mary C. Skaggs Foundation (CA) under its Dance Management Program and later under its Institutional Stabilization Program for the Performing Arts. In 1986, the Bay Area participants in the latter program—Tandy Beal and Company, Philharmonia Baroque Orchestra, and Pocket Opera—received a total of $158,000 for clearly defined purposes. The program continued into the last year of the study, when funding for three grantees for "long-range planning and organizational development" totaled $150,000. Beyond these named "stabilization" grants, Skaggs made a number of smaller grants to arts groups for fundraising, marketing, and long-range planning projects.

Additional examples of funding to strengthen management included in 1989 the William Penn Foundation's $95,625 grant to the Bushfire Theater of Performing Arts in part for "administrative staff," and the Rhode Island Foundation's $25,000 grant to Very Special Arts Rhode Island "for administrative support."

Examples of stabilization grants made to area-wide groups included a $125,000 grants by the Cigna Foundation (CT) to the Greater Hartford Arts Council in 1989 "for general management, marketing, and fundraising services to member arts groups"; and the Baltimore Community Foundation's grant of $100,000 to the Maryland Arts Stabilization Project to help that city's arts institutions "achieve high standards of financial management and secure long-term financial stability..."

The "organizational stability" grants summarized above were preventative, that is they were intended to strengthen arts organizations and keep them on track fiscally through improved management. In other cases, however, funders were called on to provide capital when organizations were already in crisis. Debt reduction, or deficit financing grants, are reported under "Capital Support." Emergency grants are reported under "Other."

Annual campaigns. Contributions to annual fundraising campaigns, conducted by organizations either throughout the year or in briefer, periodic time frames, accounted for the smallest portion of operating support grants—well under 2 percent each year.

But this tiny percentage may be misleading, because most staffed foundations, especially those with articulated program objectives, make grant decisions and renewals on an annual basis, and therefore are unlikely to report their grant as an annual campaign grant. Continuing operating support, provided by many local funders to preferred local institutions, may be given for three or four years, or may be renewed yearly. Prior to the restructuring or downsizing of many corporate foundations in the 1980s, they frequently gave to annual campaigns or for continuing operating support.

CAPITAL SUPPORT

Construction and renovation of buildings, and establishment or enhancement of endowments, are the two primary purposes for which capital support funds are granted. Other purposes include the purchase of equipment and land, acquisition of art objects especially for museums, and debt reduction. Funds donated in response to a capital fundraising campaign, which may ultimately be used for a mix of capital purposes, are designated capital campaigns.

BUILDING GRANTS
REMAINED HIGHEST, BUT SHARE DIPPED

During the 1980s, the largest share of capital support dollars for the arts paid for building construction or renovation (Figure 6-5). But the rate of growth of this type of support declined, from three out of every five capital dollars in 1983 ($54 million out of $90.3 million), to two out of five dollars in 1986 and 1989.

As a portion of all types of support, funds for buildings declined from about a fifth to an eighth during the study period (Table 6-1).

The share of the number of capital grants dedicated to buildings, also the highest, likewise declined, but less sharply, from slightly more than half of all capital grants (464 out of 831) at the start to slightly below half (515 out of 1,162) at the end.

As noted elsewhere in this report, many of the largest arts grants awarded throughout the study period funded buildings, especially theaters, performing arts centers, museums, and university fine arts or media facilities.

Funders providing large grants to capital projects during the study years included: Ahmanson, ARCO, Astor, Benedum, Boettcher, Bradley, Brown, Dayton Hudson, Dillon, Foundation for the Carolinas, Getty, Hewlett, Houston Endowment, Irvine, Keck, Kiewit, Krannert, Kresge, Lilly, McCune, Meadows, Mellon (Richard King), Meyer Memorial Trust, Murdock, Noble, Penn, Pew, Regenstein, Starr, Weingart, Whitehead, and Woodruff.

Very few of the above funders gave nationally. Exceptions were Kresge, the only funder giving exclusively for capital projects; ARCO, a corporate sponsor; and a handful of foundations supporting the Statue of Liberty/Ellis Island renovations and other national monuments.

Rather, most foundations favored capital arts projects in their own cities or states, helping to renovate cultural landmarks such as Carnegie Hall, the Shubert Theater, and the Guthrie Theater, or build new facilities such as the Orange County Performing Arts Center, the Menil Collection, the Museum of Contemporary Art (Los Angeles), the St. Louis Science Center, the Portland Performing Arts Center, and the Buffalo Bill Historical Center.

Several of the largest capital grants were cited earlier in the discussion of giving by arts fields and will not be repeated here. Exceptionally large grants—those among the top ten in each year of the study—are listed in Chapter 4, Table 4-7.

Capital Campaigns. The share of capital support dollars in the arts awarded in response to specific capital campaigns (most of them no doubt intended for building projects) grew significantly at first, from about one in 17 capital dollars to almost one in four by mid-decade; it then dropped down to about one

in five at the end (Figure 6-5). The proportionate number of capital grants given to campaigns also grew, from around one in 11 capital grants in 1983 to over one in six by decade's end.

As a percent of all arts grant dollars, capital campaigns jumped from just 2 percent in 1983 to 10 percent in 1986, and ended at 6 percent in 1989. Clearly, some (but not all) of the steep decline in share of dollars for building and renovation, noted above, represented no more than a transfer of dollars between categories of capital support.

Endowments. Although technically a form of capital support, endowment funds can be used to underwrite a variety of program and operating expenses. Professorships, fellowships, seminars, exhibitions, publications, and even research, as well as salaries and other administrative costs, can be financed by the income generated from endowments. As a result, some endowment grants are coded twice, e.g, endowed fellowships.

As a form of capital support, endowment gifts grew from about one in six capital grant dollars in 1983 to one in four by 1989 (Figure 6-5). The number of endowment grants, as a portion of capital donations, remained steady during the first part of the period at around one in nine capital grants, and then rose to one in seven such grants by the end.

On average, endowment grants tend to be larger than other capital grants. The mean endowment grant in 1989 was $243,000 compared with $123,800 for building/renovation, and with $139,200 for capital campaigns.

Debt Reduction. Despite hard times in the arts world, funding for debt reduction or deficit financing was limited throughout the study years. It rose slightly as a share of capital support in 1986, up to 3.2 percent, and then dropped back to 2.4 percent in 1989 (Figure 6-5).

Collections Acquisitions. Of the other types of capital support, the only noteworthy development during the 1980s was the declining share allocated for collections acquisitions, most of which went to museums, with a smaller amount to arts libraries. In 1983, the sampled foundations allocated one in 11 capital dollars for the purpose of acquiring art works; by 1989, that share had slipped to fewer than one in 43 capital dollars.

Data from other sources complement this finding. In 1990, member institutions of the American Association of Art Museums reported spending 4 percent less money on purchases of art objects than they had the year before, attributing the drop both to higher prices for the objects and to lower acquisition budgets.[4]

In 1983, the W. Alton Jones Foundation (VA) gave $1 million to the Walters Art Gallery in Baltimore to strengthen its collection through purchases of art. Also in that year the Mary Flagler Cary Charitable Trust (NY), which has an exclusive interest in music, gave $500,000 to the Pierpont Morgan Library for acquisition of musical manuscripts, to be added to the existing Cary Music Collection.

In each of the study years major grants were made by the Ahmanson Foundation (CA) to the Los Angeles County Museum of Art for the acquisition

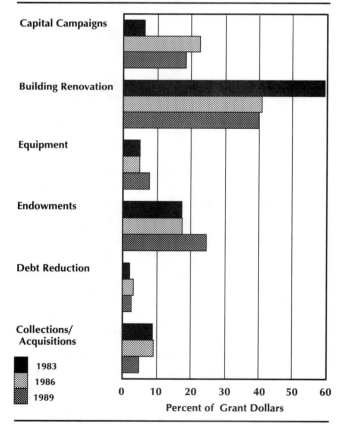

FIGURE 6-5. CAPITAL SUPPORT, GIVING TO SUBCATEGORIES

Percent of Grant Dollars

- 1983
- 1986
- 1989

Source: The Foundation Center, 1992.

of European paintings. In 1986, Ahmanson's grants for acquisitions (to various recipients) reached over $4.1 million, including three gifts to the Los Angeles art museum.

The largest single gift for acquisitions was also reported in 1986: $2.66 million from the Morris and Gwendolyn Cafritz Foundation (DC) to the National Gallery of Art to purchase a work of art. In the same year, the Anne Burnett and Charles D. Tandy Foundation (TX) gave nearly $1.1 million to the Fort Worth Art Museum for acquisitions, and the Getty Grant Program provided two large grants to art museums for library acquisitions.

In 1989, in addition to an Ahmanson Foundation gift of $1.85 million to the LA County Museum of Art, exceptionally large grants for acquisitions were made by the Cafritz Foundation to the National Gallery ($2.5 million), the Regenstein Foundation (IL) to the Art Institute of Chicago ($1.17 million), and Coral Reef Foundation (NY) to the Metropolitan Museum of Art ($880,000). Coral Reef and Regenstein had previously given generous support to these institutions for art purchases. Similarly, the Meadows Foundation (TX) gave ongoing grants for acquisitions to the Meadows Museum at Southern Methodist University in Dallas.

PROGRAM SUPPORT

STEADY GROWTH IN GRANT DOLLARS AND NUMBER

Grants to fund programs of arts organizations or arts departments—e.g., performances, exhibitions, publications, professorships, and collections management—or to develop new programs, grew steadily throughout the study period, from 29 percent of all grants at the start to nearly 34 percent at the end (Table 6-1). The number of program grants, as a share of all grants, also grew, from 32 percent in 1983 to 35 percent in 1989. (As noted earlier, program support grew substantially in spite of the greater proportion of grants coded "unspecified.")

Of the 12 specific types of programs tracked each year, the largest share of both dollars and number of grants was allocated to the general "program development" category (Figure 6-6). In part, this reflects that the description of many grants, as provided by the foundations in annual reports or grant lists, stipulated only the word "program."

But the lack of specificity in grant descriptions was not the only factor accounting for the overwhelming proportion of program grant dollars allocated to the general program development category. For that share had increased dramatically between 1986 and 1989, from about a third of all program grant dollars to one-half, no doubt reflecting giving trends associated with the expanded funder sample. (Funders added to the sample, especially corporate foundations and newly large independent funders, were less likely to award highly specialized program grants.)

A closer examination reveals that the concurrent loss of share was borne principally by collections management programs, such as those dealing with materials preservation, and to a lesser extent by performances, faculty and staff training, and seed money.

Performances' Share Drops. The share of program dollars allocated to specified performance costs increased by mid-decade, from one in eight (12.0 percent) to one in seven, and then fell to around one in ten by 1989 (Figure 6-6). As a portion of total arts grants, the performance category fared better: it rose from 3.4 percent to 4 percent, then dropped back to 3.2 percent.

It is important to remember that while these figures reflect the growth rate of performance grants, they understate the true proportions, which are buried within the program development category. *The program of a performing arts organization, above all, is its performances, and the performing arts collectively received the largest share of grant dollars in all three years of the study period.* (See Chapter 5, Table 5-3.)

For example, in 1989, the W. M. Keck Foundation awarded $400,000 to the American Music Theater Festival "for educational activities for children." In all likelihood, those activities included performances; statistically, however, the grant was recorded in the general programs category, since "activities" may also apply to planning, staffing, or development of instructional materials.

Examples of large grants to underwrite performances during the study period included:

- $575,745 from the Moody Foundation (TX) to the Lone Star Historical Drama Association, to

assist with the theater's performance season, 1983;

- $600,000 from the Pew Charitable Trusts (PA) to the Opera Company of Philadelphia, for telecast productions, 1986;

- $250,000 from the Morris and Gwendolyn Cafritz Foundation (DC) to the John F. Kennedy Center for the Performing Arts, to underwrite a visit of the Stuttgart Ballet, 1986;

- $250,000 from the Geraldine R. Dodge

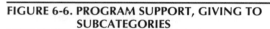

FIGURE 6-6. PROGRAM SUPPORT, GIVING TO SUBCATEGORIES

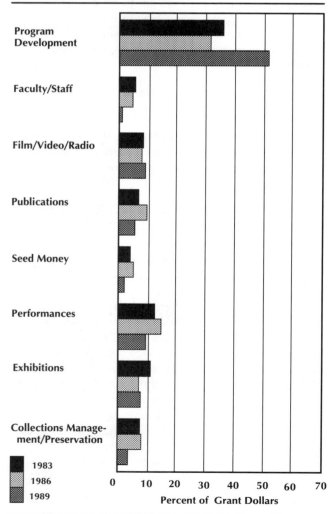

Source: The Foundation Center, 1992.

Foundation (NJ) to the Metropolitan Opera Association, for four free concerts in New Jersey parks, 1989;

- $300,000 from the Rockefeller Foundation (NY) to Dance Theatre Workshop for the "Suitcase Fund," a program of reciprocal touring by artists and performing arts companies in the United States and foreign countries, 1989;

- $250,000 from the Knight Foundation (OH) to the Miami City Ballet, as a challenge grant to build a world class production of the "Nutcracker," 1989. (The foundation has since relocated to Florida.)

Exhibitions. Grants dedicated to exhibitions of works of art fell slightly, as a share of all program funds, from 11 percent to 8 percent, from the start to the end of the period (Figure 6-6). However, as with performances, the data in the table reflect the trend of stated "exhibition" grants throughout the 1980s, but they understate the true share of funds directed towards exhibitions. The actual proportions, buried within the "program development" category, were presumably far higher, since museums or museum programs had received the second largest share of arts grants each year of the study period (see Chapter 5, Table 5-3).

Among the largest grants funding exhibitions during the study period were:

- $400,000 from the Vincent Astor Foundation (NY) to the Metropolitan Museum of Art, for the loan of an exhibition of paintings, furniture, and other objects from the private collection of the Prince of Lichtenstein, 1983;

- $275,000 from the Pew Charitable Trusts (PA) to the Brandywine Conservancy in part to fund two exhibitions, and also for the acquisition of Andrew Wyeth's *Raccoon*, 1983;

- $750,000 from the Lilly Endowment (IN) to the Indianapolis Museum of Art, for the "Son of Heaven" exhibit, 1986;

- $500,000 from the James Irvine Foundation (CA) to the California Academy of Sciences, for construction of the "Wild California" exhibit, 1986;

- $1 million from the Regenstein Foundation (IL) to the Field Museum of Natural History in Chicago, for exhibits, 1989;

- $900,000 from the Richard King Mellon Foundation (PA) to the National Gallery of Art, for "Matisse in Morocco," 1989;

- $321,000 from the Peter Kiewit Foundation (NB) to the Omaha Children's Museum, for a "Dinamation" exhibit, 1989;

- $300,000 from the M. J. Murdock Charitable Trust (WA) to the Middle Oregon Indian Historical Society, for various exhibits on tribal culture, 1989.

Collections Management. One component of program support, usually pertaining to museums and galleries, but applicable as well in the fields of historic preservation and libraries, is management of collections. This includes both cataloging (sometimes in preparation for a publication to accompany an exhibit), and preserving or conserving various materials in the collections.

As illustrated in Figure 6-6, the share of program dollars for this purpose fell steeply during the study period, from one in 13 dollars to one in 28, from beginning to end. The number of collections management grants, as a share of program grants, had also grown at first, but it too fell back after 1986.

As a portion of total arts grant dollars, collections management dropped from 2 percent to 1.2 percent from start to finish of the study period (Table 6-1).

Much of the funding for conservation and preservation of materials came from a handful of foundations, chief among them the Andrew W. Mellon Foundation. Examples of Mellon's grants included:

- $270,000 in 1983 and $285,000 in 1986 to the Intermuseum Conservation Association, for an advanced program in conservation and related activities;

- $750,000 to the American Museum of Natural History, to develop a conservation program for anthropological collections, 1986;

- Two grants of $285,000 each to Harvard University's Fogg Museum-Center for Conservation and Technical Studies, for advanced level conservation training programs, 1986.

The J. Paul Getty Trust, an operating foundation, administers a national program in art conservation, and, since 1984, has awarded grants in the field. In 1989, for example, the Getty Grant Program gave $270,000 to the National Institute for Conservation of Cultural Property, for an inventory and conservation assessment of American sculpture.

Large grants by other foundations for collections management or preservation included, in 1983, $1 million from the Starr Foundation (NY) to the Metropolitan Museum of Art, to establish an endowment fund for Far Eastern art conservation training; and in 1989, $300,000 from the Henry Luce Foundation (NY) to the New Museum of Contemporary Art, for a catalog to accompany its exhibition, "The Decade Show."

Examples of smaller grants for collections management in 1989 included:

- $113,000 from the Ford Foundation to the Government of Senegal, in part to improve the use of computers in cataloging and managing art collections;

- $28,565 from the William Penn Foundation to the Philadelphia Maritime Museum, to conserve and catalog its collections.

Presenting or commissioning new works. Funding to create or commission new work never rose above 2 percent of all arts grant dollars (Table 6-1), although it grew steadily through the 1980s. As a share of program support, it rose from 2.8 percent to 5.6 percent. (To an extent, funding for new works is an indirect form of support for performances and exhibitions, since newly created works are ultimately performed or exhibited.)

Despite enhanced grants coding to better track funding of this aspect of arts programming, the data may reflect undercounting due to the lack of specificity provided by foundations regarding the purposes of their program grants.

Nonetheless, by the end of the study years, grantmakers such as the Lila Wallace-Reader's Digest Fund had announced a special commitment to fund new works. They joined the Ford Foundation, Jerome Foundation, and others that had backed experimental works earlier in the decade. Examples

of grants for this purpose throughout the study years included:

- $300,000 in 1983 and $500,000 in 1986 from the Ford Foundation to the Brooklyn Academy of Music, for the Next Wave Festival Production and Touring Fund. (The festival presents new works;)

- $260,000 from the San Francisco Foundation to Antenna Theater, to support original productions, 1986;

- $700,000 from the Marin Community Foundation to the Marin Arts Council, "for services that help artists create new works," 1989;

- $250,000 from the Ford Foundation to the Tisch School of the Arts, for a music theater program under which young writers and composers work with professionals to create new work, 1989;

- $105,000 from the Jerome Foundation to the Minnesota Composers Forum's commissioning project, 1989;

- $100,000 from the Lila Wallace Fund to the University of California, for the creation of a new dance piece by choreographer Bill T. Jones, and for related efforts, 1989.

PROFESSIONAL DEVELOPMENT

Professional development includes grants only to institutions for student aid, professional training, and awards and prizes. A limited number of arts grantmakers do provide grants directly to individuals, but these grants are not represented in the sampled database. (See box on grants to individual artists.) Nevertheless, an exploration of professional development funding can provide a window on the extent to which certain grants to organizations are, in effect, recycled to individuals, often through regranting mechanisms. These may include, in addition to those mentioned above, grants for artists' housing and work space, internships, fellowships, scholarships, and residencies.

Support for professional development inched up over the study years, from 5.2 percent of all arts dollars in 1983, to 6.1 percent in 1986, and stayed at that level in 1989 (Table 6-1). The share of number of arts grants ranged from 4 to 5 percent.

Within the category of professional development, fellowships commanded the lion's share of grant dollars in each of the three study years, but that share dropped from over 70 percent to 61 percent (Figure 6-7).

Scholarship funds to art institutes and performing arts schools commanded 14 to 15 percent of professional development dollars.

By 1989, awards, prizes, competition support, and individual artists' services captured one in seven professional development grant dollars, up from only one in 20 in 1983. As a percentage of all arts grants, however, this category represented less than 1 percent of total dollars at decade's end (Table 6-1).

Fellowships. Throughout the study years, the Andrew W. Mellon Foundation supported scholarship in the humanities, and to a lesser extent in arts conservation, through its fellowship programs. Other grantmakers, especially the Knight Foundation, funded journalism fellowships at universities.

Examples of large fellowship and scholarship grants from Mellon, Knight, and other funders included:

- $297,000 from the Mellon Foundation to the Research Foundation of the State University of New York, for stipends for students in the Program for the Conservation of Historic and Artistic Work, 1983;

- $3.08 million from the Knight Foundation to Stanford University, for journalism fellowships, 1983;

- $816,100 from the W. K. Kellogg Foundation to the Smithsonian Institution, to establish a national fellowship and internship program for museum curators and board members, 1986. (Kellogg's total assistance for this project came to $1.73 million;)

- $500,000 and $250,000 from the Ahmanson Foundation to California Institute of the Arts, for scholarship support, 1986;

- $578,887 from the Getty Grant Program to the Woodrow Wilson National Fellowship Foundation, for art history fellowships, 1986;

FIGURE 6-7. PROFESSIONAL DEVELOPMENT, GIVING TO SUBCATEGORIES

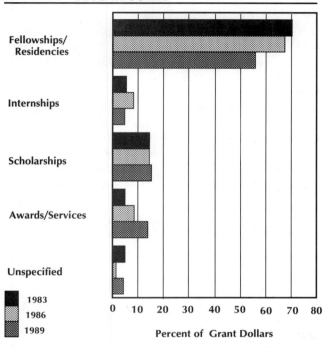

Source: The Foundation Center, 1992.

- $5 million from the Mellon Foundation to the Woodrow Wilson National Fellowship Foundation, for humanities fellowships, 1989;

- $700,000 from the James Irvine Foundation to the California Institute of the Arts for minority and general scholarships, for a Visiting Artists Program, and for other purposes, 1989.

Awards and Prizes. Grants for awards, prizes, and competitions tended to be smaller than fellowship grants. Examples included: $5,000 from the Grand Metropolitan Food Sector Foundation (MN) to the Mid-Columbia Symphony Foundation to sponsor a young artist competition for local youth, 1983; $15,000 from the MacArthur Foundation to UCVideo to convert an existing artist access awards program from a partial to a full grant basis, 1986; and $25,000 from the Morgan Guaranty Charitable Trust to the Dance Theatre Workshop for dance and performance awards, 1989.

PROGRAMMATIC GRANTS ALSO SUPPORT INDIVIDUALS

Institutional funding that benefits individual artists is broader than what is revealed through professional development grants alone. To gain a fuller perspective on the individual in arts funding, it is necessary to look across categories to programmatic or disciplinary support. For example, program grants earmarked for the commissioning of new works—whether to a theater company, dance company, or music ensemble—provide crucial funds to individual artists. As shown in Table 6-1, funding for presenting or commissioning new works grew steadily in the 1980s, reaching 2 percent of arts grant dollars in 1989 ($9.6 million).

Similarly, grants for choreography, playwriting, and music composition, although awarded to arts groups, may be construed as indirect support for individual artists. As seen in Table 5-3, only $2.6 million (out of nearly $503 million) was earmarked for these combined purposes in 1989. The number of grants so specified was equally tiny: six for choreography, 23 for music composition, and 34 for playwriting.

The data reveals that—*at least through their institutional grants*—foundations were far more likely to support academic training and the development of young artists and scholars at colleges, universities, and professional institutes, than to support the artistic creation of working artists through grants to arts groups.

For a summary of major foundation programs that directly support individual artists, see box in this chapter.

OTHER TYPES OF SUPPORT

LIMITED FUNDING FOR RESEARCH

Research, emergency funds, and technical assistance grants comprise the remaining, less funded categories of support for the arts.

Of the three, research was the only category that consistently claimed more than 1 percent of arts dollars (Table 6-1). Very few foundations support arts, humanities, or media-related research. A notable exception is the Andrew W. Mellon Foundation. In conjunction with its overall interest in scholarship

FOUNDATION GRANTS TO INDIVIDUAL ARTISTS: A SUMMARY OF KEY FUNDERS

As noted elsewhere, study data from the *Grants Index* cover only grants to institutions. A *very limited number* of foundations do offer grants or awards to individuals. Some of the major funders of artists, writers, musicians, or dancers include:

- **Art Matters, Inc. (AMI), NY:** Provides project support and fellowships to artists, especially emerging artists, involved in the visual arts, film, theater, and performance art.

- **Bush Artist Fellowship, MN:** Awards fellowships to selected writers, choreographers, composers, and visual artists residing in Minnesota, North Dakota, South Dakota, and 26 counties in western Wisconsin.

- **Cintas Foundation, NY:** Awards fellowships to individuals of Cuban citizenship or lineage for continuing work outside Cuba in the arts, including the fine arts, music, and literature.

- **Fleischhacker Foundation, CA:** Awards fellowships to individual artists, 25 years or older, in the San Francisco Bay, CA, area, for basic living and working expenses.

- **Adolph and Esther Gottlieb Foundation, NY:** Provides grants for painters, sculptors, and printmakers who have spent at least 20 years in a mature phase of their art.

- **John Simon Guggenheim Memorial Foundation, NY:** Provides fellowships to published authors, exhibited artists, and others in the fine arts. One of the few foundations that gives only to individual artists, critics, and scholars, and also the largest.

- **Jerome Foundation, MN:** Provides grants for film and video projects for artists residing in New York City, and for travel and study for individuals in dance, literature, media arts, music, theater, and the visual arts residing in the Twin Cities area.

- **John D. and Catherine T. MacArthur Foundation, IL:** Awards fellowships *by nomination only* to a small number of "exceptionally talented" individuals (artists, writers, philosophers, scientists, educators, etc.) who have given evidence of originality and dedication to creative pursuits.

- **Pew Fellowships in the Arts, PA:** Provides grants to artists working in 12 different disciplines, with four categories eligible each year. During the program's three-year pilot phase (1991-94), up to 16 awards are made annually to artists residing in the five-county Philadelphia area.

- **Pollock-Krasner Foundation, NY:** Provides assistance to working visual artists in the U.S. and abroad, including painters, sculptors, and graphic and mixed media artists. One of the few programs established uniquely for individuals.

- **Rockefeller Foundation, NY:** Through its Multi-Arts Production Fund and Intercultural Film/Video Fellowships, provides project support to creative artists and scholars whose work strives to advance international and intercultural understanding in the U.S. Under the Intercultural Film/Video Fellowships program, artists must be nominated by the National Nominating Committee.

- **Lila Wallace-Reader's Digest Fund, NY** Through its International Artists Program, administered by Arts International, provides grants for visual artists to live and work around the world; through its Writers' Award program, provides support for writers, playwrights, and poets who have published "works of exceptional merit."

More information on these and other grant programs appears in the Foundation Center's *Grants to Individuals*, "Arts and Cultural Support"; and in several other specialized guides listed in the Bibliography.

and scholarly publications, Mellon provided most of the large research grants during the study period. Examples included:

- $650,000 to the Public Broadcasting Service, for establishing and sustaining a research and development fund for programs in arts and humanities, 1983;

- $300,000 to the Los Angeles County Museum of Art, as a matching endowment supporting research and publication "of substantial scholarly quality," 1986;

- $400,000 to the Cleveland Museum of Art, for scholarly research and publications, 1989.

For current grantmaker views on arts research funding, see Chapter 8.

QUALIFYING SUPPORT

Some foundation grants are awarded on a *conditional* or *qualifying* basis. These include grants that are renewed or given as "continuing" support, and those stipulating that they be matched by other donations. Of the two types, continuing support is most often sought by recipients, because, by definition, it provides a more steady source of income than single-year grants. Matching support serves as an impetus for more intensive fundraising by the arts organizations. From the funder's point of view, it serves to leverage limited resources.

Qualifying types of support are tracked in addition to the other primary support types. An example would be a challenge grant for construction, or renewed program or operating support.

As revealed in Table 6-1, in 1983 nearly 28 percent of all arts grant dollars were awarded on a continuing basis. That share dropped in 1986, then finished in 1989 at close to 25 percent. The share of number of renewed or continuing support grants dropped more sharply over the study period: from nearly 29 percent to only 21 percent.

Finally, the share of grant dollars awarded on a matching basis grew to 13 percent by mid-decade, but dropped to 8 percent in 1989. Matching grants represented less than 3 percent of arts grants by number of grants in 1989, down from over 4 percent in 1986.

The drop in both continuing and matching support shares at the end of the study no doubt resulted in part from the expansion of the funder sample in 1989.

ENDNOTES

1. Loren Renz and Steven Lawrence, *Foundation Giving: Yearbook of Facts and Figures on Private, Corporate and Community Foundations*, The Foundation Center, New York, 1992.

2. Nello McDaniel and George Thorn, *The Quiet Crisis in the Arts*, Foundation for the Expansion and Development of the American Professional Theater (FEDAPT), New York, 1991, Pages 10-16.

3. Paul DiMaggio, "Support for the Arts From Independent Foundations," PONPO Working Paper No. 105 and ISPS Working Paper No. 2105, Program on Non-Profit Organizations, Yale University, January 1986, New Haven, Pages 4-8.

4. Nathan Weber (ed.), *Giving USA 1990*, AAFRC Trust for Philanthropy, New York, 1991, Page 159.

Arts Funding by Ten Leading Corporate Giving Programs

Business corporations in the United States donate roughly 11 to 12 percent of their total yearly contributions to the arts, according to separate surveys conducted by The Conference Board and Business Committee for the Arts[1]. Relatively few of these companies, however, choose to distribute their funds through foundations, although grants so dispensed account for about a quarter of all U.S. business giving[2].

Among most firms, gifts are allocated directly from corporate revenues. Grants administration is typically the responsibility of a contributions office, which may report to public affairs, public relations, or marketing departments. In some cases, contributions officers report directly to the chief executive officer.

Unlike company-sponsored foundations, corporate giving programs are under no obligation to disclose grants data to the Internal Revenue Service, so no comprehensive information on their allocations is available. For the purposes of this study, 20 leading corporate arts donors, identified by Business Committee for the Arts, were asked to provide their data on arts grants (through corporate giving programs) for the year 1989. Ten of them responded. They were Chase Manhattan, Chevron, Dayton Hudson, Exxon, General Mills, Hallmark Cards, International Business Machines (IBM), Morgan Guaranty Trust, Philip Morris, and Texaco. Four of these companies—Dayton Hudson, General Mills, Texaco, and Morgan Guaranty Trust—also give substantially to the arts through corporate foundations. Their foundation giving is excluded from this analysis.

Together, these ten companies donated $26.2 million to the arts in 1989 through 994 grants of at least $5,000 each. (IBM was able to report only grants of at least $25,000, since the firm does not monitor smaller gifts made by its branches; its giving, therefore, is understated in the data.)

All corporate arts grants were coded in accordance with the Foundation Center's Grants Classification System and the National Taxonomy of Exempt Entities (NTEE). Grants were indexed both by subject and by type of support or purpose, allowing comparisons with foundation arts grants and especially with the more than 2,400 corporate foundation arts grants for 1989 reviewed elsewhere in this study.

Table 7-1 shows the total amount of money given to the arts in 1989 by the ten sampled corporate giving programs, and Tables 7-2 and 7-3 show how the funds were distributed.

Because the sample of companies is so small, the data are not at all intended to serve as a proxy for all corporate direct giving to the arts. Instead, findings below reflect patterns associated with only the largest corporate donors, and more specifically, with ten of the largest. To the extent that the largest givers strongly influence overall trends, these find-

TABLE 7-1. ARTS GRANTS OF TEN MAJOR CORPORATE GIVING PROGRAMS, 1989*

Corporate Giving Program	Grant Amount	No. of Grants
Philip Morris Companies Corporate Contributions Program	$5,391,265	184
IBM Corporate Support Program	5,244,950	79
Dayton Hudson Corporation Charitable Giving Program	3,960,950	340
Chevron Corporate Giving Program	3,958,845	90
Exxon Corporate Giving Program	2,392,400	78
Hallmark Cards Corporate Contributions Program	1,411,528	47
Texaco Corporate Giving Program	1,205,400	35
General Mills Corporate Giving Program	1,078,400	38
J.P. Morgan and Company Corporate Giving Program	785,500	70
Chase Manhattan Corporation Philanthropy Department	756,000	36

Source: The Foundation Center, 1992.
* Totals include only grants of at least $5,000; for IBM, includes grants of at least $25,000.

TABLE 7-2. ARTS GRANTS OF TEN MAJOR CORPORATE GIVING PROGRAMS BY MAJOR SUBJECT AND SUBCATEGORY, 1989*

Subject≠	Amount	%	No.	%
Performing Arts	**$10,971**	**41.9**	**542**	**54.5**
Performing Arts Centers	2,226	8.5	54	5.4
Dance	1,626	6.2	74	7.4
Ballet	1,234	4.7	42	4.2
Dance Unspecified—Other	362	1.4	30	3.0
Choreography	30	0.1	2	0.2
Theater	1,774	6.8	123	12.4
Theater—General	1,734	6.6	118	11.9
Playwriting	40	0.2	5	0.5
Opera/Musical Theater	1,638	6.3	54	5.4
Music	2,964	11.3	183	18.4
Orchestra	1,834	7.0	125	12.6
Ensembles/Groups	260	1.0	14	1.4
Choral Music	29	0.1	4	0.4
Music Composition	34	0.1	3	0.3
Music Unspecified	807	3.1	37	3.7
Performing Arts Education	268	1.0	24	2.4
Performing Arts/Multi-Media	60	0.2	4	0.4
Circus Arts	86	0.3	6	0.6
Performing Arts Unspecified	332	1.3	20	2.0
Museums/Museum Activities	**$5,632**	**21.5**	**177**	**17.8**
Art Museums	3,403	13.0	87	8.8
Children's Museums	164	0.6	12	1.2
Ethnic/Folk Museums	269	1.0	18	1.8
History Museums	312	1.2	10	1.0
Natural History Museums	300	1.1	11	1.1
Science/Technology Museums	628	2.4	15	1.5
Museums—Other	556	2.1	24	2.4
Media/Communications	**$6,241**	**23.8**	**59**	**5.9**
Film/Video	64	0.2	5	0.5
Television	6,056	23.1	46	4.6
Publishing/Journalism	14	0.1	2	0.2
Radio	93	0.4	5	0.5
Media Unspecified—Other	15	0.1	1	0.1
Multidisciplinary Arts	**$1,826**	**7.0**	**114**	**11.5**
Multidisciplinary Centers	463	1.8	30	3.0
Ethnic/Folk Arts	171	0.6	15	1.5
Arts Education	463	1.8	30	3.0
Multidisciplinary—Other	730	2.8	39	3.9
Arts-Related Humanities	**$76**	**0.3**	**7**	**0.7**
Humanities—General	40	0.2	2	0.2
Literature	36	0.1	5	0.5
Historical Activities	**$192**	**0.7**	**17**	**1.7**
Historic Preservation	187	0.7	16	1.6
Historical Societies	5	0.0	1	0.1
Visual Arts	**$302**	**1.2**	**17**	**1.7**
Visual Services	289	1.1	15	1.5
Sculpture	5	0.0	1	0.1
Drawing	8	0.0	1	0.1
Other	**$972**	**3.7**	**61**	**6.1**
Advocacy/Policy/Technical Assistance	103	0.4	5	0.5
Associations	40	0.2	4	0.4
Fundraising	184	0.7	14	1.4
Volunteer Services	5	0.0	1	0.1
Art Libraries/Higher Education	111	0.4	7	0.7
International Exchange	160	0.6	1	0.1
Unspecified	369	1.4	29	2.9
Total	**$26,212**	**100.0%**	**994**	**100.0%**

Source: The Foundation Center, 1992.
* Dollar figures in thousands. Due to rounding, figures may not add up.
≠ Arts categories are those used in the Foundation Center's grants classification system and are adapted from the National Taxonomy of Exempt Entities (NTEE). See Appendix B.

ings add a useful perspective on corporate funding of the arts. More important, they provide a unique opportunity for comparable analysis not possible with data from other sources, such as The Conference Board and Business Committee for the Arts, which employ disparate classification systems.

MAJOR CORPORATE GIVING PROGRAMS FAVORED PERFORMING ARTS AND MEDIA

Like foundations in general, and company-sponsored foundations in particular, these ten large corporate giving programs provided the largest proportion of their arts funding in 1989 to the performing arts. However, unlike their peers in the foundation world, they allocated the second largest share to media and communications rather than to museums. As seen in Table 7-2 , media received nearly 24 percent of grant dollars, compared to less than 22 percent for museums.

(For a comparison with arts giving by company-sponsored foundations, see Chapter 5, Table 5-2. For a comparison with all U.S. corporate giving in 1988 as measured by Business Committee for the Arts, see Table 7-4.)

Other differences are apparent in the ways these large corporate giving programs distributed their arts funds. For example, although they gave a share of their arts dollars to the performing arts equal to corporate foundations (42 percent), they gave a far higher share of *number* of grants (55 percent vs. 46 percent).

Within the performing arts, funds were broadly distributed. More than one out of four dollars went to music—in particular symphony orchestras. Performing arts centers received one out of five dol-

TABLE 7-3. TYPES OF SUPPORT AWARDED BY TEN MAJOR CORPORATE ARTS FUNDERS, 1989*

Type of Support	Amount	%	No.	%
Operating Support	**$4,188**	**16.0**	**217**	**21.8**
Annual Campaigns	49	0.2	4	0.4
Unrestricted	2,565	9.8	170	17.1
Income Development	1,546	5.9	41	4.1
Management Development	29	0.1	2	0.2
Capital Support	**2,312**	**8.8**	**46**	**4.6**
Capital Campaigns	876	3.3	23	2.3
Building/Renovation	860	3.3	16	1.6
Equipment	130	0.5	1	0.1
Computer Systems	20	0.1	1	0.1
Endowments	381	1.5	3	0.3
Debt Reduction	25	0.1	1	0.1
Collections Acquisitions	21	0.1	1	0.1
Program Support	**13,569**	**51.8**	**461**	**46.4**
Program Development	1,879	7.2	122	12.3
Conferences	65	0.2	6	0.6
Professorships	10	0.0	1	0.1
Film/Video/Radio	5,806	22.1	25	2.5
Publications	58	0.2	5	0.5
Curriculum Development	23	0.1	2	0.2
Performances	3,957	15.1	261	26.3
Exhibitions	1,657	6.3	32	3.2
Collections Management/ Preservation	75	0.3	4	0.4
Commissioning New Works	40	0.2	3	0.3
Professional Development	**567**	**2.2**	**31**	**3.1**
Fellowships/Residencies	235	0.9	17	1.7
Internships	5	0.0	1	0.1
Scholarships	90	0.3	4	0.4
Awards/Services	236	0.9	9	0.9
Research	**40**	**0.2**	**2**	**0.2**
Unspecified	**6,468**	**24.7**	**274**	**27.6**

Source: The Foundation Center, 1992.
* Dollar figures in thousands. Grants may occasionally be for multiple types of support, i.e., a grant for new works and for an endowment, and would thus be counted twice.

lars. Dance, theater, and opera received nearly equal shares of funding, or about one in six dollars each.

The sampled corporate giving programs gave twice as large a share of grant dollars to media and communications (24 percent) as did the business foundations (12 percent), but only half the number of grants. Only 6 percent of the number of grants made by these large corporate giving programs went to media, compared with 10 percent from business foundations.

The disproportionate share of dollars to grant number in media resulted from a few exceptionally large grants to public television. In fact, virtually all the media money—97 percent—was given to television.

Just a little more than one-fifth of the dollars, but less than one-fifth of the arts grants reported by these ten corporate giving programs, went to muse-

ums. Corporate foundations in the sample gave slightly more to museums—about one-fourth of both dollars and grants. Within the museum category, 60 percent of the dollars went to art museums. Science and technology museums received the next highest share, at 11 percent.

The bulk of remaining grants from these corporate giving programs went to multidisciplinary arts programs (7 percent of grant dollars and nearly 12 percent of grants). Arts education and arts centers each received about a quarter of the corporate contributions to the field. (If arts education is more broadly defined to include performing arts schooling and such programs as museum tours or theater performances in public schools, then the share from the participating companies was actually higher than indicated in Table 7-2. For a fuller explanation of "Arts in Education" funding, see Chapter 5.)

PROGRAM SUPPORT RECEIVED LARGEST SHARE; CAPITAL SUPPORT WAS MINOR

Program support in 1989 was a much higher priority for the ten participating corporate giving programs than for foundations in general or for business foundations in particular. More than half of all arts funding that year by the ten large corporate donors funded programming. By contrast, business foundations gave only a fifth of their funds (19.7 percent) for program expenses. Foundations in general gave slightly above a third (33.8 percent).

By far the largest share of program dollars from the sampled corporate giving programs went for

TABLE 7-4. DISTRIBUTION OF U.S. BUSINESS CONTRIBUTIONS TO THE ARTS, 1988

Subject	%
Museums	16.0
Symphony Orchestras	16.0
Theater	12.0
Dance	8.0
Opera	8.0
Public Radio/Television	8.0
Libraries	7.0
Music	7.0
Cultural Facilities	5.0
Art Education	3.0
All Other	10.0
Total	100.0%

Source: Research & Forecasts, Inc., *The BCA Report: A New Look at Business Support to the Arts in the U.S.*, New York: Business Committee for the Arts, 1989.

STRATEGIES FOR ARTS FUNDRAISING FROM CORPORATE PROGRAMS

Projects and programs that relate to corporate objectives and receive high marks from other companies will remain priorities for private firms....Commercial banks often prefer arts programs that bolster regional development. Petroleum firms have long favored public television and radio. Makers of film products have been fond of photographic exhibits.

Yet, within these strategically shaped corporate preferences, companies vary considerably in their funding criteria. Specific priorities depend, instead, on other factors, such as top management's interest in specific arts....In an era when bottom line business concerns have become prevalent, development efforts require a keen understanding of a firm's managerial culture and specific priorities.[3]

— Michael Useem

film, video, and radio productions. This reaffirms the finding that media, as an arts subject, received the second largest share of dollars from the ten donors.

But if the dollars in the category were high, the number of grants were, by contrast, extremely low. Only 25 grants accounted for the nearly $6 million allocated for film and video. Far more grants—261 out of the nearly 1,000 reported by these ten corporate donors—paid specifically for performances rather than general programs. These performance grants amounted to nearly $4 million, or 15 percent of all grant dollars in the sample.

The ten large business donors were also much less likely than their corporate foundation peers to provide capital support for the arts. In 1989, they gave fewer than one in 11 arts dollars for that purpose, compared to one in six by company-sponsored foundations, and one in three by foundations in general.

Only one out of six grant dollars and one out of five grants from the sampled corporate giving programs were allocated for operating support. These were slightly higher than the proportions reported for company-sponsored foundations.

For lack of a grant description, one-fourth of all dollars and slightly more than one-fourth of grants by these ten corporate giving programs fell into the "unspecified" category.

ENDNOTES

1. Anne Klepper, *Corporate Contributions, 1990*, The Conference Board, 1992, New York, Chart 6; Research and Forecasts, Inc., *The BCA Report: A New Look at Business Support to the Arts in the U.S.*, Business Committee for the Arts, November 1989, New York, Page 10. Data for 1989 were not collected. Figures for 1991 were released by BCA in December 1992, in the *National Survey of Business Support to the Arts.*

2. Hayden Smith, *To Have or Have Not...A Corporate Foundation*, Council for Aid to Education, 1990, New York, Page 1. See also Renz and Lawrence, "Corporate Foundations," *Foundation Giving*, The Foundation Center, 1992, New York, Pages 32-36.

3. Michael Useem, "Corporate Funding of the Arts in a Turbulent Environment," *Nonprofit Management and Leadership*, Summer 1991, Pages 340-341.

8

Arts Grantmaking in the 1990s: Perspectives of Funders and Grantees

How far apart are the nation's nonprofit arts organizations and their financial benefactors over matters of fundamental concern to both of them?

This question lies at the heart of the relationship between the groups and the funding sources on which they depend. The issue, endemic to any funder/recipient relationship, has been the focus of a great deal of controversy during the past two years years, largely as a result of two major developments: a) fiscal and organizational instability faced by the arts groups—itself a reflection of a broader malaise affecting nonprofits during the long economic recession, as well as of shifting demographics; and b) political attacks on the content of the artists' visual and performing works.[1]

The heated nature of the controversy has contributed to a general impression that a vast and perhaps unbridgeable gulf has emerged between the artists and their funders, both governmental and private.

How valid is this impression with regard to foundation and corporate grantmakers?

Not very, judging by results of a national survey of grantmakers and arts organizations conducted by the Foundation Center in early 1992. The findings reveal that the nation's arts professionals and their private institutional benefactors are not nearly as divergent in their positions on basic funding and

political and social issues as implied by the controversy. On many of the most pressing concerns, including types of support most needed by arts groups, criticisms of grantmaker policies, and fields of artistic endeavor most underfunded today, grantmakers and their beneficiaries agree more often than not. The consensus, to be sure, is by no means universal. On such issues as the need for artistic salaries versus the need for long-range planning, or the quality of a grant proposal versus the ability of the grantmaker to evaluate it, notable differences do emerge.

TABLE 8-1. ARTS GRANTMAKER RESPONDENTS BY TYPE

Type of Grantmaker	No.	%
Independent Foundations	91	50.0
Corporate Foundations	44	24.2
Corporate Giving Programs	15	8.2
Community Foundations	26	14.3
Operating Foundations	2	1.1
Anonymous	4	2.2
Total	**182**	**100.0%**

Source: The Foundation Center, 1992.

TABLE 8-2. ARTS GRANTEE RESPONDENTS BY TYPE *

Type of Grantee	No.	%
Arts Producer	76	57.1
Arts Presenter	44	33.1
Arts Service Provider	29	21.8
Not Specified	3	2.3

Source: The Foundation Center, 1992.
* Percentages based on multiple responses of 133 grantees.

TABLE 8-3. ARTS GRANTEE RESPONDENTS BY MAJOR FIELD*

Arts Field	No.	%
Performing Arts	72	54.1
Music/Symphonies	28	21.1
Theater	18	13.7
Dance/Ballet	14	10.5
Opera	6	4.5
Presenting	6	4.5
Media/Communications	16	12.0
Multidisciplinary Arts	14	10.5
Museums	13	9.8
Arts Services	6	4.5
Visual Arts (Non-Museum)	3	2.3
Arts-Related Humanities	1	0.8
Other	6	4.5
Not Specified	2	1.5
Total	**133**	**100.0%**

Source: The Foundation Center, 1992.
* Percentages based on 133 grantees; due to rounding, figures may not add up.
Abbreviated table. For more detailed breakdown, see Table 8-6.

In part to explore these questions, in part to gain a broader understanding of recent thinking among both the grantmaking and creative worlds, and in part to gauge the changes occurring within the funding community itself, Grantmakers in the Arts—a network of foundations and corporate donors—asked the Foundation Center to survey funders and arts grantees on a variety of issues with which both populations are concerned. This chapter presents the findings from the surveys.

It cannot be emphasized too strongly that the findings reflect, above all, *perceptions*, not hard data. Grantseekers were asked their opinions on funding needs and grantmaker performance. Similarly, grantmakers were asked to express their views and intentions—not their actual outlays or operations. To state the obvious, intentions are not always realized; plans do change from one year to the next. For data on historical trends, revealing what foundations actually did rather than thought, readers are directed to Chapters 4, 5 and 6.

Further, the findings in this chapter represent a national picture only. State or even regional surveys might well yield different perceptions and intentions among both grantmakers and arts organizations. Indeed, one conclusion from the current survey is that more localized research on the views of institutional donors and grantees alike is much in need.

Throughout this chapter, the comments of advisors to this study appear either directly in the text, or in italicized print. The advisors had been asked to assist in interpreting survey data after the preliminary findings were released. Several participated in a roundtable discussion held in late 1992. Advisors and their affiliations are listed in the front of this report. Where comments by responding grantmakers and arts groups are included, they remain anonymous.

ORGANIZATIONS SURVEYED

Questionnaires were sent between December 1991, and January 1992, to 498 grantmakers with a special interest in the arts, and to 316 arts organizations.

Surveyed grantmakers included those identified by Grantmakers in the Arts (GIA), foundations included in the most recent annual *Grants for Arts, Culture and the Humanities* published by the

Foundation Center, and selected members of Business Committee for the Arts.

Surveyed grantees were selected to represent a diversity of arts fields, size, geographic distribution, and ethnicity where appropriate. The selections were made by ten major arts service organizations, who were themselves surveyed.

Among the grantmakers, 182 or 37 percent returned usable responses. Among the arts organizations, 133 or 43 percent returned usable responses. Survey repondents are listed in Appendix C.

Percentages may not equal 100 percent in all tables and figures due to rounding off. Some tables reflect multiple responses. Most figures presented within the text are abbreviated; the complete listings appear at the end of the chapter.

Table 8-1 presents characteristics of the responding grantmakers, Tables 8-2 and 8-3 describe grantee characteristics. (A more detailed breakdown of survey respondents by arts field may be found in Table 8-6, and Table 8-7 provides a complete analysis by state of grantmaker and grantee location.)

THE NEEDS OF ARTS GROUPS

A major issue facing funders and recipients pertains to the evaluation of arts organizations' needs: the types of grant support most critical to effective functioning. The survey asked both groups of respondents to indicate what they considered the most critical needs, from a list of more than 35 (see questionnaires, Appendix D). They were limited to six choices. Figure 8-1 compares the responses of grantmakers and grantees.

UNRESTRICTED OPERATING SUPPORT DEEMED MOST CRITICAL NEED OF ARTS GROUPS

Both grantmakers and grantees agree that operating support—restricted and unrestricted—is the most critical need of arts organizations, although a far greater proportion of grantees than grantmakers said so (Figure 8-1).

But the data in Figure 8-1 represent only the broad categories of support. As such, they may be misleading: any response indicating, for example, board development as most critical, was counted as a form of "Restricted Operating Support," even though only 15.4 percent of grantmakers and 9.1

FIGURE 8-1. GRANTMAKER AND GRANTEE VIEWS: MOST CRITICAL NEEDS OF ARTS ORGANIZATIONS BY BROAD TYPES OF SUPPORT*

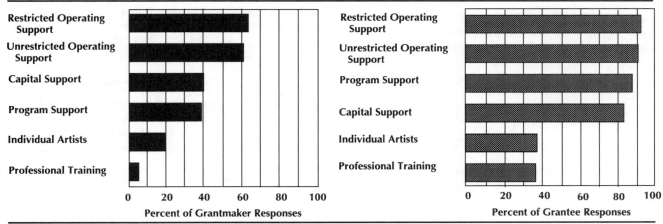

Source: The Foundation Center, 1992.

*Percentages based on multiple responses of 156 grantmakers and 132 grantees. Categories represent collapses of specific categories presented in Table 8-8.

percent of grantees checked board development as most critical (Table 8-2). The same is true for other broad categories, such as program and capital support: the data is cumulative, not specific.

Unrestricted Operating Support. A more insightful picture is revealed in the responses to specific, or subcategory types (Figure 8-2). Here again, both grantmakers and grantees agree on two of the six most critical needs of arts organizations: unrestricted operating support, and endowment. In fact, both populations view unrestricted operating support as the most important specific need, although far more grantees (92 percent) than grantmakers (61 percent) said so.

Concerning endowment, a type of capital support, half the grantees view it as among the most critical, while less than a fifth of the grantmakers point to it as among the primary needs. (More on endowment appears below.)

This is where agreement ends. According to the funders, the four other most critical needs of arts groups include audience development, long-range and strategic planning, support for individual artists, and general program support.

Arts organizations, however, cite administrative and artistic salaries, internships or apprenticeships, and creating and commissioning new works as the

remaining most critical types of support.

While there may be no basic difference between the grantmakers citing the needs of individual artists, and the grantees citing the need for salaries and commissions, the other differences in this table are telling. The emphasis placed by grantmakers on audience development and long-range planning may reflect a desire to have grantees take steps to stabilize their operations through such methods as developing staff and generating alternative revenue streams—especially earned income and endowment and investment income. The funders are saying, in effect, that they are not bottomless founts (although not all experts agree on this interpretation; see comments below.

The arts groups have a different message. To them, salaries, artistic training (internships), and the opportunity to create and commission new works amount to life support. Sufficiency (or insufficiency) of these resources speaks to the heart of their ability to make art. As one grantee, a musical group, stated in obvious frustration, "It is nearly impossible to earn a living as a musician [yet] no one will support artists' salaries."

It is not that the arts organizations uniformly downplay the importance of audience development; although it was ranked eleventh in importance by the grantees as a whole, more than a fifth (21.2 per-

cent) of the responding arts groups did cite it as among the most critical needs (see Table 8-8).

The issue of salaries may speak to the broader question of the role of private philanthropy in the arts: "Are salaries the best use of foundation funds?" asked advisor Suzanne Sato of the Rockefeller Foundation. "Or should foundations focus, rather, on creating and supporting a climate within which the arts can survive?"

> *I disagree that the emphasis on long-range planning reflects a desire to have grantees...stabilize their operations and generate alternative sources of income. Rather, funders are agreeing with grantees that the times are precarious. Money is very, very tight and the competition for dollars continues to increase. We all have to reexamine our mission, take clear looks at priorities and plan futures accordingly. Most funders I know are placing as much emphasis on their own internal long-range planning as they are on the long-range planning of their recipients. For effective survival, both have to know clearly what they're about and how to meet their goals. It's about a lot more than generating alternative sources of money. It's a hard look at programs and priorities—money follows mission and program assessment.*
> —Cynthia Gehrig, Jerome Foundation

> *Yes, long-range planning is aimed at institutional stabilization, but highlighting alternative sources of income is a limiting emphasis. Alternative*

income generation is a subset—admittedly under-utilized—of a spectrum of survival techniques that must include mission clarification, facility and staff development, endowment building, and always keeping an eye on the artistic prize.
> —Suzanne Sato, Rockefeller Foundation

ENDOWMENTS

Although both of the surveyed groups cited endowment as among the six most critical needs, grantees cited it in far greater numbers than grantmakers. According to one observer, an advisor to this study, this disparity is a "tragedy."

"Grantmakers offer pronouncements about the need to stabilize operations, as endowment can best do," said Peter Hero of the Community Foundation of Santa Clara County, "yet [they] don't put their money where their mouths are. Instead, their funding priority—audience development—seems to indicate a naive assumption that more tickets will solve the problem at a time when many houses are often nearly full. The problem is that tickets cover perhaps 50-60 percent of costs at best, and so the income gap widens. More outreach is not the answer."

"And what good is long-range planning without follow-up to shore up balance sheets, pay off deficits, build cash reserves?" he continued. "Again, except for the NEA Challenge Program and the Arts

FIGURE 8-2. GRANTMAKER AND GRANTEE VIEWS: MOST CRITICAL NEEDS OF ARTS ORGANIZATIONS BY SPECIFIC TYPE OF SUPPORT*

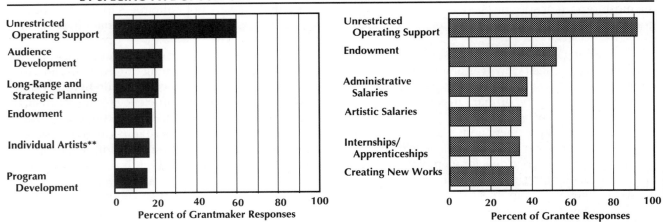

Source: The Foundation Center, 1992.
*Percentages based on multiple responses of 156 grantmakers and 132 grantees. Abbreviated list. For complete list see Table 8-8.
**Includes both direct grants and regranting.

Stabilization Fund, what funder is addressing this critical need?"

Hero maintained that the problem "will be worse in the future. That is, it is estimated that in the next ten-20 years, $7 trillion dollars will transfer from one (aging) generation either to government, heirs, or charities, including the arts....Those arts groups which fail to put an endowment program in place now, devising strategies for planned gifts, creating a 'bucket' to catch this generational flow, will be left high and dry. And the $7 trillion will only go by once. The next generation is not nearly as wealthy."

Arts groups, as constituents, are "telling [their funders] that endowments are more important than their own salaries," he added, "yet fewer than one funder in five even hears the message, apparently. Instead they are placing all their priority dollars on annual operating support and audience development while saying that operations must be 'stabilized.' With what? Without greater unearned income, even huge new audiences only mean huge new debt."

In terms of the allocation of actual dollars tracked in this study's grants analysis, endowments accounted for only 7.7 percent of all arts grants in both 1986 and 1989 (see Chapter 6, Table 6-1).

AUDIENCE DEVELOPMENT

Audience development may also pose particular problems to artists, especially in the theater. "The responsibility to audiences creates one of the more pressing questions artistic directors face," according to a report of a foundation-funded series of meetings among theater directors in 1985.[2]

"How to strike a balance between two extremes—their responsibility to their own artistic fulfillment and the pressure to fill the theatre with a satisfied audience, getting what it wants....Some [artistic directors] resent the fact that theatre is the one art form expected to fulfill a popular role as entertainment; they resist the phrase 'show business' and seek a way to market the art, not just the package of individual productions. One such artistic director described choosing plays according to what audiences 'should see' as 'a bloodless form of self-censorship.' Others believe that theatre is first and foremost obligated to please a broad audience and that without such an audience there can be no theatre."

In a separate survey of 260 museums and performing arts organizations conducted in 1992 by Business Committee for the Arts, 93 percent of the respondents indicated that "developing new audiences" would be a major priority in the coming years. The next largest number of respondents—82 percent—cited "identifying new individual donors to replace aging individual donors."[3]

The emphasis on marketing as almost synonymous with audience development...[is] a short-sighted, functional approach to a much more important issue. Artistic directors and artists talk about communicating with audience members and viewers, about creating meaning for the art they make in dialogue among the maker, the producer/presenter and the receivers. Audience members are increasingly valued as thinking individuals who do a lot more than fill seats. They connect with the artist's work. Artists and arts organizations desire audiences and viewers because art is incomplete unless it exists as a dialogue....Audiences and viewers are the reason why art has meaning for society.
—Cynthia Gehrig, Jerome Foundation

Audience development that measures its success only by head count is ultimately short sighted. Many arts audiences are still white and aging, when the population as a whole presents a very different profile. Audience development grants today are often aimed at bridging generational and cultural divides, attempting to build the arts-going habit in the population as a whole.
—Suzanne Sato, Rockefeller Foundation

INDIVIDUAL ARTISTS

Concerning other issues, the focus by funders on the needs of individual artists may reflect a growing awareness of the disadvantage faced by individual artists vis-a-vis organizations in the competition for grants. More than four out of five surveyed grantmakers (86 percent) do not plan to offer grants directly to individuals. Of those few (24) who do, nearly half make grants for living and working space, and for commissions. The remainder give direct fellowships, scholarships, and prizes. (For a full discussion of these findings, see "Little Change Expected in Individual Artist Grants," Figures 8-11 and 8-12.)

The fact that grantees did not rank the needs of individual artists among the top six needs may

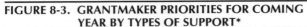

FIGURE 8-3. GRANTMAKER PRIORITIES FOR COMING YEAR BY TYPES OF SUPPORT*

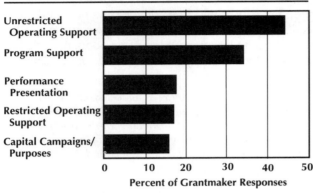

Source: The Foundation Center, 1992.
*Percentages based on multiple responses of 169 grantmakers. Abbreviated list. For complete list see Table 8-9.

reflect simply that all grantee respondents were organizations. On the other hand, almost a third of the grantees did cite the need for creating and commissioning new works (Figure 8-2), along with the need for salaries; taken together, this may reflect the arts organizations' focus on the very specific needs of the individual artist, according to advisor Ruth Mayleas of the Ford Foundation. This view was echoed by Margaret Wyszomirski of the National Endowment for the Arts, and by other advisors.

GRANTMAKER INTENTIONS ON TYPES OF SUPPORT

How do funders act on their views? If they perceive certain types of support as most critical to arts grantees, are they likely to provide their primary funding for those needs?

UNRESTRICTED OPERATING SUPPORT MOST OFTEN CITED TO RECEIVE PRIMARY FUNDING

Unrestricted operating support—recognized both by grantmakers and grantees as the most critical specific need faced by arts organizations—is also the category most often cited by donors among the four types of support likely to receive most of their funding in the coming fiscal year. It was mentioned by more than two out of five respondents (44.4 percent).

(Note: This does not mean that two out of five arts dollars or arts grants will go for unrestricted operating support. The number represents grantmakers, not dollars or grants.)

Grantmakers were asked to indicate four types of support likely to receive most of their funding in the coming fiscal year. Figure 8-3 shows the results.

But a comparison of Figures 8-2 and 8-3 reveals a gap between perception and policy. Only one in six grantmakers views program support as among the six most critical needs, and even fewer grantees cite it. Nevertheless, program support and performance presentation (one type of program support) were cited most frequently after unrestricted operating support as among the four priorities likely to receive primary funding.

This finding also confirms that tomorrow's policy often follows yesterday's. Elsewhere in the survey, grantmakers were asked what types of support were *eligible* for their funding in 1991. Most frequently cited was program support (91 percent). And within this category, performance presentations were cited most often (64 percent). However, restricted operating support was also cited by more than 66 percent as eligible for funding in 1991. (See Table 8-10.)

Moreover, according to one expert, the difference between program and operating support is not always so marked in actuality as it appears to be in print. Ruth Mayleas observed that "program support, and even performance presentation, while not the same as unrestricted operating [support], represent some funders' ways of supporting the basic operation of the institution. Program support, especially if it is loosely interpreted as support for the whole program of the institution, can be a kind of stand-in for basic operating support."

Another reason for grantmaker emphasis on program support, according to Suzanne Sato, is that it lends itself more easily than other types of support to evaluation and accountability.

As a proportion of all arts grant dollars during the previous decade, program support ranged from 28.5 percent in 1983 to 33.8 percent in 1989. For a breakdown of arts grants during the study years by type of support, see Chapter 6, Table 6-1.

As for operating support, one observer commented that the vast majority of it "goes to the same large organizations year after year." For historical

data on the small proportion of arts organizations securing a relatively large share of grant dollars, see Chapter 4, "Overview of Foundation Activities in the Arts."

Other types of support most often cited by funders to receive primary funding in the coming fiscal year include, in order of frequency: restricted operating support (that is, funds geared to specific administrative expenses, such as long-range and strategic planning, salaries, etc.); and capital campaigns and purposes, which include endowment (Figure 8-3). Since both planning and endowment were viewed by funders as among the six top critical needs faced by arts organizations, their intention to fund these areas coincides with their views on basic need.

CRITICISM OF GRANTMAKERS

Fearful of offending those whose largesse necessarily affects their operations—when not determining their very existence—arts organizations rarely present their own critical views of funding policies to the funders themselves. In this anonymous survey, however, they were very clear as to grantmaker policies in need of change. Funders themselves were equally clear.

FUNDERS CHIDED FOR FAVORING LARGE GROUPS, "NEW" PROGRAMS

Grantmakers and grantees agree that the two most serious criticisms of funder policy include: a) imbalance in grants, which favor larger, more established arts organizations, and b) an overemphasis on funding "new" programs rather than basic support. However, more grantmakers (36 percent) cite the first criticism as most important, while more grantees (32 percent) cite the second (Figure 8-4).

After these two criticisms, grantees cite short-term rather than long-range funding as most serious; grantmakers give equal weight to short-term funding, reluctance to fund risky works, cultural or ethnic or racial bias, and an unrealistic expectation of grantee self-sufficiency. Nevertheless, very few recipients (14 percent) actually cited short-term funding; and only 8 percent of funders selected one of the four third-ranked criticisms.

Among surveyed arts groups, less than 3 percent cited ethnic or racial bias as a serious criticism of funders. (See Table 8-11.) This finding was questioned by advisor Juan Carillo of the California State Arts Council, who attributed the low percentage to possible underrepresentation of ethnic arts groups in the sampled population.

FIGURE 8-4. GRANTMAKER AND GRANTEE VIEWS: MOST SERIOUS CRITICISMS OF GRANTMAKERS*

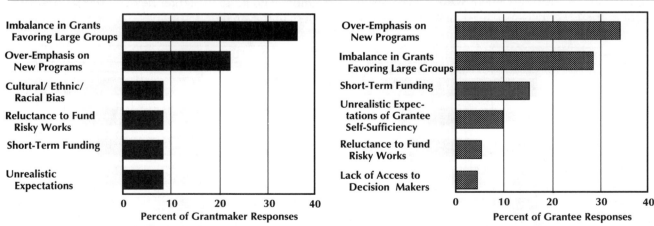

Source: The Foundation Center, 1992.
*Percentages based on multiple responses of 144 grantmakers and 119 grantees. Abbreviated list. For complete list see Table 8-11.

FIGURE 8-5. GRANTMAKER AND GRANTEE VIEWS: MOST UNDERFUNDED ARTS FIELDS*

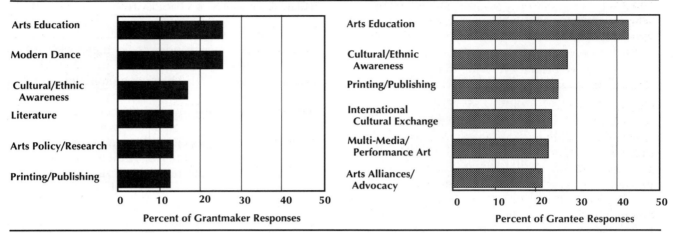

Source: The Foundation Center, 1992.
*Percentages based on multiple responses of 142 grantmakers and 128 grantees. Abbreviated list. For complete list see Table 8-13.

Regardless of the agreement or disagreement over which criticisms are the most serious, at least 50 percent of the funders agreed with only four of the 12 criticisms offered. (See Table 8-12.) These include imbalance in grants, short-term rather than long-term funding, a reluctance to fund risky works, and favoring new programs over basic support. (The question asked respondents whether they basically agreed, basically disagreed, or had no opinion on, each of the criticisms.)

By contrast, at least 50 percent of the arts organizations are in basic agreement with each of seven (out of the 12) criticisms. These include, in addition to those just cited, unrealistic demands for grantee self-support, lack of grantee access to decision makers within the foundation or corporation, and unclear or rigid guidelines.

FUNDING WITHIN THE ARTS: WHO GETS THE MONEY?

Because arts fields vary considerably in terms of size—performing arts is much larger than, say, visual arts—grants tend to flow unevenly, with more money going to the larger fields or disciplines, and less to the smaller disciplines. To elicit arts group

FIGURE 8-6. GRANTMAKER AND GRANTEE VIEWS: BEST FUNDED ARTS FIELDS*

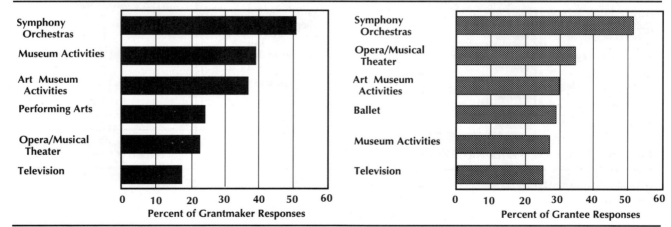

Source: The Foundation Center, 1992.
*Percentages based on multiple responses of 136 grantmakers and 107 grantees. Abbreviated list. For complete list see Table 8-14.

and grantmaker perceptions, respondents were asked to state the arts fields, or subjects, that in their opinion were the most underfunded and the best funded today.

ARTS EDUCATION SEEN AS MOST UNDERFUNDED

Grantmakers and grantees agree that arts education is the field most underfunded by foundations and corporations. Both groups of respondents also agree that arts activities promoting cultural or ethnic awareness are poorly funded, although a greater percentage of grantees than funders makes this case.

Finally, both groups cite printing/publishing as among the six most underfunded; grantees cite it third, grantmakers sixth, along with art alliances and humanities.

Agreement on this issue does not extend beyond these items. According to the grantmakers, literature, modern dance, and arts policy and research also qualify for the five fields least funded. To the arts organizations, printing and publishing, international cultural exchange, and performance art merit the dubious distinction. Figure 8-5 presents the six top-ranking grantmaker and grantee views.

SYMPHONY ORCHESTRAS AND MUSEUMS BELIEVED TO RECEIVE MOST ARTS ALLOCATIONS

Grantmakers and grantees are remarkably close in their estimation of arts fields or subjects receiving the greatest attention from foundation and corporate funders today. Findings are illustrated in Figure 8-6. To both groups of respondents, five of the best funded fields include symphony orchestras, museum activities in general, art museum activities in particular, opera/musical theater, and television. Respondents differ only slightly in their ordering of these fields.

Grantees, however, would add ballet to the list of six best funded fields; grantmakers cite performing arts in general.

(In 1989, based on *actual grants data*, the performing arts as a broad category received the largest share of foundation arts funds, nearly 34 percent. Symphony orchestras received the largest portion of performing arts dollars, around a fifth, which amounted to 7.4 percent of all arts grant dollars. The next largest share of all arts dollars that year went to

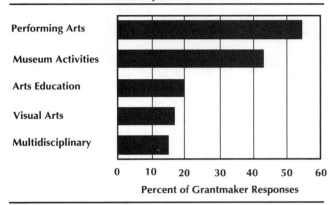

FIGURE 8-7. GRANTMAKER PRIORITIES IN COMING YEAR BY MAJOR ARTS FIELD*

Source: The Foundation Center, 1992.
*Percentages based on multiple responses of 168 grantmakers. Abbreviated list. For complete list see Table 8-15.

the general museum category—30.5 percent. Art museums got almost half of all museum funds, or about 15 percent of all arts dollars. See Chapter 5, Table 5-3.)

GRANTMAKERS' INTENTIONS ON FUNDING ARTS FIELDS

Given the *perceptions* of arts funders concerning the best funded and most underfunded fields, how are these likely to affect grantmaking priorities? Funders were asked to specify the four arts fields likely to receive their primary support in the coming fiscal year.

PERFORMING ARTS, MUSEUMS MOST OFTEN CITED TO RECEIVE PRIMARY FUNDING

In spite of a belief that the performing arts and museum activities in general rank among the *best funded* arts fields today, both these fields were most often cited by grantmakers as among the disciplines to receive their primary support in the coming fiscal year (Figure 8-7). This suggests that grantmakers view these two fields as in fact meriting their primary support. (To see how funds will be distributed within each of these fields, see Table 8-15.)

The finding also reveals that no demonstrable change in funding priorities among broadly defined fields occurred between 1991 and 1992. Elsewhere in the survey, grantmakers were asked to state which

fields or disciplines were eligible for their grants in the most recent year (1991). Symphony orchestras and art museum activities were the two most often cited, at 80.2 percent and 78.6 percent, respectively. Other performing arts disciplines—theater, performing arts centers, opera and ballet, followed close behind. (See Table 8-16.)

ARTS EDUCATION ALSO CITED AMONG TOP PRIORITIES

Arts education, which both funders and grantees cite most often as *underfunded*, is also among the three most often cited fields to receive primary funding (Figure 8-7).

It should be noted that arts education is increasingly recognized as not simply another "field," but as a process by which various artistic disciplines are employed in the service of learning itself, or education in its broadest sense. As expressed by the Silicon Valley Arts Fund—an arts endowment established as a joint venture of public and private funders and arts organizations in California:

"Recent studies indicate that early exposure to arts activities has a direct effect on increasing the development of cognitive and problem-solving skills in children. These skills contribute to the educational development of future scientists, mathematicians, designers, engineers, teachers and myriad other professions."[4]

Other scholars have stated forcefully that the arts are, in themselves, a profound educational tool. "In the last two decades," wrote Dennie Palmer Wolf and Mary Burger in "More than Minor Disturbances: The Place of the Arts in American Education," "across the fields of science, psychology and the humanities, there has emerged a view of human cognition that values imagery, representation, and a capacity for what might be called possible or multiple worlds. Out of this new view of human capacity have come many insights, not the least of which is the understanding that the arts are not just crafts, or visions, but powerful ways of *knowing and working*.[5]

"The evidence is everywhere," continued the authors, "in the investigatory nature of sketchbooks, the careful experiments with solarized film and crackly glazes, and the rigorous assessments that occur in rehearsals and in the preparation of portfolios. Out of these realizations are emerging new, and radically different, forms of art education. Rather than job training or moral education, these new forms are essentially apprenticeships in the challenging ideas and rigorous practices that adult artists and audience members pursue." (For arts education historical grants data, see Chapter 5, Table 5-3.)

That only a fifth of the responding grantmakers planned to emphasize arts education may reflect that most grantmakers view the "field" as an arena owned by the public sector. Traditionally, of course, private grants to organizations to subsidize bus trips, to place artists-in-residence in schools, or to offer after-school training to public school students have been authorized for quite some time.

As a field, however, arts education may imply a very different kind of intervention—curriculum, teacher training and retraining, advocacy, parental involvement, and school-based management, among other things. Active involvement by private foundations in arts education today requires moving beyond the models of the past, which were rarely more than cosmetic. It requires at the least a willingness to engage the public sector, where matters of educational policy are debated and played out.

One example of such engagement is the Rockefeller Foundation's Collaboratives for Humanities and Arts Teaching (CHART). Currently supported through public-private partnerships in various cities, local CHART programs are designed to enhance arts and humanities teaching in public schools. All such programs are "informed by a unifying humanities or arts component, whether it be through the involvement of reading and writing in all aspects of the curriculum, or through a greater understanding of one's culture as well as the culture of others," according to a description of the program. A typical CHART operation is ArtsPropel in the Pittsburgh public schools.

Finally, about a sixth of funders (16.7 percent) named the visual arts and another sixth (14.9 percent) named multidisciplinary arts activities among fields slated to receive the bulk of funding in the coming year.

PROSPECTS FOR GROWTH IN ARTS FUNDING

A prominent essay on the perils facing the nonprofit arts world, prepared in 1991 by the Foundation for the Expansion and Development of the American

Theater (FEDAPT), argued that "for most arts organizations, growth may have been a possibility in the 1980s; it will not be possible in the early 1990s."[6]

Is this prediction valid? Growth, or expansion, is clearly dependent on an increase in overall financial resources. For many arts organizations, grants and corporate gifts are an important source of revenue.

To gauge the future commitment of organized philanthropy, grantmakers were asked to indicate whether they expect their arts grants to increase, decrease, or remain the same as a proportion of their overall funding during the next five years. (Due to vicissitudes in market value of foundation assets and corporate profits, funders were not asked to predict whether the actual dollar amount given to the arts would rise or fall.)

ARTS FUNDING SHARE NOT LIKELY TO CHANGE FOR MOST DONORS

Taken as a whole, more than two-thirds (67 percent) of the surveyed grantmakers say their arts grants, as a proportion of their overall funding, will not change during the next five years (Figure 8-8). Among independent foundations, an even larger percentage (76 percent) expect to maintain a steady share of arts funding.

This finding raises the usual question: Is the glass half-full or half-empty? Certainly, sustaining a level of commitment to the arts is better than lowering that commitment. But just holding steady, in today's economy, may not be sufficient to nourish the financial health—and therefore the creative health—of arts organizations.

As various observers have warned, given the recession and severe government cutbacks, the absence of a higher level of contributed income leads many groups to enter the drowning waters of debt financing (see below). Combined with the fact that almost a quarter (23.4 percent) of the grantmakers report that the share of their arts grants will drop, and *only one out of 11 grantmakers plans an increase*, these findings reinforce the no-growth prediction made by FEDAPT, at least to the extent that a significant proportion of nonprofit arts income is dependent on foundation and corporate funding.

Further, in the business world, many more grantmakers are likely to reduce their arts share over the next five years. Among corporate giving programs (businesses that give directly, rather than through a foundation), *more than two out of five (44.4 percent) say they will decrease their arts grants as a percent of their overall funding*. The same number, 44.4 percent, or less than half, say their arts share will remain the same.

Among corporations that make grants through foundations, a slight majority—55 percent—expect their arts grants share to remain steady, but 40 percent of corporate foundations plan to cut back.

Data from a major national survey of corporate arts funding, "BCA Members Report on Their Alliances with the Arts," reinforce the observation that the arts will receive a lower priority within the business world during the 1990s. In 1991, 57 percent of the responding corporate members of Business

FIGURE 8-8. EXPECTED CHANGE IN ARTS FUNDING AS PROPORTION OF ALL FUNDING*

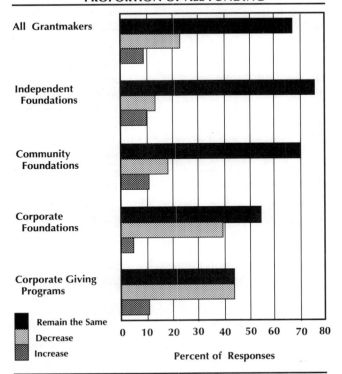

Source: The Foundation Center, 1992.
*Percentages based on 88 independent foundations, 27 community foundations, 40 corporate foundations, and 18 corporate giving programs.

Committee for the Arts decreased their arts support, while only 30 percent increased it, from the amount they gave in 1990. Reasons cited for the decline included the general economic recession, a drop in corporate earnings, and a shift in donations from arts to education and human services.[7]

In sum, among the surveyed grantmakers as a whole—consisting entirely of funders who have demonstrated a special commitment to the field—the arts face almost no likelihood of an increased share of funding. And where business donors are concerned, the arts will find themselves in an even tighter competitive position vis-a-vis other fields.

To be sure, this finding does not address the issue of whether *new* business funders or new or newly large foundations will emerge to fill the gap created by the reduced participation of some former donors.

GROWTH AND THE CRISIS OF DEBT

How do arts organizations cope with the prospect of no financial growth? According to FEDAPT, "A great number of organizations attempt to close the [financial] gap by simply spending the money anyway, and they have accumulated debts that are becoming debilitating or life threatening."[8]

Reducing debt is one form of support sometimes offered by grantmakers. Unfortunately, according to the survey, not one of the 182 responding funders indicated that debt reduction, or deficit financing, will be a priority in the near future (Table 8-9). Further, only 7.7 percent of all surveyed grantmakers—around one in 13—even accepted debt reduction as eligible for funding in 1991-92 (Table 8-10).

Commenting on the debt crisis and on the recommendation by various observers that arts groups would do well to adhere to management policies endemic to business enterprises, the Arts and Business Council noted:

"According to an NBC News study, one-third of all corporate profits in 1990 will go toward debt service. In a remarkably short time, the pattern and pathology of debt has infused virtually every sector of American life. And those who assert that the arts need to be more like business and government should take note that the arts have achieved this rather dubious goal—we are deeply and dangerously in debt."[9]

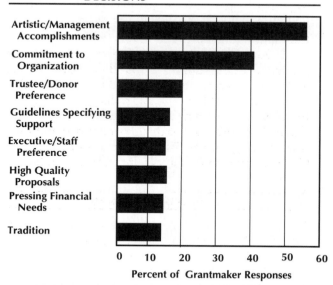

FIGURE 8-9. KEY FACTORS IN GRANT RENEWAL DECISIONS*

Percent of Grantmaker Responses

Source: The Foundation Center, 1992.
*Percentages based on multiple responses of 162 grantmakers.

Several leading arts funders in New York City and in California have, however, taken steps to address the "quiet crisis." Convinced that the solution entails nothing less than a complete reevaluation of the operating structures and missions of arts groups, New York donors established a three-year Arts Forward Fund to underwrite demonstration projects to consider sharply new approaches to long-term development. According to its literature, the Fund was formed to promote "partnerships between and among organizations, mergers of organizations, adoptions of small [groups] by larger institutions, organizations developed to meet artists' needs, [and] resource sharing." Planning grants and follow-up grants announced by the Fund in July 1992, would "enable key staff to work together and/or hire outside consultants to work with them to plan and implement approaches to long-term viability in the 1990s."

Local arts groups, however needy, were unable to tap into the Arts Forward Fund for operating expenses, emergency funds, or capital expenses. The Fund's sole purpose is to foster "divergent thinking" and innovative demonstrations of long-range viability. The Fund is administered by the New

York Community Trust, with staff provided on a pro bono basis by Art Matters, Inc. As of mid-1992, the Fund had raised more than $1.6 million from 20 foundations and corporate givers.

In Santa Clara County, California, ten major arts groups, with the support of foundations, businesses and local government, established the Silicon Valley Arts Fund (SVAF) to raise $20 million for bridge funds, venture capital, and endowments. By November 1992, the Fund had collected $6 million towards its goal. The SVAF is managed by the Community Foundation of Santa Clara County.

RENEWING ARTS GRANTS

Some funders renew grants to the same arts organizations, a practice hailed by those on the receiving end, and desired by those seeking a more stable income stream. What underlies the grants renewal process? Funders were asked to indicate the two most important factors in their grants renewal decisions.

ARTISTIC ACCOMPLISHMENT AND/OR MANAGEMENT HELD KEY TO GRANTS RENEWAL

To the extent that repeat grants are a goal of arts development officers, the message of this finding appears to be that quality art and competent management are the *sine qua non* of successful fundraising, at least from institutional donors.

Well over half the funders in this survey, as shown in Figure 8-9, maintain that the reason they renew their grants to the same arts organizations is that the groups have earned it through their artistic and/or managerial accomplishments. The only other factor that comes close, at 40.1 percent, is a commitment on the part of the grantmaker to sustain the organization.

Trustee or donor preference, the funder's own guidelines, preference of the staff, the quality of a proposal—none of these factors was cited by more than one out of five responding donors as the most important reason. It was likewise for such factors as a pressing financial need on the part of an organization, or tradition.

The definition of 'accomplishment' takes places within a very closed system. We [grantmakers] define it according to size (large), traditional forms

of management (corporate), and Western-trained artistic directors and artists. Artistic and management accomplishment carries its own set of discriminatory practices; it is imperative that we look at different ways to measure this when faced with organizations which are incredibly effective, but which don't conform to the usual models.

—Cynthia Gehrig, Jerome Foundation

All types of foundations agreed that general artistic and management accomplishment ranked first among factors affecting grant renewal decisions. Differences emerged among funder types over the second-ranked factor. For example, community foundations were just as likely to consider financial need as they were to consider commitment to organizations over time. Corporate foundations were more likely to renew grants based on guidelines and on traditions than on commitment to sustaining an organization over time.

MOST IMPORTANT PUBLIC AND GRANTMAKING ISSUES

Controversies surrounding government funding of the arts rose to fever pitch during 1989 and 1990, one to two years prior to the survey undertaken by this study. Sparked by exhibitions of artists Andres Serrano and Robert Mapplethorpe—and later fueled by performance art presentations that some critics deemed obscene—conservative and religious organizations and several U.S. Senators battled arts groups and civil libertarians over the policies and funding level of the National Endowment of the Arts (NEA).

Critics urged that the NEA be dismantled; arts groups and individual artists demanded an end to any type of censorship. Following demonstrations, letter writing campaigns, and various forms of lobbying, major changes in NEA policies—including restrictions on supporting art works containing "obscene" portrayals or depictions, and the requirement that "general standards of decency" be considered in funding decisions—were enacted by Congress in 1991. But in January of 1992, the Senate and House reversed the provisions that would prohibit funding of "patently offensive" works of art. (A half year later, in June 1992, a federal judge in

TABLE 8-4. GRANTMAKER AND GRANTEE VIEWS: KEY PUBLIC POLICY, POLITICAL, AND ARTISTIC ISSUES*

	Grantmakers		Grantees	
	No.	%	No.	%
Public Policy Issues				
Government Funding Cutbacks/Restructuring	140	83.8	103	79.8
Income Tax/IRS Policy	18	10.8	11	8.5
Non-Tax, Arts-Related Legislation	1	0.6	4	3.1
Political Issues				
Obscenity/Censorship Controversy	104	62.3	81	62.8
Other Ideological or Religious Pressures	21	12.6	21	16.3
Artistic Issues				
Standards of Quality	72	43.1	59	45.7
Restrictive Arts Discipline Classifications	21	12.6	24	18.6
Restrictions on Funding Only Professionals	18	10.8	8	6.2
Other Issues				
Ethics≠	15	9.0	21	16.3

Source: The Foundation Center, 1992.
* Percentages based on 167 grantmakers and 129 grantees.
≠ Among grantmakers, government, grantees, art dealers, etc.

TABLE 8-5. GRANTMAKER AND GRANTEE VIEWS: KEY SOCIAL/ECONOMIC ISSUES AFFECTING THE ARTS*

Grantmaker Responses	No.	%
Economic Viability of Arts in General	54	32.1
Declining Audiences for Arts Exhibitions/Performances	52	31.0
Access to Arts for Underserved Populations	48	28.6
Pluralism/Cultural Diversity	38	22.6
Recession/State of the Economy in General	26	15.5
Under-Compensation of Artists/Arts Administrators	13	7.7
Insufficient Professional Employment for Artists	10	6.0
Insufficient Work/Living Space for Artists	4	2.4
Support for U.S. Artists Abroad	0	0.0

Grantee Responses	No.	%
Economic Viability of Arts in General	40	31.5
Pluralism/Cultural Diversity	29	22.8
Under-Compensation of Artists/Arts Administrators	28	22.0
Declining Audiences for Arts Exhibitions/Performances	23	18.1
Recession/State of the Economy in General	23	18.1
Access to Arts for Underserved Populations	15	11.8
Insufficient Professional Employment for Artists	6	4.7
Insufficient Work/Living Space for Artists	4	3.1
Support for U.S. Artists Abroad	2	1.6

Source: The Foundation Center, 1992.
* Percentages based on multiple responses of 168 grantmakers and 127 grantees.

Los Angeles, in a case brought by four performance artists, ruled that the law's vagueness violated the First Amendment.)

Aftermaths of the conflict continued even after the House and Senate's action. When, in February 1992, the embattled NEA Chair, John E. Frohnmayer, announced his resignation effective May 1, it was widely believed that he had been dismissed by President George Bush, who himself was responding to pressure from the Republican Party's conservative wing.

During the time the conflict raged, management consulting organizations like FEDAPT and the Arts and Business Council sounded another, related alarm: arts organizations as a whole were facing a financial squeeze that threatened draconian consequences. The squeeze was due to a drowning debt load assumed by the nonprofits during the heated era of the 1980s and sharp cutbacks in state arts funding (NEA funding had remained fairly steady, at least prior to factoring in inflation). Data compiled by the National Assembly of State Arts Agencies (NASAA) reveal that state legislative allocations dropped 6 percent from fiscal 1990 to 1991, or more than 10 percent after inflation; they fell another 22 percent in fiscal 1992, with inflation consuming around an additional 3 percent.

Given the intensity of these developments, and the possibility of their affecting the philanthropic agenda at least in the near run, respondents were asked to rate the general political, public policy, economic, and artistic issues, as well as the grantmaking issues, that they considered most important to the arts and to arts funding today.

MAJOR PUBLIC ISSUES: GOVERNMENT CUTBACKS, CENSORSHIP, QUALITY OF ART

Grantmakers and grantees are strikingly close in terms of their positions on the most important public issues related to arts and arts funding today. Both populations provide almost identical rankings to the top three: government funding cutbacks, censorship, and standards of quality (Table 8-4).

Some disagreement, however, is evident in their respective views of social and economic issues. While both surveyed populations cited "economic viability of the arts in general" as number one, grantmakers next cited declining audiences and

access for underserved populations. Grantees, however, cited pluralism and diversity in the arts, and under-compensation of artists and administrators as the next most important socio-economic issues (Table 8-5).

> *The major problem facing the arts is funding. According to BCA research, most arts organizations have sustained funding cuts from business because companies have cut their total philanthropic budgets in response to the recession. As many businesses undertook cost-cutting measures to deal with reduced earnings, they often analyzed and redirected or shifted their funding priorities. Often, they decided to allocate available funds for educational and social programs and reduce support to the arts. This, along with the reduced support from foundations and no growth in government support, has severely affected the arts.*
> —Judith Jedlicka,
> Business Committee for the Arts

THE ISSUE OF QUALITY

Of special note here is that both grantmakers and grantees believe, in nearly identical proportions (43 and 46 percent, respectively), that "standards of quality" rank as an issue of prime importance, directly after the government cutbacks and censorship/obscenity issues.

Critics of government and of some private grantmaker funding of the arts often argue that many works funded have no intrinsic quality. In contrast, supporters of increased government and grantmaker allocations insist that the artistic quality is there, acknowledged in the government by panels of experts, and in private foundations by informed staff and board members, who decide on each grant application. Supporters argue further that outside critics, often basing their views on religious, political or ideological convictions, are unqualified to pass judgment.

The issue of quality was addressed at the start of the 1990s in a collection of essays commissioned by the American Assembly, later published as *Public Money and the Muse*, to contribute to "a broad national agenda" for government policy towards the arts. According to one of the contributors, Arthur Levitt, Jr., former Chief Executive Officer of the American Stock Exchange and a board member of leading foundations and the New York State Council on the Arts, quality is the single most important factor in arts success.

"The arts, too [like successful business enterprises], are driven by top line thinking," he wrote. "Quality comes first. Quality is what endures in art and what artists strive for above all else. And, until recently at least, quality was the deciding factor in the National Endowment for the Arts' grantmaking. Its peer panels have demonstrated a remarkable instinct for recognizing and supporting quality, as well as the promise of quality."[10]

That "standards of quality" are considered the most important public issue related to arts funding by more than two out of five surveyed grantmakers, and by the same proportion of surveyed arts organizations, may reveal that the issue is likely to receive increased attention by both donors and donees in the coming years.

Who sets standards of quality? One advisor to this study noted that "standards of quality are of utmost concern because they are contested. Why is a performance of Mozart more likely to receive funding than one by Eleanor Hovda or Anthony Davis? Standards of quality are an issue not because they're not being enforced, but because they have belonged to one class, gender and race for much of the history of support for the arts in America. In the newspapers, standards of quality are being contested between the general public and the arts community; [and] the [debate] which is occurring within the arts community is even more heated."

Another dimension to the quality debate, voiced by another observer, is that the "critical community itself (the art critics) is not educated in the variety and diversity of cultural forms. So what gets printed does not reflect the quality of non-Western esthetics."

CULTURAL DIVERSITY

On the issue of pluralism/cultural diversity, grantees ranked it second among the most important social or economic issues; grantmakers placed it fourth (Table 8-4), although around a fifth of each surveyed population cited it. It is reasonable to expect that had the survey been conducted on a regional rather than a national basis, the issue might have been cited more often by one or both surveyed populations.

In Santa Clara County, for example, where some 43 languages and dialects are spoken in the San Jose public schools, it appears to be a more urgent topic of discussion among both grantmakers and arts organizations than either censorship or artistic innovations, according to Peter Hero, director of the local community fund.

MAJOR GRANTMAKING ISSUES: COMPETITION, RISK-TAKING

Here again, grantmakers and grantees tend to agree on grantmaking issues of prime importance. As revealed in Figure 8-10, both cite competition for money between the arts and other fields, competition among arts groups themselves, and the capacity of funders to take risks as the three most important grantmaking issues.

However, they hold opposite views on two related issues: funders cite the quality (or lack thereof) of proposals submitted by arts organizations; grantees cite the capacity (or lack thereof) of grantmakers to properly evaluate proposals.

PREDICTED IMPACT OF THE ISSUES

How are these public and grantmaking issues likely to affect both the funders and recipients? Are donors about to offer more grants for advocacy, or fewer? Are they apt to show greater willingness to fund controversial works—or less willingness?

By the same token, are the arts organizations themselves more likely to engage in advocacy and coalitions, or less likely? Will they be more willing to create and promote controversial works—or will they tend to play it safe?

Specifically, both groups of respondents were asked to describe briefly how the issues they ranked highest were likely to affect their grantmaking—or, in the case of the grantees, their activities—in the near future. (For the exact wording, see question 11 on the grantee survey, and question 13 on the grantmaker survey, Appendix D.)

ARTS GROUPS FORESEE MORE ADVOCACY AND MORE FUNDRAISING

Among the 95 arts organizations offering a comment, the largest number—26, or 27.4 percent—asserted they will engage in more advocacy, often in conjunction with other organizations, a process referred to as "coalition building." The next largest number, 20 percent, reported a determination to shore up their fundraising efforts; and six groups, or slightly more than 6 percent, said they would concentrate on audience outreach and education, which can reinforce both advocacy and fundraising.

While increased fundraising is usually supported by grantmakers, candid comments by some of the grantees may raise a disturbing issue: donor control over the artistic process.

"As a small nonprofit," said the director of a Maine-based theater group, "it is difficult to get one's foot in the door. We'll be expanding programs and activities in order to 'fit' grantmakers' guidelines." And a California-based symphony orchestra noted: "Corporations and foundations are moving so completely in the direction of funding only [arts-related] youth, education, outreach and/or multicultural programs that it is getting difficult to fund

FIGURE 8-10. GRANTMAKER AND GRANTEE VIEWS: MOST IMPORTANT ARTS GRANTMAKING ISSUES*

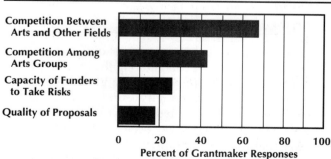

Source: The Foundation Center, 1992.
*Percentages based on multiple responses of 173 grantmakers and 127 grantees. Abbreviated list. For complete list see Table 8-17.
**Refers to the capacity of funders to make informed decisions.

our basic concert series—which is what makes all of these other programs possible."

Concerning artistic risk taking, this may amount to less of an issue than is generally believed, to judge by the survey responses. When the National Endowment for the Arts (NEA) came under intense pressure to defund works of a controversial, primarily sexual nature, two dominant reactions emerged. One foresaw a chilling effect upon arts groups, which would bow to pressure to retreat from undertaking risky or innovative works, for fear of alienating private grantmakers as well. The other reaction predicted the opposite effect: that the arts community would redouble efforts to push beyond the limits of convention.

Very few of the grantees answered either way, which may indicate that the issue of risky or unconventional artwork is not as pressing vis-a-vis private grantmakers as it is in relation to the NEA. Among the 95 arts groups who responded to the question of how the issues would affect them, nine (9.5 percent) said they would move towards greater risk taking (sometimes adding the modifier "high quality"); seven (7.4 percent) said they would be less likely to mount controversial exhibits or stage risky productions.

One explanation as to why funding controversial art and advocacy may not command much attention, at least among foundations and corporations, is that the vast majority of grantmakers fund neither area.

The only other response mentioned often enough to be categorized referred to programming cutbacks, cited by 17 organizations, or 17.9 percent of the respondents to this question. The ultimate cutback was predicted by a New York State music organization: "Despite good management and excellent artistry (among the best in the country), we are in danger of going out of business."

Other comments offered by grantees included:

We must press forward in stressing artistic excellence as [a] primary concern in balance with, and as vital as, a range of socially necessary causes related to the quality of life we lead in America.
 —New York music ensemble

We are dedicated to developing talents and audiences within underserved populations. We would

like to see more of an awareness of the needs of disabled, immigrant, impoverished and incarcerated populations.
 —New York publishing organization

Arts organizations must look to a different future. Funders don't seem willing to acknowledge the change. We need venture capital and money to plan—to engage underused resources.
 —Connecticut theater group

In the music world, very little money goes to women. This is never brought out as an issue.
 —California symphony orchestra

SOME GRANTMAKERS PREDICT FEWER FUNDS TO ARTS, MORE TO HUMAN SERVICES

Among the 140 grantmakers who responded to the question of how the public and grantmaking issues would affect their arts funding policies, the largest number—31, or more than a fifth—said they would be likely to award fewer grants to the arts, shifting resources instead to human services. Several others emphasized that while their total arts funding would remain constant, they would either give to more established organizations, or establish more rigorous evaluations of grant proposals from arts groups. The next largest number—22, or 15.7 percent—maintained that the issues would have no effect on their policies.

As with the grantees, the issue of funding controversial versus "safe" art does not appear to command much attention among the funders. Ten percent of the responding grantmakers said they would be more likely to fund risky or unconventional works, and 8.6 percent said they would be less likely to do so. In other words, for more than 80 percent of the donors, the issue itself was not important enough to warrant a position. Likewise with advocacy: 5 percent said they will be funding more advocacy, and under 3 percent, less advocacy.

Mickey Mouse, Michelangelo, and Mapplethorpe. Comments by responding grantmakers are often as revealing as aggregate statistics. The executive director of an independent foundation in Texas responded to the question of how the issues would affect him by stating: "Give me Mickey Mouse or

give me Michelangelo, but keep the Mapplethorpes away."

Another noted that while his board would probably show more resistance to risky grants, he himself *"will still recommend"* that such art be funded.

A funder in North Carolina, predicting that monies would be siphoned away from the arts, explained why: "Arts organizations will likely receive very little of our discretionary funding because human services are in such need."

And a grantmaker in Tennessee laid the challenge to arts organizations themselves: "The arts are not doing a good job of positioning themselves as important grantees versus human services, and as a result, funding is in jeopardy."

Among grantmakers planning to shift allocations away from the arts and towards human services, one Minnesota funder predicted that the current economic recession will foster a kind of social Darwinism among recipients: "Arts groups will [prevail according to] survival of the fittest," the director wrote, adding that his foundation would attribute "greater importance [to] budget management and marketing of services and audiences served."

Organizational Strengthening. That last comment was typical of the thinking of several grantmakers who cited the need for arts groups to shore up their own organizational operations. One respondent, reporting less willingness to fund risky works, argued that arts organizations would have to devote more time to effective planning and income generation, primarily through audience development and marketing. "[There is a] need for groups seeking funds to have [the] capacity to meet their own expectations and goals," this grantmaker said. Added another: "[We] may have to choose between viable arts organizations and those not likely to survive."

To some grantmakers, it may be too late for the smaller arts groups, regardless of how well they shore up their organizational structures. "So many requests—so little $$," wrote a Connecticut donor. "I'm afraid good but narrow-focus arts groups will have to be denied in favor of broader focus, larger presenters." It should be recalled that the most commonly cited criticism of grantmaker policies—cited both by grantees and by grantmakers themselves—

is precisely that they favor large, better established arts organizations over smaller, lesser known groups (Figure 8-4).

This is not to say that large arts groups have no worries. According to California-based advisor Juan Carillo, representing state arts funding, "It may be too late for some of them as well."

Further, the very economic crisis that leads some funders to favor larger groups with well-established operations has motivated others to concentrate on helping "smaller arts groups to become viable," said one Ohio grantmaker.

And a large national arts funder based in New York City noted that "it is often the most fragile smaller arts groups that are closer to the real societal tensions; precisely for that reason we must pay closer attention to them."

> *The dilemma of grantmakers who can no longer afford to support newer, smaller groups, regardless of how high quality they might be, is a regrettable but perhaps unavoidable result of grantmaker policy itself: over time, many grantmakers shifted funding from project to operating support, which in turn created a kind of expectation or entitlement mentality among such favored arts groups. This forces hard choices. Until more money is found, funders will have to juggle the twin priorities of annual, no-strings operating support for larger high quality groups, and the commitment to quality wherever it emerges.*
>
> —Peter Hero,
> Community Foundation
> of Santa Clara County

INDIVIDUAL ARTISTS

Very few foundations or corporations in the United States provide funds directly to individuals, regardless of field. For reasons of taxation and accountability, as well as a reluctance by grantmakers to change their own charters, most grants are awarded to organizations. However, among grantmakers focusing on the arts, the issue of supporting individuals has gained some currency.

In November 1991, for example, some 40 donors and artists convened in New York at a session sponsored by the Artist Fellowship Roundtable, an informal group established to explore issues pertaining to support of individual artists. The session was

FIGURE 8-11. GRANTMAKER INTENTIONS TO SUPPORT INDIVIDUAL ARTISTS DIRECTLY*

Plan to Support Individual Artists Directly** 14.5%

Do Not Plan to Support Individual Artists Directly 85.5%

Percent of
Grantmaker Responses

Source: The Foundation Center, 1992.
*Percentages based on166 grantmakers.
**Support through commissions, grants for living/workspace, scholarships and fellowships, and prizes and awards.

FIGURE 8-12. GRANTMAKER INTENTIONS TO SUPPORT INDIVIDUAL ARTISTS THROUGH REGRANTING*

Not Sure 12.1%

Plan to Use Regranting Mechanisms 24.9%

Do Not Plan to Use Regranting Mechanisms 63.0%

Percent of
Grantmaker Responses

Source: The Foundation Center, 1992.
*Percentages based on 173 grantmakers.

held at the offices of the New York Foundation for the Arts.

According to one summary of the meeting, a key problem facing both donors and individual recipients is that "it is easier to support art—the finished product—than artists. In the discourse of arts funding, the creative process itself is often elided."[11] Unlike science funding, in which support of the process of pure or theoretical research, as opposed to applied research, is widely acknowledged as essential, the "very idea of supporting individual artists for their work [process] is alien to most funders in the arts."

It bears repeating that foundations can legally make grants to individual artists, if the Internal Revenue Service approves the procedure by which such artists are selected and awarded funds. Essentially, the criteria applied by the IRS pertain to openness, fairness, and the absence of conflicts of interest for foundation staff and trustees. (See Chapter 6, for more on support for individual artists, including a summary of key funders.)

In an effort to ascertain the extent to which individual artists, rather than arts organizations, can expect private institutional patronage, the survey asked grantmakers their intentions.

LITTLE CHANGE EXPECTED IN INDIVIDUAL ARTIST GRANTS

Individual artists can expect no major change in the near future: arts funding by institutional donors will continue to be channeled overwhelmingly to non-profit organizations. Of the 166 arts grantmakers

who responded to this question, 85.5 percent said they have no intention of providing funds directly to individual artists (Figure 8-11). Of the remaining 24, nearly half (11) will provide commissions to produce visual, performing, or media works of art; ten will give grants for living and/or working space; nine will grant fellowships and scholarships directly to individual applicants, and five will support individuals through prizes and competitions. (Of the 24 respondents, several will support individual artists in two or more of the above ways.)

Direct grants, to be sure, are only one means by which funders can support individuals. Regranting mechanisms are another method; funds are given to an arts organization to be redistributed to individual applicants. How widespread is this method?

Almost two-thirds, or 63 percent, of some 173 responding donors said they would *not* utilize regranting mechanisms (Figure 8-12.) A quarter (24.9 percent) said they would, and 12.1 percent were unsure. (For historical data on indirect grants to individual artists, see Chapter 6, Table 6-1.)

There may be several ironies in the fact that so few funders plan to support individual artists either directly or indirectly, as well as in the related fact that only 8 percent of the surveyed donors consider artistic salaries (which ultimately go to individuals) as among the most critical needs arts groups face (see Table 8-8).

First, one in six funders responding to an earlier question ranked the needs of individual artists as among the top critical needs arts organizations face

(Table 8-8). In other words, "individuals" in general, or in the abstract, are considered important by at least a sixth of the responding donors; specific or concrete individual needs are not.

Second, while giving low priority to artistic salaries, grantmakers often stress the importance of audience development. Yet according to the deliberations of the Artist Fellowship Roundtable, artists need substantially higher salaries to continue to create their art, which audiences are then invited to enjoy. As expressed by a participant at the Roundtable's conference in November 1991, "Support for audience development is meaningless unless there is a concomitant support for artist development."[12]

What is the public's view on indvidual artists? Since 1987, annual national studies sponsored by the American Council for the Arts have shown that around half the American public believes that individual artists deserve support from the federal government. [13]

> With limited resources currently available for the arts, it is clear that business and foundation grantmakers want their support to be directed to strengthening the managerial aspects of arts organizations and to maintaining and developing future markets—audiences—for artistic endeavors.
>
> The priorities listed by the arts groups, such as administrative and artistic salaries and new commissions, may not be realistic considerations in this economic climate—we are in a recession, unemployment is high, and business has had to 'right-side' and table the introduction of new products and services because of market conditions.
> —Judith A. Jedlicka,
> Business Committee for the Arts

ARTS FUNDING IN SUPPORT OF OTHER SOCIAL CAUSES

Just as the arts—or more broadly, Arts, Culture, and Humanities—overlaps with many other fields, such as health, education, and environmentalism, so foundations and corporations provide arts grants to organizations that define their major purpose in areas other than the arts.

To gain a reading on this issue for the coming year, grantmakers were asked: a) whether they plan to give 10 percent or more of their arts grants to non-arts organizations; if so, to which types of organizations; and c) for which broad arts fields.

ARTS DOLLARS TO SUPPORT MANY FIELDS— BUT MOST GRANTS WILL GO TO ARTS GROUPS

Arts support will overlap with many other fields in the coming fiscal year, especially education. But, for the most part, the money will not be siphoned away from the arts groups themselves; rather, regardless of social goals, arts organizations will continue to be the principal vehicles of funds. They—not schools or service providers—will be given the money slated for the arts, and will simply use it to fulfil broad goals.

Nonetheless, about one in seven respondents reported plans to provide at least 10 percent of their arts grants to organizations that are not specifically arts groups. In these cases, the bulk of the money will go to educational institutions and human service providers, with the remainder to a variety of other groups. (For historical data on arts grants to educational institutions and other non-arts organizations, see Chapter 5, Table 5-10.)

The most significant finding, however, is that 149 of the grantmakers, or 82 percent of those surveyed, do plan to provide arts grants for a host of social purposes, regardless of whether the recipient is an arts group or represents another field.

Education is far and away the primary goal of these grants; arts funding will be used in support of formal learning by more than nine out of ten funders responding to this question—91.3 percent.

At least two explanations may be offered for this finding: a) a widening conviction that the arts are, in themselves, as essential to basic education as the traditional "reading, writing, and arithmetic"; and b) a preponderance of arts, media arts, and literary or journalism activities based on the university campus.

In any event, no other field comes close to education as a non-arts subject to be enhanced by arts funding.

Human services is the next broad field to be linked with the arts, from 30.9 percent of the respondents, or about one in three donors. Health, environmental protection, and public-society benefit (civil rights, civic improvement, etc.) will be supported by arts grants from about one in five donors each.

Education Projects. Grantmakers were asked to elaborate briefly on the nature of the educational, health, human service, and other projects they fund with arts grants. The following examples show how funders will use arts money in the service of education:

- "We will inform [the] public about the importance of arts in their lives;"

- "Broaden the base of arts support by educating students about the arts;"

- "Multi- and cross-cultural arts educational opportunities; introduction to western classical art forms for school children;"

- "Arts education programs which involve youth in concentrated arts experiences; youth arts festivals;"

- "Arts in the schools as part of dropout prevention."

Other Projects. Examples of how arts funding will be used on behalf of causes or fields other than formal education include:

- Theater about domestic violence; theater about river and fuel conservation;

- AIDS awareness and education, and support to artists living with AIDS;

- Exposing the arts to underserved populations, including the handicapped and low-income groups;

- Cultural diversity projects; community empowerment projects; increased opportunities for minority artists;

- Opera/community theater joint venture on alcohol and drug prevention for children;

- Music therapy, especially for Alzheimers patients;

- Arts workshops for the homeless;

- Environmental arts festivals;

- Projects to help children "develop their talents as a way of broadening access to educational and economic opportunity;"

- Exhibit on aging; show of works by teenage artists;

- Species preservation education for children through arts activities;

- Creation of a downtown cultural center, combined with an urban redevelopment agenda.

STABILITY VS. CHANGE IN ARTS FUNDING PRIORITIES

How steady are the policies of America's leading arts grantmakers?

Part of the motivation for this benchmark study was a sense among leading arts grantmakers that funding policies pertaining to the arts may have undergone a significant change during the past two years. The recession, corporate restructuring, stock market volatility, conflicts over NEA funding, lobbying by groups with strongly held political and religious convictions—all these factors, it has been argued, have combined to provoke significant change in the priorities and policies of arts funders.

To test this perception, the survey asked grantmakers whether their arts funding priorities or policies have changed significantly within the past two years.

No Change in Recent Priorities for Most Funders

The assumption by Grantmakers in the Arts that a sea-change had occurred in arts grantmaking at the turn of the decade was not borne out, at least not for the majority of arts funders.

Of the 179 respondents to this question, almost three-quarters, or 71.5 percent, said they had not altered their arts funding priorities recently. More than a quarter, 27.4 percent or 49, said they had, and the remaining 1.1 percent were not sure.

Among those who have altered their priorities recently, what specific factors actually led them to make the change?

Funders were asked to rank the following factors as catalysts for their changed policies: preferences of trustees, changes in staff, perceived trends in the grantmaking world, perceived trends in the arts world, societal or environmental developments, and other factors.

Only 22 respondents answered this question—less than half of those 49 who had indicated a change in recent funding priorities and only 12 percent of all respondents. Several declined to rank

their responses, which suggests that they considered all they checked as of equal, hence primary, importance. The 22 respondents provided a total of 71 answers.

STAFF AND SOCIETAL CHANGES KEY TO ALTERED PRIORITIES

More than two-thirds (15) of the 22 funders responding to this question indicated that the most important factor in their institution's decision to alter funding priorities during the past two years was a change in staff, most likely at the level of chief executive or executive director.

But developments in the environment, or society at large, were cited by almost as many—14. And "other" factors, cited by half the respondents, actually included some societal issues, such as the spread of AIDS, the censorship controversy, and the state of the economy. Relatively few of the respondents elaborated on these factors, or specified the nature of their recent changes. Most of those who cited environmental factors mentioned the economy and demographic shifts. Following is a summary of comments from those who responded.

Societal Factors Motivating Change in Arts Funding Priorities. The economy, less money and more pressing human needs, the growing underclass, social needs, lack of appreciation of the value of arts in our culture, demographic changes and economic realities, New York City's changing economic climate, censorship threat.

Other Factors Motivating Change in Arts Funding Priorities. Limited grantmaker resources, decision to re-establish an old program, growth of music therapy, first amendment and AIDS issues, the economy, change in ownership (cited by a recently merged corporate giver), more funds available, neighborhood funding focus, and long-term projection of decline in endowment.

What was the nature of these changes? Following are summaries of the responses.

- Focus on outreach and educational programming; particular support for arts education in schools, given local funding cutbacks in this area;

- Establishment of an arts advocacy component, to support freedom of expression and increased public funding;

- More flexible support for established organizations; greater commitment to underserved populations; funding programs that develop strong linkages between the arts and economic development;

- Emphasis on community-based arts; support for diversity and community collaboration; support for developing organizations;

- More rigorous selection process; more targeted funding goals; more thorough evaluation of grants;

- Increased focus on national grantmaking and individual artists.

Again, it is important to consider the limited responses to this question. At least one or more of the above factors leading to changes in funding priorities was cited by only 12 percent—a very small proportion—of the surveyed grantmakers.

CORPORATE CONTRIBUTIONS DATA

The following analysis refers to corporate grantmakers only, including company-sponsored foundations and corporate giving programs. Fifty-nine companies responded to the survey—44 company-sponsored foundations and 15 corporate giving programs. Despite the relatively small size of the sample, many of the largest corporate arts funders are represented. (Survey respondents are listed in Appendix C.)

MOST ARTS SUPPORT
DERIVES FROM CONTRIBUTIONS BUDGET

More than nine out of ten arts dollars from businesses derive from contributions budgets. In spite of much publicity about growth of cause-related marketing, only a tiny proportion of corporate arts support derived from those sources.

SOURCES OF CORPORATE ARTS FUNDING	
Contributions budget	93.9%
Advertising/PR budget	1.6
Other	1.3
Marketing budget	0.5
Unspecified	2.7

MOST CORPORATE ARTS CONTRIBUTIONS ARE MADE IN CASH

Arts support from leading corporate arts donors surveyed in this project almost always take the form of cash. Marketing and promotional services comprise 1.5 percent, and in-kind gifts, such as equipment, and supplies, account for less than 1 percent. There is no statistically significant difference between firms that have established foundations and companies that dispense grants directly.

How do these figures compare with corporate donations to other fields? According to the latest data published by The Conference Board (TCB), a business research organization annually polling corporate donors, 84.6 percent of all business donations from the TCB sample take the form of cash. Property, such as buildings, accounts for 5 percent, products and supplies, 9.8 percent, and securities, 0.6 percent.[14]

FORMS OF CORPORATE CONTRIBUTIONS

Cash	94.1%
Marketing/Promotion	1.5
Buildings	0.7
Equipment	0.5
Supplies	0.2
Unspecified	3.0

COMPANIES PROVIDE SERVICES TO ARTS GROUPS IN ADDITION TO GRANTS

Only half the 59 corporate grantmakers polled responded to the question of whether they offer services to arts organizations in addition to grants. Of those responding, more than half (16 of 29) provide some form of management consulting. Two out of five (12) allow arts groups to use their offices or building space, and slightly less than a third (9) make available such equipment as photocopying machines. Another two out of five provide a host of other services. However, these figures may be misleading, since only 29 firms, or just about half of the corporate grantmakers polled, responded. If it is assumed that those who did not answer in fact do not provide these services and facilities, then the percentage of businesses cited must be reduced by half.

ENDNOTES

1. Nello McDaniel and George Thorn, *The Quiet Crisis in the Arts*, Foundation for the Expansion and Development of the American Professional Theater (FEDAPT), 1991, New York, Pages 7, 10; *Critical Issues and the Arts*, The Arts and Business Council, Inc., May 1991, New York; Richard Mittenthal, *The State of the Arts: Report from Chicago*, The Conservation Company, 1990, New York.

2. Todd London, *The Artistic Home: Discussion with Artistic Directors of America's Institutional Theatres*, Theatre Communications Group, Inc., 1988, New York, Page 45.

3. "Second Annual Survey of American Arts Organizations," A BCA Report, July 1992, Business Committee for the Arts, New York.

4. Barbara Beerstein, "The Silicon Valley Arts Fund: A Brief Overview," Silicon Valley Arts Fund, in partnership with the Community Foundation of Santa Clara County, April 1992, San Jose.

5. Dennie Palmer Wolf and Mary Burger, "More than Minor Disturbances: The Place of the Arts in American Education," in Stephen Benedict (ed.), *Public Money and the Muse: Essays on Government Funding for the Arts*, W.W. Norton & Co., 1991, New York, Page 120.

6. McDaniel and Thorn, op. cit., Page 18

7. "BCA Members Report on Their Alliances with the Arts," Business Committee for the Arts, New York, October 1991, Page 1.

8. McDaniel and Thorn, op. cit., Page 18.

9. Arts and Business Council, op. cit., Page 17.

10. Arthur Levitt, Jr., "Introduction," in Stephen Benedict (ed.), *Public Money and the Muse*, op. cit., Pages 21-22.

11. Ken Hope, "Musings on Themes from the Artist Fellowship Roundtable," Grantmakers in the Arts *Newsletter*, Spring 1992.

12. Ken Hope, op. cit., Page 5.

13. LH Associates, *America and the Arts IV*, American Council for the Arts, March 1992, New York, Page 5.

14. Anne Klepper, *Corporate Contributions, 1989,* The Conference Board, Report #954, 1991, New York, Chart 19, Page 18.

TABLE 8-6. ARTS GRANTEE SURVEY RESPONDENTS BY SUBFIELD (COMPLETE LIST)*

Arts Field	No.	%
Music≠	19	14.3
Theater	18	13.5
Art Museums	12	9.0
Symphony Orchestras	9	6.8
Multidisciplinary Arts	8	6.0
All Other Dance (Jazz, Ethnic, etc.)	7	5.3
Printing/Publishing (Literary Journals)	7	5.3
Arts Services	6	4.5
Opera/Light Opera/Musical Theater	6	4.5
Performing Arts Centers/Presenters/Sponsors	6	4.5
Arts Alliances/Coalitions/Advocacy	5	3.8
Film/Video/Holography	5	3.8
Ballet	4	3.0
Media/Communications—General	3	2.3
Modern Dance	3	2.3
Arts Councils/Agencies	2	1.5
Visual Arts Centers/Exhibition Spaces	2	1.5
Arts Education	1	0.8
Arts Training/Schools of Art	1	0.8
Crafts	1	0.8
Cultural/Ethnic Awareness	1	0.8
Literature (Creative Writing)	1	0.8
Multidisciplinary Centers	1	0.8
Other Arts Fields	1	0.8
Specialized/Other Museums	1	0.8
Television	1	0.8
Not Specified	2	1.5
Total	**133**	**100.0%**

Source: The Foundation Center, 1992.
* Percentages based on 133 grantees. Due to rounding, figures may not add up.
≠ Does not include symphony orchestras.

TABLE 8-7. ARTS GRANTMAKER AND GRANTEE SURVEY RESPONDENTS BY STATE*

State	Grantmakers No.	Grantmakers %	Grantees No.	Grantees %
Alaska	0	0.0	4	3.0
Arizona	3	1.6	1	0.8
California	25	13.7	25	18.9
Colorado	3	1.6	2	1.5
Connecticut	3	1.6	5	3.8
District of Columbia	3	1.6	4	3.0
Florida	6	3.3	3	2.3
Georgia	1	0.5	1	0.8
Hawaii	1	0.5	1	0.8
Illinois	11	6.0	5	3.8
Indiana	3	1.6	0	0.0
Iowa	1	0.5	1	0.8
Maine	0	0.0	2	1.5
Maryland	2	1.1	3	2.3
Massachusetts	2	1.1	3	2.3
Michigan	7	3.8	2	1.5
Minnesota	11	6.0	7	5.3
Missouri	3	1.6	2	1.5
Montana	0	0.0	2	1.5
Nebraska	1	0.5	1	0.8
Nevada	1	0.5	0	0.0
New Hampshire	1	0.5	0	0.0
New Jersey	3	1.6	4	3.0
New Mexico	1	0.5	1	0.8
New York	42	23.1	21	15.8
North Carolina	2	1.1	4	3.0
Ohio	12	6.6	4	3.0
Oklahoma	0	0.0	1	0.8
Oregon	2	1.1	1	0.8
Pennsylvania	13	7.1	9	6.8
Rhode Island	1	0.5	1	0.8
Tennessee	3	1.6	0	0.0
Texas	10	5.5	3	2.3
Virginia	1	0.5	1	0.8
Washington	0	0.0	3	2.3
West Virginia	0	0.0	1	0.8
Wisconsin	2	1.1	3	2.3
Total	**182**	**100.0%**	**133**	**100.0%**

Source: The Foundation Center, 1992.
* Due to rounding, figures may not add up.

TABLE 8-8. GRANTMAKER AND GRANTEE VIEWS: MOST CRITICAL NEEDS OF ARTS GROUPS BY SPECIFIC TYPES OF SUPPORT (COMPLETE LIST)*

Grantmaker Responses	No.	%
Unrestricted Operating Support	95	60.9
Audience Development	37	23.7
Long-Range/Strategic Planning	34	21.8
Endowment	29	18.6
Individual Artists≠	26	16.7
Program Development	25	16.0
Board Development	24	15.4
Restricted Operating/Management Support	24	15.4
Marketing/Advertising/Media Relations	23	14.7
Debt Reduction/Deficit Financing	20	12.8
Fundraising/Volunteer Recruitment	16	10.3
Capital Campaigns/Purposes	14	9.0
Administrative Salaries	13	8.3
Artistic Salaries	13	8.3
Creating/Commissioning New Works	11	7.1
Budgeting/Accounting/Financial Planning	9	5.8
Curriculum Development	8	5.1
Seed Money/Program Start-Up	8	5.1
Emergency Funds	7	4.5
Facilities Acquisition/Renovation	7	4.5
Performance Presentation	7	4.5
Technical Assistance	7	4.5
Staff/Faculty Development	6	3.8
Student Aid/Professional Training	6	3.8
Program Planning	5	3.2
Staff Training	5	3.2
Arts Equipment	4	2.6
Collections Management/Conservation/Preservation	4	2.6
Program-Related Investments	2	1.3
Research	2	1.3
Scholarships/Fellowships	2	1.3
Exhibitions	1	0.6
Insurance	1	0.6
Office Equipment/Furniture/Computers	1	0.6
Media Production (Film/Video/Radio)	1	0.6
Touring	1	0.6
Other	1	0.6

Grantee Responses	No.	%
Unrestricted Operating Support	121	91.7
Endowment	69	52.3
Administrative Salaries	50	37.9
Artistic Salaries	46	34.8
Internships/Apprenticeships	45	34.1
Creating/Commissioning New Works	41	31.1
Individual Artists≠	38	28.8
Facilities Acquisition/Renovation	35	26.5
Debt Reduction/Deficit Financing	33	25.0
Performance Presentation	33	25.0
Audience Development	28	21.2
Curriculum Development	27	20.5
Touring	27	20.5
Fundraising/Volunteer Recruitment	23	17.4
Arts Equipment	22	16.7
Long-Range/Strategic Planning	22	16.7
Office Equipment/Furniture/Computers	22	16.7
Scholarships/Fellowships	18	13.6
Seed Money/Program Start-Up	17	12.9
Research	16	12.1
Emergency Funds	15	11.4
Exhibitions	15	11.4
Publications	14	10.6
Staff/Faculty Development	13	9.8
Board Development	12	9.1
Marketing/Advertising/Media Relations	11	8.3
Program Development	11	8.3
Staff Training	11	8.3
Restricted Operating/Management Support	10	7.6
Collections Management/Conservation/Preservation	9	6.8
Program-Related Investments	9	6.8
Student Aid/Professional Training	9	6.8
Capital Campaigns/Purposes	8	6.1
Media Production (Film/Video/Radio)	8	6.1
Budgeting/Accounting/Financial Planning	7	5.3
Other Types of Support	7	5.3
Collections Acquisition	6	4.5
Insurance	5	3.8
Land Acquisition	4	3.0
Professorships	3	2.3
Technical Assistance	2	1.5
Legal Services	1	0.8
Program Planning	1	0.8

Source: The Foundation Center, 1992.
* Percentages based on multiple responses of 156 grantmakers and 132 grantees.
≠ Through direct grants and regranting.

TABLE 8-9. GRANTMAKER PRIORITIES FOR COMING YEAR BY TYPES OF SUPPORT (COMPLETE LIST)*

Type of Support	No.	%
Unrestricted Operating Support	75	44.4
Program Support	58	34.3
Performance Presentation	30	17.8
Restricted Operating/Management Support	29	17.2
Capital Campaigns/Purposes	27	16.0
Curriculum Development	21	12.4
Audience Development	16	9.5
Exhibitions	16	9.5

	No.	%
Facilities Acquisition/Renovation	14	8.3
Creating/Commissioning New Works	12	7.1
Individual Artists≠	9	5.3
Seed Money/Program Start-Up	8	4.7
Long-Range/Strategic Planning	7	4.1
Program Planning	7	4.1
Marketing/Advertising/Media Relations	6	3.6
Office Equipment/Furniture/Computers	6	3.6
Scholarships/Fellowships	6	3.6
Student Aid/Professional Training	5	3.0
Touring	5	3.0
Arts Equipment	4	2.4
Publications	4	2.4
Administrative Salaries	3	1.8
Artistic Salaries	3	1.8
Collections Acquisition	3	1.8
Endowment	3	1.8
Fundraising/Volunteer Recruitment	3	1.8
Media Production (Film/Video/Radio)	3	1.8
Research	3	1.8
Technical Assistance	3	1.8
Internships/Apprenticeships	2	1.2
Other Types of Support	2	1.2
Staff Training	2	1.2
Board Development	1	0.6
Budgeting/Accounting/Financial Planning	1	0.6
Collections Management/Conservation/Preservation	1	0.6
Emergency Funds	1	0.6
Land Acquisition	1	0.6
Professorships	1	0.6
Program-Related Investments	1	0.6
Staff/Faculty Development	1	0.6

Source: The Foundation Center, 1992.
* Percentages based on multiple responses of 169 grantmakers.
≠ Through granting and regranting.

TABLE 8-10. TYPES OF SUPPORT ELIGIBLE FOR FUNDING IN 1991 (COMPLETE LIST)*

Type of Support	No.	%
Program Support	**165**	**90.7**
Performance Presentation	116	63.7
Exhibitions	110	60.4
Curriculum Development	76	41.8
Seed Money/Program Start Up	69	37.9
Creating/Commissioning New Works	62	34.1
Media Production (Film/Video/Radio)	54	29.7
Staff/Faculty Development	46	25.3
Touring	45	24.7
Collections Management/Conservation/Preservation	42	23.1
Publication	42	23.1
Professorships/Chair Endowments	12	6.6
Restricted Operating/Management Support	**121**	**66.5**
Audience Development	84	46.2
Program Planning	68	37.4
Long-Range and Strategic Planning	60	33.0
Technical Assistance	58	31.9
Marketing/Advertising/Media Relations	54	29.7
Administrative Salaries	50	27.5
Artistic Salaries	49	26.9

Staff Training	49	26.9
Fundraising/Volunteer Recruitment	47	25.8
Board Development	46	25.3
Budgeting/Accounting/Financial Planning	36	19.8
Legal Services	15	8.2
Insurance	11	6.0
Unrestricted Operating Support	**110**	**60.4**
Captial Campaigns/Purposes	**104**	**57.1**
Facilities Aquisition/Renovation	82	45.1
Office Equipment/Furniture/Computers	46	25.3
Arts Equipment	43	23.6
Endowment	33	18.1
Land Acquisition	27	14.8
Collections Acquisitions	25	13.7
Debt Reduction/Deficit Financing	14	7.7
Student Aid/Professional Training≠	**50**	**27.5**
Scholarships and Fellowships	40	22.0
Internships/Apprenticeships	26	14.3
Individual Artists	**39**	**21.4**
Individuals—Through Regranting	25	13.7
Individuals—Through Direct Grants	15	8.2
Program-Related Investments	**19**	**10.4**
Emergency Funds	**17**	**9.3**
Research	**9**	**4.9**
Other Types of Support	**3**	**1.6**

Source: The Foundation Center, 1992.
* Percentages based on multiple responses of 182 grantmakers.
≠ Support to institutions, not directly to individuals.

TABLE 8-11. GRANTMAKER AND GRANTEE VIEWS: MOST SERIOUS CRITICISMS OF GRANTMAKERS (COMPLETE LIST)*

Grantmaker Responses	No.	%
Imbalance in grants, favoring large groups	52	36.1
Over-emphasis on new programs	32	22.2
Cultural/ethnic/racial bias	12	8.3
Reluctance to fund risky or innovative works	12	8.3
Unrealistic expectations of grantee self-sufficiency	12	8.3
Short-term rather than long-range funding	12	8.3
Unclear, or rigid, guidelines	4	2.8
Funding only trendy programs	3	2.1
Insufficient contact between officers and grantees	3	2.1
Arduous grantmaker bureaucracy	1	0.7
Lack of grantee access to decision makers	1	0.7
Total	**144**	**100.0%**

Grantee Responses	No.	%
Over-emphasis on new programs	38	31.9
Imbalance in grants, favoring large groups	33	27.7
Short-term rather than long-range funding	17	14.3
Unrealistic expectations of grantee self-sufficiency	11	9.2
Reluctance to fund risky or innovative works	6	5.0
Lack of grantee access to decision makers	5	4.2
Cultural/ethnic/racial bias	3	2.5
Arduous grantmaker bureaucracy	3	2.5
Funding only trendy programs	2	1.7
Insufficient contact between officers and grantees	1	0.8
Total	**119**	**100.0%**

Source: The Foundation Center, 1992.

TABLE 8-12. GRANTMAKER AND GRANTEE VIEWS: REACTIONS TO CRITICISMS OF GRANTMAKING POLICY*

Grantmaker Responses	Basically Agree		Basically Disagree		No Opinion	
	No.	%	No.	%	No.	%
Imbalance in grants, favoring larger organizations	137	78.3	29	16.6	9	5.1
Short-term rather than long–range funding	118	68.2	35	20.2	20	11.6
Reluctance to fund risky art works	112	64.0	36	20.6	27	15.4
Favor new programs over basic support	101	58.4	56	32.4	16	9.2
Bias in grants	69	39.7	89	51.1	16	9.2
Unrealistic demand for self-support	66	38.2	89	51.4	18	10.4
Unclear or rigid guidelines	63	36.8	82	48.0	26	15.2
No grantee access to decision makers	59	33.9	91	52.3	24	13.8
Herd mentality favoring trendy works	47	27.2	100	57.8	26	15.0
Insufficient staff contact	47	27.2	95	54.9	31	17.9
Arduous grantmaker bureaucracy	38	22.0	103	59.5	32	18.5
Unreasonable or inflexible conditions	16	9.2	137	78.7	21	2.1
Grantee Responses	**No.**	**%**	**No.**	**%**	**No.**	**%**
Imbalance in grants, favoring larger organizations	110	85.3	11	8.5	8	6.2
Short-term rather than long–range funding	94	72.9	13	10.1	22	17.1
Reluctance to fund risky art works	92	71.3	27	20.9	10	7.8
Favor new programs over basic support	78	60.4	31	24.4	18	14.2
Bias in grants	77	59.2	41	31.5	12	9.2
Unrealistic demand for self-support	65	51.2	43	33.9	19	15.0
Unclear or rigid guidelines	64	50.0	41	32.0	23	18.0
No grantee access to decision makers	55	42.6	45	34.9	29	22.5
Herd mentality favoring trendy works	50	39.4	50	38.8	27	21.3
Insufficient staff contact	46	36.8	53	42.4	26	20.8
Arduous grantmaker bureaucracy	43	33.3	59	45.7	25	19.4
Unreasonable or inflexible conditions	23	18.1	80	63.0	24	18.9

Source: The Foundation Center, 1992.
* Percentages based on multiple responses of 175 grantmakers and 129 grantees.

TABLE 8-13. GRANTMAKER AND GRANTEE VIEWS: MOST UNDERFUNDED ARTS FIELDS (COMPLETE LIST)*

Grantmaker Responses	No.	%
Arts Education	36	25.4
Modern Dance	36	25.4
Cultural/Ethnic Awareness	24	16.9
Arts Policy/Arts Research	19	13.4
Literature (Creative Writing)	19	13.4
Arts Alliances/Coalitions/Advocacy	18	12.7
Arts-Related Humanities	18	12.7
Printing/Publishing (Literary Journals)	18	12.7
Arts Criticism	17	12.0
Arts Services	17	12.0
Folk or Traditional Arts	16	11.3
Music≠	16	11.3
Media/Communications	15	10.6
Visual Arts	15	10.6
Conservation/Preservation	13	9.2
Ethnic Museum Activities	12	8.5
Film/Video/Holography	12	8.5
Multidisciplinary Arts	12	8.5
Arts Training/Schools of Art	10	7.0
Multi-Media/Performance Art	10	7.0
All Other Dance (Ethnic/Jazz/etc.)	8	5.6
Crafts	8	5.6
Historical Activities	8	5.6
Performing Arts	8	5.6
Radio	8	5.6
Ballet	7	4.9
Art History	6	4.2
Mime/Puppetry/Circus Arts	6	4.2
Other Arts Subjects	6	4.2
Symphony Orchestras	6	4.2
Opera/Light Opera/Musical Theater	5	3.5
Arts Councils/Agencies	4	2.8
Folk Arts Museum Activities	4	2.8
Multidisciplinary Centers	4	2.8
Theater	4	2.8
Visual Arts Centers/Exhibition Spaces	4	2.8
Architecture and Design	3	2.1
International Cultural Exchange	3	2.1
Other History and Archeology	2	1.4
Performing Arts Centers/Presenters/Sponsors	2	1.4
Performing Arts Schools	2	1.4
Sculpture	2	1.4
Specialized/Other Museums	2	1.4
Television	2	1.4
Works on Paper (Drawing/Printmaking/Book Arts)	2	1.4
History Museum Activities	1	0.7
Museum Activities	1	0.7
Painting	1	0.7

Grantee Responses	No.	%
Arts Education	55	43.0
Cultural/Ethnic Awareness	36	28.1
Printing/Publishing (Literary Journals)	33	25.8
International Cultural Exchange	31	24.2
Multi-Media/Performance Art	30	23.4
Arts Alliances/Coalitions/Advocacy	28	21.9
Performing Arts Centers/Presenters/Sponsors	26	20.3
Literature (Creative Writing)	24	18.8
Performing Arts	24	18.8
Arts Councils/Agencies	23	18.0
Arts Services	22	17.2
Modern Dance	22	17.2
Theater	22	17.2
Film/Video/Holography	21	16.4
Multidisciplinary Arts	19	14.8
Music≠	19	14.8
Visual Arts Centers/Exhibition Spaces	19	14.8
All Other Dance (Ethnic/Jazz/etc.)	18	14.1
Multidisciplinary Centers	18	14.1
Arts Criticism	17	13.3
Opera/Light Opera/Musical Theater	16	12.5
Conservation/Preservation	13	10.2
Ethnic Museum Activities	11	8.6
Symphony Orchestras	11	8.6
Media/Communications	11	8.6
Arts Policy/Arts Research	10	7.8
Other Arts Subjects	10	7.8
Visual Arts	10	7.8
Art History	9	7.0
Folk or Traditional Arts	9	7.0
Performing Arts Schools	9	7.0
Art Museum Activities	8	6.3
Crafts	8	6.3
Ballet	7	5.5
Radio	6	4.7
Works on Paper (Drawing/Printmaking/Book Arts)	6	4.7
Arts Training/Schools of Art	5	3.9
Children's Museum Activities	5	3.9
Photography	5	3.9
Arts-Related Humanities	4	3.1
Independent Research Libraries	4	3.1
Museum Activities	4	3.1
Painting	4	3.1
Sculpture	4	3.1
Historical Activities	3	2.3
Science/Technology Museums	3	2.3
Architecture and Design	2	1.6
Mime/Puppetry/Circus Arts	2	1.6
History and Archeology	1	0.8
Specialized/Other Museums	1	0.8
Television	1	0.8

Source: The Foundation Center, 1992.
* Percentages based on multiple responses of 142 grantmakers and 128 grantees.
≠ Does not include symphony orchestras.

TABLE 8-14. GRANTMAKER AND GRANTEE VIEWS: BEST FUNDED ARTS FIELDS (COMPLETE LIST)*

Grantmaker Responses	No.	%
Symphony Orchestras	69	50.7
Museum Activities	53	39.0
Art Museum Activities	50	36.8
Performing Arts	33	24.3
Opera/Light Opera/Musical Theater	31	22.8
Television	24	17.6
Theater	21	15.4
Science/Technology Museums	15	11.0
Performing Arts Centers/Presenters/Sponsors	14	10.3
Ballet	14	10.3
Media/Communications	12	8.8
Arts Education	11	8.1
Visual Arts	10	7.4
Children's Museum Activities	7	5.1
Film/Video/Holography	7	5.1
Natural History Museum Activities	6	4.4
Cultural/Ethnic Awareness	5	3.7
History Museums	4	2.9
Visual Arts Centers/Exhibition Spaces	4	2.9
International Cultural Exchange	3	2.2
Modern Dance	3	2.2
Radio	3	2.2
Arts Councils/Agencies	2	1.5
Arts Services	2	1.5
Performing Arts Schools	2	1.5
Printing/Publishing (Literary Journals)	2	1.5
Arts Alliances/Coalitions/Advocacy	1	0.7
Arts Training/Schools of Art	1	0.7
Conservation/Preservation	1	0.7
Folk or Traditional Arts	1	0.7
Historical Activities	1	0.7
Multidisciplinary Arts	1	0.7
Multi-Media/Performance Art	1	0.7
Multidisciplinary Centers	1	0.7
Music≠	1	0.7
Painting	1	0.7

Grantee Responses	No.	%
Symphony Orchestras	55	51.4
Opera/Light Opera/Musical Theater	37	34.6
Art Museum Activities	32	29.9
Ballet	31	29.0
Museum Activities	29	27.1
Television	27	25.2
Science/Technology Museums	18	16.8
Cultural/Ethnic Awareness	16	15.0
Arts Education	13	12.1
Performing Arts Centers/Presenters/Sponsors	12	11.2
Film/Video/Holography	10	9.3
Theater	8	7.5
Natural History Museum Activities	7	6.5
Radio	7	6.5
Visual Arts Centers/Exhibition Spaces	7	6.5
Media/Communications	6	5.6
Arts Councils/Agencies	5	4.7
Children's Museum Activities	5	4.7
Conservation/Preservation	5	4.7
Architecture and Design	4	3.7
Folk/Traditional Arts	4	3.7
All Other Music	3	2.8
Arts-Related Humanities	3	2.8
Arts Services	3	2.8
Arts Training/Schools of Art	3	2.8
Painting	3	2.8
Visual Arts	3	2.8

	No.	%
All Other Dance (Ethnic/Jazz/etc.)	2	1.9
History Museums	2	1.9
International Cultural Exchange	2	1.9
Modern Dance	2	1.9
Multi-Media/Performance Art	2	1.9
Performing Arts	2	1.9
Arts Alliances/Coalitions/Advocacy	1	0.9
Ethnic Museums	1	0.9
Historical Activities	1	0.9
Mime/Puppetry/Circus Arts	1	0.9
Multidisciplinary Arts	1	0.9
Performing Arts Schools	1	0.9
Specialized/Other Museums	1	0.9

Source: The Foundation Center, 1992.
* Percentages based on up to 6 multiple responses of 136 grantmakers and 107 grantees.
≠ Does not include symphony orchestras.

TABLE 8-15. GRANTMAKER PRIORITIES IN COMING YEAR BY MAJOR ARTS FIELDS (COMPLETE LIST)*

Arts Field	No.	%
Performing Arts	91	54.2
Museum Activities	72	42.9
Arts Education	33	19.6
Visual Arts	28	16.7
Multidisciplinary Arts	25	14.9
Art Museum Activities	20	11.9
Symphony Orchestras	19	11.3
Theater	15	8.9
Cultural/Ethnic Awareness	14	8.3
Media/Communications	10	6.0
Performing Arts Centers/Presenters/Sponsors	10	6.0
All Other Music	8	4.8
Arts Services	8	4.8
Arts Training/Schools of Art	7	4.2
Historical Activities	6	3.6
Opera/Light Opera/Musical Theater	6	3.6
Arts Councils/Agencies	5	3.0
Ballet	4	2.4
Conservation/Preservation	4	2.4
Arts Policy/Arts Research	3	1.8
Children's Museums	3	1.8
Modern Dance	3	1.8
Multidisciplinary Centers	3	1.8
Natural History Museums	3	1.8
Radio	3	1.8
Television	3	1.8
Visual Arts Centers/Exhibition Spaces	3	1.8
Architecture and Design	2	1.2
Arts Alliances/Coalitions/Advocacy	2	1.2
Arts-Related Humanities	2	1.2
Film/Video/Holography	2	1.2
History Museum Activities	2	1.2
Literature (Creative Writing)	2	1.2
Multi-Media/Performance Art	2	1.2
Sculpture	2	1.2
All Other Dance (Ethnic/Jazz/etc.)	1	0.6
Art History	1	0.6
Folk or Traditional Arts	1	0.6
Other Arts Subjects	1	0.6
Painting	1	0.6
Photography	1	0.6
Printing/Publishing (Literary Journals)	1	0.6
Works on Paper (Drawing/Printmaking/Book Arts)	1	0.6

Source: The Foundation Center, 1992.
* Percentages based on multiple responses of 168 grantmakers.

TABLE 8-16. ARTS FIELDS ELIGIBLE FOR FUNDING IN 1991 (COMPLETE LIST)*

Arts Field	No.	%
Performing Arts	**172**	**94.5**
Symphony Orchestra	143	78.6
Theater	141	77.5
Performing Arts Centers/Presenters/Sponsors	133	73.1
Opera/Light Opera/Musical Theater	124	68.1
Ballet	121	66.5
Modern Dance	101	55.5
Music≠	76	41.8
All Other Dance (Ethnic/Jazz/etc.)	73	40.1
Performing Arts Schools	57	31.3
Multi-Media/Performance Art	53	29.1
Mime/Puppetry/Circus Acts	38	20.9
Museum Activities	**165**	**90.7**
Art Museums	146	80.2
Children's Museums	103	56.6
History Museums	90	49.5
Science/Technology Museums	84	46.2
Natural History Museums	80	44.0
Ethnic Museums	68	37.4
Specialized/Other Museums	46	25.3
Folk Art Museums	36	19.8
Multidisciplinary Arts	**161**	**88.5**
Arts Education	118	64.8
Cultural/Ethnic Awareness	101	55.5
Arts Councils/Agencies	84	46.2
Multidisciplinary Centers	83	45.6
Folk or Traditional Arts	68	37.4
Arts Training/Schools of Art	60	33.0
Visual Arts	**129**	**70.9**
Visual Arts Center/Exhibition Spaces	102	56.0
Painting	66	36.3
Sculpture	55	30.2
Photography	51	28.0
Works on Paper (Drawing/Printmaking/Book Arts)	45	24.7
Crafts	38	20.9
Architecture and Design	34	18.7
Media/Communications	**120**	**65.9**
Television	78	42.9
Radio	68	37.4
Film/Video/Holography	43	23.6
Printing/Publishing	42	23.1
Historical Activities	**71**	**39.0**
Conservation/Preservation	67	36.8
Arts-Related Humanities	**59**	**32.4**
Literature (Creative Writing)	40	22.0
Art History	20	11.0
Other History and Archeology	17	9.3
Arts Services	**55**	**30.2**
Other		
Arts Alliances/Coalitions/Advocacy	78	42.9
Arts Policy/Arts Research	27	14.8
International Cultural Exchange	21	11.5
Independent Research Libraries	13	7.1
Arts Criticism	13	7.1

Source: The Foundation Center, 1992.
* Percentages based on multiple responses of 182 grantmakers.
≠ Includes composition.

TABLE 8-17. GRANTMAKER AND GRANTEE VIEWS: MOST IMPORTANT ARTS GRANTMAKING ISSUES (COMPLETE LIST)*

Grantmaker Responses	No.	%
Competition for funds between arts and other fields	117	67.6
Competition among arts groups seeking funds	74	42.8
Capacity of funders to take risks	45	26.0
Quality of proposals from grantseekers	31	17.9
Standards of artistic excellence	27	15.6
Proposal evaluation/review criteria	25	14.5
Quality of trustee involvement in policy	22	12.7
Quality of artistic talent in groups	19	11.0
Needs of individual artists	17	9.8
Capacity of groups to meet foundation requirements	15	8.7
Honest feedback from grantees	14	8.1
Influence of dominant foundations	7	4.0
Competition with government agencies for grants	6	3.5

Grantee Responses	No.	%
Competition for funds between arts and other fields	71	55.9
Capacity of funders to take risks	51	40.2
Competition among arts groups seeking funds	25	19.7
Proposal evaluation/review criteria	19	15.0
Standards of artistic excellence	14	11.0
Quality of trustee involvement in policy	12	9.4
Capacity of groups to meet foundation requirements	10	7.9
Needs of individual artists	10	7.9
Influence of dominant foundations	9	7.1
Honest feedback from grantees	8	6.3
Quality of artistic talent in groups	5	3.9
Competition with government agencies for grants	4	3.1
Quality of proposals from grantseekers	3	2.4

Source: The Foundation Center, 1992.
* Percentages based on multiple responses of 173 grantmakers and 127 grantees.

9

Artists' Commentary

FREEING THEATER FROM COMPROMISE

BY MARIA IRENE FORNES

Maria Irene Fornes is a playwright, director, and teacher. She frequently works at the Theater for the New City in New York and the New City Theater in Seattle. She is the author of Fefu and her Friends, The Conduct of Life, Mud, *and* The Danube.

Art is the body of work that results from our desire to comprehend life and the human mind and emotions, its potential and limitations, its blind spots, its propensity for self destruction, its capacity for heroism, its narrowness, inability to progress, its arrogance, meanness, selflessness, and generosity.

Culture is the acquiring of perspective. It is putting our judgment and experience to work at a more profound level, instead of simply applying ourselves to the purely pragmatic. Discerning what is right and what is wrong. Questioning, examining, being objective, learning to look at ourselves as if at a distance. Learning through understanding to feel affection for the disloyal as well as for the noble, for the ruthless, for the mean of spirit, and for the mercenary. Learning to be wiser and to feel compassion for the flaws of man.

Art, like philosophy, seeks to comprehend the human soul. Even the most abstract of the arts, Music, is an effort to understand order and disorder, balance and imbalance, form and chaos, beauty and malformation, the noble and the warped.

Art fails when it is conceived as a tool for indoctrination, whether indoctrination for the good or for the bad. It fails if it is created as dogma instead of as the result of a genuine artistic impulse.

All great civilizations have had great art and all have funded the arts. Indeed, art must be funded if a society is to be proud, humanitarian, and fair. This is because art examines life the way no science does. In our criteria for funding, however, there is an ele-ment—at least in theater—that has betrayed the true purpose of funding, which should be to free institutions from compromise.

This is the question of earned income as one of the means of judging the theater's deservedness of support. This criterion has made artistic directors dependent on popular success and, therefore, desperate for popularity in a way no different from the most vulgar form of commercial theater. It has made theaters less likely to produce works of merit, since it has driven them to please a society that has no desire to be challenged, or provoked, or taken to a place other than where their values are simply confirmed and where they are reassured that their world is secure. This, while the world is falling apart around them.

This is no way of creating meaningful art or contributing to the culture of a nation. Art is not worth the labor and cost unless it provokes thought and stimulates examination. Art should not be expected to be acceptable.

MULTICULTURALISM, POWER, AND THE ARTIST-COMMUNITY RELATIONSHIP

BY DAVID MURA

David Mura is a Japanese-American writer residing in St. Paul, Minnesota, and author of Turning Japanese: Memoirs of a Sansei. *The following has been adapted from a longer essay that appeared in* Critical Angles, *1991, published by the Center for Arts Criticism, St. Paul.*

In the coming decade, the presence of multiculturalism in the arts will only increase—the result of changing demographics and various historical forces. This multicultural wave will bring about significant changes in the way we practice and receive art. But already there's been a huge backlash against multiculturalism. It's obvious that many conserva-

tives are terrified of its deeper implications, the possibilities it opens up for a more democratic vision of America.

In the end, these forces will lose out. It's not simply that the demographics are against them. No, my optimism is based far more on what I see going on in the arts: the center of creativity has shifted to the margins; that's where the energy is, where the cutting edge starts.

As we move towards the next millennium, the question of who holds the power within the world of art will become crucial. During the coming years, previously marginalized artists and their audiences will become more and more visible. Both groups will challenge established art institutions and arbiters of judgment. This will, in turn, increase an investigation of who decides which artworks are recognized, praised, and funded in our society, and how those decisions are made.

To accomplish a shift in cultural power, there will be a greater need for organizations and institutions for people of color by people of color. In other words, the creation of artists of color depends not merely on the development of the artists themselves, but also on the development of multicultural editors, curators, teachers, funders, and arts administrators of color.

This increasing visibility of multicultural artists will complicate and challenge previous aesthetic standards. As these aesthetic shifts take place, we will see a changing relationship between the artist and the community.

Many multicultural artists derive their art from the experience of communities that have not had access to traditional arts institutions. They do not view themselves as isolated from their community, but rather as contributing members of it. Indeed, many find strong links between their art and community organizing. They also see their art as part of their community's struggle to survive and to obtain an equal distribution of the economic and political power in our society. The multicultural artist may therefore perform a number of roles in the community—such as spokesperson—in addition to the creation of his or her own work. Arts programs need to be aware both of the ways in which such activity feeds the creativity of the multicultural artists, and of how it sometimes overwhelms them, leaving little time to do their own work.

As multiculturalism takes hold, definitions of what it means to be an artist will change. For example, many multicultural artists come from communities that do not recognize European genre divisions. As a result, they feel less bound to maintain an atmosphere of "high art" when they present their work to the public.

The artist of color and his or her audience occupy a different relationship to mass culture than mainstream artists or their audience. Asian-Americans, for instance, know that within mass culture, they generally do not exist. There are no images that reflect who they are. Rather than turning towards mass culture, they must look towards literature or theater, to performance artists, to smaller scale projects, to find their own stories and images.

Conversely, it is becoming increasingly clear that my audience starts with Japanese-Americans, then Asian-Americans, then multicultural audiences, and then the mainstream "white" audience. For this reason, my work as an artist, my ability to survive as an artist, depends upon the existence of a Japanese-American and an Asian-American community. If this community did not exist, my work would be further marginalized than it is.

In contrast to the "art for art's sake" attitude I was taught in graduate school and the MFA workshop, I now see a very symbiotic relationship between art and community. On a day-to-day level, this means that in my thinking, the world view of the Academy of American Poets is balanced against what's happening at the local YWCA or the Japanese American Citizens League or the Hmong Youth Leadership. This sort of balance would have been unthinkable to me a few years ago.

I predict that this conjunction of art and community will draw more and more multicultural artists towards theater and film, towards collaborations and mixtures of genres, precisely because of the social—as opposed to individual—basis of these art forms. Not surprisingly, this will bring about a renewed interest in the artistic traditions of our different ethnic backgrounds, traditions which date back to a view of art that does not find its bearings in the European Enlightenment or the Romantic Era.

Thus, the postmodern dissolution of genres becomes the rediscovery of a buried tradition, and the artist's purpose becomes more the preservation

and health of the community than his or her own individual glory or achievement. This may mean that the view of "high culture," which emphasizes a singular and/or abstract standard of excellence, will be more and more balanced by a view of art as craft, and by a valuing of art for its use value.

A very different sense of purpose, one more aligned with community, can restore meaning and energy to our sense of what it means to work as an artist. The old definitions of the artist are inadequate. At its very least, multiculturalism has helped me to see that.

MODERN DANCE: THE LONG RUN

BY BRENDA WAY

Brenda Way is the founder and artistic director of ODC/San Francisco. She has been choreographing for 30 years and holds a Ph.D. from Union Graduate School. She serves as vice president of Dance/USA and is a member of the Zellerbach Family Fund Community Arts Distribution Committee.

The role of foundations in the cultivation of American dance has been seminal and extraordinary, from the Ford Foundation's allocation in the 1950s that virtually created the national model of civic resident ballet to the recent Lila Wallace-Reader's Digest Fund's project support for modern dance. In this country, lacking a historic mandate for dance literacy (such as our public education programs in music, art, drama, and literature), foundations have functioned in many ways as the enabling parent—nurturing and responding, defining and encouraging. The family metaphor is particularly apt for modern dance by virtue of its avowedly contrary stance. Like the teenager in the family, it rejects the familiar language by definition and foils the popular expectation by design. This voluntary intransigence has often made it hard to love and harder to understand. While familiarity absorbs and transforms almost any expressive deviation (we are now comfortable with both rock and roll and abstract painting), there has been insufficient exposure to modern dance for this process of acculturation to occur.

Do we really want an American modern dance? Just because it originated on our soil is not enough. Just because it embodies the myth of American indi-

vidualism is not enough. Just because it functions as the research and development wing for the entire dance field is not enough. These things, however, taken together with a rapidly changing America and a potent trend toward the non-verbal, give it a serious place and promise in our contemporary culture. Modern dance is not bound to the syntax of the past, white European or black African. It is a democratic and welcoming host for our constantly changing demographic landscape and spiritual values. Importantly, it responds intimately to the particular ground from which it springs, ethnic, regional, sexual.

So let's suppose that we do want an American modern dance. The practical requirements are complex and it is here that we see why foundation support is the linchpin to its very survival. The field is wholly defined by collective enterprise. Choreographers, dancers, producers, funders, audience, and space are the absolute necessities, the *sine qua non*, of modern dance. Either all the aspects of this complex artistic ecology are functioning or we simply draw a blank.

In modern dance, choreographers create something from nothing with each dance; we revel in that. We build the vocabulary, put together the sentence, construct the paragraphs, and invent the form. The ideas are literally formed on people in space. No transcript, plot, score, or sketch, no idea expounded or committed to paper can approximate or specify the vision. Start-up funds for the dancers and the studio then are the first necessities.

Production is the second necessity, the public trials. Since by its nature, a dance piece is only what is seen, bodies, light, space, and spectator must come together to realize the work. There is no other way for it to exist but in the social act of theater. Significantly, modern dance is the only form where the originating artist is expected to create the work, train the interpreters, and build the institution to produce and present the finished product. There is no traditional home, no symphony hall, opera house, or museum that belongs to modern dance. Choreographers and their companies are therefore transients for whom funders (and a few intrepid presenters) are the sole enabling agents.

At this essential public juncture, we face the ramifications of a rebellious youth and the neglect of the American educational system. Our artistic lan-

guage lacks popular familiarity. It also lacks the all-American mechanism for generating and building a broad audience, namely, a profit component. There are no associated royalties, recording profits, appreciating markets, or movie contracts to be gained, no sponsors for whom our success might mean a greater quarterly return. Modern dance flies solo. Each company must market the field as well as its own work.

There is no doubt that an aggressive marketing campaign could go a long way to breaking market resistance, generating name recognition, and cultivating the popular appetite. After you create and test a product, you need a second round of funding to promote and market it. The business plan languishes on the desk, however, for want of the necessary capital and the traditional enticement of return on investment. Our educational system and our government policy towards the art, both of which might have redefined the nature of the "return" in broader terms (as they have in other cultures), have failed to rise to the task here in the U.S.

Given that the only way for the public to apprehend and value modern dance is to experience it first hand, a critical mass of ongoing performance is key to its health. Perhaps only in New York with a huge population and tradition of dance enthusiasm, can this be counted on. But even that is not enough. Density only assures survival of the field, not individual growth and quality. Without substantial help, dance companies will simply fail to reach middle age or maturity.

It is in the nature of youth to get by with very little. A child can play endlessly with a cardboard box. But later, more elaborate practical and intellectual needs arise. Reflective powers increase, and the possibilities for more complex relationships engage the imagination. In modern dance, the dancer's ability to work discretely with a specific movement language, the choreographer's interest in using this developed language to reflect on broader issues, the refinement of a brazen idea, the nuances of form, become compelling and modify or even replace a passion for novelty and outrage. Here is where we have seen the expectations of the working press make their mark.

The critics (primarily N.Y. driven) applaud the "new." And why not? Audacious newcomers are exciting and reflect the originating impulse of modern dance itself. The critics, however, are substantially less insightful about and responsive to the subtleties of change and maturation. Evolutionary innovation is harder to identify and talk about. The prevailing hierarchy of critical values does not promote development of the choreographers or of the work itself. Although it takes as many as 20 public presentations for a new piece to fulfill itself, the critics focus almost entirely on premiere performances (in contrast to their response to ballet repertory).

Further, the critics condition the public appetite to a continuing diet of "new" work. This makes it difficult for a choreographer to stick exclusively with a piece that has already opened, no matter how complex or ambitious the effort. These writing professionals, like the early moderns themselves, embrace revolutionary disruptive goals. Thus, incipient styles and self-fertilizing ideas are discarded as soon as they are born. Yet, ironically, the public depends on the very process of cultural development—redundancy—for intelligibility and emotional investment. Choreographers who are no longer driven by the almost pathological impulse to deny tradition must set their own terms and find the financial means to act on them.

What the maturation of the art form and the choreographers require is a predictable working environment, maintenance of a stable corps of dancers, and a regular and knowledgeable local following. Modern dance—inherently regional—needs to establish its place in the civic ecology. Public and private funding is essential to the task. Foundations, operating beyond the vagaries of politics and fashion are in a unique position to commit to the long view. Not all companies will or should survive, but with the perspicacity of private funders, perhaps many of the best will, and an enriched, more viable artistic ecosystem will emerge. It remains to be seen if modern dance will have staying power, but it stands to reason that choreographers, like architects, painters, and composers, will flourish with the benefit of practice and the wisdom of age.

10

Managing Change in Arts Funding Policy:

Three Case Studies

As the 1980s drew to a close, several grantmakers undertook major changes in their arts funding programs and priorities. The following case studies explore the nature and effects of these changes at the McKnight Foundation, the Lila Wallace-Reader's Digest Fund, and the Fan Fox and Leslie R. Samuels Foundation. They are based primarily on interviews with staff, and on documents provided by the funders.

THE McKNIGHT FOUNDATION

Established in 1947 by William L. McKnight, a founder of the 3M Company, and Maude L. McKnight, the McKnight Foundation had remained a fairly small family grantmaker during its first three and a half decades. Its primary interest was, and remains, human services, in particular improving the capacity of people in economic distress to "enhance their capacity for productive living" and strengthening community institutions. About 10 percent of its funds are awarded to the arts.

Through most of the 1980s, McKnight's investment income grew manifold, largely a consequence of an almost uninterrupted booming stock market. The pronounced increase in its wealth—it now ranks among the top 20 foundations by assets—impelled the board to raise its funding substantially; federal law requires annual disbursements of at least 5 percent of assets on grants and related expenses.

While satisfied with its human service and biology programs, some members of the board felt the need to look anew at the foundation's commitment to the arts, which at the time consisted primarily of donations to state and regional arts agencies for regranting. The remaining portion of its arts dollars had been placed in an investment pool, the Arts Partnership, of which the proceeds were distributed locally to four large arts groups.

Impetus for the review derived from several factors. First was the board's own inclination towards program evaluation. The foundation was then nearing the end of its latest four-year arts funding cycle, and an attempt to take stock of its accomplishments and problem areas, if any, seemed appropriate.

A second impetus was the personal involvement on the local arts scene of the board chair, James F. Binger, owner of the Jujamcyn theater chain in New York City. Virginia Binger, another board member, is equally active in local human service projects.

Finally, it helped that the foundation's president, Cynthia Boynton, the Bingers' daughter, was a visual artist herself, and aware of issues pertaining to Minnesota's arts community.

In 1989, the foundation commissioned two studies: one to evaluate reactions to McKnight's funding by Minnesota artists, the other to compare the foundation's program with other funders' programs. As explained by the foundation's arts program officer, the evaluations revealed that arts groups "wanted a more direct relationship with the foundation"—that is, they preferred dealing with the funder directly, rather than through the state regranting mechanisms.

Local groups also sought an increase in both general operating and capital support, rather than program support.

POLICY CHANGE

As a consequence of the evaluations, and of intensive reviews of the findings by both staff and board, the foundation made a five-year, $28 million commitment to the arts, emphasizing what it called "increased access and quality."

Announced in September, 1990, the initiative enabled the foundation at once to break new ground, as with its implementation of capital grants,

and to substantially increase programs it already funded, as with its fellowships for composers, writers, playwrights, choreographers, filmmakers, and international visiting artists.

The initiative also allowed McKnight to further its efforts to integrate the arts with human services, its primary programmatic orientation. For example, it tripled its earlier commitment to community organizations, in which grants stimulated the creation of art by nonprofessionals and neighborhood groups. As explained in a foundation press release, this aspect of the initiative "respond[ed] to the greatly expanded interest in the arts by neighborhoods, women's shelters, people with disabilities and others for whom traditional art may be less accessible."

STAFF CHANGES

One of the most dramatic changes reflected by the initiative pertained to grants administration. From that point on, most arts funding would be handled in-house, by staff newly hired for the purpose. Further, accommodating the artists' appeal for more direct involvement, the staff would establish a proactive outreach program, visiting arts sites and otherwise fostering communication.

To implement the new arts program, McKnight hired a visual artist and writer who had been the publisher of *Artpaper*, an "alternative arts and culture magazine." He had also worked for several years in a government arts granting agency, for which he prepared studies on such issues as the impact of the arts on the regional economy.

Even prior to the employment of this program officer and other new staff, the board's decision to review its arts policy spurred a higher level of interaction between board members and the staff. For example, after the program evaluations were submitted by the outside researchers, the staff subjected the documents to its own "reality checks," according to the program officer, developing a critique and recommendations, as requested by the board. What followed was "a lot of board discussion," which ultimately led to the general outlines of the new policy. Once the policy was set, the new staff was hired to implement it.

This more involved relationship between board and staff facilitated an easy implementation of the initiative. "It was completely supported by every-

one," the program officer said. "Any difficulties were with the design [of the initiative] itself; that's where the challenges were."

The new board-staff relationship continued even after implementation. For example, staff now provides a quarterly report to the board on developments within the arts community, information for which derives from ongoing site visits and other forms of communication with Minnesota arts groups. The memos are followed up by lengthy staff-board discussions, resulting in a "much more informed board."

To be sure, the personal involvement in the arts community by some board members has also continued, through site visits with staff or other activities. Indeed, a history of site visits by Ms. Binger helped to "establish the style of the foundation," the program officer said.

REACTION FROM GRANTEES

For the most part, arts organizations, including most former grantees, welcomed the change, according to McKnight staff. Many recipients of the regranting awards, for example, while initially "nervous" at the change in funding policy, have since received sizable increases. Further, access to the foundation's arts grants has expanded considerably; groups that are not deemed "certifiable arts organizations" according to state standards—and who were therefore ineligible for regranting funds—now secure McKnight's arts grants directly.

Not everyone, however, was pleased with the change in policy, the program officer said. Dissatisfaction was expressed by some of the organizations that had earlier received Arts Partnership investment proceeds, since that source of funding was discontinued. Also, the newly imposed grant ceilings of $100,000 for general operating support and $1 million for capital grants were not welcomed by the larger arts grantees.

SOCIOPOLITICAL ISSUES

McKnight's new foray into the arts funding world has not been marked by timidity, the program officer noted. For example, the controversy within the National Endowment for the Arts (NEA) over funding allegedly obscene art works—a controversy

some thought would influence private grantmakers as well—"has not affected us at all."

In fact, now that McKnight administers its own arts grants, rather than channeling them through the state boards, its program has become more "risky," the program officer said. "Some of the organizations we fund are just developing—ambitious, very new, [with the potential to] overreach themselves. And ranging from the very grassroots we also fund the Walker Arts Center, whose arts program is among the most progressive in the country."

He added that many so-called controversial works "come out of a community context; if you believe in developing your community, what else can you do?"

LILA WALLACE-READER'S DIGEST FUND

Currently the nation's largest private funder of the arts, the Lila Wallace-Reader's Digest Fund was one of two grantmakers formed in late 1987 from the merger of four separate foundations: L.A.W. (for Lila Acheson Wallace), High Winds, Lakeview, and DeWitt Wallace. The other foundation formed from this merger was the DeWitt Wallace-Reader's Digest Fund, which primarily funds programs addressing the educational needs of youth.

Spurred by a substantial growth in assets and a desire by the board to have a "focused and strategic impact" in the areas targeted, the Fund hired a professional staff to aggressively marshal and coordinate the resources of the four disparate foundations. To ascertain the most likely areas to have an impact, the staff immediately reviewed recent grantmaking trends and interviewed numerous representatives within the arts field.

NEW PROGRAM AND OPERATIONAL DIRECTIONS

The staff's top priority from 1988 through 1990 was to identify an area within arts grantmaking that would "fill a gap," create an identity for the Fund, and enhance the Fund's "originating spirit."

Mrs. Wallace, the founder of the Fund, started her career as a social worker, active in YMCAs and other community institutions. She was specifically interested in exposing the "working individual" to the arts, a theme that emerged as a major thrust of the Fund, and that complemented the broad philos-

ophy of the *Reader's Digest*. Mrs. Wallace and her husband DeWitt Wallace founded the world-renowned magazine to appeal to the "average American."

Since 1987, two major programmatic and three procedural changes have been instituted at the Fund. Program strategies continue to evolve as new programs raise new issues, which in turn suggest reevaluations of procedure.

The new arts program directions included:

- An emphasis on audience development, largely replacing the former support for general operating expenses, and a more recent emphasis on the creation of new works; and

- Promotion of partnerships among artists, arts organizations, and communities.

The procedural changes included:

- Collaborations between the Fund and national nonprofit arts service groups to develop and administer programs;

- Establishment of several programmatic initiatives targeting specific fields or communities, each addressing stated goals and identified as important to the field or community targeted. Application and review procedures were formalized to guide selection of those proposals most likely to achieve the desired goals;

- Proactive funding, rather than passive response to unsolicited proposals.

NEW PLANNING PROCESS

The key to the Fund's planning process—designed to ascertain whether the program met the needs of the arts community as well as the interests of the board—was the commissioning of professional studies within several arts disciplines: folk arts, dance, jazz, community schools of the arts, and other fields. In addition, the staff conducted some of its own, less formal explorations, such as roundtables on theater, writing, and literacy held at the Fund's offices. The studies and roundtables addressed a basic theme: how the arts and communities can better relate to each other and how funding can promote more "dynamic interactions between artists and communities," as expressed in

the Fund's report on community-based schools of the arts.

Each study uncovered a largely unmet need faced by arts organizations within the respective fields. For example, the study of dance touring—a major form of community access by dance companies—conducted by Dance/USA in 1991-92, concluded that touring dance companies are highly dependent on the fees they receive from the presenters, and that these fees barely cover expenses. "A pattern of financial loss to the companies" is evident, the report said.[1] "Resources to subsidize companies' direct touring costs are not linked to a national system comparable to the National Endowment for the Arts' Dance Touring Program, which ended in the early 1980s." Acting on the recommendations in the report, the Lila Wallace-Reader's Digest Fund supported a pilot project for funding dance companies' touring activity so long as it is linked to extensive community outreach.

In jazz, the Fund asked the National Jazz Service Organization (NJSO) and the New England Foundation for the Arts (NEFA) to explore the best way to support the nation's "multi-faceted jazz community." Following a series of focus groups conducted around the country, the NJSO and NEFA prepared a report on needs in the jazz field, including jazz ensembles' need to perform in more concert settings at higher compensation, the importance of more varied audiences, the need for audience education on the nature of jazz, and better documentation of jazz history.

The report proposed, and the Fund supported, the establishment of the Lila Wallace-Reader's Digest National Jazz Network. In its first year, the Network offered financial support to 16 presenting organizations and six regional arts groups providing "unprecedented financial and technical assistance to expand jazz audiences and support jazz artists." The Network's operations are managed by the NJSO and the New England Foundation for the Arts.

FOUNDATION-NONPROFIT PARTNERSHIPS

As these examples reveal, a major new operating technique of the Fund was to invite nonprofit organizations active in their respective disciplines to help design and administer grantmaking programs.

By the end of 1992, working partnerships had been developed with 11 nonprofits. They serve a dual purpose. They ensure that proposals within specific disciplines will receive expert evaluation and they free the Fund from time-consuming administrative responsibilities.

IMPLEMENTATION

Moving from a relatively small arts budget and undefined program to becoming one of the largest arts grantmakers in the country with a highly defined program would appear to be daunting, given a built-in tendency within organizational bureaucracies to resist operational change. But the difficulty was not in the implementation process, according to both the Fund's vice president and program director.

"We had the benefit of being small, with a close working relationship with the board," the program director said. "In many cases, we were creating new systems and therefore had flexibility to design the systems as we needed them."

The relationship between the board and the staff is professional, the vice president said. "They expect us to do the research and make the recommendations." Once the results of the various studies and discussions were in, the recommendations were discussed and appropriate actions for the Fund determined by the board.

What the staff did find difficult was the learning process. "It was the sheer volume of work that was most difficult," the program director continued, "simply trying to figure out what was happening in so many fields that are themselves changing."

EFFECT ON GRANTEES

Reactions from traditional grantees—organizations receiving funds prior to the revised program—were minimal, according to the fund's vice president. "Our new pool of money [resulting from asset growth during the 1980s] allowed us to shift focus with our earlier recipients, as well as increase funding to new areas," the vice president explained.

Some groups, she added, were initially disappointed "at having to go through new procedures," but the increase in their potential grant amounts tended to dissipate any lingering objections.

Given the principle of arts/community interaction, in the future the Fund may initiate other programs to help integrate the arts into people's lives. The Fund is exploring various possibilities.

PUBLIC ISSUES AND INDIVIDUAL ARTISTS

In terms of public issues in arts funding today, most notably the so-called obscenity/censorship controversy over National Endowment for the Arts funding, the controversy has had no bearing on policy decisions at the Fund. For example, asked if the Fund would be more or less likely to support advocacy in the near future, the program officer noted that the Fund's priority is audience development in the arts and programs which provide direct benefit to people in communities across the country.

"Our focus is on where the community and the arts interact," she said. "It's on how to improve that interaction. Advocacy is not a central strategy for us."

Of equal importance, the Fund takes "a long term view, which essentially precludes reaction to a particular crisis or controversy."

Another issue of concern within the arts world is the reluctance of most foundations to give grants directly to individual artists. The Fund already provides such grants through two newly instituted programs: The Lila Wallace-Reader's Digest Fund Writers' Awards and the International Artists Program. Both provide stipends to artists but also promote dialogue and other interactions between the artists and communities.

Begun in 1990, the Writers' Awards program provides $35,000 a year for three years to novelists, poets, and other writers "who have published work of exceptional merit." Recipients must propose how they will work with nonprofit institutions to "foster an exchange of ideas and experience."

The International Artists Program, administered by Arts International (a unit of the Institute of International Education), enables visual artists to live and work in foreign countries; upon their return, they "share their experiences with communities throughout the United States." Honorariums vary from $7,500 to $25,000; additional grants of $2,000 to $20,000 will support "community activities related to the artists' experience."

New programs for individuals, however, are not likely, the officer said, given the difficulty of administration. "It is very labor intensive to give grants to individuals and our staff is relatively small."

FUTURE DIRECTIONS

Two new fields of interest in which the Fund will expand activity in the coming years include Adult Literacy and Urban Parks. The literacy program will complement its existing literary arts operation—the awards program, the National Writer's Voice, and public presentation of literature programs. Adults who can learn to read are likely to constitute an enormous new audience for those who write.

The Urban Parks program will expand from a New York City-based program to a national one. Planning is underway to determine program priorities and focus.

FAN FOX AND LESLIE R. SAMUELS FOUNDATION

A relatively small grantmaker founded in Utah in 1959 and reincorporated in New York in 1981, the Fan Fox and Leslie R. Samuels Foundation was for most of its existence a family grantmaker, supporting several health care, social service, and education projects, and Lincoln Center for the Performing Arts. Like many thousands of foundations in the United States, it operated without the need for professional staff, as the programmatic interests of its founders did not vary.

In 1989, five years after the death of Mr. Samuels, the board—comprised solely of former business associates and personal friends—met at a retreat in Phoenix, Arizona, to review the foundation's history and chart directions for its future. Its most significant decision was to retain the institution as a grantmaker in perpetuity, rather than spend down, or deplete, its assets over a set number of years.

That decision, however, immediately forced the board to confront a major problem: how to sustain continuity with the Samuels family and grantmaking tradition, given the absence of any Samuels relatives on the board, and in light of the advanced ages of almost all the board members.

NEW STAFF, BROADER POLICY

It was agreed that new, professional staffing would serve as one approach to these problems. The person hired by the board had been close to the Samuels, and had established and profitably operated his own business (a construction firm).

"I knew the Samuels as a child," explained the new arts program officer. "To me they were 'Aunt Fan' and 'Uncle Les.' My father, who is the chairman of the foundation, had worked for Mr. Samuels."

His immediate and primary responsibility entailed expanding the performing arts program, but only so far as it would not compromise the foundation's tradition of basing grant decisions on three criteria: artistic excellence, serious intent, and effective fiscal and organizational management. The need to expand the program was a result of a substantial increase in foundation assets during the booming stock market years of the early to mid-1980s.

By mid-1992, the expansion was well under way. "Our criteria have remained the same," he explained, "but we are now accessible to a much wider performing arts community." The evidence is that in the past two and a half years, unsolicited proposals have increased some 400 percent.

For its part, the board faced another decision: whether to retain all the program areas previously funded, and expand them by hiring new staff, or to pare them down for greater leverage and sharper focus. They chose the second option, eliminating all grants for education and community services. Funds from those budgets were transferred to the arts and health care areas.

These decisions ultimately led to additional changes, entailing types and duration of support. As the foundation has informed itself of the needs of its newly eligible grantees, awards for general operating support have grown, while grants for specific projects have declined, and multi-year grants have become more widely available.

GRANTEE REACTION

According to the foundation's program officer, disappointment over the change in policy was felt most keenly by organizations active in social services and education, since they were no longer eligible for funding. Within the arts, however, wariness was expressed prior to the implementation of the new policy, according to the officer. "They did not know who this new player—myself—was, let alone what influence I would have. A general fear of the unknown."

As it became clear that the seven institutions affiliated with Lincoln Center—Metropolitan Opera, the Chamber Music Society of Lincoln Center, New York City Ballet, New York City Opera, Lincoln Center for the Performing Arts, Inc., New York Philharmonic, and Lincoln Center Theater—would not only continue receiving support, but that grant amounts would remain relatively stable (because of the elimination of other program areas), the concern dissipated.

IMPLEMENTATION

The expansion was accomplished in stages, beginning with a round of site visits and other meetings with artists, administrators, and grantmaking colleagues. Though the arts were always a personal interest, the program officer's professional experiences had been developed outside the arts and philanthropic worlds *per se*. He therefore felt the need to immerse himself in arts issues: "Though no actual funds were spent on research, I tried to open an in-depth, honest dialogue with as many members of the arts community as I could, and of course I read a great deal."

Following his personal outreach, he made verbal and written presentations to the board, a process that is ongoing, as is the outreach and research.

Was the new policy difficult to implement? No and yes, according to the officer.

No, for three reasons: a) the ability of small private foundations to be flexible and respond quickly to new initiatives and conditions; b) an obvious willingness of the board to facilitate enactment of its own policy directive; and c) as the son of the chairman, the officer was accorded a great deal of leeway, probably not available to most foundation staff.

On the other hand, difficulties were encountered, in part because of the board's comfort with a funding tradition that entailed no consideration of potential arts grantees outside of Lincoln Center and its affiliated institutions.

In addition, the board's makeup is homogeneous; its mostly elderly white male trustees are fairly conservative, at least as concerns notions of legitimate arts institutions. "It makes for a singular perspective," the officer explained. "They are unfamiliar with some of the organizations I recommend for funding; these groups are very new to them."

He added, however, that the board has been highly "open and responsive."

The absence of previous staff also made for an easier transition than might have been the case; there had been no need to reconfigure any board-staff interactions.

Nevertheless, some tension adheres in any such relationship, given their different—and sometimes conflicting—roles, the officer explained. "Staff has the responsibility to advocate on behalf of the foundation's constituents, after we do our research. The board's crucial role, however, is oversight and, to a certain degree, restraint."

Adding to the problem, he said, was the difficulty staff faced in marshaling sufficient information on the quality and needs of new recipients to make a convincing presentation. The board meets only four times a year, which limits its exposure to the expanded arts community now eligible for Samuels Foundation support. Limited exposure leads to greater hesitancy.

For example, although the board has been more willing to provide general operating support over project support, that is not always a foregone decision. "The groups themselves have to make more of an effort to show the foundation's board that general operating support does not just mean paying the electric bill," the officer said. "It means, literally, putting on the play or dance."

He continued that the staffs of grantmakers have to vest their boards more fully in such issues. "I am not sure quite how. But arts grantmakers have to discuss this. The relationship between the board and the staff, I believe, is the most important [internal] issue facing arts philanthropy today."

ARTS FUNDING ISSUES

Disputes over government funding of controversial works of art have had "no effect whatsoever" on the policies or deliberations of the foundation. "We are focused on our own criteria," the officer said, "which, again, are excellence, serious intent, and responsible management." He added that since the outbreak of the controversy, the foundation has funded such groups as Franklin Furnace, a presenting organization at odds with the National Endowment for the Arts.

On the issue of funding individual artists, the grantmaker is not likely to alter its policy, although some support is given to individual artists through regranting mechanisms.

GOALS

Having accomplished his first goal—expanding the pool of arts organizations eligible for foundation support—the officer set a long-range goal of: a) broadening the foundation's concept of what the arts are, and b) fostering a fuller understanding of the roles the arts can and do play in U.S. society.

"To be sure," he added, "our ongoing goal is to be a more effective grantmaker."

Note: The program officer interviewed for the above article has since left the foundation.

ENDNOTES

1. Dance/USA, *Guidelines for the American Dance Touring Initiative*, Dance/USA underwritten by the Lila Wallace-Reader's Digest Fund, 1992, Washington, D.C., Page 3; *Domestic Dance Touring: A Study with Recommendations for Private-Sector Support*, Dance/USA commissioned by Lila Wallace-Reader's Digest Fund, 1992, Washington, D.C.

11

Grantmaker Profiles

The following 61 profiles offer a snapshot policy view of some of the nation's leading private arts funders—foundations and corporate giving programs—selected because they provide a substantial amount of money or a significant portion of their overall grants to the arts, or otherwise express a strong programmatic commitment to the field.

Emphasis in the selection process was placed in part on geography, with first choice for funders who gave beyond their communities' borders.

Intended solely as an introductory overview for grantseekers, grantmakers, researchers, and others interested in the policies of some key arts patrons, these profiles are neither exhaustive nor comprehensive. Many other foundations and corporations support the arts through generous contributions, and readers are advised to consult Foundation Center directories for additional information.

Sources for the profiles included annual reports, grantmaker guidelines, news accounts, press releases, and other documents, as well as occasional phone interviews.

To ensure accuracy, profiles were sent to each of the funders for their review. All but one or two were verified prior to publication.

In several profiles, reference is made to the "1992 survey." This pertains to an arts funding questionnaire completed for this study by 182 grantmakers in the early months of 1992. Findings from the survey appear in Chapter 8.

AHMANSON FOUNDATION (CA):
FAVORING CAPITAL PROJECTS

Culture—one of four broad subject areas favored by the Ahmanson Foundation—received the largest share of allocations in 1991, $7.3 million or 42 percent, up from 36 percent the year before (nearly $6.6 million in 1990). Most of its grants are awarded to institutions in the Greater Los Angeles area.

While supporting a variety of performing and visual arts organizations, some of its largest grants go to museums for the acquisition of works of art. Over $4.3 million was awarded to Museum Associates (the Los Angeles County Art Museum) for that purpose.

Other capital and endowment projects ranked high among Ahmanson's priorities in 1991. Two examples included a $203,000 grant to the Huntington Library & Art Gallery towards purchase and installation of a computer information system in the Development Office, and $100,000 to the National Gallery of Art towards an endowment fund.

Types of support include capital campaigns, equipment purchases, renovation projects, scholarships funds (to institutions), and special projects. Grant amounts tend to range between $10,000 and $25,000, but can go considerably higher.

Recipients of arts grants include museums, performing arts organizations, historical societies, libraries, and school districts. No funds go to continuing support or annual campaigns, deficit financing, professorships, internships, individual scholarships or fellowships, exchange programs, film production, or loans. Individual artists likewise receive no grants.

ALCOA FOUNDATION (PA):
APPRECIATION FOR ARTS AND HISTORY

Grants to "encourage awareness in the arts," reach underserved audiences, and foster an "appreciation for history" comprise the bulk of the Alcoa Foundation's cultural program. Beneficiaries are performing arts groups and museums, usually those in or near communities where the Alcoa Company has facilities.

Difficult economic times created "challenges" for the foundation in 1991, according to its annual report; as a consequence, arts groups received less

both in absolute dollars and in the share of Alcoa's total grants.

Giving to all fields by the aluminum company during the year amounted to $11.9 million, down 1 percent from the year before. Arts grants, however, which reached $1.3 million, were down by 13 percent. As a share of its total allocations, the arts in 1991 received 11.3 percent, down from 12.5 percent the year before.

The foundation does not fund endowments, deficit reduction, individuals, organizations seeking to influence legislation, religious activities, fundraising, documentaries, or videos.

AMERICAN EXPRESS PHILANTHROPIC PROGRAM (NY): CROSS-CULTURAL COMMUNICATION

Viewing the arts as "enhancing the quality of life for individuals, communities and nations," as well as promoting "cultural diversity and cross-cultural communication," the American Express Philanthropic Program supports arts projects that: a) reach large audiences and increase accessibility, b) provide arts education for young people and their families, and c) preserve historic and cultural assets, and promote environmentally responsible tourism.

Grants from American Express are distributed through several organizational units within the program, including two foundations and two corporate giving plans. Domestic and overseas projects in the visual and performing arts, and historic preservation, are eligible for support. In other areas, the company funds efforts in education, employment, and community service.

Cultural funding in 1991 amounted to $7.9 million, a 2 percent drop from the $8.9 million given the year before. In both years, the arts received about a third of the multinational company's entire giving, including employee matching gifts.

Major exhibitions supported in 1991 included the works of Rembrandt in Berlin and Amsterdam; Annie Leibowitz (photographer) in New York City and Washington, DC; and Manuel Alvarez Bravo (photographer) in Detroit, Vancouver, Kansas City, and Santa Barbara. The company also supported The Micro Gallery, a computer information room for both visitors and art historians, in the National Gallery in London.

Other arts projects supported in 1991 included the Young Playwrights Festival, the Fund for New American Plays, and the American-Russian Youth Orchestra.

Historic preservation and conservation projects also received funding during the year, including those operated by both local and international preservation organizations like the Fresno County Historical Society and the World Monuments Fund.

Priority is given to projects over general support, and activities embodying partnerships among the public, private, and nonprofit sectors. The international company is also partial to projects in which its own employees participate, and those entailing company promotional support for the nonprofits' activities. Most grantmaking occurs in states and countries where the firm has a geographic presence.

Special projects, scholarships for employees and their relatives, seed money, and programs are eligible for funding. Grants are not available to groups that discriminate ethnically or sexually, individuals, or religious organizations. Support is not given for fundraising events, travel, political causes, publications, or lobbying. Endowments and capital campaigns are rarely supported.

AMERITECH FOUNDATION; AMERITECH CORPORATE GIVING PROGRAM (IL): ESTABLISHING THE MIDWEST AS CULTURAL CENTER

With the twin goals of "establish[ing] the midwest as a cultural center, both nationally and internationally," and benefiting the communities in which it maintains operations, the Ameritech Foundation allocated $1.5 million in 1991—roughly a quarter of its total disbursements of $5.8 million—to the arts. The foundation was established by the telecommunications firm in 1984, the year of the restructuring of AT&T into several independent operating companies.

Most of the funds went to nationally recognized cultural institutions located in the Great Lakes region. A few went to national organizations and to presenters of touring performances of midwestern artists.

Support by Ameritech during the year facilitated the production of the critically acclaimed *Turandot* by the Lyric Opera of Chicago, and the participation of the Cleveland Orchestra at the Salzburg Festival.

Arts funding rose 20 percent in 1991 over the year before, compared to an increase of 15 percent in the foundation's giving as a whole. Grants to cultural organizations may go as high as $400,000, although most fall between $10,000 and $50,000.

Beyond the arts, Ameritech funds education—its primary concern—civic and community improvement, and health and human services. However, each of the company's 13 subsidiary corporations—various state Bell companies and communications firms—administers its own awards programs and adheres to separate funding priorities. Combined giving in all fields from all Ameritech firms totaled $21.5 million in 1991, independent of matching gifts.

The foundation does not make grants to political, labor, military, or international organizations, sports programs, individuals, or for religious purposes. Nor will it consider requests for second-party giving, or special occasion or special interest magazines.

ARCO FOUNDATION (CA):
ARTS AS A BRIDGE TO UNDERSTANDING

A policy of furthering intercultural understanding and broadening the availability and relevance of arts and cultural experiences, especially in minority neighborhoods of ARCO communities, underlies the ARCO Foundation's giving decisions. The policy extends an earlier goal of addressing root causes of educational, social, and cultural disparities in American life. In the 1992 survey, ARCO restated its goal to emphasize projects promoting artistic diversity and access for underserved populations.

Most ARCO grants are allocated to education and community programs, with an emphasis on minority achievement and retention, and job creation. In the arts, priority is given to groups offering quality art for enrichment experiences in underserved neighborhoods; multicultural community and emerging neighborhood arts organizations; and programs that assist arts groups in strengthening their donor bases and volunteer resources—in other words, projects that help cultural organizations improve their own fundraising capacity. Thus, ARCO views board development, long-range and strategic planning, and audience development as among the most critical needs faced by arts groups

today. Artistic salaries and commissioning new works are also viewed by the funder as critical.

Arts organizations in the Los Angeles area and a few other "key" ARCO cities in the Southwest, West, and Alaska are favored. The foundation awards grants to groups in the performing arts and to museums, and for coalitions/advocacy.

ARCO grants tend to range between $5,000 and $10,000, but they go as high as $100,000. Nearly $2.4 million was allocated through 195 arts grants in 1991, representing 14 percent of the foundation's total giving of $12.8 million.

While grants are awarded for art education in the schools, recipients may not be individual schools or schools districts, and proposals from professional schools of art, academic art programs, and college museums are discouraged. Finally, no grants are given for buildings, film or video, endowment, annual or capital campaigns, or deficit financing.

Administratively, Atlantic Richfield Corporation (ARCO) completed the transfer of virtually all its grantmaking functions in 1990 from the foundation to the corporate giving program. Nevertheless, company executives continue to refer to the giving program as the "ARCO Foundation," and they advise grantseekers to address their proposals to the foundation.

AT&T FOUNDATION, AT&T COMPANY CORPORATE GIVING PROGRAM (NY):
SUPPORT FOR ARTISTIC INNOVATION

Funding priorities of the AT&T Foundation as of 1989 included the creation and presentation of new artistic work, women and minority artists, ensembles and art groups that show promise, and cultural groups undertaking major institutional development or expansion projects. By 1992, this commitment to sponsoring the "innovative, risk-taking work of artists of diverse cultures" also included "ensuring that arts programs are open and available to all segments of communities."

Consistent with this national arts policy, the communications and computing giant has expressed a special interest in funding the creation and presentation of new artistic works, especially in theater, dance, visual arts, and symphonic music. In the 1992 grantmaker survey, it also reported a continuing willingness to fund controversial works, even in the

wake of battles over federal funding of art some observers considered obscene.

Arts grants totaling more than $4.8 million in 1991 (or 15 percent of total grants of $31.9 million) were distributed to several hundred organizations nationally, including theater, dance, and opera companies; symphony orchestras; art museums; presenters such as the New Jersey Center for the Performing Arts and Performance Space 122; and arts stabilization projects, such as the New York Community Trust/Arts Forward Fund.

Grants fund artists' fees, production expenses for new works, and restricted endowments and matching gifts. Most grants range between $5,000 and $15,000, with several considerably higher.

The AT&T Foundation does not support student or amateur groups, artistic training or scholarships, competitions, arts education projects, science museums, planetariums, zoos, and most film and media production projects. Grants are not awarded for historic restoration, unrestricted endowments, equipment purchases, planning endeavors, or most capital campaigns. No grants go to individuals; lobbying, political, or religious organizations; or groups practicing ethnic or sex discrimination.

Beyond its regular grants, the foundation funds performances of 20th century American music by major symphony orchestras through "AT&T American Encore," tours by nationally recognized dance companies through the "AT&T Dance Tour," the production of new plays and musicals through "The AT&T New Plays for the Nineties Project," and the exhibition of recently created visual art at museums of art through "AT&T New Art/New Visions."

AT&T also offers some arts grants through its direct corporate giving program (separate from the foundation). The locally controlled giving program tends to focus on performing arts groups, arts education, and economic development projects.

THE BROWN FOUNDATION, INC. (TX): RISING SHARE TO THE ARTS

Historically, arts and humanities groups have secured less than a third of all disbursements by the Brown Foundation—$97.4 million out of $306.7 million during the 40 years from 1951 through 1991. The share appeared to increase by the late 1980s. For

example, in 1989, allocations to the arts reached 38 percent of the total, and in 1991, the arts secured almost half, or $6.2 million out of $13.1 million. (The foundation's other program areas are education, health, and community service.)

Provided mainly to groups in Texas—Houston in particular—arts grants are available to museums and other visual arts organizations, theater, opera, ballet, symphony, and film festivals.

In evaluating proposals for all program areas, the foundation looks for projects that "address the root causes of a problem, rather than treating symptoms." It also values efforts to leverage other resources, and favors projects that motivate cooperative efforts within the community to deal with various issues. In general, only one application is considered within any 12-month period.

Support is available for operating expenses, annual and capital campaigns, building and renovation, endowments, equipment, fellowships, professorships, special projects, and publications. No grants are available for individuals, religion, politics, or other foundations. No support is given for testimonials, deficit financing, or fundraising events other than ongoing campaigns.

THE MORRIS AND GWENDOLYN CAFRITZ FOUNDATION (DC) : COMMITMENT TO THE COMMUNITY

One of four major program areas (Community Services, Education, and Health are the others) funded by the Cafritz Foundation, the Arts and Humanities consistently receives the largest share of overall funding, but the proportions have diminished. In 1991, Cafritz awarded $3.6 million for the arts, or 36 percent of a $9.9 million grants budget. This compared with a high of $4.7 million (63 percent of total grants) allocated to the arts from a $7.3 million grants budget in 1989. Given its high level of funding, the foundation consistently ranked among the 25 largest funders of the arts during the study period. In 1989, the final year of the study, it ranked sixteenth.

The Cafritz Foundation concentrates it grantmaking within the greater Washington, DC, metropolitan area. Although it generously funds the national museums and other federal cultural institutions located in the District, it also supports smaller community-based arts organizations.

Cafritz makes grants in all areas of the arts and humanities; grantees reflect the District's culturally diverse population. In addition, the foundation funds arts education, artists' residencies, and arts programs for children and the elderly. In 1991, arts grants ranged from $2,000 to a high of $1 million (to the National Gallery of Art). Most of its 53 arts grants were between $10,000 and $50,000. Examples of average-size grants include: $37,440 to Virginia Center for the Creative Arts for residencies for Washington artists, $20,000 to Gala Hispanic Theatre toward a campaign to increase their English- and Spanish-speaking audiences, and $60,000 to the Washington National Cathedral in support of the 1990-91 music program.

In general, Cafritz arts grants reflect a strong commitment to the black and Hispanic communities in the District area and to programs for children. Cafritz provides support for operating budgets, seed money, matching funds, scholarship funds, fellowships, and general purposes. No grants are made to individuals, or for demonstration projects or conferences. The foundation does not provide loans, nor will it make grants for deficit, capital, or endowment financing, or toward emergency or building funds.

MARY FLAGLER CARY CHARITABLE TRUST (NY): TARGETING SMALL AND MID-SIZED MUSIC PERFORMANCE INSTITUTIONS AND MUSIC EDUCATION

The Mary Flagler Cary Charitable Trust funds within three areas of life-long interest to its founder: music in New York City, Atlantic and Gulf coastal ecology, and New York City urban environmental programs. In music, the Trust's aim is to maintain the vitality of New York City's musical life through the support of smaller professional institutions and of educational programs that provide music instruction to young people.

Excluding its annual support of the Cary Arboretum, music programs received the largest share of grants from the Trust in fiscal 1991, as they have since the Trust was established. Music grants totaled $1.56 million, out of $6.3 million in total giving. From its inception through 1991, tbe Trust gave approximately $20 million to music programs.

Established in 1968 through the will of Mary Flagler Cary, the Trust has a term of 50 years.

During the 1970s and 1980s, its trustees established grantmaking policies targeting smaller music institutions in New York City. These were typically ensembles and concert venues presenting adventurous repertoire and providing performance opportunities for young musicians.

The Trust continues to support New York's small and mid-size music institutions with grants for general operating costs to professional orchestras, opera companies, ensembles, and presenters of contemporary music. Through its Live Music for Dance program, the Trust provides support for musicians accompanying dance performances. Through its contemporary music initiative, it encourages the commissioning and recording of contemporary music.

The aim of the Trust's music education program is to offer children the opportunity to "learn and experience firsthand the pleasures of singing, dancing and playing an instrument," primarily through the support of basic music training at community music schools.

In 1991, most music grants ranged between $5,000 and $25,000, although several were higher.

The foundation does not provide grants to other foundations, hospitals, religious institutions, schools or colleges (except for music schools), libraries, museums, or to individuals.

CHASE MANHATTAN CORPORATION PHILANTHROPY DEPARTMENT (NY): COMMUNITY WELL-BEING AND EMPLOYEE SERVICE

Enhancing "the well being of the communities it serves" is the overall philosophy governing Chase's grantmaking, including arts funding. Among its specific goals, the bank strives to promote effective nonprofit management, and to encourage its employees to devote their nonworking hours both to nonprofit groups and to the populations they serve.

Chase Manhattan awards grants through a direct corporate giving program and through the Chase Manhattan Foundation, but the foundation does not award grants to the arts. Arts organizations receive grants from five separate Chase programs administered through the corporation's philanthropy department: Culture and the Arts,

Nationwide Grants, Neighborhood Grants, Major Gifts, and Matching Gifts.

These programs, however, have been reduced lately under the impact of a slow economy. As with all company-based philanthropies, Chase's grantmaking is strongly dependent on the corporation's previous year's earnings. As earnings dropped, so did contributions. Total giving in 1991 was $5.6 million, down from $9.6 million the year before, while total arts grants dropped from about $1.2 million in 1990 to about $860,000 in 1991. (Notwithstanding the drop in actual dollars in 1991, arts' share of total giving rose over 2 percent from the previous year.)

Further, fewer and smaller grants characterized the 1991 grantmaking strategy. Most arts grants ranged between $1,000 and $5,000, although a few were for sharply higher funds, such as the $100,000 granted to Lincoln Center for the Performing Arts.

Beyond gifts of cash, Chase donates equipment and other services. Grants through the Neighborhood Grants program are geographically confined to New York City; Long Island; and Dutchess, Orange, Putnam, Rockland, and Westchester counties. Grants are not made to individuals; religious, fraternal, or veterans organizations; for medical research or single-focus health organizations; or for endowments.

CHEVRON CORPORATE GIVING PROGRAM (CA): ENCOURAGING ONGOING SUPPORT FOR ARTS GROUPS

Supporting the arts has been a Chevron hallmark since 1928, when the energy company sponsored Symphony Broadcasts on radio's "Standard Hour" program. Music, not surprisingly, has remained one of the firm's major arts funding priorities, although it also supports opera, museums, dance, theater, and public broadcasting, along with symphonies.

National, international, and regional arts organizations are eligible for arts grants, but the company favors groups in the localities where it does business. Most grants range from $5,000 to $15,000, although some museums and symphonies receive higher amounts.

Arts funding in 1990 totaled more than $4.7 million, a 3 percent decline from the amount given in 1989. As a share of all 1990 contributions ($25.7 million), the arts obtained 18 percent, virtually unchanged from the 19 percent reported the year

before. Central to Chevron's funding policy is facilitating the development of ongoing, local support for arts groups. The Chevron Community Concerts, for example, are designed to "help local symphonies build their base of community support." All proposals, in fact, must specify the applicant's plans for continuing support.

Ineligible for support are individuals, religious and political organizations, school-related bands, and sports activities. No grants are available for building and equipment, endowment, conferences, United Way participants, travel funds, freelance film or videotape productions, or tickets.

CHICAGO COMMUNITY TRUST (IL): MORE RISK-TAKING FOR THE ARTS IN CHICAGO

In response to political, economic, and grantmaking issues confronting the arts world today, the Chicago Community Trust is likely to engage in "more risk-taking," according to the Foundation Center's 1992 survey, but will remain committed to keeping "high quality product" as its major criterion.

Proposals that deal with the problem of dwindling audiences for the arts are likely to be well received. In the near future, support is likely to be directed towards artists and administrative salaries, staff training, and board development.

Over the past few years, arts and humanities grants awarded by the Chicago Community Trust have seemingly followed a see-saw pattern, rising and falling dramatically from year to year. This does not represent constantly changing priorities; rather, it reflects the Trust's practice of awarding large, multi-year grants, and the recording of these grants under the year authorized.

Thus, the nearly $5 million in three-year grants awarded in 1990 to Chicago's 14 major cultural institutions raised arts grants that year to 16 percent of the Trust's total grants, well above 1989's 3 percent. In 1991, arts grants totaled nearly $2.7 million and represented 8.2 percent of total grants of $32.5 million.

Arts and humanities groups receiving the Trust's grants, which tend to range between $20,000 and $50,0000, include ballets, chamber music ensembles, symphonies, architectural groups, operas, historical societies, and festivals. Almost all grants are restricted to the Cook County area.

No grants are available for religious purposes, government agencies, or individuals, except fellowships. The Trust does not support annual campaigns, deficit financing, endowments, publications, scholarships, conferences, or computer equipment.

Robert Sterling Clark Foundation (NY): Strengthening Cultural Management

Cutbacks in public arts funding have led the Robert Sterling Clark Foundation to urge arts organizations to "reduce their dependence on traditional sources of support." Thus it will favor proposals from New York City and State cultural institutions that are designed to accomplish the following aims: increase earned income as a percentage of total operating costs; improve internal management; reduce operating costs through resource sharing; and increase contributions from individuals.

Other arts projects supported by Clark include those addressing the issue of artistic freedom. The foundation is likely to fund more advocacy projects in the near future, according to the 1992 survey. Examples of 1991 grants in this area included $30,000 and $50,000 to the National Campaign for Freedom of Expression, and to People for the American Way, respectively.

Arts grants in 1991 amounted to $814,000, or 31 percent of total grants that year of $2.6 million, which represented an increase of 7 percent over total grants the year before. Grant amounts tend to range from $10,000 to $50,000.

The foundation does not give grants to individuals, or for operating budgets, annual campaigns, seed money, emergency funds, deficit financing, capital and endowment funds, matching gifts, scholarships, fellowships, conferences, or films.

The Cleveland Foundation (OH): The Arts Connect Cleveland's Past and its Future

Three quarters of a century after its founding in 1914 as the nation's first community trust, the Cleveland Foundation focused its grantmaking in the 1990s on issues "critical to the future" of the city. In the area of cultural affairs, this meant not only looking ahead, but also working to preserve those arts institutions with histories as long as the foundation's. To this end, grants were made to three groups celebrating their 75th anniversaries: Karamu House, the Cleveland Playhouse, and a multi-year, special grant of $2.1 million to the Cleveland Orchestra, "to keep vibrant one of the reasons Cleveland is such a wonderful place to live."

Grants in cultural affairs in 1990 (excepting the one-time special grant to the Cleveland Orchestra) totaled $3.1 million. That figure jumped to $3.9 million in 1991 and remains at about 12 percent of the foundation's total grantmaking.

In an effort to foster public awareness of Cleveland as a major regional arts center, the foundation made several grants to support significant marketing efforts. Examples of this were a two-year, $180,000 grant to the Cleveland Arts Consortium, an organization concerned with marketing the arts to Cleveland and regional audiences, and a market research grant to Playhouse Square Foundation.

As the city's arts groups faced a 20 percent cutback in funding from the Ohio Arts Council and a diminishing pool of corporate support, the Cleveland Foundation favored grants for enhanced business administration, management capacity, and strategic planning in 1990. In addition, the foundation contributed to the financial stabilization of Cleveland Ballet with a major grant of $300,000, and provided challenge grants for increased contributed income for smaller groups. In 1991, additional emphasis was placed on collaborative and cooperative projects among Cleveland arts groups.

Recipients include tax-exempt organizations and government agencies in the greater Cleveland area. Designated grants—funds for organizations or purposes specified by donors—start at $145 and reach over $200,000. Most grants, however, range between $5,000 and $50,000. Discretionary grants are limited to the Cleveland area.

Types of support include seed money, planning support, matching funds, consulting and technical assistance, special project support, and artistic programming. Limited support is available for capital purposes and for program-related investments. No funding is provided for sectarian or religious activities, individuals, endowment, operating costs, debt reduction, fundraising campaigns, publications, or films.

NATHAN CUMMINGS FOUNDATION (NY): RECOGNIZING THE RICH CULTURAL PLURALISM OF THE UNITED STATES

Four decades after its founding as a small, informal grantmaker supporting projects in the arts, medicine and science, the Nathan Cummings Foundation reconstituted itself in 1989 as a fully operational national and international foundation, with board, staff, advisors, and guidelines. The motivation for the transformation was the bequest several years earlier of $200 million from the estate of the deceased founder. Following its reorganization, and as a result of sharply higher assets, total grants in 1990 increased more than sevenfold from the year before.

The foundation's goal is to realize the convictions of its namesake and his descendants, including "respect for cultural differences, concern for the underserved, and leadership development." Not surprisingly, it reported a likelihood of funding "more grants for [arts] advocacy" in the 1992 grantmaker survey.

The arts are one of four program areas supported by Cummings grants—the other three being health, the environment, and Jewish life. A fifth, interprogram area also receives support for projects that touch on more than one of the core programs, such as multimedia interpretations of environmental issues.

Within the arts, the foundation emphasizes three broad concerns: supporting the autonomy of artists and art institutions and supporting those who advocate on their behalf; arts education for youth in at-risk situations; new agendas; and access and diversity. Grants are aimed at supporting model arts education projects, increasing the visibility and accessibility of multi- and cross-cultural experiences in the United States, and fostering free expression in the arts.

Strong support for "the right to free, artistic expression" has earned the grantmaker a reputation as a leading voice in the battle against censorship. Two projects begun with grants from Cummings in 1990 reflect this commitment: the Art Censorship project created in conjunction with the American Civil Liberties Union, and Artsave, a national research and technical assistance effort to protect freedom of expression, developed by People for the American Way. Both projects were generously funded by the foundation again in 1991.

Exclusive of cultural grants within the Jewish life and interprogram areas, the foundation's arts grants in 1991 amounted to $1.6 million, or 18 percent of total grants of over $9 million that year. Jewish life and interprogram arts grants, plus several cultural grants made under the rubric Community Programs (unsolicited grants of particular interest to the Cummings family) brought the total proportion of Nathan Cummings' arts grants to 26 percent. In 1990, total combined arts grants from all program areas were much higher, due in part to a payment of $1.1 million to the American Friends of Israel Museum to complete the Nathan Cummings Twentieth Century Art Building.

Grants made in the arts program typically range between $35,000 and $50,000, with a high of $150,000.

The foundation does not fund individuals.

DAYTON HUDSON FOUNDATION; DAYTON HUDSON CORPORATE CHARITABLE GIVING PROGRAM (MN): EXCELLENCE, LEADERSHIP, ACCESS

Artistic excellence, artistic leadership, and greater access to the arts undergird the funding policies of one of America's retail giants, the Dayton Hudson Corporation. Through its foundation, its separate corporate giving program, and the giving programs of its three major divisions (Mervyn's, Target Stores, and Department Store Division), the general merchandise retailer dispensed $27.1 million in 1991, down from the $30.7 million in 1990. Roughly 40 percent of all Dayton Hudson giving in 1991 went to the arts.

The foundation and each of its divisions, which shared a Distinguished Achievement Award from Business Committee for the Arts and *Forbes Magazine*, tend to favor groups in the cities where they respectively operate.

Supporting multicultural artistic expression and strengthening emerging minority artists were among the firm's more pronounced initiatives in 1990 and 1991. In California, for example, Mervyn's established "Expressions '90," a program helping 15 arts groups develop multicultural arts programming for families. In Texas, Target Stores funded the establishment of a database of "diverse local cultural resources" for schools and neighborhood groups. The aim of the database, developed by a Fort Worth arts alliance, is to foster intercultural communica-

tion. And in Los Angeles, the foundation and its subsidiaries jointly sponsored an exhibition of 30 centuries of Mexican art.

Dayton Hudson's decade-old strategy of encouraging local artistic excellence is realized through its Comprehensive Arts Support Program (CASP) in the Twin Cities, through which arts groups are awarded for setting objectives, measuring results, and otherwise sharpening their operations. In 1990, CASP was also made available to arts groups in Chicago, the home of Marshall Field, a recent Dayton Hudson acquisition.

Increased access to the arts is fostered in part by Dayton Hudson's support for Urban Gateways: The Center for Arts in Education, through which professionals teach and perform in workshops in financially strapped urban schools.

Arts grants typically range from $3,000 to $40,000, but grants of six and seven figures are also available. The Minneapolis Institute of Arts received more than $1.2 million in 1990 to support an endowment for special exhibits, and the Minnesota Opera received $300,000 during its capital campaign.

The grantmaker and its subsidiaries tend to fund general programming and project support, with priority to full-time projects in which artistic personnel are paid, professional arts programming is developed, and the work of living artists is enhanced. Performing, visual, and media arts groups all are eligible.

Capital and endowment funding is available, but extremely limited. No grants are given to individual artists, although in 1991 the foundation announced that a portion of its arts dollars "will increase support for the work of individual artists." Religious groups and fundraising dinners also are ineligible for grants.

AARON DIAMOND FOUNDATION (NY): DEVELOPING YOUNG MINORITY ARTISTS AND NEW AUDIENCES

In addition to focusing on the development of young minority artists in new and established companies, the Aaron Diamond Foundation encourages programs that reach out to new audiences and make the arts more accessible and relevant to public school children and their families. These policies, however, will last only until the end of 1996, when the foundation plans to cease operations through the expenditure of all of its funds.

During 1991, the foundation provided arts funding in five categories: dance, music, general performing arts, the New York Public Library, and special purpose grants. In education, the foundation funds its Arts in Schools program, which emphasizes "projects that enhance the academic achievement and life opportunities of public school students, largely minority."

Funding for the arts comprises roughly one-third of the foundation's total grants, which in 1991 amounted to $27.1 million. The remainder went to education, medical research, and human rights and civil liberties. The foundation restricts its grantmaking to New York City.

Examples of 1991 arts grants included $250,000 to the Dance Theatre of Harlem for the training of minority dancers, and $185,000 to the New York City Ballet, a portion of which supported a project to develop new choreographers. In music, the foundation funded organizations that assist artists starting out in their careers, including $15,000 to Composers' Forum and $100,000 to Young Concert Artists. Grants also went to organizations such as Jazzmobile, awarded $15,000, that actively reach beyond traditional audiences.

Grants range between $10,000 and $50,000, with several special projects receiving higher grants such as the New York Public Library, which received $500,000 in 1992 as a final payment for a $2 million, four-year grant for a book cataloging project.

According to the 1992 grantmaker survey, the foundation is likely to continue its support of arts organizations by providing operating funds, both restricted and unrestricted, and program support. The foundation does not fund building programs, endowments or other capital expenditures, production costs, or individuals.

DIGITAL EQUIPMENT CORPORATE GIVING PROGRAM (MA): SOLUTIONS TO CRITICAL CHALLENGES

As the company that won a Corporate Conscience Award in 1989 from the Council on Economic Priorities, and two arts support awards from Business Committee for the Arts, the Digital Equipment Corporation has earned a reputation for exemplary corporate citizenship. Digital's giving policy seeks to promote "solutions to critical chal-

lenges facing the company and the community," as well as to encourage "active employee participation" and "equal access for all citizens."

Disappointing financial performance for the company during 1992 may ultimately affect its grantmaking, although no official statements to this effect have been made. Digital reported assets of almost $11.9 billion in fiscal 1991. It suffered a net loss that year of $617 million.

Arts and culture grants in recent years—in the form of cash or equipment—have supported programming for public television, national and international art, science and technology exhibitions, and various needs of performing arts groups and museums in communities where the company has a major presence, inside and outside the United States. Among its most notable cash awards, Digital gave $1.4 million to Boston's Museum of Fine Arts for a 1990 Monet exhibition.

Digital's goals specific to the arts include cultural enrichment of employees and their families; greater public access to high quality artistic programming; and diverse cultural programming. The firm also views equipment grants to the arts as one means of "increasing the awareness and knowledge of computers as a valuable resource to business operations and exhibitions."

Another primary factor in Digital's evaluation of proposals is the extent to which the grant will benefit Digital's employees and encourage employee participation. Grants are not made to individuals, capital campaigns, endowments, organizations that adhere to discriminatory policies, or to groups that are politically or religiously partisan.

GERALDINE R. DODGE FOUNDATION, INC. (NJ): CROSSING DISCIPLINES, WITH EDUCATION AS KEYSTONE

The summer of 1991 marked a shift in the direction of the Geraldine R. Dodge Foundation's arts policy. In an effort to assure that "as many people as possible could be touched by the arts," the foundation replaced its traditional programmatic areas, which had been organized by discipline (i.e., dance, music, visual arts), with five new categories emphasizing impact rather than art form. These include Education in the Arts, Improving Access, Developing Institutions, Major Institutions, and Individual Artists.

In describing its new policy, the foundation used the metaphor of an arch to symbolize both the transcendence of separate arts disciplines and the interdependence of the new categories. The keystone of this new structure is education in the arts, which "holds together every other element in an aesthetic arch that the Foundation seeks to assist."

Arts funding in 1991 totaled nearly $1.8 million, down slightly from the previous year. However, as a proportion of Dodge's total donations, arts funding has remained fairly steady at about a fifth over the past six years.

Arts in Education grants are directed to organizations working in New Jersey schools; the grants reflect the foundation's conviction that "lessons learned when one is young often have a long afterlife." Improving Access grants fund projects to increase the availability of the arts to those who are "culturally and geographically underserved."

Developing Institutions grants seek to help new arts groups achieve financial stability and managerial expertise; Major Institutions grants help more established "exemplary" groups uphold standards of artistic excellence.

The Individual Artists program supports organizations backing "promising people," such as choreographers and visual artists. No individuals themselves, however, receive the grants directly.

Notwithstanding the new cross-disciplinary emphasis, the foundation's Poetry Program—aimed at the creation and appreciation of poetry in New Jersey schools—remains as a stand-alone project. Poetry has been a special interest of the foundation since the mid-1980s, when the grantmaker discovered that the field receives a tiny percentage of all arts funding in the country. In 1992, supported by a grant of almost $84,000, students from 70 schools attended the fourth annual Dodge Poetry Festival and competed in the first comprehensive poetry contest in the state's high schools.

Dodge's 1991 arts grants ranged from $6,000 to $120,000—the latter awarded to the Newark Museum for renovation of its science galleries. Most grants fall between $10,000 and $75,000.

The foundation limits its arts funding primarily to projects with impact in New Jersey. It does not support capital programs, equipment purchases, indirect costs, endowments, deficit financing, or scholarships.

EXXON CORPORATION (TX):
NEW AUDIENCES, STRONGER GROUPS

Building new audiences for the arts, and strengthening the financial base of cultural organizations, were the two articulated goals of Exxon Corporation's arts funding in 1991, as they were the year before. But less money was allocated for these purposes: the $3.18 million in Exxon's arts grants in 1991 represented a drop over the year before of almost 4 percent. Still, as a proportion of its total U.S. disbursements, donations to the arts jumped to 14 percent from 9 percent.

Most of the 1991 arts grants ranged from $5,000 to $30,000. Several, however, were considerably higher, including $500,000 to the American Museum of Natural History in New York City (on a pledge of $2.5 million) for renovation of the world-famous dinosaur collection; $300,000 to the Dallas Symphony Association; and $100,000 to the Museum of African American Life and Culture.

Smaller grants in 1991 included $5,000 to the International Theatrical Arts Society in Dallas and $10,000 to the Alaska Center for the Performing Arts.

Cultural productions in key cities where the firm has significant operations stand the best chance of securing funding. Beyond arts projects funded through application, Exxon provided more than $750,000 to cultural groups receiving matching gifts from the firm's employees.

Exxon tends to fund capital campaigns, purchases of equipment, renovation, research, and general operating costs. In the 1992 grantmaker survey, it confirmed that program support was also likely to receive much of its funding. Funding proposals for controversial art works, whether visual or performing, are not likely to be well-received.

Recipients include museums, public broadcasting stations, performing arts groups and presenters. No grants are awarded to individuals.

Exxon's cultural grants are made through its direct giving program and not through its foundation, which supports education.

THE FORD FOUNDATION (NY):
MINORITY ARTS, DIVERSIFICATION, NEW WORKS

Arts programming at the nation's largest and perhaps best-known independent foundation addresses three broad themes: support of minority arts; diversification of established arts institutions and disciplines in terms of programming, staffing, and audiences; and development of new works in the performing arts.

In the mid-1980s, Ford initiated support for Hispanic theater, and in 1989, it undertook a program to improve the preservation, management, and display of collections held by black and Hispanic museums. During 1991, under the collection preservation effort, Ford dispensed $2.1 million to 16 minority museums.

One example of funding to diversify programs at mainstream institutions is a $250,000 grant to the Arena Stage to broaden its repertory to attract a multicultural audience as part of an institution-wide diversity initiative. Support was also given to Arts Midwest to establish a professional development and intern program for minority arts administrators.

To encourage new works, Ford supported the Brooklyn Academy of Music's "Next Wave Festival," which commissions and presents large-scale new works combining music, theater, and dance. It also provided $600,000 to Meet the Composer's Composer/Choreographer Commissioning Program, a national initiative to support collaborations for creation of new music and dance.

Ford's funding for the arts extends to developing countries, where it supports documentation and preservation of traditional cultures. An example in 1991 was a grant to the Bangla Academy for research on Bangladesh's folklore, crafts, and performing arts.

Arts programming is administered through the Education and Culture Program. In fiscal 1991, Ford dispensed $264 million in total grants (exclusive of $4 million for program-related investments), of which $49 million, or 19 percent, went for education and culture.

Grant amounts vary considerably, with no apparent typical range. No grants support programs for which significant other sources of funding are

readily available, or general operating costs, construction, or building maintenance.

Among the types of support likely to receive a majority of Ford's arts grants in the near future, according to the 1992 grantmaker survey, are program and restricted operating support.

FORD MOTOR COMPANY FUND (MI): FINANCIAL CONSTRAINTS CURTAIL GRANTS

Difficult economic conditions affecting the American automobile industry are likely to exact a heavy toll on the Ford Motor Company Fund's total contributions budget for the foreseeable future, slicing as much as 20 percent off the allocations of previous years, according to the Fund's director. The cutbacks became evident in 1991, when total grants dropped 30 percent from the year before ($20 million versus $28.8 million). Arts grants alone fell 25 percent, but at nearly $5 million in 1991, they continued to account for almost a fifth of all the automobile company's giving.

As with many corporate foundations, the Ford Motor Company Fund—which bears no relation to the Ford Foundation, an independent grantmaker—provides its largest arts grants to institutions located in or near areas of the corporation's primary business activities. To the Edison Institute in Dearborn, it gave $600,000 in 1991 for a "Made in America" exhibition. To the Detroit Symphony Orchestra in 1990, the Fund gave $1.1 million—more than a fifth of all the money it donated to the arts that year.

Still, the Fund, incorporated in 1949, awards a wide range of grants to arts groups throughout the country. Notable 1991 examples include $400,000 to the Los Angeles County Museum of Art and $200,000 to the Art Center College of Design in Pasadena. Most grants, however, range between $10,000 and $50,000.

Grantees include large and small performing arts groups, art centers and historical societies, museums and libraries, arts councils, and public television and radio. Grants are not awarded to individuals or for endowments.

GENERAL MILLS FOUNDATION; GENERAL MILLS CORPORATE GIVING PROGRAM (MN): FAVORING ONGOING, UNRESTRICTED SUPPORT

Three grantmaking policies render the arts program of the General Mills Foundation distinctive, according to its literature : a) it provides ongoing support over several years to the same groups, thereby encouraging stability; b) it favors unrestricted operating grants over both capital and project support; and c) it funds both large and small, established and experimental organizations, thereby serving as a "catalyst for innovative action."

With a goal of nurturing "creativity and excellence," the foundation funds the visual arts and museums, performing arts, public broadcasting, cultural centers, and support organizations.

In addition, the company has amassed a noteworthy visual arts collection, open to the public as well as to its employees. One of the reasons for the collection is to expose staff "daily to new ideas and information. They are challenged by what they see. They are stimulated by it. They are encouraged to question it."

Greater cooperation with other grantmakers and with the community at large was an announced policy goal of General Mills for the 1990s. In pursuit of that goal, the grantmaker often presents its plans at community meetings.

It also places high emphasis on employee volunteerism. During 1991, some 3,500 employees engaged in volunteer activities with community groups in Minneapolis. For its efforts, the company received the President's Volunteer Action Award in 1991—one of two corporate winners, out of 3,500 nominees.

About a quarter of the $14.2 million in 1992 foundation grants went to the arts, roughly the same proportion as the year before. Arts grants in 1992 were up about 10 percent. In addition to foundation grants, the company and its affiliates gave another $2 million to various fields, including the arts, through direct corporate gifts.

Operating support, again, is favored, although some capital and program grants are awarded. In general, the foundation does not support publications, film, television shows, or endowments. Grants are not given to individuals, religion, political campaigns, lobbying groups, travel, disease-specific organizations, research, or fundraising.

J. PAUL GETTY TRUST; THE GETTY GRANT PROGRAM (CA): ARTS CONSERVATION, DOCUMENTATION AND SCHOLARSHIP

As an operating foundation, the J. Paul Getty Trust is dedicated to preserving and furthering understanding in the visual arts and the humanities. The

Trust encompasses seven operating programs and a grant program. Projects related to scholarship in the history of art, conservation of art and architecture, and art museums are the primary areas eligible for funding from the Getty Grant Program.

To promote scholarship, the Grant Program funds postdoctoral fellowships for scholars within six years of earning their doctorates, collaborative research efforts by teams of historians, and short-term research fellowships for scholars from Central and Eastern Europe. Funding is also available for research centers, archival projects, and reference works.

Conservation of art is supported by the Grant Program through funding of surveys to analyze conservation requirements of art museums and other institutions, special conservation treatment of outstanding works, and training programs. Support is also available for conserving buildings "of outstanding architectural, historical and cultural significance."

Getty also funds projects to document, in a scholarly fashion, art objects in permanent collections, as well as efforts to enhance public appreciation of those collections.

Grants from the Trust tend to range between $5,000 and $250,000, but most are under $50,000.

The Trust's operating expenditures in the arts and humanities in 1990 amounted to almost $71.9 million (excluding $9.5 million for investment administration). Of that amount, between $5 and $6 million was dispensed through the Grant Program.

The Trust's grantmaking program does not fund operating expenses, endowment, building maintenance, or art acquisition.

GRAHAM FOUNDATION FOR ADVANCED STUDIES IN THE FINE ARTS (IL): ARCHITECTURAL AWARENESS

Almost all grants from the 38-year-old Graham Foundation are geared to architecture, not surprising for an institution founded by Ernest R. Graham, a prominent Chicago architect and protege of Daniel H. Burnham. Mr. Graham died in 1936.

Most grants support projects across the nation that are educational in nature, promoting an understanding and appreciation of architecture. These include symposia, books and journals, catalogs, exhibitions, competitions, films, videos, and even software.

Examples of projects funded in 1991 included a lecture series on progress in urban planning, student architectural journals, cataloging architectural drawings and models in the Museum of Modern Art, and a national high school architectural competition sponsored by the Architectural Studies Foundation. Also in 1991, Graham funded the acquisition of a Wright-designed chair by the Frank Lloyd Wright Home and Studio Foundation.

The previous year, Graham grants funded a monograph on the Resurrection Chapel in Turku, Finland; a video on the work of John Lautner; and an instruction guide for teaching architectural students about the structural behavior of buildings.

Beyond its grantmaking operations, the foundation presented 14 public lectures and six exhibitions in 1991 at its headquarters in the Madlener House, a turn-of-the-century landmark. The House is also made available to other organizations for a nominal fee.

In 1991, the grantmaker awarded 91 grants amounting to $716,275. Nearly half of Graham's grants supported individuals, mostly for research and preparation of books and catalogs, but also for curriculum development and design projects. Grants usually range from $5,000 to $10,000.

No grants are made for endowment, annual operating expenses, construction, overhead, fringe benefits, or architectural fees in support of construction projects. The Graham Foundation does underwrite scholarships, but only to schools (not directly to students), and only "for exceptional students in unusual circumstances."

JOHN SIMON GUGGENHEIM MEMORIAL FOUNDATION (NY): NO-STRING FELLOWSHIPS IN THE ARTS AND SCIENCES

The Guggenheim Memorial Foundation, in operation nearly seven decades, offers only one type of grant: fellowships directly to individuals. What distinguishes "Guggenheims" from other fellowships is that they impose only one condition: that recipients "engage in research in any field of knowledge and creation in any of the arts." Recipients are selected solely on the basis of achievement and potential. Guggenheim awardees have included some of the country's and the world's most accomplished artists and scholars.

In 1991, the Guggenheim Foundation awarded 167 fellowships with a combined value of almost

$4.5 million, about the same amount the grantmaker awarded the year before. Since the foundation reported fundraising efforts to enhance its endowment, grants, which have been significantly reduced in number since 1988, are likely to remain about the same in the next two or three years and will rise in number thereafter. Its assets at the end of 1991 amounted to $145.1 million, a 17 percent increase over their value in 1990.

The fellowship term is typically one year with grant amounts reflecting the needs of the individuals and their projects. Grants range from a high of $30,000 to $12,000 or less with a grant average of $26,500.

Guggenheim fellowships are limited to published authors, exhibited artists and others in the fine arts who are citizens and permanent residents of the U.S., Canada, Latin America and the Caribbean. Individuals from all areas of the humanities and the creative arts may apply, as well as all branches of the sciences, mathematics and social sciences.

All awards are made to individuals, and only for fellowships. Institutions are not eligible to apply. No grants are available for endowments, operating budgets, special projects, or any other expenses of institutions.

In 1991, 37 percent of Guggenheim awards went to arts creators, 36 percent to scholars in the humanities, with the rest distributed to scientists and social scientists. Winners of Guggenheims in 1991 included: a dance critic and contributor to *The New Yorker* magazine; an associate professor of art history at Columbia University; and a scholar who wrote a biography of Isabel of Castile, as well as painters, sculptors, photographers, film- and video-makers, dramatists, poets, novelists, composers, and choreographers.

HALLMARK CARDS CORPORATE CONTRIBUTIONS PROGRAM; HALLMARK CORPORATE FOUNDATION (MO): EVALUATING OVERALL MANAGEMENT, ARTISTIC QUALITY

Arts organizations in Kansas City, MO, and other communities in which Hallmark Cards has facilities must rigorously demonstrate their capabilities in overall management, artistic quality, and effective audience outreach in order to secure funding from the greeting cards giant.

Evaluation is thorough. For example, once a year Hallmark formally reviews its four major arts recipients' staffing, board strengths, and staff-board relationships. It also explores the arts organizations' financial health (capitalization, debts, earned income, etc.). Evaluation of the organizations' artistic programming and community outreach efforts appears equally thorough. The four major arts groups are rated on a numerical scale, and contributions reflect the rating. Recipients are also required to provide periodic written progress reports, and a written narrative accounting for all disbursements at the end of a project.

All art forms are eligible for funding, but theater, symphony, and art museums are likely to receive the bulk of the donations in the coming year, according to the 1992 grantmaker survey. Recipients must be located in the Hallmark facility communities in Kansas, Missouri, Connecticut, Georgia, Illinois, and Texas.

Arts grants authorized in 1991 amounted to more than $1.4 million, an increase of 8 percent from the amount given to the arts the year before. Most grants fall in the range between $5,000 and $50,000, although several are considerably higher, such as the $100,000 grant to the Kansas City Art Institute for 1991 general support, or the $261,000 grant to the Missouri Repertory Theatre for 1991 "formula funding."

Hallmark favors program and general operating grants over capital funding. Support is not given to individuals or to religious, fraternal, international, labor, veterans, or athletic groups. Grants are not given for endowment, deficit financing, travel, conferences, research, media campaigns, charitable advertisements, or for fundraising events.

WILLIAM AND FLORA HEWLETT FOUNDATION (CA): PERFORMING ARTS, ART SERVICES, TRAINING, AND CAREERS

The Hewlett Foundation, formed in 1966, ranks among the top five arts funders in California. Although not geographically limited by its charter, the foundation gives primarily to organizations in the San Francisco Bay area.

Classical music, theater, opera, dance, and presenting organizations receive the bulk of Hewlett's arts grants. In keeping with its emphasis on strengthening the financial and managerial bases of

performing arts groups, Hewlett usually recommends that grant proposals contain matching grants requirements; further, a portion of the matching funds are expected to be applied to cash reserves or endowments rather than to current operating expenses.

Artistic, managerial, and institutional development remain the foundation's key concerns. Grantseekers would do well to emphasize their artistic and administrative achievements in their proposals. By the start of the current decade, the foundation began to favor projects offering advanced artist training, organizations providing services to performing arts ensembles, and efforts to enhance artists' career opportunities. Among recipient types, presenting organizations received the greatest increase in funding because of the broad services they offer: providing opportunities for local groups to perform, commissioning new works, sponsoring emerging artists, and featuring artists who have already made a name for themselves.

Hewlett's collaborations with other foundations, and with local arts organizations, have also increased during the past decade. This outreach evolved from a conviction that "foundations must themselves stimulate and encourage the search for partners on the part of applicants and grantees and be willing to experiment with the support of new cooperative arrangements," as expressed in the 1989 annual report.

One effect of the cooperative endeavors has been the emergence of several regranting programs, under which well-established local organizations redistribute Hewlett funds to groups outside the foundation's normal reach.

The foundation does not fund visual or literary arts, most radio and video projects (with the exception of some in the Bay Area), the humanities, school or university programs, community art classes, folk arts and crafts, popular music, or social service arts projects. No grants go to individuals, seminars, festivals, or foreign exchange projects.

In 1991, arts grants ranged between $5,000 and $500,000. Performing arts grants amounting to $3.6 million, which, combined with $700,000 appropriated to cultural organizations under the category of Special Projects, represented 12 percent of the foundation's $34.9 million total allocations authorized in fiscal 1991. The foundation's asset base that year was almost $752 million. Despite fluctuations in assets by as much as $193 million, total grants budget dollars and arts grants percentages have varied little over the last three years.

IBM (NY):
CONTRIBUTING CASH, EQUIPMENT, AND EMPLOYEE TALENTS

Long acknowledged as providing the largest amount of overall giving among corporate donors, IBM is a pacesetter that encourages its employees to donate time and talent to arts and culture as well as to education, environment, health, and human services.

In 1990, the company reorganized its giving function under a new organization known as Corporate Support Programs (CSP), to coordinate its various programs in the focus areas. The CSP organization also supports job training for the economically disadvantaged and persons with disabilities, general work skills, literacy, volunteerism, and paid assignments for employees in certain colleges and community service groups.

In 1991, the company contributed more than $134 million to a variety of charitable groups and educational institutions. That amount includes cash, donations of equipment, and in-kind services. Grants to the arts alone in 1991 amounted to $15.4 million worldwide, which includes IBM's match of employee contributions.

The company remains committed to good corporate citizenship despite announcements of disappointing financial results in 1992. A spokesperson for IBM reported to the *Chronicle of Philanthropy* (December 7, 1991) that donations would most likely be cut, but that IBM was likely to remain the largest corporate donor.

IBM's rationale for artistic support is that "it makes good business sense" and that it enhances the quality of life in the communities where its employees and customers live and work.

Grantees are well-known visual and performing arts organizations and presenters, including orchestras, opera companies, theaters, museums, and public television. In the visual arts, the company operates its own gallery, decorates its buildings with contemporary paintings, and sponsors exhibitions in museums around the country of such artists as Bonnard, Cezanne, Degas, Picasso, Renoir, Rodin, and many others.

IBM began building a collection of art in the 1930s by purchasing works from countries around the world in which it did business. It exhibited its collection for the first time at the 1939 World's Fair. Since opening in late 1983, the IBM Gallery of Science and Art in New York City has drawn more than 4 million visitors. IBM exhibitions often demonstrate the role of computers in the humanities, such as showing how they facilitate analyses of archeological artifacts

While educational institutions have been the traditional recipients of IBM equipment, increasingly other nonprofits are demonstrating the need to use computers for interactive educational purposes. Computers have been particularly beneficial to job training programs and for use by physically challenged groups.

No grants go to political, religious, fraternal, or animal welfare organizations, individuals, athletic and competitive events, telethons, raffles, or auctions.

THE JAMES IRVINE FOUNDATION (CA): STABILITY, QUALITY, ACCESS

In awarding arts grants, the James Irvine Foundation favors proposals geared toward: improving management and financial stability; enhancing both artistic quality and organizational vitality; reducing economic and geographic barriers to arts exposure; collaborations among arts organizations; and multicultural works reflecting California's diverse population. Grants are limited to that state.

Maintaining that the arts—one of its five program areas—are "essential to the well-being of all Californians," the grantmaker funds organizational improvement, program, policy studies, and capital projects. Groups demonstrating that their proposed activity can attract ongoing funding from other sources stand a higher chance of winning an Irvine grant.

Grants under the Cultural Arts program in 1991 amounted to almost $3.7 million, or 15 percent of total grants of $22.1 million; the usual budget, however, is around $3 million. In addition, awards made under other programs, such as Higher Education, also serve the arts. Examples include $100,000 to the California College of Arts & Crafts for scholarship support, $600,000 to Pitzer College to help in the construction of a center for intercultural study and the arts, and $254,000 to Operation Samahan for a cultural awareness summer day camp program.

In the 1992 grantmaker survey, the foundation indicated that it expects arts funding as a proportion of all funding to increase moderately in the future.

Museums, photography projects, folk culture, all the performing arts, and service organizations received Cultural Arts funding in 1991. Basic research, films or publishing are not usually eligible.

Grants are generally not made for endowment, deficit reduction, short-term festivals, conferences, or for arts education activities in elementary and secondary schools. A tax restriction in the original trust prevents assistance to organizations receiving substantial support from government sources.

JEROME FOUNDATION (MN): ARTIST-CENTERED GRANTS

The Jerome Foundation was established as the Avon Foundation in 1964 by Jerome Hill (1905-1972), the grandson of a railroad magnate, a visual artist, composer, and filmmaker known for his engagement in the avant-garde film movement.

In fiscal 1991, Jerome provided nearly $1.8 million in arts and humanities grants, on an asset base of $41.4 million. Of that amount, theater and visual arts each received 18 percent; film/video and music each received 14 percent; dance received 12 percent; multidisciplinary arts, 9 percent; literature, 8 percent; and criticism, 6 percent. Grants tend to range between $5,000 and $30,000.

The directors of the Jerome Foundation—one of the few grantmakers confining its funding solely to the arts and humanities—spent two days in retreat in July of 1989 to review the foundation's grantmaking history, current programs, and financial status. Among the policies resulting from the program evaluation:

- The foundation will remain "artist-centered," continuing grants to organizations supporting emerging visual, performing, media, and literary artists. Emerging artists are those who have not yet received broad professional recognition from the established art world, but who nevertheless show "clearly promising production and exhibition records." At present, Jerome offers grants to artists and arts organizations in New York City and Minnesota.

- A few highly selective grants will be made to mid-career artists who "face a critical juncture" in their works.

- The total amount of grants for the next few years is expected to remain flat at around $1.7 million—which translates into fewer effective dollars in an era of growing, albeit moderate, inflation.

- Theater, film, and video will receive fewer funds; literary and visual artists will receive more.

- Arts projects reflecting the nation's cultural diversity will receive a strong favorable reception in the coming years.

- Individual artists remain eligible for some grants through two projects: the Travel and Study program, which the Jerome Foundation cosponsors with the Dayton Hudson and General Mills foundations; and the New York City Film and Video program. In the 1992 grantmaker survey, Jerome reported intentions to continue to fund the commissioning of new works.

J. M. KAPLAN FUND, INC. (NY): FREE EXPRESSION AND INNOVATION

Supporting innovation and outspokenness among artists, the J. M. Kaplan Fund argues that foundations must "remain steadfast in defense of the Constitution and the Bill of Rights, and...take chances so that fresh ideas in both the private and public realms can be safely tried out," as the Fund's stated philosophy affirms. These principles are reflected not only in the foundation's arts grants, but in its support of projects in public policy (largely human rights) and in environmental protection and land use planning.

In 1992, the foundation began a major revaluation of its funding policies. Future grants criteria may differ from those specified below.

Most of Kaplan's arts grants are presently concentrated in New York State and City, but preservation support is often national. Arts categories include printing and publishing—often in conjunction with library support, museums, and performing arts.

Arts and historic preservation awards in 1991 ranged from $1,000 to the Eastport Historical Committee to compile a history of this architecturally unique and racially integrated community near Annapolis, to $150,000 for the New York Shakespeare Festival. The range for most arts grants was between $10,000 and $50,000. The Kaplan Fund also makes program-related investments.

Total grants in 1991 amounted to $6.3 million, a drop of almost 13 percent from the $7.2 million made the year before. Arts grants accounted for about 13 percent of the allocations, not counting grants for historic preservation, which are included in the foundation's environmental program.

The Fund generally does not contribute to operating budgets of cultural and other institutions, construction and renovation, film, video, scholarships, fellowships, research, prizes and travel, or to individuals.

JOHN S. AND JAMES L. KNIGHT FOUNDATION (FL): COMMUNITY ENHANCEMENT, ARTISTIC INNOVATION

Established in 1950, the John S. and James L. Knight Foundation (formerly the Knight Foundation) today funds four major areas: the arts, which receive roughly a quarter of its grants, journalism (15 percent), education (23 percent), and community initiatives (31 percent). The remainder goes to special projects.

Within the arts the grantmaker prefers: a) local projects that "enhance the quality of life" in the 26 communities where the Knight brothers published newspapers, and b) major national institutions that undertake innovative works in music, dance, theater, historic preservation, and museums. Proposals to broaden audiences and stabilize arts organizations are also favored.

Knight's Journalism Program is national in scope. Grants are made to organizations and institutions that offer special promise of advancing the quality and effectiveness of a free press. The foundation gives particular emphasis to the education of current and future journalists, including programs to recruit and train minority journalists, and to the defense of First Amendment rights and support of a free press at home and worldwide.

In 1991, Knight relocated from Akron, Ohio, to Miami, Florida, and in the last three years has increased its staff from eight to 17 persons, reflecting strong growth in both assets and total giving.

Assets of the foundation grew by a healthy 16 percent in 1991 to $605 million, which allowed the

grantmaker to increase its total gifts almost 13 percent over the year before. New arts grants surpassed $5.3 million, or almost a quarter of its total giving. Journalism represented an additional 22 percent of funding.

Most grants range from $20,000 to $75,000, although some go as high as $1 million or more: the Community Foundation of Santa Clara County in 1991 received more than $1 million toward the Silicon Valley Arts Fund, an arts stabilization program.

No grants go to fundraising drives, ongoing requests for general support, deficit financing, regranting mechanisms, religious propagation, uniforms, conferences, research, or honoraria. Individuals are not eligible for funding.

KRESGE FOUNDATION (MI):
CAPITAL CHALLENGE GRANTS

A quarter of the Kresge Foundation's $57.5 million in 1990 grants was awarded to arts and humanities groups—a noteworthy increase over the 16 percent of grant dollars awarded the previous year. In 1991, arts grants amounted to $12.9 million, 21 percent of total funding. Levels of funding to the arts may fluctuate since the foundation's programmatic thrust is organized by grant purpose rather than by discipline or subject.

Virtually all of Kresge's funding supports capital and endowment purposes, primarily construction, expansion, and renovation of buildings. As a consequence, the foundation's grants typically run higher than those of most other grantmakers, averaging several hundred thousand dollars each. In the arts, the foundation is most likely to support museum programs, the performing arts, and historic preservation. Recipients have included museums, cultural centers, orchestra halls, and theater houses. Grants are awarded regionally, nationally, and internationally.

Beyond limiting its grants to capital and endowment purposes, Kresge funds only on a matching basis. This long-held policy stems from the belief "that the partnership of our funds with others will help strengthen and broaden an organization's donor base."

Potential grantees seeking Kresge awards are expected to have an ongoing fundraising program, under which "early leadership grants" for the project in question have already been obtained from other sources. The Kresge challenge grant may then be applied to the project's remaining needs, or towards the establishment of an endowment.

Examples of 1991 arts and humanities grants included $150,000 to the Dubuque County Historical Society, $500,000 to the Hartford Stage Company, and $150,000 to the New York Experimental Glass Workshop.

SAMUEL H. KRESS FOUNDATION (NY):
CONSERVATION OF INTERNATIONAL VISUAL ARTS

The Samuel H. Kress Foundation, a national arts funder created in 1929, gives solely in the visual arts. In 1991, Kress grants totaled nearly $2.4 million, with most grants ranging from $5,000 to $25,000. Within the visual arts, the foundation's interest is centered around the study and preservation of European artistic heritage.

Programs to fulfill this mission include: a) Kress fellowships for pre-doctoral research in art history and advanced training in fine arts conservation (awarded to institutions, not to individuals); b) development of resources for scholars; c) symposia, journals, and other forums for the exchange of experiences among art historians and conservators; d) European archeological fieldwork; e) scientific study of art conservation; e) support for conserving European monuments; and f) special projects.

One of the more dramatic ways in which Kress promoted an appreciation in the United States of classical European art works took place in 1960, 30 years after the grantmaker's founding. Kress donated its 3,000 paintings, sculptures, illuminated manuscripts, tapestries, and other masterpieces to 50 American museums and libraries, deliberately dispersed throughout the country to reach a broad American population. At the time of the distribution, the collection was valued at more than $100 million. In a related program, Kress established "study collections" of art works and rare books at 25 U.S. universities.

To win support from the Kress foundation, proposals should reflect "clearly defined practical projects," which "meet a specific need, implement a creative approach, or provide a tangible benefit to the field."

Grants awarded in 1991 include $50,000 to the World Monuments Fund for the restoration of the sculpted portal of the Church of St. Trophime in Arles, France; $25,000 to George Washington University for travel expenses of foreign scholars presenting papers at the conference on "Spain and Portugal of the Navigators"; and $15,000 towards a catalog of the North Carolina Museum of Art's collection of Italian Renaissance art.

No grants are awarded to fund individual artists, art history programs below the pre-doctoral level, or purchases of works of art. Nor does Kress fund operating support, capital or annual campaigns, or films.

LANNAN FOUNDATION (CA):
SUPPORTING NEW VISUAL AND LITERARY ARTISTS

Furthering the careers of emerging and under-recognized artists is among the goals of the Lannan Foundation's visual arts program. Other goals of the foundation, established in 1960, include bringing the work of contemporary artists to a wider audience, encouraging museums to focus attention and scholarship on their own collections of contemporary art, and supporting a more flexible approach by established arts institutions towards new works.

Given its focus, Lannan is among the few foundations exclusively devoted to the arts. National exhibitions, performance art presentations, and interdisciplinary projects with a strong visual presence are eligible for funding. No visual arts grants go to individuals, or support general operating expenses, endowments, juried exhibitions, annuals, or permanent installations.

Through its literary program, founded in 1987, Lannan supports projects that increase public appreciation, understanding, and support for contemporary prose and poetry. This is accomplished through annual Literary Awards and Fellowships to authors (who may not, however, apply for them directly), and grants to nonprofit literary organizations.

Recent literary grants funded honoraria for authors presented in reading series, author payments by literary journals and small presses, residencies, audience development, and marketing efforts by journals. No literary funds are available to individuals, or for operating costs, endowments, publications or specific books, reprinting, general production, or book fairs.

In 1991, Lannan provided $1.5 million in grants, down 4 percent from 1990. All of Lannan's funds support the arts and literature. Grants may range from $5,000 to $200,000, but most fall between $10,000 and $50,000.

HENRY LUCE FOUNDATION (NY):
PROMOTING AND RESEARCHING AMERICAN VISUAL ARTS

American visual arts are heavily promoted by the Henry Luce Foundation, which began its arts underwriting in 1982 through the establishment of a scholarship fund to support the cataloging of American fine and decorative arts in the nation's museums. By 1990-91, the grantmaker continued to support arts research and scholarship, but also funded exhibitions at 65 museums across the nation.

In 1984 and 1986 the foundation made major grants totaling $3.5 million to the Metropolitan Museum of Art, New York City, to display the museum's entire reserve collection of American fine and decorative arts.

American visual arts in general, and art museums in particular, are expected to receive the bulk of the foundation's arts grants in the near future, according to the 1992 grantmaker survey.

In 1990-91, Luce provided arts grants of $4.9 million, or 11 percent of its total allocations, a proportion that has remained roughly constant over the years. Besides the arts, Luce funds projects in Asian affairs, higher education, theology, and public affairs.

Most arts grants range from $50,000 to $200,000, although both smaller and larger grants are available. Funding is awarded largely to major museums for specific projects. No grants for endowment, domestic building campaigns, general operating support, annual fund drives, or individuals are available.

JOHN D. AND CATHERINE T. MACARTHUR
FOUNDATION (IL): EXCELLENCE, DIVERSITY, ACCESS

The MacArthur Foundation seeks to encourage artistic excellence in all arts disciplines, develop culturally diverse programming, improve access to the arts, and identify and address concerns facing the leadership of Chicago's cultural institutions.

Support to Chicago's cultural organizations derives primarily from the Community Initiatives

Program (CIP), which provides unrestricted operating grants and project support to the city's cultural community.

Incorporated in 1970, with funding operations established in 1979, MacArthur underwrites cultural initiatives outside Chicago through its General Program which has a national focus and supports a wide range of issues. The Fellows Program, also national in scope, includes among its recipients a significant number of artists. MacArthur fellowships are awarded through a foundation-initiated process, and are not open to applications.

Total cultural grantmaking in 1991 reached over $15.4 million, more than two and a half times the amount allocated the year before, and roughly 10 percent of the foundation's total giving. Other program areas include world environment, education, mental health, peace and international cooperation, and population.

The size of cultural grants awarded through CIP varies widely. Multi-year, general support grants to Chicago institutions range from $10,000 to $50,000 annually, while technical assistance grants range from $3,000 to $25,000. Capital campaign grants to mid-size arts organizations for institutional development range from $50,000 to $250,000. Grants from the Strategic Initiatives Fund for projects addressing issues of community concern range between $5,000 and $100,000. Grants from the Fund for Cultural Innovations to major cultural institutions range from $20,000 to $100,000 for planning grants, and from $100,000 to $500,000 for projects grants.

Recent examples of issues addressed by CIP include meeting the space needs of performing groups, developing new audiences, strengthening the role of artists in the community, delivering high quality arts education, and integrating the arts more fully into community life. In addition, CIP is exploring how the arts can encourage economic development in Chicago.

In recent years, arts support through the national General Program has focused largely on film and video work. In 1991, MacArthur provided $2 million for media arts centers and another $3.65 million to a number of film and video projects.

The foundation does not support religious or political activities, nor does it provide scholarships or support individual artists (except through the Fellows Program). Generally, no support is awarded for capital projects, endowments, equipment, construction, debt retirement, fundraising campaigns, conferences, or publications.

THE ROBERT MAPPLETHORPE FOUNDATION, INC. (NY): PHOTOGRAPHY AND AIDS PROJECTS

Founded in 1988 by the renowned photographer, who died in 1989, the Robert Mapplethorpe Foundation funds photography as a fine art and projects in AIDS research. With assets as of May 31, 1991, of $4 million, its grants in fiscal 1991 amounted to $525,000, compared to the $1.7 million disbursed in fiscal 1990. Besides monetary grants, the foundation donated a number of photographs taken by the late photographer.

In photography, the foundation's priority is supporting the creation or expansion of photography departments in museums and other public institutions. In addition, the foundation funds special exhibitions, particularly if accompanied by quality catalogs or other publications to serve as documentation of photography as a fine art.

The foundation awarded 28 grants in 1991. The largest grants, in AIDS research, included $90,000 to The Robert Mapplethorpe Laboratory at the New England Deaconess Hospital and $212,000 to the American Foundation for AIDS Research. Art grants ranged from $2,500 to $25,000—the latter to the Addison Gallery of American Art for a photography exhibit catalog.

In 1992, the foundation announced a gift valued at an estimated $5 million to the Solomon R. Guggenheim Museum. The gift consisted of $2 million in cash and a collection of more than 200 photographs by Mapplethorpe.

No grants go to individual photographers, or for scholarships.

THE MCKNIGHT FOUNDATION (MN): ACCESS, EXCELLENCE, MANAGEMENT

A twofold increase in grants and a dramatically new approach to funding the arts marked the McKnight Foundation's grantmaking policy in 1991 (see Chapter 10).

Prior to 1991, the foundation had allocated all its arts funds—around 8 to 10 percent of total giving—to local government and nonprofit boards for redistribution. It now administers arts grants itself, pro-

viding them directly to area arts organizations. It has also doubled the amount it will commit to the arts over the next five years to $28 million, even though human services remain its primary orientation. In 1991, it gave more than $3.9 million to the arts.

Arts grants are directed towards expanding access throughout Minnesota, encouraging excellence, and improving management of cultural organizations. Grants often cover an extended period, up to three years.

Performing, literary, and visual arts organizations are eligible for support, as are regional arts councils and multidisciplinary groups. Under a separate public affairs program, the foundation supports public television. Arts grants for capital projects may reach as high as $1 million, but most fall between $10,000 and $100,000.

The foundation supports capital campaigns, operating support, general support, renovation, and special projects. No grants go to individuals or research (except in plant biology), endowments, scholarships, fellowships, or fundraising.

ANDREW W. MELLON FOUNDATION (NY): INSTITUTION BUILDING, TRAINING, CONSERVATION, AND SCHOLARSHIP

Arts funding by the Andrew W. Mellon Foundation expanded significantly in 1991, both in absolute dollars and as a proportion of the funder's total grants. More than $19.2 million in grants were awarded during the year to *preselected* groups (no grants are made in response to unsolicited proposals) in the visual, performing, museum, and literary arts—a 47 percent increase over 1990. As a portion of total giving, the arts commanded 23 percent in 1991, compared to 16 percent the year before.

Support for the arts, to Mellon, is essential: "Present-day concerns in this country with economic and social problems, while entirely appropriate, do not justify neglecting those aspects of life that give meaning to everyday pursuits, stimulate mind, eye and ear, and sustain the spirit. Indeed, continued nourishment of the arts is surely essential to the long-term health of the entire society."

Highlights of Mellon's cultural policy in 1991 included support for: a) the long-term needs of major theaters, a reflection of its institution-building orientation; b) training in ballet; c) rehearsal costs of

modern dance companies, and dance documentation and preservation; d) improvements in the long-term fiscal and administrative capabilities of smaller orchestras; e) literary presses; and f) museum conservation, curatorial work, and research and scholarship pertaining to a museum's permanent collection.

Mellon's arts funding philosophy is summarized best in a program officer's analysis: "The Foundation has tried to develop ways of operating that seem best suited to a particular field's demands and characteristics. Balancing the demands of artistic integrity with social goals is not simple, and all institutions should not be expected to proceed in the same ways or bear equal responsibility for change."

Mellon grants generally range from $50,000 to $300,000—but some are greater.

Funds are used for endowments, research, internships, matching grants, and occasional special projects. No support goes for general operating support, advocacy, construction, renovation, symposia, festivals, or individuals.

METROPOLITAN LIFE FOUNDATION; METROPOLITAN LIFE INSURANCE COMPANY CORPORATE GIVING PROGRAM (NY): PROMOTING EDUCATION IN THE ARTS

Ten grants made nationally by the Metropolitan Life Foundation in 1991 funded collaborations between schools and arts organizations, in which students learned to apply their new experiences in the arts to different subject areas. Eleven other grants for the theater included support for children's educational programs. Yet another grant underwrote an effort to help museums strengthen their educational role.

"As the Foundation's overall interest in education grows," explained the insurance company foundation in its latest annual report, "the arts program focuses increasingly on the interaction between education and the arts."

This emphasis is national in scope. Two examples of Arts and the Schools grants: a) Atlanta's High Museum's grant for a curriculum handbook to teach grades 6-12 about the museum's African art; b) The Music/Theater Workshop in Chicago's award to stage a play on substance abuse for elementary school pupils and their parents. The foundation's Multicultural Initiatives Program serves as the chief mechanism for funding in the visual arts. The pro-

gram fosters interactive projects involving black, Hispanic, Asian, and Native American cultures.

The company provides grants through a separate Public Broadcasting program, largely for informational television such as the program "Adam Smith's Money World," and other programs regarding AIDS education and prevention. Most of these grants are made through the company's direct giving program, not through the foundation.

Combined Culture grants awarded by Metropolitan Life in 1991 amounted to over $1 million (exclusive of $111,500 for libraries, botanic gardens, and zoos), or 10 percent of total giving that year of $10 million. Public Broadcasting grants totaled an additional $1.7 million. Although the 1991 figures for total giving were down more than $600,000 from the previous year, the combined culture and broadcasting shares were identical.

The foundation does not award grants to individuals, or for endowments, advertising, or festivals. No grants fund religious, fraternal, political, athletic, labor, social, veterans, or disease-specific organizations, nor groups involved primarily in international activities, patient care, or direct treatment. Local chapters of national organizations and organizations receiving support from United Way are also excluded.

The foundation also contributes goods and services to nonprofit organizations and encourages volunteerism by its employees.

MORGAN GUARANTY TRUST COMPANY OF NEW YORK CHARITABLE TRUST; J.P. MORGAN AND COMPANY CORPORATE GIVING PROGRAM (NY): ADVOCACY AND STABILITY FOR NEW YORK'S ARTS

Most of J. P. Morgan's arts grants are for general support, but the donor also funds advocacy and organizational stability.

Advocacy, according to the bank, helps "to create a climate in which the arts can prosper." And its support of stability appears to reflect a belief that the New York arts community is in need of strong management skills. In the 1992 grantmaker survey, Morgan noted that its grantmaking would place "more focus on institutional strengthening."

Grantees include technical assistance groups and organizations in the performing and visual arts, arts services, and arts-in-education. Recipients are both large and small arts groups, the latter because of their importance in "fostering artistic vitality and cultural diversity." Arts-in-Education programs receive arts grants based on the company's conviction that children—especially low-income children—cannot thrive educationally without access to cultural activities that "enhance their basic skills instruction and help them expand their minds and talents beyond the classroom." Morgan does not fund public schools themselves.

Arts grants in 1991 ranged from $3,000 to $100,000, but the majority were under $10,000. In 1991, total arts program grants amounted to around $1 million (excluding about $200,000 in matching gifts), a drop of around 6 percent from the year before. As a portion of its total giving, the arts captured 12 percent in 1991, down from about 15 percent in 1990.

Grants are not available for religious objectives, for most medical research or programs, or for scholarly research. No grants are made to individuals.

Most donations are currently made through the Charitable Trust. International grants are given directly, from income earned by the company.

NEW YORK COMMUNITY TRUST (NY): COMMUNITY BUILDING, ARTS ADVOCACY, AND ACCESS TO THE ARTS

Having reached a billion dollars in assets in 1991, the New York Community Trust found itself among the top twelve U.S. grantmakers that year, enabling it to allocate $68.1 million to New York City's nonprofit institutions, a 21 percent increase over the year before. But the Trust's president was quick to note that the sum "just doesn't go very far," in light of the city's overwhelming social problems.

Nevertheless, through its arts program, as in other areas, the community foundation, founded in 1924, attempts to deal with some of the more pressing issues. Thus it funded the Jewish Museum's exhibition documenting the history of the complex relationship between African Americans and Jews. It also funded a variety of minority arts organizations, including the Boys Choir of Harlem, the Ballet Hispanico of New York, and the Asian American Art Center.

The Trust awards both restricted ("donor advised") and unrestricted grants. In 1991, unrestricted arts and culture grants amounted to nearly

$1.8 million, or 13 percent of total unrestricted grants, unusually high as a result of monies from a fund that became available to the Trust that year. Also in 1991, arts groups received a small amount of grants from restricted funds. Unrestricted grants generally account for a fifth of the Trust's yearly allocations.

Goals of the Trust's arts policy include building the financial and managerial capacity of ethnic and minority arts groups, promoting partnerships between community and mainstream organizations, increasing the availability of the arts to underserved school children, promoting arts advocacy in the face of such issues as censorship, and supporting the professional development of minority and disadvantaged young artists. In the 1992 survey, the grantmaker said it expects to increase its arts funding.

All art forms are eligible for support. Grants do not fund individuals or religion, and are rarely made for endowments, building campaigns, deficit financing, or general operating support.

DAVID AND LUCILE PACKARD FOUNDATION (CA): STABILIZATION, NEW AUDIENCES, ARTS EDUCATION

Stabilization of local performing arts groups and developing new audiences remained key themes of the Packard Foundation's arts funding program in 1991, as they had the year before. Towards that end the grantmaker provided significant support—well above the amounts spent in its typical grants—for the Silicon Valley Arts Fund, a joint funding effort by local foundations and businesses designed to sustain cultural organizations in Santa Clara County. The Fund is managed by the Community Foundation of Santa Clara County (see profile, this chapter).

Individual stabilization grants were also made by the Packard Foundation during the year, such as $25,000 to TheatreWorks of Palo Alto for a fundraising director.

Performing arts education is another prime interest of the foundation, which maintains that the arts play a critical role in the way children learn and develop.

The arts are funded through Packard's Community program, one of the foundation's five program areas. Packard's other programs are

Science, Future of Children, Population, Conservation, and Special Areas. Some of the foundation's arts stabilization grants are awarded through the Management Assistance focus of the Special Areas program.

Arts funding in 1991 surged to almost $2.2 million from $1.3 million the year before, an increase of almost 65 percent. This growth reflected an increase in Packard's overall grants budget. As a proportion of its total grants, the arts in 1991 accounted for almost 7 percent, up from 4 percent in 1990.

Arts grants in 1991 tended to range between $10,000 and $40,000. These included grants to performing arts groups in general, and to educational institutions under the Music in the Schools program, which introduces children—in particular minority children—to playing instruments. Several grants during the year, however, were considerably higher. In the 1992 grantmaker survey, the foundation said it expected its arts funding to increase as a proportion of all grants.

Recipients in 1991 included music groups, arts councils, theater organizations, operas, ballets, and schools. Funding is available for general operating support, challenge grants, salaries, technical assistance, renovation, seed money, emergency funds, equipment, and capital campaigns. No funds go directly to individuals.

WILLIAM PENN FOUNDATION (PA): PROMOTING AWARENESS OF PHILADELPHIA'S HERITAGE

Preservation of museum collections and historic sites, one of the William Penn Foundation's funding priorities, was highlighted by the 1991 publication of *Cultural Connections*, a book commissioned by the foundation. It describes some 100 museums and libraries throughout Philadelphia and the Delaware Valley, many of which have received support from the foundation.

Arts and culture grants, one of Penn's four grantmaking concentrations, comprise about a quarter of the foundation's allocations, and represent the largest distribution of funds after human development. In 1991, Penn's arts grants amounted to $7.6 million out of a $30.5 million grants budget. Grants start at $2,000 and may reach $3 million, with no apparent average range. Grantees include performing arts organizations, art schools, museums and

galleries, media groups, and historic preservation projects.

The foundation's culture grantmaking, which is limited to the Philadelphia area, seeks to implement three priorities: improve the quality of the performing and visual arts; increase access to the arts by nontraditional audiences and participants, particularly students and community groups; and preserve museum collections and historic sites.

The foundation's most important ongoing arts program is its $13 million, six-year project to develop Philadelphia's South Broad Street as a "cultural corridor." Begun in 1990, this program is providing creative spaces for the city's artists to develop their work and new showcases for the performing arts. It is also intended to generate employment opportunities for area residents and to attract both residents and tourists to downtown Philadelphia. In 1991, $220,000 was allocated to create and support the Sassafras Corporation, a nonprofit group organized to oversee the project's planning and management.

Penn prefers to fund projects which demonstrate a broad base of support. Its grants are used for seed money, special projects, capital projects, and technical assistance. No awards are made for operating budgets, annual campaigns, deficit financing, endowments, scholarships, or fellowships.

THE PEW CHARITABLE TRUSTS (PA): PROMOTING TIES BETWEEN ARTS AND COMMUNITIES

To the Pew Charitable Trusts, the arts help to bridge cultural differences by "affirming the common wellspring of humanity."

Pew's Grantmaking in Culture Program focuses on strengthening the links among artists, cultural institutions, and their communities. Grants are awarded to increase and broaden public access, strengthen artists' involvement with both cultural institutions and communities, and support a wide range of disciplines and cultural expressions that "represent the full diversity of the American cultural experience." Recent grants for this purpose included an initiative in community-based arts education for children; a program to encourage working collaborations between established cultural institutions and communities underserved by those institutions; and citywide festivals that provided opportunities for broad public participation in cultural events.

In support of the needs of working artists, recent Pew grants have gone to service organizations concerned with artists' housing and work space; provided opportunities for artist residencies and exchanges; and promoted the development and dissemination of new work. Grants in this area included a fellowship program for Philadelphia-area artists working in various disciplines; and a 1991 national theater residency program, developed in cooperation with the Theatre Communications Group, to address the growing alienation between theater artists and institutions through support for collaborations around the creation and development of new work.

To help arts organizations plan for and address significant issues affecting their fields, the Pew Trusts have supported, among other projects, a national study by the American Association of Museums on expanding the educational role of museums, and a study by the American Symphony Orchestra League on the future of the American orchestra industry.

Although the Trusts' Culture Program is national in scope, it does have a special commitment to the Philadelphia cultural community, where it traditionally allocates about 55 percent of its grants. Grants range between $20,000 and $500,000 although higher and lower amounts are regularly awarded.

Pew has consistently ranked among the largest of U.S. arts funders. In 1991, the Culture program awarded 88 grants for a total of $17.7 million, approximately 12.4 percent of the Trusts' total grantmaking budget for that year. The Trusts also support activities in the areas of conservation and the environment, education, health and human services, public policy, and religion.

PHILADELPHIA FOUNDATION (PA): BRINGING THE ARTS TO THE NEIGHBORHOOD

Identifying its mission as a "voice for change," the Philadelphia Foundation gears its arts funding policy towards bringing the arts into the mostly lower-income neighborhoods it serves. It accomplishes this goal programmatically by assisting grass roots efforts to encourage new museums and maintain those already in existence; by funding exhibits, festivals, and low-cost visual and performing arts classes; and by promoting the works of low-income artists or those from underrepresented groups.

Believing in the benefits of continued support, the Philadelphia Foundation frequently makes multi-year grants to locally based arts and culture organizations, such as Taller Puertorriqueno, Inc., and the Afro-American Historical and Cultural Museum.

Arts and culture grants in fiscal 1991 accounted for more than 12 percent of total distributions, a slight rise from the 11 percent apportioned to the arts the year before. But in terms of dollars, arts grants in fiscal 1991 amounted to $613,061, a growth rate of 15 percent (before inflation) over the previous year. Total assets grew almost 13 percent during the same period. Culture grants range from $400 to more than $31,000, with most between $5,000 and $20,000.

As with all community trusts, the Philadelphia Foundation is accountable to its own donors; more than 82 percent of gifts are restricted by donor preference or other designated interests. Undesignated grants are limited to the five-county Philadelphia area. Little funding is available for large-budget or national organizations, private schools, government, or religious organizations. No loans or gifts go to individuals, for endowment, annual or capital campaigns, research, publications, conferences, or deficit financing.

Beyond standard types of support, the Philadelphia Foundation aids arts groups, along with other nonprofits, through a series of special grants for such needs as executive search and staff and board training. The grantmaker also provides technical services, including endowment management, workshops on accounting, and fundraising.

PHILIP MORRIS COMPANIES (NY): THE CORPORATE MEDICI

Referred to by the *Wall Street Journal* as a "modern-day corporate Medici," Philip Morris is one of the nation's best-known corporate arts funders. Beyond its own varied private collections of hundreds of paintings, sculptures, quilts, and other media, the corporation funds exhibitions, performances, film, video, literature, specialized libraries, educational arts programs, and studies exploring the impact of the arts on American life. Conferences, competitions, and anthologies also receive funding.

Under its "focused giving" initiative, arts funds are directed to programs that "explore new ground in artistic expression," alternative arts groups, projects that stimulate learning, projects to expand access to underserved populations, and touring projects scheduled for one or more Philip Morris locations.

For its 35 years of arts support, the company has received dozens of awards from arts and business organizations. To provide an arts environment for its employees, as well as to reinforce the importance of private arts patronage, the company has devoted a ground level atrium space of its New York headquarters to a sculpture court of the Whitney Museum of American Art for exhibitions of large sculptures.

Exhibitions and performances of experimental work have received Philip Morris funding. In 1986, for example, the company provided what it called "the largest grant ever given" to an avant-garde performing arts presentation ("The Next Wave Festival") at the Brooklyn Academy of Music. It has also funded exhibitions of op, pop, and minimalist art.

Reflecting its roots in the South, Philip Morris has sponsored some of the earliest exhibitions of African American artists. The firm also regularly funds minority performing arts companies.

Funding is national and international, with most grants going to communities in which the company operates. These include locations in New York, Virginia, Kentucky, North Carolina, Wisconsin, California, and Colorado. Performances, especially dance presentations, traveling to cities in these states stand a better chance of grant approval.

Grants can go as high as a million dollars and above, but most are much smaller. The company supports general and continuing operations, special projects, endowments, professorships, scholarships, research, and matching gifts.

THE POLLOCK-KRASNER FOUNDATION, INC. (NY): AIDING VISUAL ARTISTS IN FINANCIAL NEED

Organized in 1985 and endowed through the will of Lee Pollock Krasner (1908-1984), noted abstract expressionist and wife of the painter Jackson Pollock, the Pollock-Krasner Foundation was established "to help artists continue their work" by pro-

viding grants to temporarily ease pressing financial burdens. It is one of the few private foundations giving funds exclusively to individual established artists.

Recipient needs eligible for support are broad, ranging from medical emergencies to subsidizing studio rental and art expenses. Grants range from $1,000 to $30,000, with the majority between $5,000 and $15,000.

The foundation awards internationally, although most funding goes to the United States. Artists in Eastern and Western Europe, Asia, and Central and South America have also received grants.

Recipients must be working painters, sculptors, or artists who work on paper, including printmakers, but the foundation does not limit awards to practitioners of any specific school or style of art. It does not fund students or academic study, or those working in the fields of photography, film, or crafts.

In fiscal year 1992, grants awarded totaled $1.4 million. The number of grants distributed in 1992 was 119. Since inception the foundation has awarded $9.3 million to 959 artists.

ROCKEFELLER FOUNDATION (NY): ARTS FOR INTER-CULTURAL UNDERSTANDING

The arts and humanities were strongly supported by the Rockefeller Foundation, one of the nation's largest independent grantmakers, in 1991, though more than 60 percent of the foundation's resources were devoted to science-based development in the Third World. Although total grants that year declined by almost 7 percent from the year before (largely due to calendrical considerations rather than policy shifts), donations to the arts and humanities increased by almost 6 percent, to $13.4 million. And as a portion of its disbursements, grants to the arts and humanities grew from 13 percent to 15 percent during the same period.

These increases reflect only those grants in the foundation's Arts and Humanities program; an additional $2.5 million for a multi-city education project with an arts/humanities emphasis was awarded in 1991 by the foundation's School Reform program.

Since 1987, the mission of Rockefeller's arts grants has been to promote "international and inter-

cultural understanding." This has included increasing artistic experimentation across cultures, enhancing the role of American artists in international visual and performing arts festivals, and commissioning new works. The Arts and Humanities program in 1991 was expanded to include funding for projects of a selected group of non-U.S. institutions and artists to complement its work through U.S. recipients—e.g., the U.S.-Mexico Fund for Culture in Mexico City. In addition, a portion of 1991 Arts and Humanities grants supported projects that combined the division's work and the foundation's environmental program, such as a television series of Third World filmmakers' perspectives on development and the environment, and an art exhibition entitled, "Fragile Ecologies: Artists' Interpretations and Solutions."

The range of grants in the Arts and Humanities program is wide, although most fall between $20,000 and $75,000. Most arts education grants are limited to the CHART (Collaborative for Humanities and Arts Teaching) program through the School Reform division and tend to higher figures of $100,000 to $200,000, although a few are smaller.

Funding for Arts and Humanities activities is not expected to increase as a percentage of total giving during the coming fiscal year, but the trends and patterns of 1991—including grants for new works and exhibitions and in support of international initiatives in the developing world—are likely to continue, according to the 1992 grantmaker survey.

Across all of its programs, Rockefeller funds research, fellowships (including individual fellowships), publications, conferences, special projects, program-related investments, and employee matching gifts. Individuals are eligible for funding, as long as the money is not for "personal use." No support goes for churches, schools, or welfare agencies. The foundation does not fund efforts to influence legislation, capital or general support, endowment, or scholarships.

FAN FOX AND LESLIE R. SAMUELS FOUNDATION (NY): REACHING BEYOND TRADITIONAL CONSTITUENCY

While Lincoln Center for the Performing Arts and the New York City Opera remained the primary beneficiaries of the Fan Fox and Leslie R. Samuels Foundation's arts funding in 1991, the grantmaker

decided that year to "reach out past its traditional constituencies and provide assistance to a number of organizations [in New York City] which foster innovation and support for emerging artists and new works," according to its annual report. (See Chapter 10.)

Examples included $5,000 to Dance Works for Pentacle, an innovative service organization for performing artists; $5,000 to En Garde Arts; and $10,000 to House Foundation for the Arts in support of productions by Meredith Monk.

In addition to the performing arts, the foundation supported various cultural institutions and arts-in-education programs. Giving to the arts in 1991 amounted to almost $2.6 million, a 30 percent increase over 1990 (total grants had grown only 6 percent). As a portion of total giving, arts funding in 1991 accounted for two-thirds, not including several discretionary awards to cultural organizations. The year before, the arts accounted for half. Health care receives the grantmaker's remaining funds.

Grants are made for program and general operating support. Grants are not given to individuals or for scholarships.

SAN FRANCISCO FOUNDATION (CA): CULTURAL DIVERSITY AND ORGANIZATIONAL STRENGTH

As with all community trusts, the San Francisco Foundation serves as a mechanism through which various donors can realize their desires of contributing to the enhancement of the quality of life in their community. For the Bay Area, quality of life pertains to "its diversity of race and culture, its richness of artistic creation and appreciation, and the beauty and quality of its land, air and water...."

In the field of arts and humanities—one of the grantmaker's five broad program areas—recent grantmaking has centered on two issues: cultural diversity, and improvement of the program and administrative capacity of cultural organizations.

Arts grants of about $2.3 million during 1991 amounted to about 20 percent of total grant disbursements, the same proportion as the year before. The actual amount of arts grants, however, dropped from almost $2.5 million in 1990. In 1992, the foundation reported special emphasis on literary arts, dance, and experiential arts education, though all arts disciplines are eligible for support.

Giving is limited to the Bay Area: Alameda, Contra Costa, Marin, San Francisco, and San Mateo counties. No support is given for religion, annual or general fundraising campaigns, or for emergency or endowment funds.

COMMUNITY FOUNDATION OF SANTA CLARA COUNTY (CA): CONVENER OF SILICON VALLEY ARTS FUND

With assets of $30 million in 1992, the Community Foundation of Santa Clara County was one of the nation's mid-size community trusts, but beyond its own resources, it has made a significant contribution to the arts through the central role it played in organizing the Silicon Valley Arts Fund, a source of income from which 11 major arts organizations in the area will secure funding.

Types of support under the Arts Fund include endowments to provide "ongoing, predictable income," bridge money to eliminate current operating deficits, and venture funds to allow the arts organizations "to address changes in financial position."

The community foundation will manage the Fund and develop its investment goals. Honorary chairman is David Packard, chairman of the Hewlett-Packard Company and founder of the David and Lucile Packard Foundation (see profile).

As of October, 1992, the Fund received over $6 million towards its goal of $20 million from 25 founding donors, including corporations, foundations, individuals, and government.

Beyond its work on behalf of the Fund, the Community Foundation of Santa Clara County also provided grants of $414,000 to the arts in 1992, about 18 percent of its total giving that year.

Grants, distributed primarily in Santa Clara County, are awarded for "new and expanded levels of community service in response to the needs of individuals, families and communities within Santa Clara County." No grants are available for religious or sectarian purposes, deficit financing, or building funds.

SARA LEE FOUNDATION (IL): ARTS AND THE DISADVANTAGED

Forty percent of Sara Lee Foundation grants dollars are awarded to the arts, one of two broad areas of interest to Sara Lee Corporation, an international

packaged food and consumer products company with annual sales of over $12 billion. The other area is what the foundation refers to as "The Disadvantaged," by which it means health, education, human service, and social action programs aiding low- and moderate-income people who are "struggling to improve their lives." Groups assisting the disadvantaged—especially those that help combat hunger and homelessness, and help women to realize their full potential—receive 50 percent of the grants. The remaining 10 percent is divided among a variety of organizations.

While the foundation distributed only $3.5 million in grants during fiscal 1992, the foundation's Matching Grants Program and other giving programs of the corporation and its divisions brought the total disbursed to nearly $13 million. For the arts, Sara Lee Foundation grants amounted to $1.4 million, an increase of 15 percent from the $1.2 million given in fiscal year 1991.

While the parent company concentrates almost entirely on the Chicago area, its subsidiaries distribute gifts in communities throughout the United States where they or their branches are located. Some of the better known subsidiaries of Sara Lee, each with its own giving program, include: Aris Isotoner, Champion Products, Coach Leatherware, Playtex Apparel, Sara Lee Bakery, and Sweet Sue Kitchens. Further, the subsidiaries adhere to their own giving guidelines, which do not limit grants either to the arts or to the disadvantaged.

Average foundation grants range between $1,000 and $5,000, although much higher sums may go to well-established Chicago institutions, such as the Art Institute of Chicago ($135,000), Lyric Opera of Chicago ($120,000), and the Chicago Historical Society ($85,000).

Sara Lee Foundation awards grants for general operating support as well as special project support. Grants are not given to: capital and endowment campaigns; individuals; political organizations; elementary or secondary schools; government; organizations with limited constituency, such as fraternities, veteran's groups, single sect religious organizations or houses of worship; disease-specific health organizations; or fundraising events or goodwill advertising.

SHUBERT FOUNDATION AND SHUBERT ORGANIZATION (NY): STRENGTHENING THEATER AND DANCE

The Shubert Foundation is one of a handful in the country devoted entirely to the performing arts. More than half the grant dollars from both the Shubert Foundation and the Shubert Organization are awarded to professional theater groups on a national basis, and about a third go to dance and other performing arts-related organizations (the remainder is directed toward university drama departments and grants to non-arts related groups). The link to the performing arts is manifest for a grantmaker whose name is so closely associated with American theater.

Established in 1945, the Shubert Foundation gives to both large and small theatrical and dance companies. To receive grants, the larger organizations must demonstrate "a continued ability to develop and produce significant additions to the American theatre [and dance] repertory." Small groups "are expected to demonstrate a meaningful capacity for innovation and/or to develop and advance new talent" for both disciplines.

Grants of more than $3.5 million in 1991 showed an increase of almost 16 percent over the year before, even though assets (principal balance) grew by only two percent, to $115.1 million. The increase in grants may have reflected the executive director's concern, stated in the foundation's 1991 annual report, that "millions of today's children...will be far less fortunate in their access to the arts than the generation that preceded them." He lamented funding cutbacks from both the National Endowment for the Arts and private benefactors.

Shubert grants tend to range between $5,000 and $60,000, although several are considerably higher. Proposals for operating support are favored, so long as the grantee demonstrates overall program merit, excellence in a specific area, organizational efficiency, and the ability to raise additional funds.

No grants are awarded for audience development, ticket price reduction subsidies, or capital projects. Neither individuals nor groups appealing only to specialized audiences are eligible.

Beyond its awards, the grantmaker operates an increasingly valuable archive, open by appointment to qualified researchers in the performing arts.

SOUTHWESTERN BELL FOUNDATION (TX): HELPING LEADERS IDENTIFY SOLUTIONS

Performing arts, museums, public broadcasting, and arts councils are eligible for grants from the Southwestern Bell Foundation, especially those applying for program or project support, and those that "make arts accessible to more people."

The foundation, established in 1985 in Missouri following the breakup of AT&T into regional telecommunications companies, sees its own role essentially as providing an "impetus for change," by helping civic and cultural leaders "identify and pursue the most promising solutions" to area problems.

In reviewing grants, the telephone company favors organizations in the five states it serves— Arkansas, Kansas, Missouri, Oklahoma, and Texas—although it does make some awards to national organizations elsewhere. It relies heavily on evaluations and recommendations made by its corporate subsidiaries, and supports groups that are "judged effective by the communities they serve, by business, by professional colleagues, and by philanthropic advisory services."

In 1990, the latest year for which data were available, the foundation disbursed $2.2 million to the arts, about 14 percent of total disbursements. The company currently ranks among the nation's 20 largest corporate foundations by assets and is among the ten largest corporate foundation donors to the arts.

In spring 1993, the foundation relocated from St. Louis, Missouri, to San Antonio, Texas.

US WEST FOUNDATION (CO): ECONOMIC INDEPENDENCE AND WESTERN CELEBRATION

Unlike most arts grantmakers, the US WEST Foundation, created in 1985 after the breakup of AT&T, does not maintain a distinct arts funding category. Rather, donations to visual and performing arts organizations, in western and midwestern states served by the firm, are made through two of its five program areas: Celebrating Western Imagination, and General Grants. (The three other areas are Educational Initiative, Economic Independence Initiative, and Employee Involvement.) However, the foundation considers unsolicited proposals only for its General Grants Program, not for Celebrating Western Imagination grants.

As an example, under Celebrating Western Imagination, it funded "I Dream a World," a touring photography exhibition of portraits and interviews with 75 African American women who changed America, by photojournalist Brian Lanker of Oregon.

Proposals for the General Grants Program are welcome. Of special interest to the foundation are projects that broaden the audience base, expand cultural opportunities for underserved populations, preserve the artistic and cultural traditions of the West, and shore up the management and economic viability of performing and visual arts groups.

Most grants range from $10,000 to $50,000. Total grants in 1991 amounted to almost $24 million, a 10 percent increase over the amount granted in 1990. Arts funding in 1991 amounted to $2.4 million, roughly 10 percent of overall giving.

No support is given for international organizations, school boards, choral groups, individual artists, endowments, deficit financing, scholarships, athletic funds, or goodwill advertising.

VICTORIA FOUNDATION (NJ): `CARING, BUT STREET SMART'

Riots that seared the nation's cities in 1967 were the catalyst in persuading the Victoria Foundation, established during the 1920s, to redirect its funding policy towards the alleviation of urban problems. Its 1991 arts grants continued to reflect this policy. Examples included funds for the Ensemble Theatre Company's workshops in acting for public school students, and support for the Newark Community School of the Arts' instruction for low-income residents of that city.

The most significant expression of the grantmaker's motto, which it cites as "Caring, but street smart," was a 1991 five-year pledge of $2.5 million— the largest it ever made—for the New Jersey Performing Arts Center. Sponsors expect the Center to spur renewed economic development in Newark.

Gifts to the arts in 1991, made under several programmatic areas, reached $805,000 of Victoria's $9.3 million distributed. Total grants that year more than doubled over the year before, owing in part to a 29 percent increase in assets.

Grant amounts range between $10,000 and $75,000, and all grants are limited to New Jersey.

Funding in the arts will be considered only if it directly bears on education, or if the organization is a major cultural organization.

Giving is limited to Greater Newark, with environmental grants limited to New Jersey. Grants are not made to individuals, organizations that address a specific disease or affliction, or for geriatric needs or day care. Support is not available for publications or conferences. The foundation does not make loans.

LILA WALLACE-READER'S DIGEST FUND (NY): PROMOTING OUTREACH AND COLLABORATION

By the spring of 1992, the Lila Wallace-Reader's Digest Fund had gained a reputation as the top institutional arts donor in the United States (see Chapter 10). One of a handful of foundations focusing almost entirely on the arts, the Fund announced grants of $41 million in 1991; it paid out almost $33 million, with the remainder scheduled for the following years. (The $41 million in commitments, however, reflected a drop of 16 percent from the previous year's authorizations.)

Outreach and collaboration are the two keys to the Fund's grantmaking decisions. Its twin goals are to make the arts more widely available, and to foster interaction between artists and the communities in which they perform or create.

In the visual arts, for example, the Fund supports touring exhibitions and "increased public access and educational activities" related to permanent collections. It also funds an international residency program, in which visual artists work abroad and then share their experiences with communities at home.

In theater, the Fund supports three programs—one for resident theaters, one for community-based theaters, and one for youth-serving theaters. These programs underwrite the work of "selected theaters...to expand and diversify their repertories and audiences." In dance and opera, the Fund supports expanded touring and residency projects.

The push for new and broader audiences reflects the Fund's belief that "the future growth of the arts depends on a vital, engaged and demanding audience," according to its president. "We can help artists and arts organizations create a broader audience by supporting their efforts to build bridges to communities which they have not yet reached."

Presentations emphasizing underrepresented cultural communities and American art forms are likely to be favored in coming years.

Funding is available primarily to 501(c)(3) organizations, although individuals are supported through awards and fellowships. Grants tend to range from $50,000 to $500,000, but they have surpassed $6 million (for example, to the New York City Parks Foundation for an urban forest and education program).

There are no geographic restrictions on funding. Grant purposes generally exclude long-term, ongoing support. No funds go to other private foundations, fraternal, religious or veterans organizations.

THE ANDY WARHOL FOUNDATION FOR THE VISUAL ARTS, (NY): CURATORIAL WORK, EDUCATION, PRESERVATION

Established in 1987 to promote "the advancement of the visual arts," the Andy Warhol Foundation funds the visual arts and historic preservation in the U.S. and abroad through three funding areas: Curatorial, Educational, and Historic Preservation and Parks. The foundation is also in the midst of supporting the establishment of the Andy Warhol Museum (in Pittsburgh, PA) through grants of art and through initial staff support. Funding is distributed nationally, with an occasional grant overseas.

Within its Curatorial Program, the foundation supports organizations that assist in the innovative presentation of the visual arts through painting, sculpture, printmaking, photography, film, video, decorative arts, and arts publishing. Performing arts organizations are not eligible unless the visual arts are an inherent element of both the production and the creative process. The Historic Preservation and Parks Program funds parks and historic building preservation, and also supports "increasing public participation in the urban planning process."

Organization of the foundation was directed by the late artist's will; it was endowed primarily through the 1988 auction of Warhol's personal collection of art, furniture, and decorative arts and will continue to be supported through sales of art.

Assets rose dramatically in 1991—from $30 million to $103 million—with the transfer of over $77 million in Warhol's art from his estate to the foundation. As a result, grants jumped to almost $4.7 million that year, up from $3.7 million in 1990.

Grants in 1991 generally ranged between $10,000 and $30,000, with a few multi-year grants over $100,000. Recent grants have supported exhibitions, artist assistance programs, and general support of arts organizations, educational programs, historic structure reports, and conservation plans.

The foundation does not fund exhibitions or other activities directly related to its namesake, and does not encourage projects that contemplate the use of Andy Warhol's name.

Grantmakers in the Arts

Grantmakers in the Arts (GIA) is a national membership organization of primarily private sector grantmakers interested in the arts and arts-related activities. Its purpose is to strengthen arts philanthropy and its role in contributing to a supportive environment for the arts nationwide.

Grantmakers in the Arts fulfills its mission by:

- Providing educational opportunities by sponsoring conferences, forums, and meetings for members and invited guests;

- Offering professional development opportunities for staff and trustees;

- Identifying research needs in arts philanthropy and encouraging, and on occasion supporting, significant and useful research programs;

- Providing technical assistance to arts grantmakers in the development, implementation, and evaluation of arts giving programs;

- Encouraging information exchange and dissemination among grantmakers, as well as a collegial environment for inquiry and collaborations; and

- When appropriate, taking positions on issues of arts policy.

Among Grantmakers in the Arts' major activities are the sponsorship of an annual conference; the publication of a newsletter several times a year; and the development and management of special projects that address concerns of arts funders, practitioners, and participants.

MEMBERSHIP

Grantmakers in the Arts' members have priority access to a variety of information sources and individuals that provide a broad understanding of issues confronting the arts and arts philanthropy today. Grantmakers in the Arts offers two categories of membership: Institutional and Affiliate. All memberships are open to both staff and trustees.

Institutional Membership is open to private foundations, community foundations, corporate giving programs, and nonprofit cultural organizations whose primary activity is grantmaking. Affiliate Membership is open to individuals active in the arts funding field whose organizations are not eligible for institutional membership, primarily public sector funders.

FURTHER INFORMATION

All Grantmakers in the Arts activities and programs are managed on a volunteer basis by its board of directors. Grantmakers in the Arts is incorporated as a non-profit 501(c)(3) organization and is an affinity group of the Council on Foundations. For further information about Grantmakers in the Arts and its activities, please contact: Grantmakers in the Arts, c/o Pew Fellowships in the Arts, 250 S. Broad St., Suite 400, Philadelphia, PA 19102.

Grantmakers in the Arts
Board of Directors (1993)

President—Ella King Torrey
Pew Fellowships in the Arts

Vice President—Sarah Lutman
The Bush Foundation

Treasurer—John Kreidler
The San Francisco Foundation

Secretary—Tim McClimon
AT&T Foundation

Penelope McPhee
John S. and James L. Knight Foundation

Myra Millinger
The Flinn Foundation

John Orders
The James Irvine Foundation

Nick Rabkin
The John D. and Catherine T. MacArthur
 Foundation

Janet Sarbaugh
Heinz Endowments

Klare Shaw
Boston Globe Foundation

Joan Shigekawa
The Nathan Cummings Foundation

Holly Sidford
Lila Wallace-Reader's Digest Fund

Bruce Sievers
Walter and Elise Haas Fund

Sam Yanes
Polaroid Corporation

Tomas Ybarra-Frausto
The Rockefeller Foundation

The following individuals served as directors during the planning and oversight of the *Arts Funding* Benchmark Study. The institutions with which they were associated are also noted.

Margaret Ayers
Robert Sterling Clark Foundation

Jessica Chao
Lila Wallace-Reader's Digest Fund

Patricia Doyle
The Cleveland Foundation

Lorraine Garcia-Nakata
Marin Community Foundation

Cynthia Gehrig
Jerome Foundation

Ruth Mayleas
The Ford Foundation

Rebecca Riley
The John D. and Catherine T. MacArthur
 Foundation

APPENDIX B

The Grants Classification System

The Foundation Center established a computerized grants reporting system in 1972. From 1979 to 1988 the Center relied on a "facet" classification system, a multidimensional system employing a fixed vocabulary of four-letter codes, that permitted categorization of each grant by broad subject, type of recipient, population group, type of support, and scope of grant activity.

In 1989, the Center adopted a new classification system with links to the National Taxonomy of Exempt Entities (NTEE), a comprehensive coding scheme developed by the National Center for Charitable Statistics. NTEE establishes a unified national standard for classifying nonprofit activities; it also provides a more concise and consistent hierarchical method to classify and index grants.

The new system uses two- or three-character alphanumeric codes to track institutional fields and entities, governance or auspices, population groups, geographic focus, and types of support awarded. The universe of institutional fields is organized into the 26 "major field" areas (A to Z) listed below. The first letter of each code denotes the field, such as "A" for Arts and "B" for Education. Within each alpha subject area, numbers 20 to 99 identify services, disciplines, or types of institutions unique to that field, organized in a hierarchical structure. The categories and subcategories of "Arts and Culture" are presented below.

While based on NTEE, the Center's system added indexing elements not part of the original taxonomy including a secondary set of codes to classify specific types of grant support (shown below); and a third set of codes to track different grant beneficiary populations.

SUMMARY OF THE 26 NTEE MAJOR FIELD AREAS

A Arts, Culture, Humanities

B Educational Institutions & Related Activities

C Environmental Quality/Protection

D Animal-Related Activities

E Health—General & Rehabilitative

F Mental Health/Crisis Intervention

G Disease/Disorder/Medical Disciplines (Multipurpose)

H Medical Research

I Public Protection: Crime/Courts/Legal Services

J Employment/Jobs

K Food, Nutrition, Agriculture

L Housing/Shelter

M Public Safety/Disaster Preparedness & Relief

N Recreation, Leisure, Sports, Athletics

O Youth Development

P Human Service—Other/Multipurpose

Q International

R Civil Rights/Civil Liberties

S Community Improvement/Development

T Philanthropy & Voluntarism

U Science

V Social Sciences

W Public Affairs/Society Benefit

X Religion/Spiritual Development

Y Mutual Membership Benefit Organizations

Z Unknown, Unclassifiable

NTEE Institutional/Program Activity Codes for Arts and Culture

A01	ARTS ALLIANCES & COALITIONS		A62	DANCE
A03	ARTS ASSOCIATIONS		A63	BALLET
A05	ARTS RESEARCH		A64	CHOREOGRAPHY
A06	ARTS POLICY		A65	THEATER
A12	ARTS FUNDRAISING		A66	PLAYWRITING
A20	**ARTS/CULTURAL ORGANIZATIONS—MULTIPURPOSE**		A67	MUSICAL THEATER
			A68	MUSIC
A23	CULTURAL/ETHNIC AWARENESS		A69	SYMPHONY ORCHESTRAS
A24	FOLK ARTS/TRADITIONAL ARTS		A6A	OPERA/LIGHT OPERA
A25	ARTS EDUCATION/SCHOOLS OF ART		A6B	SINGING/CHORAL
A26	ARTS COUNCIL/AGENCY		A6C	MUSIC GROUPS/BANDS/ENSEMBLES
A30	**MEDIA/COMMUNICATIONS ORGANIZATIONS**		A6D	MUSIC COMPOSITION
A31	FILM/VIDEO		A6E	PERFORMING ARTS SCHOOLS
A32	TELEVISION		A6F	MULTIMEDIA, EXPERIMENTAL COMPANIES/PERFORMANCES
A33	PRINTING/PUBLISHING			
A34	RADIO		A6G	CIRCUS/CIRCUS ARTS
A40	**VISUAL ART ORGANIZATIONS/SERVICES**		**A70**	**HUMANITIES ORGANIZATIONS**
A41	ARCHITECTURE CENTERS/SERVICES		A71	ART HISTORY
A42	PHOTOGRAPHY		A72	HISTORY & ARCHAEOLOGY
A43	SCULPTURE		A73*	CLASSICAL LANGUAGES
A44	DESIGN CENTERS/SERVICES		A74*	FOREIGN LANGUAGE SCHOOLS/SERVICES
A45	PAINTING		A75*	LANGUAGE & LINGUISTICS
A46	DRAWING		A76	LITERARY SERVICES/LITERATURE
A47	CERAMIC ARTS		A77	PHILOSOPHY/ETHICS
A50	**MUSEUMS/MUSEUM ACTIVITIES**		A78	THEOLOGY/COMPARATIVE RELIGION
A51	ART MUSEUMS		**A80**	**HISTORICAL SOCIETIES**
A52	CHILDREN'S MUSEUMS		A82	HISTORIC PRESERVATION
A53	FOLK ARTS/ETHNIC MUSEUMS		A83	GENEALOGICAL ORGANIZATIONS/SERVICES
A54	HISTORY MUSEUMS		A84	COMMEMORATIVE EVENTS
A55	MARINE/MARITIME MUSEUMS		A85	VETERANS' & WAR MEMORIALS
A56	NATURAL HISTORY/NATURAL SCIENCE MUSEUMS		**A90**	**ARTS SERVICE ORGANIZATIONS AND ACTIVITIES**
A57	SCIENCE & TECHNOLOGY MUSEUMS		A91	ARTIST'S SERVICES
A58	SPORTS/HOBBY MUSEUMS		**A99**	**ARTS/CULTURE/HUMANITIES**
A59	SPECIALIZED MUSEUMS			
A60	**PERFORMING ARTS ORGANIZATIONS/ACTIVITIES**		B76≠	**SPECIAL LIBRARIES**
A61	PERFORMING ARTS CENTERS		Q21≠	**INTERNATIONAL CULTURAL EXCHANGE**

* Non arts-related humanities; not included in this study.

≠ Additional codes used to classify arts and culture grants.

Types of Support

Annual Campaigns—any organized effort by a nonprofit to secure gifts on an annual basis; also called annual appeals.

Awards/Services*—grants for artists' awards, prizes, competitions, housing, living space, and work space.

Building/Renovation—grants for constructing, renovating, remodeling, or rehabilitating property.

Capital Campaigns—a campaign, usually extending over a period of years, to raise substantial funds for purposes such as building or endowment.

Collections Acquisition—grants to libraries or museums to acquire permanent materials as part of a collection, usually books or art.

Collections Management/Preservation*—grants for maintenance, preservation, and conservation of materials.

Computer Systems/Equipment—grants to purchase or develop automated systems.

Commissioning New Works*—grants to support the creation of new artistic works.

Conferences/Seminars—a grant to cover the expenses of holding a conference.

Curriculum Development—grants to schools, colleges, universities, and educational support organizations to develop general or discipline-specific curricula.

Debt Reduction—a grant to reduce a recipient organization's indebtedness; also referred to as deficit financing. Frequently refers to mortgage payments.

Emergency Funds—a one-time grant to cover immediate short-term funding needs on an emergency basis.

Endowments—a bequest or gift to be kept permanently and invested to provide income for continued support of an organization.

Equipment—a grant to purchase equipment, furnishings, or other materials.

Exhibitions—grants to museums, libraries, or historical societies to mount an exhibit or to support the installation of a touring exhibit.

Faculty/Staff Development—includes staff training programs.

Fellowships—funds awarded to educational institutions to support fellowship programs.

Film/Video/Radio—a grant to fund a film, video, or radio production by a nonprofit resulting from research or projects of interest to the funder.

General Support—funds for general purpose or work of an organization, and funds to cover the day-to-day personnel, administration, and other expenses for an existing program or project.

Income Development*—grants for fundraising, marketing, and to expand audience base.

Internships—usually indicates funds awarded to an institution or organization to support an internship program, rather than a grant to an individual.

Land Acquisition—a grant to purchase real estate property.

Management Development*—grants for salaries, staff support, staff training, strategic and long-range planning, and budgeting and accounting systems.

Matching or Challenge Grants—grants to match funds provided by another donor and grants paid only if the donee is able to raise additional funds from other sources.

Performance/Productions—a grant to cover costs specifically associated with mounting a performing arts production.

Professorships—a grant to an educational institution to endow a professorship or chair.

Program Development—grants to support specific projects or programs as opposed to general purpose grants.

Publication—a grant to fund reports or other publications issued by a nonprofit resulting from research or projects of interest to the funder.

Research—funds awarded to institutions to cover costs of investigations and clinical trials. Research grants for individuals are usually referred to as fellowships.

Scholarships—a grant to an educational institution or organization to support a scholarship program, mainly for students at the undergraduate level.

Seed Money—a grant to start, establish, or initiate a new project or organization. Seed grants may cover salaries and other operating expenses of a new project. Also known as 'start-up funds.'

Student Aid—assistance in the form of educational grants, loans, or scholarships.

Technical Aid—operational or management assistance given to nonprofit organizations, including fundraising assistance, budgeting and financial planning, program planning, legal advice, marketing, and other aids to management.

* Types of support codes added to the classification system for the enhanced analysis of arts grants in this study.

APPENDIX C

Survey Respondents

GRANTMAKERS

ALCOA Foundation

Altman Foundation

Amarillo Area Foundation

American Express Company

American Express Minnesota Foundation

Amoco Foundation

ARCO Foundation

Art Matters, Inc.

AT&T Foundation

The Baltimore Community Foundation

Claude Worthington Benedum Foundation

The Mary Duke Biddle Foundation

The Blandin Foundation

Boettcher Foundation

Boston Globe Foundation, Inc.

BP America

Carol Franc Buck Foundation

Burlington Northern Foundation

Edyth Bush Charitable Foundation, Inc.

The Morris and Gwendolyn Cafritz Foundation

California Community Foundation

The Cargill Foundation

Mary Flagler Cary Charitable Trust

CBS Foundation

The Champlin Foundations

Chase Manhattan Bank, N.A.

Chevron Corporation

Chicago Community Trust

Chrysler Corporation Fund

CIGNA Foundation

Robert Sterling Clark Foundation

The Cleveland Foundation

Coletta Brewer & Company, Inc.

The Columbus Foundation

Consolidated Edison

Coors Brewing Co.

James S. Copley Foundation

Corning Foundation

Arie & Ida Crown Memorial

The Nathan Cummings Foundation, Inc.

Cummins Engine Foundation

Dade Community Foundation

The Eleanor Naylor Dana Charitable Trust

Dana Corporation Foundation

Dayton Hudson Foundation

The Aaron Diamond Foundation

Djerassi Foundation

Geraldine R. Dodge Foundation, Inc.

Dodge Jones Foundation

Jessie Ball duPont Fund

Exxon Corporation

First Bank System Foundation

First Interstate Bank of California Foundation

The Fleishhacker Foundation

The Flinn Foundation

Richard A. Florsheim Art Fund

The Ford Foundation

Ford Motor Company Fund

A. Friends' Foundation Trust

The Fund for Folk Culture

Gates Foundation

GATX

General Electric Foundation

Wallace Alexander Gerbode Foundation

The Getty Grant Program/J. Paul Getty Trust

Horace W. Goldsmith Foundation

The Philip L. Graham Fund

The Grand Rapids Foundation

The Greenwall Foundation

John Simon Guggenheim Memorial Fund

The George Gund Foundation

Hall Family Foundations

Hallmark Corporate Foundation

The Greater Harrisburg Foundation

The Hartford Courant Foundation, Inc.

Hartford Foundation for Public Giving

The HCA Foundation

William Randolph Hearst Foundation

Howard Heinz Endowment

Vira I. Heinz Endowment

The William & Flora Hewlett Foundation

Stewart W. & Willma C. Hoyt Foundation

Hunt Manufacturing Company Foundation

The Indianapolis Foundation

The James Irvine Foundation

ITT Hartford Insurance Group Foundation, Inc.

Jerome Foundation

Johnson & Johnson Family of Companies Contribution Fund

The Joyce Foundation

Alexander Julian Foundation

The Greater Kansas City Community Foundation

The J. M. Kaplan Fund, Inc.

John S. and James L. Knight Foundation

Koret Foundation

The Kresge Foundation

Samuel H. Kress Foundation

The Kroger Company Foundation

Kulas Foundation

Albert Kunstadter Family Foundation

Lilly Endowment, Inc.

Community Foundation of Greater Lorain County

The Henry Luce Foundation

Lyndhurst Foundation

The John D. & Catherine T. MacArthur Foundation

Robert Mapplethorpe Foundation

Marshall Field's

The Marshall Fund of Arizona

McGregor Fund

McInerny Foundation

The McKnight Foundation

Meadows Foundation, Inc.

The Medtronic Foundation

The Andrew W. Mellon Foundation

Joyce Mertz-Gilmore Foundation

Metropolitan Life Foundation

Eugene and Agnes E. Meyer Foundation

Meyer Memorial Trust

The Minneapolis Foundation

Mobil Foundation, Inc./Mobil Corp.

J. P. Morgan & Co., Inc.

John P. Murphy Foundation

Nationwide Insurance Foundation

New Hampshire Charitable Foundation

The New York Community Trust

The New York Times Company Foundation, Inc.

Edward John Noble Foundation

The Nord Family Foundation

Northwest Area Foundation

The Oregon Community Foundation

Bernard Osher Foundation

Pacific Telesis Foundation

David & Lucile Packard Foundation

The William Penn Foundation

The Pew Charitable Trusts

The Philadelphia Foundation

Philip Morris Companies, Inc.

The Pittsburgh Foundation

Pittsburgh National Bank Foundation

Polk Brothers Foundation

The Pollock-Krasner Foundation, Inc.

Prince Charitable Trust

The Principal Financial Group Foundation, Inc.

Progressive Corporation

The Prudential Foundation

Ragdale Foundation

Sid W. Richardson Foundation

The Rockefeller Foundation

Rockwell Fund, Inc.

Helena Rubinstein Foundation, Inc.

Sacramento Regional Foundation

The Saint Paul Foundation

Fan Fox and Leslie R. Samuels Foundation

San Diego Community Foundation

San Francisco Foundation

Community Foundation of Santa Clara County

Sara Lee Foundation

The Scherman Foundation, Inc.

Scott Paper Company Foundation

Security Pacific Foundation

Shell Oil Company Foundation

L. J. Skaggs and Mary C. Skaggs Foundation

The Skillman Foundation

John Ben Snow Memorial Trust

Community Foundation for Southeastern Michigan

Stackner Family Foundation, Inc.

Stockton Rush Bartol Foundation

Anne Burnett and Charles D. Tandy Foundation

T. L. L. Temple Foundation

Times Mirror Foundation

Toyota Motor Sales, U.S.A.

Tucson Community Foundation

Union Pacific Foundation

The USF&G Foundation, Inc.

Lila Wallace-Reader's Digest Fund

Andy Warhol Foundation for the Visual Arts

Wells Fargo Bank

Westinghouse Foundation

The Norman and Rosita Winston Foundation, Inc.

The Winston-Salem Foundation

Wisconsin Energy Corporation Foundation, Inc.

Robert W. Woodruff Foundation, Inc.

Greater Worcester Community Foundation

ARTS ORGANIZATIONS

Akron Art Museum

Alaska Center for the Performing Arts

The American Council for the Arts

American Dance Festival, Inc.

American Repertory Theatre

Amherst Saxophone Society, Inc.

Arlington Arts Center

Art Papers

Artists' Television Access

The Arts Council

Arts on the Park

Asian American Writer's Workshop

Association of Performing Arts Presenters

Ballet Metropolitan, Inc.

Baltimore Clayworks

Baltimore Museum of Art

Bella Lewitzky Dance Company

Beyond Baroque

Billings Symphony Orchestra

Boston Film/Video Foundation

Brass Ring

Brooklyn Museum

California E.A.R. Unit

Carolina Quarterly

Cedar Rapids Symphony Orchestra

Center for Contemporary Arts

Chamber Music America

Chestnut Brass Company

Chinese-American Arts Council, Inc.

Cine Accion

Cleveland Opera

Cleveland Performance Art Festival

Coalition of Women's Art Organizations

Coffee House Press

College Art Association

Colorado Springs Fine Arts Center

Connecticut Opera

Cooper-Hewitt Museum

Corporate Council for the Arts

Council of Literary Magazines and Presses

Crossroads Theatre Company

Cunningham Dance Foundation, Inc.

Da Camera Society

Da Capo Chamber Players

Dance Bay Area

Denver Young Artists Orchestra

Detroit Chamber Winds

Duke University, Office of Cultural Affairs

1800 Square Feet

18th Street Arts Complex

Forest Hills Symphony

Frameline

Goodman Theatre

Guadalupe Cultural Arts Center

The Guthrie Theater

Harrisburg Symphony Orchestra

Hartford Ballet

Hartford Stage Company

Headlands Center for the Arts

Helena Presents

Honolulu Theatre for Youth

Houston Ballet

Hubbard Street Dance Co.

Hult Center for the Performing Arts

INTAR Hispanic Arts Center

Intermedia Arts Minnesota

Intersection for the Arts

Jacob's Pillow Dance Festival

Japanese American Cultural and Community Center

Kansas City Artists Coalition

Laguna Art Museum

Loretta Livingston & Dancers

Madison Opera

Magic Theatre

Manchester Craftsman's Guild

Meet the Composer

Milwaukee Art Museum

Minnesota Composers Forum

Music Before 1800, Inc.

Music of the Baroque Chorus and Orchestra

National Alliance of Media Arts Centers

National Association of Artists Organizations

Native American PBC

New Jersey Symphony Orchestra

New Langton Arts

Norton Gallery & School of Art, Inc.

Oklahoma Visual Arts Coalition, Inc.

On the Board

Opera America

Pacific Northwest Ballet

Painted Bride Art Center

Pan Asian Repertory Theatre

Paper Mill Playhouse

The Paris Review

Pentacle

Perseverance Theatre

Philadelphia Dance Co.

Phoenix Art Museum

Pittsburgh Dance Council

Pittsburgh Opera, Inc.

Portland Stage Company

Portland Symphony Orchestra

Pyramid Atlantic

Quintet of the Americas

Real Art Ways

Relache, Inc.

Rhode Island School of Design Museum

St. Louis Black Repertory Company

Saint Paul Chamber Orchestra

San Francisco Contemporary Music Players

San Francisco Symphony

Sarasota Opera Association

Scribe Video

Sitka Summer Music Festival

Source Theatre Company

Southwest Alternative Media Project

Strategies for Media Literacy

Studio Arena Theatre

Studio Museum in Harlem

Ten Penny Players, Inc.

Theatre de la Jeune Lune

Tia Chucha Press

Townsend Opera Players

Turtle Island String Quartet

Urban Institute for Contemporary Arts

Victory Gardens Theater

Visual Arts Center of Alaska

Walker Arts Center

Wheeling Symphony Orchestra

The Women's Philharmonic

Carter G. Woodson Foundation

ZYZZYVA

Survey Questionnaires

THE FOUNDATION CENTER/GRANTMAKERS IN THE ARTS
GRANTMAKER QUESTIONNAIRE ON FOUNDATION/CORPORATE ARTS FUNDING

Name _____ Title _____

Grantmaker _____

Address _____

City _____ State _____ ₂ Zip _____ 3

Phone () _____ Fax () _____

1. Grantmaker type: 4
- ☐ Independent Foundation 4/a
- ☐ Community Foundation 4/b
- ☐ Operating Foundation 4/c
- ☐ Company-Sponsored Foundation 4/d
- ☐ Corporate Giving Program 4/e
- ☐ Marketing/PR Program 4/f

2. Please indicate the geographic focus of your arts grants. Check all that apply: 5
- ☐ Local 5/a
- ☐ Regional 5/b
- ☐ National 5/c
- ☐ International 5/d

3. Please indicate the arts subjects or activities your foundation has funded in 1990-91. Check all that apply. 6-14
- ☐ **Multipurpose arts** 6/01
 - ☐ Multidisciplinary 6/02
 - ☐ Cultural/ethnic awareness 6/03
 - ☐ Folk or traditional arts 6/04
 - ☐ Arts education 6/05
 - ☐ Arts training/schools of art 6/06
 - ☐ Arts councils/agencies 6/07
- ☐ **Media/Communications** 7/08
 - ☐ Film/video/holography 7/09
 - ☐ Television 7/10
 - ☐ Radio 7/11
 - ☐ Printing/publishing (e.g., literary journals) 7/12
- ☐ **Visual Arts** 8/13
 - ☐ Architecture & Design 8/14
 - ☐ Photography 8/15
 - ☐ Sculpture 8/16
 - ☐ Painting 8/17
 - ☐ Crafts 8/18
 - ☐ Works on paper (drawing, printmaking, book arts) 8/19
 - ☐ Visual arts centers/exhibition spaces 8/20

- ☐ **Museum Activities** 9/21
 - ☐ Art museums 9/22
 - ☐ Children's museums 9/23
 - ☐ Folk arts museums 9/24
 - ☐ Ethnic museums 9/25
 - ☐ History museums 9/26
 - ☐ Natural history museums 9/27
 - ☐ Science/technology museums 9/28
 - ☐ Specialized/other museums 9/29
- ☐ **Performing Arts** 10/30
 - ☐ Performing arts centers/presenters/sponsors 10/31
 - ☐ Modern dance (includes choreography) 10/32
 - ☐ Ballet (includes choreography) 10/33
 - ☐ All other dance (ethnic, jazz dance, etc.) 10/34
 - ☐ Theater (includes playwriting) 10/35
 - ☐ Mime, puppetry, circus arts 10/36
 - ☐ Symphony orchestra (includes composition) 10/37
 - ☐ All other music (includes composition) 10/38
 - ☐ Opera/light opera/ musical theater 10/39
 - ☐ Performing arts schools 10/40
 - ☐ Multi-media/performance art 10/41
- ☐ **Arts-related Humanities** 11/42
 - ☐ Art history 11/43
 - ☐ Other history and archeology 11/44
 - ☐ Literature (creative writing) 11/45
- ☐ **Historical Activities** 12/46
 - ☐ Conservation/preservation 12/47
 - ☐ _____ 12/48
- ☐ **Arts Services (Arts & artist service organizations such as Dance USA, Opera America, etc.)** 13/49
- ☐ **Other** 14/50
 - ☐ Arts alliances/coalitions/advocacy 14/51
 - ☐ Arts policy/arts research 14/52
 - ☐ International cultural exchange 14/53
 - ☐ Independent research libraries 14/54
 - ☐ Arts criticism 14/55

1

Arts Grantmaker Questionnaire

4. From the above list (question 3), to which arts subjects or activities are you likely to provide your primary support in the coming fiscal year? (Either major or sub-categories.) Please list no more than three. 15
- ☐ _____ 15/01-55
- ☐ _____ 15/01-55
- ☐ _____ 15/01-55

5. In your opinion, from the list of arts subjects or activities in question 3, which are the most underfunded today? (Either major or sub-categories.) List no more than six. 16
- ☐ _____ 16/01-55
- ☐ _____ 16/01-55
- ☐ _____ 16/01-55
- ☐ _____ 16/01-55
- ☐ _____ 16/01-55
- ☐ _____ 16/01-55

6. In your opinion, from the list of arts subjects or activities in question 3, which are the best funded today? (Either major or sub-categories). List no more than six. 17
- ☐ _____ 17/01-55
- ☐ _____ 17/01-55
- ☐ _____ 17/01-55
- ☐ _____ 17/01-55
- ☐ _____ 17/01-55
- ☐ _____ 17/01-55

7. Please indicate the types of support that were eligible for your funding in 1990-91. Check all that apply: 18-27
- ☐ **Unrestricted Operating Support** 18/01
- ☐ **Restricted Operating/Management Support** 19/02
 - ☐ Artistic salaries 19/03
 - ☐ Administrative salaries 19/04
 - ☐ Staff training 19/05
 - ☐ Board development 19/06
 - ☐ Long range & strategic planning 19/07
 - ☐ Program planning 19/08
 - ☐ Audience development 19/09
 - ☐ Fund raising (includes volunteer recruitment) 19/10
 - ☐ Budgeting/accounting/financial planning 19/11
 - ☐ Insurance 19/12
 - ☐ Legal services 19/13
 - ☐ Marketing/advertising/media relations 19/14
 - ☐ Technical assistance 19/15

- ☐ **Capital Campaigns/Purposes** 20/16
 - ☐ Endowment 20/17
 - ☐ Facilities acquisition/renovation 20/18
 - ☐ Land acquisition 20/19
 - ☐ Office equipment, furniture (includes computers) 20/20
 - ☐ Arts equipment (instruments, speakers, costumes, etc.) 20/21
 - ☐ Collections acquisition 20/22
 - ☐ Debt reduction (deficit financing) 20/23
- ☐ **Program-related Investments** 21/24
- ☐ **Emergency Funds (Specify purpose, if known)** 22/25
- ☐ **Program Support** 23/26
 - ☐ Exhibitions 23/27
 - ☐ Performance presentation 23/28
 - ☐ Media production (film/video/radio) 23/29
 - ☐ Creating/commissioning new works 23/30
 - ☐ Seed money (program startup) 23/31
 - ☐ Touring 23/32
 - ☐ Collections management/conservation/preservation 23/33
 - ☐ Curriculum development (in public/private schools to develop arts-related curricula) 23/34
 - ☐ Professorships (chair endowment) 23/35
 - ☐ Staff/faculty development (training, rehearsals, workshops, seminars, conferences, retreats) 23/36
 - ☐ Publication 23/37
- ☐ **Student Aid/professional training (to institutions, not directly to individuals)** 24/38
 - ☐ Scholarships & fellowships 24/39
 - ☐ Internships/apprenticeships 24/40
- ☐ **Research (Specify topic, if known):** _____ 25/41
- ☐ **Individual Artists** 26/42
 - ☐ Through direct grants 26/43
 - ☐ Through regranting mechanisms (Indicate artist field, if known: _____) 26/44
 - ☐ Other (Specify)_____ 27/45

8. From the above list (question 7), which types of support are likely to receive most of your funding in the coming fiscal year? Please list no more than four (either major or sub-categories). 28
- ☐ _____ 28/01-45
- ☐ _____ 28/01-45
- ☐ _____ 28/01-45
- ☐ _____ 28/01-45

2

Arts Grantmaker Questionnaire

9. In your opinion, from the types of support listed in question 7, which are the most critical needs among arts organizations today? Please list no more than six (either major or sub-categories). 29

- ☐ _____ 29/01-45
- ☐ _____ 29/01-45
- ☐ _____ 29/01-45
- ☐ _____ 29/01-45
- ☐ _____ 29/01-45
- ☐ _____ 29/01-45

10. In your opinion, from the types of support listed in question 7, which are the best funded among arts organizations today? List no more than six (either major or sub-categories): 30

- ☐ _____ 30/01-45
- ☐ _____ 30/01-45
- ☐ _____ 30/01-45
- ☐ _____ 30/01-45
- ☐ _____ 30/01-45
- ☐ _____ 30/01-45

11. Which are the most important issues or problems related to arts and arts funding in general today? (Check no more than one in each category): 31-35

Political Issues
- ☐ Obscenity/censorship controversy 31/a
- ☐ Other ideological or religious pressures 31/b

Public Policy Issues
- ☐ Government (NEA, states) funding cutbacks & restructuring 32/a
- ☐ Income tax/IRS policy 32/b
- ☐ Nontax, arts-related legislation (e.g., painters' rights to sold works, fair use citation of copyrighted papers) 32/c

Artistic Issues
- ☐ Standards of quality 33/a
- ☐ Restrictions on funding only "professionals" 33/b
- ☐ Restrictive arts discipline classifications 33/c

Social/Economic Issues
- ☐ Pluralism/cultural diversity 34/a
- ☐ Access to the arts for underserved populations (rural, disabled, low-income, etc.) 34/b
- ☐ Declining audiences for arts exhibitions and performances 34/c

- ☐ Undercompensation of artists and arts administrators 34/d
- ☐ Insufficient professional employment for artists 34/e
- ☐ Insufficient work & living space for artists 34/f
- ☐ Economic viability of the arts in general 34/g
- ☐ The recession, or state of the economy in general 34/h
- ☐ Support for U.S. artists abroad 34/i

Other Issues
- ☐ Ethics (among grantmakers, government, grantees, art dealers, etc.) 35/a
- ☐ _____ 35/b

12. Which are the most important grantmaking issues facing you as an arts funder today? (Check no more than three): 36

- ☐ Quality of board or trustee involvement in policy making 36/a
- ☐ Proposal evaluation/review criteria (e.g., quality of board or staff expertise in making informed evaluations) 36/b
- ☐ Standards of artistic excellence (or absence thereof) 36/c
- ☐ Influence of dominant foundations 36/d
- ☐ Capacity of funders to take risks, be innovative 36/e
- ☐ Quality of proposals from grant seekers 36/f
- ☐ Quality of artistic talent in groups seeking funds 36/g
- ☐ Capacity of arts groups to meet foundation requirements 36/h
- ☐ Honest feedback from grantees 36/i
- ☐ Competition among arts groups seeking funds 36/j
- ☐ Competition for funds between arts and other fields (human services, environment, etc.) 36/k
- ☐ Competition with government agencies (e.g. schools) for grants 36/l
- ☐ Needs of individual artists 36/m

13. Please describe briefly how the issues you have indicated are likely to affect your grantmaking in the near future: More—or fewer—grants for advocacy; greater—or less—willingness to fund controversial works, etc.

3

Arts Grantmaker Questionnaire

14. In which of the following ways do you plan to directly support individual artists in the coming fiscal year? 37

- ☐ Commissions to individual artists to produce works 37/a
- ☐ Direct grants to individual artists for living/working costs 37/b
- ☐ Prizes and awards to individual artists 37/c
- ☐ Direct scholarships/fellowships to individual artists (as opposed to schools or organizations) 37/d
- ☐ Do not plan to directly support individual artists 37/e

15. Notwithstanding your answer to question 14, do you plan to assist individual artists in the coming fiscal year through regranting mechanisms? 38

☐ Yes 38/a ☐ No 38/b ☐ Not Sure 38/c

16. Grantmakers sometimes provide arts grants to non-arts organizations, such as a social service center to host a community artist exhibition. Are you likely to give 10 percent or more of your arts grants dollars to non-arts organizations in the coming fiscal year? 39

☐ Yes 39/a ☐ No 39/b ☐ Not Sure 39/c

17. If you answered 'Yes' to question #16, which of the following non-arts organizations are likely to receive ten percent or more of your arts dollars in the coming fiscal year? 40

- ☐ Educational institutions (colleges, schools, libraries) 40/a
- ☐ Environmental and animal-specific groups 40/b
- ☐ Health agencies, hospitals, medical care facilities 40/c
- ☐ Human service providers (shelters, youth development groups, senior centers) 40/d
- ☐ International organizations (Oxfam, CARE) 40/e
- ☐ Public or community improvement organizations (civil rights, social justice, urban or rural development, government improvement, etc.) 40/f
- ☐ Religious organizations, houses of worship 40/g
- ☐ Other _____ 40/h

18. Arts funding, whether to arts groups or non-arts groups, may serve social goals. Which of the following broad fields of activity are you likely to support with your arts grants in the coming fiscal year? 41

- ☐ Education 41/a
- ☐ Environment/wildlife/animals 41/b
- ☐ Health 41/c
- ☐ Human services 41/d
- ☐ International/foreign affairs 41/e
- ☐ Public/society benefit (social justice, government improvement, etc.) 41/f
- ☐ Religion 41/g
- ☐ Other _____ 41/h

For each of the fields of activity you checked in the above question, please elaborate briefly on the specific nature of these grants. For example, community empowerment, AIDS education, rain forest preservation, access to arts by handicapped, etc.

19. Some funders renew grants to the same arts groups consistently over time. Please indicate the most important factors in your grants renewal decisions. (Check only two): 42

- ☐ Trustee/donor preference 42/a
- ☐ Executive/staff preference 42/b
- ☐ Guidelines specifying support for a type of organization 42/c
- ☐ Commitment to sustaining an organization over time 42/d
- ☐ Tradition (i.e., you have always funded them) 42/e
- ☐ General artistic/organizational accomplishments of grantees 42/f
- ☐ Pressing financial need of grantees 42/g
- ☐ High quality proposals 42/h
- ☐ Other _____ 42/i

20. To the best of your knowledge, have your arts funding priorities or policies changed significantly within the past two years? 43

☐ Yes 43/a ☐ No 43/b ☐ Not sure 43/c

4

Arts Grantmaker Questionnaire

21. (For those who answered 'Yes' or 'Not Sure' to the above question): Please rank the following factors in your organization's decision to revise its funding program. (Indicate "A" for most important, "B" for next most important, etc. Rank only those that apply.) 44-49

☐ Preference of trustees 44

☐ Changes in staff 45

☐ Perceived trends in the grantmaking world 46

☐ Perceived trends in the arts world 47

☐ Societal/environmental developments (Specify:_____) 48

☐ Other _____ 49

Please describe briefly the nature of the change in your funding priorities. (Please attach descriptive documents, such as press releases, on the change):

22. Over the next five years, do you expect your arts funding, as a percent of overall funding, to: 50

☐ Increase ☐ Decrease ☐ Remain the same
50/a 50/b 50/c

23. Arts grantees sometimes criticize grantmakers on policy and philosophical grounds. For each of the following criticisms, which are directed at the grantmaker world in general, please indicate whether you basically agree or basically disagree. 51-62

	Basically Agree	Basically Disagree	No Opinion
(A) Imbalance in grants, favoring larger, more established arts organizations	☐ 51a	☐ 51b	☐ 51c
(B) Cultural/ethnic/racial bias	☐ 52a	☐ 52b	☐ 52c
(C) Unclear, or rigid, guidelines	☐ 53a	☐ 53b	☐ 53c
(D) Over-emphasis on new programs rather than basic support	☐ 54a	☐ 54b	☐ 54c
(E) Reluctance to fund risky or innovative works	☐ 55a	☐ 55b	☐ 55c
(F) Funding only trendy programs; adhering to a 'herd mentality'	☐ 56a	☐ 56b	☐ 56c
(G) Unrealistic expectations that grantees become self-supporting	☐ 57a	☐ 57b	☐ 57c
(H) Arduous grantmaker bureaucracy	☐ 58a	☐ 58b	☐ 58c
(I) Unreasonable or inflexible conditions imposed on grantees	☐ 59a	☐ 59b	☐ 59c
(J) Insufficient contact between officers and grantees	☐ 60a	☐ 60b	☐ 60c
(K) Lack of grantee access to foundation decision-makers	☐ 61a	☐ 61b	☐ 61c
(L) Short-term rather than long-range funding	☐ 62a	☐ 62b	☐ 62c

24. From the above list of criticisms, please rank the three most serious: 63-65

☐ Most serious _____ 63/A-L.

☐ Second most serious _____ 64/A-L.

☐ Third most serious _____ 65/A-L.

The following questions are intended for corporate givers only:

25. What percent of your current arts support takes the form of

Cash grants	____%	66
Securities	____%	67
Equipment/Furniture	____%	68
Buildings/land	____%	69
Supplies/products	____%	70
Marketing/promotion	____%	71

26. Which, if any, of the following services do you offer arts groups? 72

☐ Personnel time (management consulting) 72a

☐ Use of office equipment (e.g., photocopying) 72b

☐ Use of office or building space 72c

☐ Other services

_____ 72d

27. What percent of your arts grants derives from: 73-75

Contributions budget	____%	73
Marketing budget	____%	74
Advertising/PR budget	____%	75
Other	____%	76

Please feel free to add any comments on the issues raised in this questionnaire, or on any aspects of grantmaker funding of the arts. Use additional paper if necessary.

Thank you for your cooperation. Please return this completed questionnaire to:
Loren Renz, Research Director
The Foundation Center
79 Fifth Avenue
New York, NY 10003

5

THE FOUNDATION CENTER/GRANTMAKERS IN THE ARTS
GRANTEE QUESTIONNAIRE ON FOUNDATION/CORPORATE ARTS FUNDING

Name _____ Title _____

Organization _____

Address _____

City _____ State _____ 2 Zip _____ 3

Phone () _____ Fax () _____

1. Respondent type: 4

☐ Arts Producer (visual, performing, etc.) 4/a
☐ Arts Presenter (Lincoln Center, museums, etc.) 4/b
☐ Arts Service Organization 4/c

2. Geographic focus of your program. (Check all that apply): 5

☐ Local 5/a
☐ Regional 5/b
☐ National 5/c
☐ International 5/d

3. Which of the following comprise the primary population(s) you represent: 6

☐ No specific population type 6/a
☐ Women 6/b
☐ Men 6/c
☐ Black/African American 6/d
☐ Hispanic/Latino 6/e
☐ Asian/Pacific Islanders 6/f
☐ Other ethnic _____ 6/g

4. From the following list of arts subjects or activities, which in your opinion are the most underfunded today? (Please check no more than six.) 7-15

☐ **Multipurpose arts** 7/01
 ☐ Multidisciplinary 7/02
 ☐ Cultural/ethnic awareness 7/03
 ☐ Folk or traditional arts 7/04
 ☐ Arts education 7/05
 ☐ Arts training/schools of art 7/06
 ☐ Arts councils/agencies 7/07
☐ **Media/Communications** 8/08
 ☐ Film/video/holography 8/09
 ☐ Television 8/10
 ☐ Radio 8/11
 ☐ Printing/publishing (e.g., literary journals) 8/12

☐ **Visual Arts** 9/13
 ☐ Architecture & Design 9/14
 ☐ Photography 9/15
 ☐ Sculpture 9/16
 ☐ Painting 9/17
 ☐ Crafts 9/18
 ☐ Works on paper (drawing, printmaking, book arts) 9/19
 ☐ Visual arts centers/exhibition spaces 9/20
☐ **Museum Activities** 10/21
 ☐ Art museums 10/22
 ☐ Children's museums 10/23
 ☐ Folk arts museums 10/24
 ☐ Ethnic museums 10/25
 ☐ History museums 10/26
 ☐ Natural history museums 10/27
 ☐ Science/technology museums 10/28
 ☐ Specialized/other museums 10/29
☐ **Performing Arts** 11/30
 ☐ Performing arts centers/presenters/sponsors 11/31
 ☐ Modern dance 11/32
 ☐ Ballet 11/33
 ☐ All other dance (choreography, ethnic dance, etc.) 11/34
 ☐ Theater (includes playwriting) 11/35
 ☐ Mime, puppetry, circus arts 11/36
 ☐ Symphony orchestra 11/37
 ☐ All other music 11/38
 ☐ Opera/light opera/ musical theater 11/39
 ☐ Performing arts schools 11/40
 ☐ Multi-media/performance art 11/41
☐ **Arts-related Humanities** 12/42
 ☐ Art history 12/43
 ☐ Other history and archeology 12/44
 ☐ Literature (creative writing) 12/45
☐ **Historical Activities** 13/46
 ☐ Conservation/preservation 13/47
 ☐ _____ 13/48
☐ **Arts Services (Arts & artist service organizations such as Dance USA, Opera America, etc.)** 14/49

1

Arts Grantee Questionnaire

4. (continued)

☐ **Other** 15/50
 ☐ Arts alliances/coalitions/advocacy 15/51
 ☐ Arts policy/arts research 15/52
 ☐ International cultural exchange 15/53
 ☐ Independent research libraries 15/54
 ☐ Arts criticism 15/55

5. From the list of arts subjects or activities in Question 4, which in your opinion are the best funded today (major or sub- categories). List no more than six: 17

☐ _____ 17/01-55
☐ _____ 17/01-55
☐ _____ 17/01-55
☐ _____ 17/01-55
☐ _____ 17/01-55
☐ _____ 17/01-55

6. From the following types of support, which are the most critical needs among arts organizations today? (Please check no more than two from each category.) 18-27

☐ **Unrestricted Operating Support** 18/01
☐ **Restricted Operating/Managing Support** 19/02
 ☐ Artistic salaries 19/03
 ☐ Administrative salaries 19/04
 ☐ Staff training 19/05
 ☐ Board development 19/06
 ☐ Long range & strategic planning 19/07
 ☐ Program planning 19/08
 ☐ Audience development 19/09
 ☐ Fund raising (includes volunteer recruitment) 19/10
 ☐ Budgeting/accounting/financial planning 19/11
 ☐ Insurance 19/12
 ☐ Legal services 19/13
 ☐ Marketing/advertising/media relations 19/14
 ☐ Technical assistance 19/15
☐ **Capital Campaigns/Purposes** 20/16
 ☐ Endowment 20/17
 ☐ Facilities acquisition/renovation 20/18
 ☐ Land acquisition 20/19
 ☐ Office equipment, furniture (includes computers) 20/20
 ☐ Arts equipment (instruments, speakers, costumes, etc.) 20/21
 ☐ Collections acquisition 20/22
 ☐ Debt reduction (deficit financing) 20/23

☐ **Program-related Investments** 21/24
☐ **Emergency Funds** 22/25
 (Specify purpose, if known)_____
☐ **Program Support** 23/26
 ☐ Exhibitions 23/27
 ☐ Performance presentation 23/28
 ☐ Media production (film/video/radio) 23/29
 ☐ Creating/commissioning new works 23/30
 ☐ Seed money (program startup) 23/31
 ☐ Touring 23/32
 ☐ Collections management/ conservation/preservation 23/33
 ☐ Curriculum development (in public/privateschools to develop arts-related curricula) 23/34
 ☐ Professorships (chair endowment) 23/35
 ☐ Staff/faculty development (training, rehearsals, workshops, seminars, conferences, retreats) 23/36
 ☐ Publication 23/37
☐ **Student Aid/professional training (to institutions,not directly to individuals)** 24/38
 ☐ Scholarships & fellowships 24/39
 ☐ Internships/apprenticeships 24/40
☐ **Research (Specify topic, if known):** 25/40
☐ **Individual Artists** 26/41
 ☐ Through direct grants 26/42
 ☐ Through regranting mechanisms 26/43
☐ **Other (Specify)** 27/45

7. In your opinion, from the listed types of support in question 6, which are the most underfunded today? (Either major or sub-categories). List no more than six. 28

☐ _____ 28/01-45
☐ _____ 28/01-45
☐ _____ 28/01-45
☐ _____ 28/01-45
☐ _____ 28-01-45

8. In your opinion, from the listed types of support in question 6, which are the best funded today? (Either major or sub-categories). List no more than six. 29

☐ _____ 29/01-45
☐ _____ 29/01-45
☐ _____ 29/01-45
☐ _____ 29/01-45
☐ _____ 29/01-45
☐ _____ 29/01-45

2

Arts Grantee Questionnaire

9. Which are the most important issues or problems related to arts and arts funding today. (Check no more than one in each category):

30-38

Political Issues
☐ Obscenity/censorship controversy 30/a
☐ Other ideological or religious pressures 30/b

Public Policy Issues
☐ Government (NEA, states) funding cutbacks & restructuring 31/a
☐ Income tax/IRS policy 31/h
☐ Nontax, arts-related legislation (e.g., painters' rights to sold works, fair use citation of copyrighted papers) 31/c

Artistic Issues
☐ Standards of quality 32/a
☐ Restrictions on funding "professionals" only 32/b
☐ Restrictive arts discipline classifications 32/c

Social/Economic Issues
☐ Pluralism/cultural diversity 33/a
☐ Access to the arts for underserved populations (rural,disabled, low-income, etc.) 33/b
☐ Declining audiences for arts exhibitions and performances 33/c
☐ Undercompensation of artists and arts administrators 33/d
☐ Insufficient professional employment for artists 33/e
☐ Insufficient work & living space for artists 33/f
☐ Economic viability of the arts in general 33/g
☐ The recession, or state of the economy in general 33/h
☐ Support for U.S. artists abroad 33/i

Other Issues
☐ Ethics (among grantmakers, government, grantees, art dealers, etc.) 34/a
☐ _____ 34/b

10. Which are the most important grantmaking issues affecting you as an arts grantee today? (Select no more than two.) 35

☐ Quality of Board or trustee involvement in policy making 35/a
☐ Proposal evaluation/review criteria (e.g., quality of Board or staff expertise in making informed evaluations) 35/b
☐ Standards of artistic excellence (e.g., absence thereof) 35/c
☐ Influence of dominant foundations 35/d

☐ Capacity of funders to take risks, be innovative 35/e
☐ Quality of proposals from grant seekers 35/f
☐ Quality of artistic talent in groups seeking funds 35/g
☐ Capacity of arts groups to meet foundation requirements 35/h
☐ Honest feedback to grantmakers 35/i
☐ Competition among arts groups seeking funds 35/j
☐ Competition for funds between arts and other fields (human services, environment, etc.) 35/k
☐ Competition with government agencies (e.g. schools) for grants 35/l
☐ Needs of individual artists 35/m

11. Please describe briefly how the issues you have indicated are likely to affect your activities in the near future. For example: More—or less—likelihood to engage in advocacy and coalitions; greater—or less—willingness to create or promote controversial works, etc.

12. Arts grantees sometimes criticize grantmakers on policy and philosophical grounds. For each of the following criticisms, which are directed at the grantmaker world in general, please indicate whether you basically agree or basically disagree. 36- 47

	Basically Agree	Basically Disagree	No Opinion
(A) Imbalance in grants, favoring larger, more established arts organizations	☐ 36a	☐ 36b	☐ 36c
(B) Cultural/ethnic/racial bias	☐ 37a	☐ 37b	☐ 37c
(C) Unclear, or rigid, guidelines	☐ 38a	☐ 38b	☐ 38c
(D) Over-emphasis on new programs rather than basic support	☐ 39a	☐ 39b	☐ 39c
(E) Reluctance to fund risky or innovative works	☐ 40a	☐ 40b	☐ 40c
(F) Funding only trendy programs; adhering to a 'herd mentality'	☐ 41a	☐ 41b	☐ 41c
(G) Unrealistic expectations that grantees become self-supporting	☐ 42a	☐ 42b	☐ 42c

3

Arts Grantee Questionnaire

12. (continued)

	Basically Agree	Basically Disagree	No Opinion
(H) Arduous grantmaker bureaucracy	☐ 43a	☐ 43b	☐ 43c
(I) Unreasonable or inflexible conditions imposed on grantees	☐ 44a	☐ 44b	☐ 44c
(J) Insufficient contact between officers and grantees	☐ 45a	☐ 45b	☐ 45c
(K) Lack of grantee access to foundation decision-makers	☐ 46a	☐ 46b	☐ 46c
(L) Short-term rather than long-range funding	☐ 47a	☐ 47b	☐ 47c

13. From the above list of criticisms, please rank the three most serious: 48

☐ Most serious _____ 48/A-L
☐ Second most serious _____ 48/A-L
☐ Third most serious _____ 48/A-L

14. Please indicate your organization's budget for the latest fiscal year:

$ _____ 49

Thank you for your cooperation. Please feel free to add any comments on the issues raised in this questionnaire, or on any aspects of grantmaker funding of the arts. Use additional paper if necessary.

Please return this completed questionnaire to:
Loren Renz, Research Director
The Foundation Center
79 Fifth Avenue
New York, NY 10003

4

Bibliography of Arts Funding

Adams, D., and A. Goldbard. *The Bottom Line: Funding for Media Arts Organizations.* San Francisco: National Alliance of Media Arts Centers, 1991.

American Foundations and Their Fields. New York: Twentieth Century Fund, (several editions during the 1930s and 1940s).

Andrews, F. E. *Philanthropic Giving.* New York: Russell Sage Foundation, 1950.

Ardali, A. *Black and Hispanic Art Museums: A Vibrant Cultural Resource.* New York: Ford Foundation, 1989.

Arts and Business Council, Inc. *Critical Issues and the Arts.* New York: Arts and Business Council, 1991.

Arts and Business Council, Inc. *Helping Arts Organizations in Crisis.* New York: Arts and Business Council, 1991.

Balfe, J. H., and M. J. Wyszomirski. "Public Art and Public Policy," *The Journal of Arts Management and Law,* (Winter 1986).

Beerstein, B. "The Silicon Valley Arts Fund: A Brief Overview." San Jose: Silicon Valley Arts Fund, in partnership with the Community Foundation of Santa Clara County, 1992.

Benedict, S., ed. *Public Money and the Muse.* New York: W.W. Norton & Co., 1990.

Berry, K., and S. N. Katz. *The American Private Philanthropic Foundation and the Public Sphere, 1890-1939.* London: Minerva, 1981.

Billington, J. H. *The Intellectual and Cultural Dimensions of International Relations.* Washington, DC: President's Committee on the Arts and the Humanities, 1991.

Bowles, E. *Cultural Centers of Color.* Washington, DC: National Endowment for the Arts, 1992.

Business Committee for the Arts. *The Arts Report on Their Alliances With Business.* New York: Business Committee for the Arts, 1991.

Business Committee for the Arts. *BCA Members Report on Their Alliances With the Arts.* New York: Business Committee for the Arts, 1991.

Business Committee for the Arts. *Second Annual Survey of American Arts Organizations.* New York: Business Committee for the Arts, 1992.

Business Committee for the Arts. *Why Business Should Support the Arts: Facts, Figures and Philosophy.* New York: Business Committee for the Arts, 1992.

Cheney, L. V. *The Value of the Humanities.* Washington, DC: President's Committee on the Arts and the Humanities, 1992.

Cummings, C., and M. Schuster, eds. "Who's to Pay for the Arts?" Research Series, New York: American Council for the Arts, 1989.

Dance/USA. *Domestic Dance Touring: A Study with Recommendations for Private-Sector Support.* Washington, DC: Dance/USA, 1992.

Dance/USA. *Guidelines for the American Dance Touring Initiative.* Washington, DC: Dance/USA, 1992.

DiMaggio, P. "Government and the Arts, 1990." In *The Arts & Government: Questions for the Nineties.* New York: The American Assembly, 1991.

DiMaggio, P. "Support for the Arts from Independent Foundations." PONPO Working Paper, no. 105. New Haven: Yale University, 1986.

Faul, R. "The Filer Report: Is It Good for Museums?" In *Beauty and the Beasts,* Weil, S.E., ed. Washington, DC: Smithsonian Institution Press, 1983.

Getty Trust, J. Paul. *Beyond Creating: The Place for Art in America's Schools.* Los Angeles: J. Paul Getty Trust, 1985.

Goody, K. "The Funding of the Arts and Artists, Humanities and Humanists, in the United States." Report to the Rockefeller Foundation, November 1983. New York: Rockefeller Foundation.

Grantmakers in the Arts. "Grantmakers in the Arts: A Newsletter of Ideas and Items of Interest to Arts Grantmakers," (various editions).

Harris, L. *Americans and the Arts VI.* New York: American Council on the Arts, 1992.

Hodgkinson, V., et al. *Nonprofit Almanac 1992-1993: Dimensions of the Independent Sector.* Washington, DC: National Center for Charitable Statistics, Independent Sector (biennial).

Janowitz, B. "Theatre Facts 89." *American Theatre,* (April 1990).

Jubin, B. *Program in the Arts, 1911-1967.* New York: Carnegie Corporation, 1968.

Kaplan, A. E., ed. *Giving USA.* New York: AAFRC Trust for Philanthropy, 1992.

Karl, B. D., and S. N. Katz. "Foundations and Ruling Class Elites." *Daedalus,* (Winter 1987).

Katz, S. N. "History, Cultural Policy, and International Exchange in the Performing Arts," *Performing Arts Journal 9,* (1985).

Katz, J., ed. *Presenting, Touring and the State Arts Agencies.* Washington, DC: National Assembly of State Arts Agencies, 1992.

Klepper, A., et al. *Corporate Contributions.* New York: The Conference Board, (annual).

LH Associates. *America and the Arts IV.* New York: American Council for the Arts, 1992.

Lindeman, E. C. *Wealth and Culture: A Study of One Hundred Foundations and Community Trusts and their Operation During the Decade 1921-1930.* New York: Harcourt, Brace and Company, 1936.

London, T. *The Artistic Home.* New York: Theatre Communications Group, 1988.

McDaniel, N., and G. Thorn. *The Quiet Crisis in the Arts.* New York: Foundation for the Expansion and Development of the American Professional Theater (FEDAPT), 1991.

Mittenthal, R. *The State of the Arts: Report from Chicago.* New York: The Conservation Company, 1990.

Mittenthal, R. *A Survey of MacArthur Foundation Grantees.* New York: The Conservation Company, 1991.

Mittenthal, R. "Testimony Submitted to the Independent Commission Reviewing the National Endowment for the Arts, July 23, 1990." New York: The Conservation Company.

Murfee, E. *The Value of the Arts.* Washington, DC: President's Committee on the Arts and the Humanities, 1992.

National Assembly of State Arts Agencies. *The State of the State Arts Agencies, 1992.* Washington, DC: National Assembly of State Arts Agencies, 1992.

National Endowment for the Arts. *1991 Annual Report.* Washington, DC: National Endowment for the Arts, 1992.

National Endowment for the Arts. *The Arts in America 1990.* Washington, DC: National Endowment for the Arts, 1990.

National Endowment for the Arts. *The Arts in America 1992.* Washington, DC: National Endowment for the Arts, 1992.

Pottlitzer, J. *Hispanic Theater in the United States and Puerto Rico.* New York: Ford Foundation, 1988.

Renz, L., and S. Lawrence. *Foundation Giving: A Yearbook of Fact and Figures on Private, Corporate and Community Foundations.* New York: The Foundation Center (annual).

Research & Forecasts, Inc. *The BCA Report: A New Look at Business Support to the Arts in the U.S.* New York: Business Committee for the Arts, 1989.

Richardson, M., P. Aall, and J. Sarbacher. *Shaping the New World Order: International Cultural Opportunities and the Private Sector.* Washington, DC: President's Committee on the Arts and Humanities, 1992.

Scanlon, R., P. Jones, et al. *The Arts as an Industry: Their Economic Importance to the New York-New Jersey Metropolitan Region.* New York: Port Authority of New York, and New Jersey and the Cultural Assistance Center, 1983.

Segal, A. *United Arts Fundraising 1990.* New York: American Council for the Arts, 1991.

Sternburg, J. "Views from an Unstable Landscape." *New American Film and Video Series,* Whitney Museum of Modern Art #64, (April-May 1992).

Useem, M. "Corporate Funding of the Arts in a Turbulent Environment." Nonprofit Management and Leadership, (Summer 1991).

Weaver, W. *U.S. Philanthropic Foundations: Their History, Structure, Management, and Record.* New York: Harper and Row, 1967.

Weber, N., ed. *Giving USA.* New York: AAFRC Trust for Philanthropy, editions 1988-91.

Williams, H. *The Language of Civilization: The Vital Role of Arts in Education.* Washington, DC: President's Committee on the Arts and the Humanities, 1991.

Wyman, T. *Corporations and Communities.* Washington, DC: Council on Foundations, 1988.

Wyszomirski, M. J. "Philanthropy, the Arts, and Public Policy." *The Journal of Arts Management and Law,* (Winter 1987).

Wyszomirski, M. J. "The Politics of Art: Nancy Hanks and the National Endowment for the Arts." In *Leadership and Innovation,* ed. Doig, J.W. and Hargrave, E.C. Baltimore: Johns Hopkins University Press, 1990.

Wyszomirski, M. J., and P. Clubb, eds. *The Cost of Culture: Patterns and Prospects of Private Arts Patronage.* ACA Arts Research Seminar Series, no. 6. New York: American Council for the Arts, 1989.

ARTS FUNDRAISING AND FUNDING DIRECTORIES

Bergin, R. *Sponsorship and the Arts: A Practical Guide to Corporate Sponsorship of the Performing and Visual Arts.* Evanston, IL: Entertainment Resource Group, 1990.

Blum, L. *Free Money for People in the Arts.* New York: Macmillan Publishing Company, 1991.

The Foundation Center. *Grants for Arts, Culture and the Humanities.* New York: The Foundation Center (annual).

The Foundation Center. *Grants for Film, Media and Communications.* New York: The Foundation Center (annual).

The Foundation Center. *National Guide to Funding for Arts and Culture.* New York: The Foundation Center, 1992.

Hoover, D. A. *Supporting Yourself as an Artist: A Practical Guide.* New York: Oxford University Press, 1989.

Margolin, J., ed. *Foundation Fundamentals.* New York: The Foundation Center, 1991.

Mills, C.O., ed. *Grants to Individuals,* 8th ed. New York: The Foundation Center, 1993.

Niemeyer, S. *Money for Film & Video Artists.* New York: American Council for the Arts, 1991.

Niemeyer, S. *Money for Performing Artists.* New York: American Council for the Arts, 1991.

Niemeyer, S. *Money for Visual Artists.* New York: American Council for the Arts, 1991.

Richards, G., and P. Burton, eds. *Dramatists Sourcebook: Complete Opportunities for Playwrights, Translators, Composers, Lyricists and Librettists.* New York: Theatre Communications Group, 1990.

Sarbacher, J.J. *Guide to Funding for Emerging Artists and Scholars.* Washington, DC: President's Committee on the Arts and the Humanities, 1991.

Sloper, C. L., and K. B. Hopkins. *Successful Fundraising for Arts and Cultural Organizations.* Phoenix: Oryx Press, 1989.